SCOTTISH PAINTING

1837 TO THE PRESENT

WILLIAM HARDIE

WAVERLEY
BOOKS

For Fleur and Evie

This edition published 2010 by Waverley Books,
144 Port Dundas Road,
Glasgow,
G4 0HZ,
Scotland

First edition (1976 and reprinted 1980) and second edition (1990 and reprinted as a paperback 1995) published by Studio Vista, an imprint of Cassell, London

ISBN 978-1-84934-035-9

A catalogue record for this book is available from the British Library

Printed and bound in Poland

CONTENTS

LIST OF PLATES

ACKNOWLEDGEMENTS

The present book has had a lengthy gestation. The acknowledgements made below for the First and Second Editions are as they appeared in each edition of the book and although much will have changed in the interim I would still wish to thank all those who have helped in the development of this volume from its inception.

FIRST EDITION (1976)

When it first began to take shape in my mind in 1966-67, the late Professor Andrew McLaren Young and the late Dr T.J. Honeyman gave me early encouragement, which I recall with gratitude. My original intention – to outline the response of Scottish artists (hitherto perhaps undervalued because not appraised as a separate entity) to problems of style in the period 1860-1914 – was clear enough. But any historian of that period of Scottish art soon finds himself hampered by a dearth of such primary material as dealers' records or artists' letters. As a result, it is at present difficult to reach conclusions on a number of interesting questions, such as the role of the dealers, the nature of patronage, or the theories and beliefs of some of the main artists. To the following I am therefore particularly grateful for allowing me access to manuscript material in their custody or possession, and in certain cases for permission to quote: the late Mrs M.G. Brown, formerly County Librarian, Castle Douglas, Kirkcudbrightshire, and the Trustees of Hornel House, Kirkcudbright; Mr and Mrs John Cadell; the late Dr Stanley Cursiter; Mr Ian Mackenzie Smith, Director of Aberdeen Art Gallery; Mrs Margaret Morris Fergusson; Mr Neil Foggie; Miss S. Fox-Pitt of the Tate Gallery Archive; Dr C.M. Grieve; Mrs M. Harrison; Dr Margaret McCance; Mr R.O. Mackenna, Librarian of Glasgow University; Mrs N. Mills and Mrs Helen Sandercock (granddaughters of Sir W.Q. Orchardson); Mr Denis Peploe; Miss Marjory Robertson of the MSS Department of Edinburgh University Library; Mr S. Simpson of the National Library of Scotland; Miss J. Macaulay Stevenson; Dr Ruth Waddell; the late Professor Emeritus John Walton; and Mrs J.I.C. Wilson and her father, the late Dr T.J. Honeyman.

The chief documents remain the paintings themselves. Here also, however, there are obstacles to a full study. The present whereabouts of too many once-exhibited pictures remains a mystery, and even those in public collections are often not catalogued or documented or easily seen. To the many individuals who in a public or private capacity have shown me paintings I therefore owe a very real debt, for without their cooperation and hospitality this book could not have been written.

To those collectors and institutions, acknowledged individually elsewhere, who have allowed their pictures to be reproduced here I am especially grateful.

For over a decade a few special exhibitions arranged in public galleries, by the Scottish Arts Council, and by the Fine Art Society have provided the best available opportunity of seeing Scottish painting and have been almost the sole evidence of interest in the subject. With the encouragement of Mr J.D. Boyd, my Director at Dundee City Art Galleries and Museum, I have been fortunate enough to be involved in some of these exercises in revaluation, and I am indebted to Mr W. Buchanan, Art Director of the Scottish Arts Council, and Mr Andrew Mcintosh Patrick of the Fine Art Society, and also to Mrs H. Maclean, editor of the Scottish Art Review, for permission to use material they have published in the past over my name. Much of the research embodied in this book was carried out initially for exhibitions.

The Scottish Arts Council and the Carnegie Trust for Universities in Scotland have contributed substantial grants towards the publication costs of this book, and I duly tender thanks to the Art and Literature Committees of the Council and to Professor Anthony Ritchie, Director of the Trust, and his Trustees for their generous support. My studies have been aided by research grants from the Paul Mellon Centre for Studies in British Art (London). A travel grant from the same source, added to funds made available by the English-Speaking Union of the Commonwealth and by the Corporation of Dundee, enabled me to undertake a study tour of galleries in the United States and Canada in 1973. To Professor Ellis K. Waterhouse, then Director of the Mellon Centre, Mr Ian Gilmore, Director of the English-Speaking Union of Edinburgh, and their Trustees, and to the Museums and Art Galleries Committee of Dundee I acknowledge my appreciation. It should also be recorded that Mrs Ailsa Tanner conducted extensive bibliographical research for this book at my request, and that Mr David Walker, Mrs J.I.C. Wilson, and Mr N.S. Macfarlane have shown extraordinary tolerance of my tendency to borrow for indefensibly protracted periods from their bookshelves. For a variety of kindnesses I should also like to thank Mr Stephen Adamson of Studio Vista; Mr L.A. Arkus, Director of the Carnegie Institute of Pittsburgh, Pa; Miss Elizabeth Aslin; Mr Donald Bain; Mr Roger Billcliffe of Glasgow University Art Collections; Miss Vera Black; Dr David Brown of the Tate Gallery; the Dowager Countess and the late Earl of Crawford and Balcarres; Mr and Mrs Stanley Baxter; Miss Elizabeth Cumming, Keeper of Art, Edinburgh City District Council; Mr George Buchanan, Deputy Director, and Miss Anne

Donald, Assistant Keeper, at Glasgow Art Gallery and Museums; Mr J. Davidson, formerly Curator of Perth Art Gallery and Museum; Miss Dilys Davies, Curator of Kirkcaldy Art Gallery; Mr Andrew Dempsey; Mr Brinsley Ford; Frances Hamilton; Mrs M. Harrison; Mr David Herbert of the Graham Gallery, New York; Mr Alex Hidalgo of Aberdeen Art Gallery and Museum; Professor Thomas Howarth of Toronto University; Mrs Margaret Macdonald of Glasgow University Library; Professor Alex Macfie; Mr Joseph McIntyre, Curator of the Orchar Art Gallery, Broughty Ferry; Mr Ian McNicol; Mrs Hazel Nichols; Mr Richard Ormond of the National Portrait Gallery; Miss Sybil Pantazzi of the National Gallery of Ontario, Toronto; Mr George Parks, formerly of Dundee Central Reference Library; Mr Andrew Mcintosh Patrick of the Fine Art Society; and also Mr Peyton Skipworth, Mr Simon Edsor, and Mrs Una Rota of the Fine Art Society; Mrs Emily Pulitzer of the St. Louis Art Museum; Mr J. Roussakov of the Leningrad Library; Miss Magda Salvesen; Mrs Morag Sharp; Mr Robin Spencer of St. Andrews University Fine Art Dept.; Vice Admiral Sir James and Lady Troup; Susan Waterston; and especially my wife, Gillian.

William R. Hardie,
Broughty Ferry, April 1976

SECOND EDITION (1990)

Raymond Johnstone, Chairman of Murray Johnstone Ltd., heads the list of those to whom my gratitude is due. His interest in the second edition of Scottish Painting led to his distinguished company's association with the publishers in the production of this book. That he should have found time to become involved while steering Murray Johnstone Ltd. to their present eminence as one of Scotland's most successful financial enterprises, with the chairmanship of Scottish Opera and, more recently, of the Forestry Commission and Scottish Financial Enterprise making additional demands, is to me a matter of wonder. I here record my heartfelt thanks to him. His fellow board members at the head office of Murray Johnstone Ltd. in Glasgow have also been immensely supportive and helpful at various stages: Nick McAndrew, Ross Peters, and Fred Dalgarno. At Cassell, Barry Holmes as Senior Editor has been enthusiastic, practical and professional – everything an editor should be and more – from the start of our lengthy project. Lai-Ngau Pauson has compiled the Index and Ailsa Tanner has assisted with the Bibliography. I would also thank my readers, who, in exhausting two impressions of the first edition, have provided the conditions for a second one, which permits me to amplify and modernize the text. I renew my thanks to those acknowledged in 1976, and I would like to add the names of the following for their kind assistance in various ways: the owners of pictures reproduced; the many private collectors who have so generously shared with me their delight in their treasures; Louise Annand; Eunice Bain; Richard Calvocoressi at the Scottish National Gallery of Modern Art; Dr J. Lorne Campbell; Dr James Coxson; Andrew Crawford, formerly of Christie's: Richard Demarco; Mr and Mrs M.C. Everist; the late Sir Hugh Fraser Bt.; Anne-Marie Fitzpatrick at Turnkey Computers; the Governors of Glasgow School of Art for permission to quote in full Charles Rennie Mackintosh's description of his Cabbages in an Orchard; Principal and Mrs M. Hamlin of the University of Dundee; Susan Hardie; Colin Harper: Professor J. Ross Harper; Iain Harrison; Ronald Harrison; Professor Thomas Howarth; Joan Hughson: James Hume; Margaret Cursiter Hunter; James-Hunter Blair; William Jackson of the Scottish Gallery; the late William Johnstone; Jack Knox; the Librarians of Gray's School of Art, Aberdeen, and the Edinburgh College of Art; Ian McCulloch; John Milne; the Earl and Countess of Moray; James Morrison; the Trustees of the National Library of Scotland for permission to quote from Anne Mackie's Diary; Sir Robin Philipson; Fiona Robertson, who has so capably held the fort at the William Hardie Gallery in Glasgow; Bill Smith at Robert Fleming Holdings Ltd.; George Smith; William Turnbull; the University of Glasgow (Mackintosh Collection) for permission to quote from Charles Rennie Mackintosh's 'Seemliness'; and Clara Young at Dundee Art Gallery.

Finally, to Gillie, who has contrived again and again to snatch domestic normality from the jaws of literary disruption and has encouraged me from start to finish, and to Andrew and Marion for their continued good humour – I did relish the latter's 'it's your own fault, you shouldn't have left it so long' – my very special thanks.

William Hardie,
New Lanark, April 1990

THIRD EDITION (2010)

Aberdeen Art Gallery and Museum Collections for William Dyce – *Titian Preparing to Make His First Essay in Colouring* and *A Scene in Arran*, John Phillip – *Gypsy Musicians of Spain*, Sir John Lavery – *The Tennis Party*, James Cowie – *Noon*.

Bourne Fine Art for David Roberts – *A Recollection of the Desert on the Approach of the Simoon*.

Bridgeman Art Library for Hugh Cameron – *The Italian Image Seller*, John Maclauchlan Milne – *The Harbour, St. Tropez* and John MacWhirter – *Night, Most Glorious Night, Thou Wert Not Made for Slumber*; and for permission to reproduce the following copyright paintings: *Kinlochbervie* and *The Bereaved One* by John Bellany, *The Beatles* and *Self Portrait: The Yellow Cigarette* by John Byrne, *Boy with a Basket* by Robert Colquhoun and *Still Life with a Jug of Flowers* by Anne Redpath.

Culture and Sport Glasgow (Museums) for Sir George Harvey – *Drumclog*, Thomas Faed – *The Last of*

the Clan, Sir William Quiller Orchardson – *Mariage de Covenance*, Joseph Crawhall – *The Racecourse*, William Kennedy – *The Deserter*, George Henry – *A Galloway Landscape*, Edward Atkinson Hornel – *The Dance of Spring* (inside and cover), John Duncan Fergusson – *Damaged Destroyer*, William McCance – *Conflict*.

Design and Artists Copyright Society (DACS) for permission to reproduce the following copyright paintings: *Rain on Princes Street, The Ribbon Counter* and *The Sensation of Crossing the Street, West End, Edinburgh* by Stanley Cursiter, *Mask* by William Turnbull, *My Baby Moon* by June Redfern and *Red Sandstone Cliff Study with Blue-Green Veining* by the Boyle Family.

Dumfriesshire Educational Trust for Joan Eardley – *Girl with a Squint*.

Eardley Editions for permission to reproduce the following copyright paintings: *Girl with a Squint* and *Catterline in Winter* by Joan Eardley.

Felix Rosenstiel's Widow and Son Ltd, London on behalf of the Estate of Sir John Lavery for permission to reproduce the following copyright paintings: *The First Wounded in London Hospital, August 1914* and *The Tennis Party* by Sir John Lavery.

Fergusson Gallery, Perth for permission to reproduce the following copyright paintings: *Afternoon Coffee, The Blue Hat, Closerie des Lilas* and *Damaged Destroyer* by John Duncan Fergusson.

Flowers Galleries, London for permission to reproduce the following copyright paintings: *The Stool Pigeon* by Peter Howson and *The Scottish Mercenaries* by Ken Currie.

University of Dundee Museum Services for Arthur Melville – *A Spanish Sunday: Going to the Bullfight*, Hugh Adam Crawford – *Theatre*, Robert Colquhoun – *Boy with a Basket*.

Edinburgh City Art Centre, City of Edinburgh Council for John Quinton Pringle – *Muslin Street, Bridgeton*, John Duncan Fergusson – *The Blue Hat, Closerie des Lilas*, Caroline McNairn – *In the Making*.

Fife Council Libraries and Museums; Kirkcaldy Museum and Art Gallery for Samuel J. Peploe – *Spring, Comrie*.

Glasgow School of Art Archives and Collections for Charles Rennie Mackintosh – *The Descent of Night, The Shadow, Cabbages in an Orchard, The Tree of Influence, The Tree of Personal Effort*.
Hunterian Museum and Art Gallery, University of Glasgow for David Scott – *The Russians Burying their*

Dead, Sir James Guthrie – *Causerie*, James Paterson – *Moniaive*, Edward Atkinson Hornel – *The Brook*, John Quinton Pringle – *Tollcross, Glasgow*, Frances Macdonald – *'Tis a long Path which wanders to Desire*, Margaret Macdonald – *La Mort Parfumée*, Charles Rennie Mackintosh – *A Basket of Flowers* (inside and cover).

McLean Museum and Art Gallery, Greenock, Inverclyde Council for William Clark of Greenock – *The Queen's Visit to the Clyde*, Francis Campbell Boileau Cadell – *Crème de Menthe* (inside and on front cover).

The McManus: Dundee's Art Gallery and Museum, Dundee City Council for George Dutch Davidson – *Self-Portrait, Abstract, Envy, The Hills of Dream* and *The Tomb*, Thomas Faed – *Visit of the Patron and Patroness to the Village School*, George Paul Chalmers – *Girl in a Boat* and *The Head of Loch Lomond*, Sir George Reid – *Evening*, Robert Macgregor – *The Knife Grinder*, Joseph Crawhall – *A Lincolnshire Pasture*, Thomas Millie Dow – *Sirens of the North*, James Stuart Park – *Girl with Poppies*, Stanley Cursiter – *Rain on Princess Street*, Sir John Lavery – *The First Wounded in London Hospital, August 1914*, Sir David Young Cameron – *Bailleul*, William McCance – *Mediterranean Hill Town*, Alan Fletcher – *Lamp and Pear*, James Howie – *Wait*.

Manchester Art Gallery for John Byrne – *Self Portrait: The Yellow Cigarette*.

The Earl of Mansefield, Scone Palace, Perth for Sir David Wilkie – *The Village Politicians: Vide Scotland's Skaith*.

Margaret Morris Movement for permission to include the following copyright paintings: *Les Toits rouges/ Red Roofs, Dieppe* by Margaret Morris.

Marlborough Fine Art, London for permission to include the following copyright paintings: *Resolve: In a Sea of Trouble He Tries to Scale the Wind* (inside and cover detail) by Stephen Conroy, *A Man Perceived by a Flea, To the North with Good Luck* and *The Mousetrap: A Play based on the Inability of Animals to Breed in Zoos* by Steven Campbell.

Museum of Fine Arts, Ghent/Lukas-Art in Flanders VZW for Sir James Guthrie – *Schoolmates*.

Museum of Modern Art, the Calouste Gulbenkian Foundation, Lisbon for Donald Bain – *Pleasure Craft*.

National Gallery of Scotland, Edinburgh for George Paul Chalmers – *The Legend*, Alexander Nasmyth – *Distant View of Stirling*, Robert Scott Lauder – *Christ Teacheth Humility*, Sir Joseph Noel Paton – *The Quarrel of Oberon and Titania*, David

Scott – *Philoctetes left on the Isle of Lemnos by the Greeks on their Passage towards Troy* and *Vintager*, Sir David Wilkie – *The Letter of Introduction*, Sir George Harvey – *The Curlers*, John Phillip – *A Presbyterian Catechising* and *'La Gloria': A Spanish Wake*, James Archer – *Summertime, Gloucestershire*, William McTaggart – *Spring, The Sailing of the Emigrant Ship, The Coming of Saint Columba* and *The Storm* – Sir James Guthrie – *A Hind's Daughter*, Edward Arthur Walton – *Bluette*, William York Macgregor – *The Vegetable Stall*, David Gauld – *Saint Agnes*.

National Trust for William Bell Scott – *Iron and Coal on Tyneside in the Nineteenth Century*.

National Trust for Scotland for John Faed – *A Wappenschaw*.

Perth Museum and Art Gallery, Perth and Kinross Council for Tom Graham – *Alone in London*, William Baillie of Hamilton – *Painting*, John Laurie – *The Cocktail*, Donald Bain – *Ossian*.

Portland Gallery, London for permission to reproduce the following copyright painting: *The Harbour, St. Tropez* by John Maclauchlan Milne.

Royal Collection, Buckingham Palace and Her Majesty Queen Elizabeth II for Sir David Wilkie – *The Penny Wedding*.

Royal Holloway and Bedford New College, Surrey, UK for John McWhirter – *Night, Most Glorious Night, Thou Wert Not Made For Slumber*.

Royal Scottish Academy (Diploma Collection) for Robert Gemmell Hutchinson – *Shifting Shadows*, Sir James Guthrie – *Midsummer*.

Scottish National Gallery of Modern Art, Edinburgh for Steven Campbell – *A Man Perceived by a Flea*, William Johnstone – *A Point in Time*, Edward Baird – *The Birth of Venus*, William Crosbie – *Heart Knife*, Alastair Morton – *Untitled*, Sir William MacTaggart – *Poppies Against the Night Sky*, Margaret Morris – *Les Toits rouges/Red roofs, Dieppe*, Donald Bain – *The Children of Llyr*, Joan Eardley – *Catterline in Winter*, Alan Davie – *Jingling Space*, William Johnstone – *Celebration of Earth, Air, Fire and Water*, John Bellany – *Kinlochbervie* and *The Bereaved One*, June Redfern – *My Baby Moon*.
Swindon Art Gallery for William Turnbull – *Mask*.

Tate for William Dyce – *Pegwell Bay: A Recollection of October 5th, 1858*, Ken Currie – *The Scottish Mercenaries*.

Yale Center for British Art for George Henry– *Blowing Dandelions*.

The following paintings are to the best of our knowledge still held in private collections and we are grateful to all the owners who have given their permission for us to reproduce their paintings in the past and to those we have been able to contact for this edition. In some instances, and with our apologies, we have not been able to identify the current owners and we would be happy to hear from any who may wish to be acknowledged should we decide to publish a new edition in the future.

Where possible we have acknowledged the copyright holders of any copyright paintings in private collections on the same page as the image but all works in copyright are copyright © the artist or the artist's estate.

Yellow, Pink and Red Roses by James Stuart Park
A Recollection of the Desert on the Approach of the Simoon by David Roberts
Roger, Jenny and Peggy by William Bonar
The Last Dance and *The Morning Call* by Sir William Quiller Orchardson
The Italian Image Seller by Hugh Cameron
An Unrecorded Coronation by Charles Martin Hardie
Good King Wenceslas by Alexander Roche
Japanese Dancing Girls by Edward Atkinson Hornel
West End of St Vincent Street, Glasgow by Thomas Corsan Morton
Boultenère by Charles Rennie Mackintosh
Afternoon Coffee by John Duncan Ferguson
Boats at Royan and *Roses in a Blue Vase* by Samuel John Peploe
The Sensation of Crossing the Street, West End, Edinburgh and *The Ribbon Counter* by Stanley Cursiter
Still Life – Lobster on a Blue and White Plate and *House Boats, Loch Lomond* by George Leslie Hunter
The White Room by Francis Campbell Boileau Cadell
The Admiral's House, Tangier by Alexander Graham Munro
The Harbour, Saint-Mâlo by John McNairn
Boatyard, Charleston and *The Bedroom* by William McCance
Abstract by William Johnstone
Harvest Moon by John Maxwell
Still Life with a Jug of Flowers by Anne Redpath
Disobedient Jane at Elie and *Homage to Demeter, Provence* by Sir William Russell Flint
New Art Club Meeting by Louise Annand
Rondo by William Bunting
Bright Morning by David Donaldson
Children's Tale by David McClure
Intérieur by William Gear
The Beatles by John Byrne
The Stool Pigeon by Peter Howson
To the North with Good Luck and *The Mousetrap: a Play based on the Inability of Animals to breed in Zoos* by Steven Campbell
Theresa's Place by Fionna Carlisle.

PREFACE

During the hundred years from the beginning of the Victorian era in 1837 to the outbreak of the Second World War in 1939, Scottish artists made a lively and varied contribution to British painting. Particularly from about 1860 to 1914, painting in Scotland developed an individual character which is especially marked in the work of three successive generations of painters represented by William McTaggart and his friends trained in Edinburgh in the 1850s, the Glasgow School painters, who emerged in the early 1880s, and the small but influential group of J.D. Fergusson and the Scottish Colourists, who reached maturity in the early part of the twentieth century. I have therefore given proportionately greater attention in the following chapters to the period of little more than fifty years from the middle of Victoria's reign until 1914, during which the individual flavour of Scottish painting was at its most pronounced. When the Glasgow School painters made their London debut alongside some of their older compatriots such as Orchardson and Pettie at the Grosvenor Gallery exhibition of 1890, *The Times* reviewer of the exhibition was able to discern in the work of these Scots 'a kind of family likeness' which seemed to him to indicate 'that existence of common tradition and common methods which constitutes a school of painting'. In attempting to evoke that likeness, I have tried to strike a balance between what is typical and what is not, and between what is familiar and of acknowledged importance and what is less well known but often of equal interest. My hope has been to provide a résumé of the best Scottish painters of the period, but it should be added that I have tended to prefer work by a painter or a group who began excitingly but fell away later to work which is competent but dull.

Sir John Rothenstein commented in his *Modern English Painters* on the dearth of writing about English art of the later nineteenth and earlier twentieth centuries. This applied with even greater truth to Scottish painting of the same period. Such a situation provides *a raison d'être* for the present volume, which describes the development of certain fairly well-defined movements in Scottish painting without attempting the detailed account of the careers of numerous artists, or of artists of other periods.

The publication of the second edition of the book provided a welcome opportunity for a necessary enlargement of the existing text together with the addition of three new chapters and as a result, the volume was more than twice the length of the

original. Some might have said that it was too long, others, including the author of course, that it was still too short. The book was never intended to be an encyclopaedia, and although that might have been one way of solving problems of balance and content, it would have meant sacrificing the narrative thread. My method has been to try to trace the elements which have gone into the formation of an artist's style. I believe that the processes by which an artist first arrives at maturity and individuality often – though not always – provide the key to later productions as well. Hence a tendency throughout the book to concentrate on earlier work.

The chapters on The Glasgow School, the Fin de Siècle, and Between the Wars were substantially rewritten for the second edition and three final chapters added to bring the story to a more resounding conclusion than was permitted by the earlier, decidedly downbeat, terminus of 1939. It was a satisfaction to publish several interesting documents which shed new light on important areas, notably Macaulay Stevenson's *Notes towards a History of the Glasgow School,* Anne Mackie's *Diary,* which includes an account of a visit paid to Gauguin, and some letters written by Stanley Cursiter about his Futurist paintings of 1913.

Subsequent years have seen the publication of the short illustrated monographs on *Modern Scottish Painters* published by The Edinburgh University Press and Edward Gage's survey of contemporary Scottish painting which he titled *The Eye in the Wind;* Billcliffe's invaluable studies on C.R. Mackintosh and the same author's contributions to the literature of the Glasgow Boys and the Colourists; monographs by other authors on Dyce, Crawhall, Cadell, Redpath, Eardley, Walton, Russell Flint and Blackadder; and autobiographies by William Johnstone and Benno Schotz, together with an extensive list of exhibitions with useful catalogues. Among the most important of these were *Tribute to Wilkie, Master Class,* and *William McTaggart* at the National Gallery of Scotland, and *Scottish Art since 1900.* I tried to reflect as much as possible of all this in the revisions to the Bibliography. The absence of footnotes was decided on for the first edition, and those interested in the primary sources used should consult the Bibliography, where I have tried to list them all.

With the publication of this, the third edition of Scottish Painting it is hoped that a new generation will enjoy it afresh. Since the second edition was published, we are both more and less 'Scottish'.

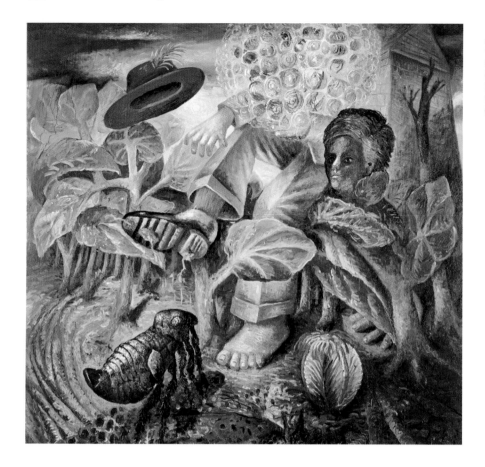

1 Steven Campbell
A Man Perceived by a Flea
1985
Oil on canvas, 272 x 242 cm
Scottish National Gallery of
Modern Art
Courtesy Marlborough Fine Art,
© The Estate of Steven Campbell

There is now a devolved Scottish Parliament, but artists have perhaps more of an international view than ever before. Other capitals vie with London and New York and gone, emphatically, are the days when it was enough to conquer at home.

With the dominance of the Schools of Art has come a new academicism of the *avant-garde*. In Scotland, there has been an equal and opposite reaction, and many painters and collectors have nostalgically preferred a kind of *gesamtkunstwerk*, manifestly Scottish in vigour, colour and dependence on the Scottish Colourists, whose work is so fashionable today. An antidote to this common appropriation of landscape and still life was provided by the remarkable figure painter, the late Steven Campbell.

Painting has temporarily been in abeyance, in a welter of Performance, Conceptual, or Installation Art. Art it may be, but it is clearly not painting. I hope my readers will indulge this book's partiality to that field of art. While painters like Jenny Saville or the Glasgow- and Edinburgh-trained Richard Wright, the 2009 winner of the Turner Prize, are around, 'Painting' is very much alive in Scotland. Wright's huge gold-leaf mural has not come a moment too soon.

INTRODUCTION

It might be expected that a small nation lying on the Atlantic fringes of Europe, remote from the continental sources of style but inextricably if not always amicably linked to its southern neighbour, would develop qualities both independent and derivative, with the latter perhaps predominating. Scotland's contribution to the arts, reflecting her long but often turbulent past in which for centuries stability and prosperity could hardly ever be taken for granted, bears this out. Beginning about the year 397, when St. Ninian founded a monastery at Whithorn in Galloway, and especially after the arrival of St. Columba and his missionaries on the Hebridean island of Iona in the year 563, Scotland echoed the Celtic, Norman, and Gothic phases of Christian art, usually belatedly. Her sculptured stones and illuminations and her abbeys and cathedrals show successive Irish, Anglo-Norman, or Anglo-French influence, often interpreted with power and conviction, but containing little enough that is *sui generis*. The great *Book of Kells*, probably executed on Iona, shows a dominant Irish influence, and only the still-unelucidated symbol stones and sculptured cross slabs of the Picts represent a high level of indigenous art, but one which had no sequel beyond the Dark Ages. It is to the much later vernacular architecture of Scotland, from the medieval castles and keeps of the feudal aristocracy to the stone houses built for gentry and burgher in the sixteenth and seventeenth centuries, that one must look to find the beginnings of a tradition as native as the early works in dialect to which can be traced the origins of Scottish literature.

The Reformation in Scotland deprived painting of the patronage which at its most enlightened had brought to Edinburgh the *Trinity Altarpiece* by Hugo van der Goes at the end of the fifteenth century. However, by the time of the Union of the Crowns of England and Scotland in 1603 under James I and VI, son of Mary, Queen of Scots, the taste of the Stuarts and a few aristocratic houses for the secular graces of life had begun to bear fruit, as the palace of Linlithgow (completed in James V's reign) and the walled garden pleasance at Edzell Castle (completed in 1602) testify. But seventeenth-century England, rather than Scotland, was to be the scene of the great period of Stuart patronage. A remodelling of the Edinburgh palace of Holyroodhouse was the largest royal commission received by the distinguished Scottish contemporary of Wren, Sir William Bruce (1630-1710). The removal of the Scottish court to London in 1603 meant a considerable loss of artistic patronage in Scotland, and partly explains the attractive unpretentiousness of the best local work of the period, particularly in architecture, as well as the feeble condition of painting at the same time.

In Scotland as in England, easel painting in the seventeenth century was chiefly the preserve of Flemish-influenced portraitists, the earliest of whom was the Aberdeen-born George Jamesone (1587?-1644). Jamesone had an extensive but not very lucrative practice in Aberdeen and later in Edinburgh, and his apparent prosperity at his death may have been due to being involved in picture-dealing – a possibility suggested by his *Self-Portrait* (collection Earl of Seafield) posed against a background of pictures. In the century and a half from Jamesone's time until Raeburn's return to Scotland from Italy in 1787, during which Italian taste eclipsed Flemish, the best Scottish painters almost invariably left Scotland for long periods to work as expatriates, like Gavin Hamilton (1723-98) and Jacob More (1740-93) in Rome, or Allan Ramsay (1713-84) in London. The most famous of the architects who undertook the Italian journey and then practised in London was Robert Adam (1782-92), who in a letter of 1755 gave succinct reasons for not staying at home: 'Scotland is but a narrow place. [I need] a greater a more extensive and more honourable scene, I mean an English Life.' A training abroad followed by residence in London was still the normal pattern for Scottish artists who wished to be successful.

Although it produced a further concentration of patronage in London, the Act of Union of 1707, which united the Parliaments of England and Scotland, left virtually untouched such important attributes of national identity as the Scottish judicature and the body of Scots Law, the ancient universities of St. Andrews, Aberdeen, Glasgow and Edinburgh, the Kirk, the parish schools, and the Scottish army regiments. Its great benefit to Scotland was that for the first time for centuries a basis now existed for the development of a stable and prosperous community. Above all, freedom of trade, encouraged by the Act and given an internationalist direction by Adam Smith's *The Wealth of Nations* (1776), had a gradually invigorating effect on the Scottish economy. Government-sponsored instruction in design-related subjects was instituted in Edinburgh with the foundation of the Board of Manufactures in 1727, although painting was not taught at the Trustees'

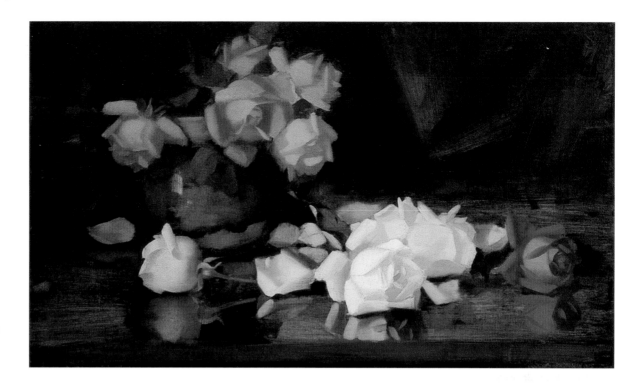

2 James Stuart Park
Yellow, Pink and Red Roses
c. 1888
Oil, 46.50 x 76.50 cm
Private collection
One of the small group of
flower paintings of 1888-89 that
form Park's contribution to the
decorative style of the Glasgow
School.

Academy until the end of the eighteenth century and the exodus of Scottish artists from Scotland continued. However, the last quarter of the century witnessed a remarkable upsurge in the cultural life of the country – Robert Burns and Sir Walter Scott in poetry and the novel, David Hume in philosophy, and Raeburn in painting – which was owed to the new prosperity, or rather to the more evolved and sophisticated society which it helped create. By the beginning of the nineteenth century, especially in Edinburgh, where the Adam contributions to the New Town had been built by 1800, most of the necessary preconditions for the foundation of a national school of painting were at last present.

Only one factor was missing: the existence of a sustaining native tradition. This could not be supplied overnight. Scottish painting of the first half of the nineteenth century still tended to look to London or Rome or even Madrid for inspiration, even if Velazquez reminded David Wilkie (1785-1841) of Raeburn, or if Wilkie himself seemed to many of his fellow Scots the chief ornament of contemporary English painting. The nineteenth-century Scottish school owed much to Raeburn and Wilkie, but in a limited sense only. Their individual importance as the most eminent and successful Scottish artists of their respective eras brought them numerous imitators, but their influence on their more progressive successors (as distinct from followers) was slight or transitory. Raeburn's technique was much admired but its relevance was chiefly to portraiture and his followers (with the exception of the young Wilkie) were on the whole craftsmen who lacked his artistry. Wilkie's, on the other hand, produced a type of rustic or historical genre which was easily trivialized

and it had an unhappy influence on a good deal of subsequent Victorian painting, English and Scottish (as did his unsound later use of asphaltum).

In fact, the most interesting of the Scottish painters who came to prominence in the years between Queen Victoria's accession in 1837 and the rise of the Scott Lauder group in Edinburgh about 1860 – the post-Wilkie generation – are those whose mature styles show little or no Scottish influence as such: David Scott, William Dyce, Noel Paton, Scott Lauder, and the later John Phillip. These artists spent important formative years outside Scotland – in Rome or in London – and the professional careers of Dyce. Lauder, and Phillip belong largely to the history of painting south of the Border. Later, when Pettie and Orchardson and others in the 1860s went to live in London, they were already equipped with a Scottish training which had a fundamental and lasting influence on their work. Prior to about 1860, then, there had indeed been Scottish painters, but not a readily identifiable Scottish style, whereas after that date a few of the more forward-looking artists in Scotland adopted methods significantly different from those current elsewhere in Britain. In addition, a measure of stylistic cross-fertilization and self-propagation was reached and sustained which allows Scottish painting of the period 1860-1914 to be seen as a distinct species, its blooms often short-lived and tending to reticence, and occasionally showing some want of cultivation, but nevertheless possessing an identity and character of their own.

Within that period, the Scottish school is a school of little masters in which the whole is greater than the sum of its parts. Some of them, indeed, are essentially *homines unius imaginis,* men of one picture. Stuart

Park, for example, would seem relatively insignificant were it not for his *Yellow Roses* now in Glasgow Art Gallery, painted in 1889 when the artist was twenty-seven. Equally, it is somehow characteristic of the cultural climate in Scotland in the nineteenth century that the creative years of several of her best painters were relatively brief, and usually occurred in the earlier part of an artist's career. David Scott (1806-49), Thomas Duncan (1807-45), George Paul Chalmers (1833-78), Arthur Melville (1858-1904), and George Dutch Davidson (1879-1901) all seem to have died too young, while the Glasgow School painters' best work was done in little more than a mere decade between 1885 and 1895 whereupon bathos rapidly supervened. Anything approaching an *avant-garde* in Scotland never quite found the strength or the encouragement it needed to take firm root, and much of the best painting was the product of a youthful originality which was all too soon nipped in the bud. Often, it is not hard to imagine how this happened. Reading the lengthy correspondence (preserved in the National Library of Scotland) between George Paul Chalmers and the patient and discerning Dundee collector G.B. Simpson in 1864-65, which refers to the painter's difficulties in composing

The Legend (never quite finished and now in the NGS), one becomes aware of the penalty paid by a talented artist for his isolation from enlightened, as opposed to well-meaning, patronage and the contact of intelligent colleagues in an artistic backwater. Had Edinburgh only been Paris! Perhaps Chalmers might have discarded his tonal palette and experimented with an optical mixture of colours on the canvas; perhaps we should have had McTaggart paint the steam locomotives in Waverley Station and life in Edinburgh as well as the Scottish coast and countryside; perhaps Orchardson would then have painted the contemporary London theatre of which he was so fond, instead of wasting his talents on factitious *Directoire* costume pieces.

Yet unexpected parallels with contemporary developments in Europe do sometimes arise in the work of the more adventurous younger Scottish artists in the latter half of the nineteenth century. Those youthful phases did not, of course, consciously aspire to the condition of advanced painting in Paris (or later, in Munich or Vienna), but rather offered independent and less complete solutions to somewhat similar problems. McTaggart's canvases bring us as close to the spirit of Impressionist landscape as

3 George Paul Chalmers
The Legend
Begun about 1864-67
Oil on canvas, 103 x 153 cm
National Gallery of Scotland

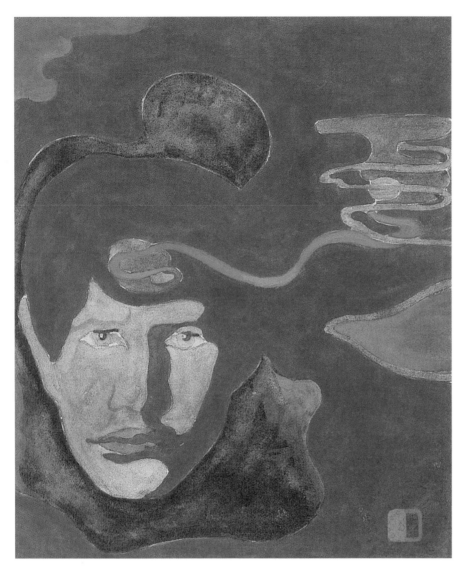

4 George Dutch Davidson
Self-Portrait
1898
Watercolour, 30.50 x 25.40 cm
Dundee Art Galleries and
Museums (Dundee City Council)
This psychoanalytical portrait
seems to situate the eighteen-
year-old artist in an aerial plan of
the Tay Estuary, where he lived.

the work of any other British painter, although his son-in-law tells us that he did not see a work by Monet until 1902. Certain pictures by the Glasgow School and their contemporaries contain elements of Symbolism or Expressionism, others are reminiscent of the Nabis, and contacts (albeit rather tenuous ones) can be shown to have existed between the Scots and Gauguin, Van Gogh and Sérusier. John Duncan's *Evergreen* illustration *Surface Water* (1896) and Georges de Feure's lithograph *La Source du mal* (1897); George Dutch Davidson's *Self-Portrait* (1898) and Edvard Munch's lithograph *Im Menschenkopf* (1897); J.W. Herald's crinoline ladies of the nineties and Kandinsky's *Lady with Fan* (Roethel 2; 1903) are only three instances of a sometimes striking parallelism. J.D. Fergusson both looks and was a member of the post-Cubist school of Paris, and represents the conscious francophilism of a later generation of painters. In a few of the works of artists such as these, Scotland contributes a marginal gloss to the European canon.

Comparisons of this kind are, however, only rarely appropriate, because on the whole Scottish artists

remained remote from the European *avant-garde*. Much more representative of the everyday tenor of Scottish painting was and is the Royal Scottish Academy (founded in Edinburgh in 1826 and granted the royal charter in 1838), whose period of greatest authority lasted until the 1860s. Modelled on the Royal Academy, the Royal Scottish Academy's chief *raison d'être* was its annual exhibition; until 1858 (when a Treasury minute made it responsible for a Life Class) it appears not to have seriously rivalled the government-sponsored Trustees' Academy as a teaching institution. This was founded in 1760 in Edinburgh, but from the headmastership of William Allan in 1826 its posts were held by Academicians. The RSA thus filled a crucial role from its inception as the main channel of patronage and, less directly, as an influence on style and taste. Its spirited early struggle for existence, its popularity as 'the most fashionable lounge in Edinburgh', the fact that its early membership constituted a roll of the best painters in Scotland, and its usefulness to struggling young artists, made it widely respected by artists and laymen alike. It was to set the tone of Scottish painting until the middle of Victoria's reign, when its tenets began to be questioned.

The architect C.R. Cockerell, writing to his friend William Dyce in 1838 to console him on the failure of his candidature for Associateship of the Royal Academy, refers to 'an old superstition that "when we shall have five Scotchmen in the RA of London, it will be a Scotch Academy"'. Partly perhaps from necessity, the early Victorian painters in Scotland were convinced supporters of the academic system; and they show what that system, in a state of innocence, was capable of producing. The provincial situation of Edinburgh seemed for a while to foster talent rather than to inhibit it; local artists – those who did not go to London – were concerned and often content with local reputations; and from the 1830s onwards the RSA exhibitions contained pictures which ranged from David Scott's ambitious and imaginative essays in the grand manner to the native genre of George Harvey (1806-76) and the Scottish landscapes of Horatio McCulloch (1805-67). It is typical of the devotion of the RSA in its first decades to serious and sensitive craftsmanship even in a novel medium that the Secretary of the Academy from 1830 to 1869 was the pioneer photographer D.O. Hill. Were the pictures of the era immediately after Wilkie in Scotland more easily seen – and many of them have disappeared – it is quite likely that they would prove more interesting than we generally allow today. Their influence on the next generation of artists was limited to the more incidental aspects of national style, such as themes taken from Scottish history or literature. But the RSA itself broke valuable ground in gaining a wider audience for painting in Scotland, and in emphasizing the virtues of sound craftsmanship. The sheer professionalism of

much nineteenth-century painting in Scotland is largely due to the stimulus provided by the early exertions of the Academy. 'The never-failing dexterity of the Scotch' (in Ruskin's words) became something of a commonplace of later Victorian art criticism as a result.

In the 1860s, however, attitudes to the Academy and to what it represented changed subtly. When William McTaggart became an Associate of the RSA in 1859 his father had advised against acceptance with the words 'you are better to be free'. According to his biographer McTaggart later regretted having accepted. In the previous year control of the Trustees' Academy passed into the distant hands of the Department of Science and Education at South Kensington; Scott Lauder was the last Master under the old regulations, and the change seems to have been to the detriment of the academic instruction available to artists in Edinburgh, or at the very least to have offered nothing to challenge the rising attractions of study elsewhere, especially in France. With the foundation of the Glasgow Institute of the Fine Arts in 1861 the RSA's virtual monopoly of large annual exhibitions was at an end. To make matters worse, the Academy began to adopt a position which made it difficult for Glasgow artists to become members, culminating in open hostility between it and the young men of the early Glasgow School in the 1880s.

The Glasgow School's most vital period coincides with the time of its strongest antipathy towards the RSA, and it is worth remarking that this anti-academic feeling resulted not only in new exhibiting habits, but also in a novel approach to the training of the artist. The life classes held in Glasgow in W.Y. Macgregor's studio seem to have resembled the more informal kind of Paris atelier, and were an important factor in cementing a group style among the young artists who attended them. But it is equally noteworthy that many of these artists later became Academicians, a reminder that in the context of Scottish painting the word 'independent', meaning anti-academic, must be used with caution. Yet it can begin to be applied to the early eighties in Glasgow, well before the nugatory 'London Salon of the Independants' (*sic,* the French spelling unnecessarily emphasizing its origin) which J.D. Fergusson and others (including Alexander Jamieson and Charles Rennie Mackintosh) attempted to re-start at the end of the First World War. The gradual rise of this independent strain gives to Scottish painting of that time its own leaven of individuality. At its most general, this can be equated with an increasingly complete departure from academic technical procedures involving high finish and imitative drawing. Gradually too, conventionally sentimental subject-matter of the sort associated with the Academy was abandoned.

'Painterliness' – a consistent reliance on the expressive possibilities of the brushstroke and on the beauties of the medium of oil paint itself – is a notable characteristic of the work of many of the Scottish artists discussed in this book. It is precisely this quality which enables Orchardson and Pettie in their best pictures to walk the difficult tightrope of genre, as Wilkie had done before them, with an indefinable balance of delicacy and strength usually lost in reproduction and forgotten in the rush to label these painters 'literary'. Although in other technical respects they and their contemporaries differ from the artists of the Glasgow School as much as the Glasgow School differs from the Colourists, it is possible to distinguish a continued predominance of the painterly mode in each of these phases of Scottish art. The national taste seems to have been for the well-made article, in terms of oil pigment which declares its own natural properties and is rarely illusionistically disguised or, at the other extreme, used as a mere vehicle of anecdote or theory.

It is tempting to wonder whether the conspicuous materiality of Scottish painting may be linked in some way with the Scots' apparent feeling for the sister discipline of architecture (and indeed for naval architecture and engineering) in the same period. But before invoking a hypothetical Scottish collective unconscious which would prefer concreteness to abstraction and the working definition to the general theory, it is as well to bear in mind that 'inhabitable sculpture', as architecture has been called, has precisely the economic and social advantage over sculpture that it is inhabitable. Sculpture has long made rather a poor showing in Scotland, except as commemorative portraiture or architectural ornament. On the other hand, a significant contribution was made by Scottish architects and designers to the succession of styles in Britain from Gothic Revival (J. Bruce Talbert, 1838-81) and Victorian neo-Greek (Alexander 'Greek' Thomson, 1817-75), via Aestheticism (R. Norman Shaw, 1831-1912) and the Art Nouveau (George Walton, 1867-1933) to the Modern Movement (Charles Rennie Mackintosh, 1868-1928). Indeed, the most considerable figure of the whole period now appears to us to have been not a painter, but an architect, Charles Rennie Mackintosh, whose work combines independence of thought and respect for traditional materials in a way that is wholly although not exclusively Scottish.

Nineteenth-century Scottish architecture indicates by its rich variety the vigour of a society based on flourishing commerce and ever-accelerating industrial growth. Throughout the Victorian and Edwardian eras Scots played a full part in the development of Britain as the industrial centre of the Empire, and in the development of the Empire itself. Queen Victoria's attachment to Scotland was in the main fervently reciprocated, as well it might be, since the Scottish cities, particularly Glasgow, had never seen such prosperity as resulted from the Union under her reign. Yet although nineteenth-century Britain was

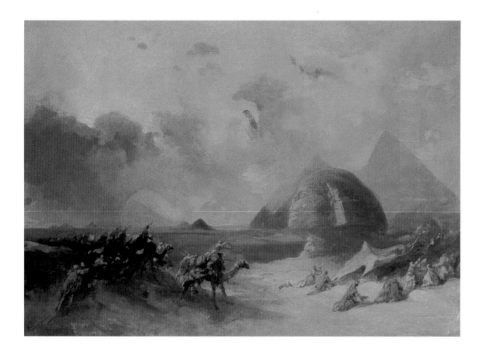

5 David Roberts
*A Recollection of the Desert on
the Approach of the Simoon*
1850
Oil on panel, 33.60 x 50.10 cm
Private collection
Image courtesy of Bourne
Fine Art
The artist inscribed the back
of the painting: 'Presented to
Charles Dickens Esqre as a
mark of respect and admiration
for his talent and work by his
very sincere friend and admirer
David Roberts Jan 1850.' The
composition was first published
in Roberts's *Egypt, Syria and the
Holy Land, 1846-50*.

pre-eminently an industrialized community one would hardly guess so from Scottish painting or literature of the period. In England the contemporary school of painting was accompanied by remarkable achievements in literature, particularly in the novel, and some painters such as the St. John's Wood Clique and writers like Dickens did indeed deal with the new realities of modern life. This was not paralleled in Scotland, where an Arcadian rusticity was the staple commodity of many genre painters and of the 'kailyard' schools of novelists and poets. If one can judge by the importance of the results, the Scottish intellect seemed to find its most characteristic expression in the area of technology and the physical sciences. Here it can be noted that some of these achievements include the civil engineering projects of Thomas Telford (1757-1834), one of which Sir Walter Scott regarded as the greatest work of art, and the Forth Rail Bridge (1890); Henry Bell's Comet (1812) and the *Cutty Sark* (1869); the work of James Clark Maxwell (1831-79) in telegraphy, optics, and X-rays and Lord Kelvin's restatement in 1851 of the Second Law of Thermo-dynamics. From the twentieth century one can cite Frederick Soddy's description of the properties of the isotope in 1913; the Clyde-built liners *Queen Mary* (1934) and *Queen Elizabeth* (1938); John Logie Baird's work on television in the 1920s and Watson Watt's development of radar during the Second World War. In all these examples, chosen at random, there is a notable absence of metaphysical speculation; intellectual inquiry is directed to physical problems and inventive energy to practical results. But if Scottish culture during the period discussed was quintessentially materialistic, it evidently was not devoid of vitality and originality nor was it without influence on the shaping of the modern world.

With the sole exception of William Dyce, Scottish artists had little or no direct contact with scientific advance, or apparent interest in it. Significantly, it was left to a French artist, Camille Pissarro, to refer in a famous letter of 1886 to Durand-Ruel to the relevance to contemporary painting of the colour experiments of Dyce's relative Clark Maxwell and others.

On the other hand, had Scottish patrons shown more willingness to regard painting as being susceptible to the tests of intelligence as well as to those of sensibility or sentiment, there might have been greater evidence in the work of the painters of real involvement with the main currents of thought of their own time. But science and art were out of touch with each other and their very polarity partly accounts for the presence of a mood of escapism or fantasy in Scottish art of the period.

The widespread belief that 'beauty', which was often mentioned but never conclusively defined, was the artist's chief goal was pernicious to much Victorian art because it led to a confusion of aims. The achievements of Victorian engineering might have suggested that engineers, and perhaps painters too, are more likely to create at a high aesthetic level when they submit to the physical disciplines imposed by their materials rather than when they endeavour self-consciously to realize a concept of beauty. The best of Victorian and Edwardian Scottish painting has a certain plastic emphasis which parallels the approach of those engaged on the other side of the cultural divide.

The Modern Movement in painting, as in architecture, has led 'away from representational values (historicism in architecture is only representation in another guise). Dadaism and Surrealism in Europe (with their frequent use of collage or readymades which allowed real objects to be incorporated into paintings and even sculpture, suggesting the artificiality of the division between art and reality), fundamentally changed the techniques and procedures of art, sometimes blurring the old distinctions between the different disciplines of painting, sculpture, printmaking and photography. Cubism and its offshoots connect ultimately with Realism in the classic succession of Courbet–Cézanne–Picasso; Surrealism adds dreams to the artist's subject matter; but abstract painting in Europe and America introduces radically new thematic material as well as new techniques. The post-war dominance of abstract and conceptual art led to a situation where the linguistics of art were becoming more important than what it had to say. Such extensions of the parameters of art possess their own logic, but they have seemed to some to offer only a *reductio ad absurdum*, at best a diversion from traditional methods and concerns. Hydra-headed Modernism (abstraction, Pop, colour field, Op, Tachisme, minimal, conceptual art) in the belief of some artists of the eighties, had had its day.

The best one could make of it was to teach it at an art college; the public collections were full of it and did not want any more, and the art galleries could not sell it even to them. The fact that the galleries which presented modernist work in Scotland were with the honourable exception of the Scottish Gallery almost to a man non-profit-distributing companies limited by guarantee – in other words, in enjoyment of charitable status – spoke for itself. Pluralism had arrived. In another form, it provided patronage through the exhibitions and purchases of the public galleries on an unprecedented scale. The new bureaucracy provided welcome support for uncommercial work, but it sometimes failed to discern that not all 'difficult' art is good art.

Writers on art are often justly accused, by artists as much as anyone else, of employing terms which cast an air of spurious intellectualism, pretentiousness or preciousness – and sometimes all three – over the subject. Problems arise when attempts are made to reflect the social, political, psychological, and historical aspects of art in a vocabulary which loads words with an unbearable weight of would-be significance.

We are too often confronted with a word which, like a cuckoo in the nest, is more imposing than helpful. 'Eidetic imagery' only means image-imagery; 'pluralism' can mean anything from public-with-private to abstract-with-concrete; 'post-painterly-abstract' and 'post-modernist' are manifestly absurd; 'post-modernist consensus' or the lack of it is a chimaera, a will-o'-the-wisp, which has something to do with whether or not the ivory tower is believed by its occupants to be haunted. 'Trans-avant-garde' is not a place imagined by Bram Stoker, although it is true that Van Helsing, the mild-mannered doctor who disposes of Dracula, has appeared in paintings by one of the Scottish trans-avant-garde, Steven Campbell. 'Trans-avant-garde', incidentally, means roughly the same thing as 'post-formalist'.

Yet these and similar neologisms, frequently used in discussions of Scottish painting of today, reflect the search for new modes of expression which inevitably take account of the developments of the past, especially the recent past, and therefore are equally inevitably post-something or other: post-structuralist, post-conceptual, even post-painting. New Image painting in Glasgow was indeed eidetic in the sense of dealing in strong, memorable images, which reassert the importance of the human figure and human action. This return to centre stage of the theme of humanity after decades of formal experimentation is sometimes called post-formalist. On the other hand, non-figurative painting, as we have seen, historically divides into two modes, the geometrical and the painterly; and in more recent Scottish painting certain artists, many of them connected with the 369 Gallery in Edinburgh, continued within the traditions of painterly abstraction – although their work frequently had a figurative basis.

Although the recognizable Scottish hallmarks of strong colour and vigorous brush work were continued in the work of the 369 artists in Edinburgh, it is the Glasgow artists who mirrored the social and psychological realities of modern Scotland.

New Image Glasgow was the apt title of an exhibition at the Third Eye Centre in Glasgow in 1985. The city was undergoing a period of far-reaching change as it attempted to slough off the accumulation of decades of industrial stagnation and the sooty patina which was its visible symbol. The erection in the early eighties of exciting new buildings to house the Hunterian Art Gallery at the University and the Burrell Collection in Pollok Park was a sign, literally as well as metaphorically, of a better atmosphere. Sir William Burrell's stipulation of a site outside the city had been able to be waived by his Trustees as an anachronism, since the estate gifted by the Stirling Maxwell family was centrally located in a city whose air was now clean enough to pose no threat to Sir William's great collection of tapestries. In terms of cultural provision the city had never been livelier. Music, the theatre, the ballet and the opera were in a thriving condition. Mixed-economy funding, a determination at City Chambers to get things done in co-operation with business or central government despite political differences, and an evident public desire for a city of which its inhabitants could again be proud: all these factors determined the course which led to Glasgow's accolade as European Capital of Culture in 1990.

The demise of the old skilled labour-intensive industries had left swathes of unemployment in some of the largest housing estates in Europe whose bleak architecture, reminiscent of East Berlin, could no longer be indulgently viewed as the aberration of post-war utopianism. The glamorous restoration of Glasgow's architectural splendours co-existed with inner-city deprivation. Those who experienced the latter found themselves as much stranded by economics as those who lived in the estates were physically separated from the good things that were happening in town. A local government responsible for institutions of national importance cannot be blamed if its first thoughts are for the neediest of its own constituents. The concern continues and so must the transformation which had already achieved so much. In this contemporary dilemma Glasgow may be seen as a microcosm of Scotland – and of conurbations anywhere in the world where man aspires to live by more than bread alone.

Since the above was written, politically driven painting has been espoused by the artist and film-maker Ken Currie, whose trade unionism and anti-Thatcher position have struck a chord in the Scotland of Red Clydeside and the Red Road Flats, the poll tax and unemployment. This is political painting with an edge not seen in the effete renderings of Erskine Nicol, Sir John Lavery and

Sir D.Y. Cameron; and, be it said in passing, Currie is a beautiful draughtsman. Peter Howson too has specialized – guided to who knows what extent by the Asperger's Syndrome in his psyche – in the world of the deprived and the violent and it is no accident that he was in Bosnia as a war artist when the Balkans were ablaze with internecine war. A magician with the brush, Howson's aesthetic again, like Currie's, is emphatically not 'art for art's sake'. Hugh Byars and Martin Kane opt for similarly industrial-urban subjects while Adrian Wiszniewski has made an occasional foray into drug culture as a theme, for example in the large painting *Shafted* which should be in a museum collection.

If mural painting has not exactly proliferated in recent Scotland, two important murals are some consolation: Alasdair Gray's magisterial work, more refined and abstract than anything I have seen by him, covering the walls and ceiling at Òran Mór; and Deirdre McCrimmon's *Two Fat Ladies* at the eponymous restaurant in Dumbarton Road. Other murals worthy of mention include a Japanese-style animé mural commissioned by an enterprising Edinburgh bar, Treacle; Alexander Goudie's mural-like Tam o'Shanter paintings, now in the Maclaurin Gallery in Ayr; and William Crosbie's series of illustrations based on James Bridie's words in the song 'West End Perk' (originally sited near the entrance to the Citizens Theatre and now in the James Bridie Memorial Room in the Glasgow University Union), including the immortal line:

'The phentoms are dencing in the West End perk.'

John Clark's windows for the Café Gandolfi restaurant, the Jewish Synagogue in Cathcart, and Safeway (now Morrisons) in Anniesland, and Patricia Leighton's landscape art – huge geometrical grass mounds by the M8 Motorway between Glasgow and Edinburgh – are among the regrettably few designs which have embellished our public spaces. David Mach's commissions include only a tiny handful undertaken in his native Scotland. Andy Scott's wire Clydesdale Horse – reminiscent of Laura Antebi's wire horses but much bigger – calmly dominates its stretch of the M8.

At the same time there have been fresh discoveries which have again broadened our view of earlier artists. A group of 1977 watercolour drawings of 'The Devil's Rock' by Robert Cargill near his native Arbroath evoke Tapiès (a lifelong fascination) and Christo in a

finely executed style far removed from the muscular Scottish tradition. Work by Charles Pulsford from the 1950s, never exhibited and kept by the artist, has more in common with New York than Edinburgh. Sir William Gillies and Charles Pulsford shared teaching duties at Edinburgh College of Art, Gillies formed by his French training and acquaintance with the Scottish Colourists, Pulsford by Graham Sutherland and Arshile Gorky. Two more different artists could hardly be imagined, but this was only the old split between the traditional and the new.

Contemporary Scottish painting has no lack of traditionalists, some of them taught by David Michie at Edinburgh College of Art or John Cunningham at Glasgow School of Art, others privately by Norman Kirkham. Works by, for instance, Cara McKinnon Crawford, Liz Knox, Laura Harrison and and Connie Simmers are highly agreeable without making claims to the shock of the new. Duncan Shanks is a fine, painterly interpreter of the landscape of the Clyde at Crossford, Christine McArthur's pastel studies and Brenda Lenaghan's romantic confections show great individuality and Denise Finlay is a remarkable draughtsman who has specialized in large portraits. Taking an architectural cue perhaps from James Morrison (q.v.), Avril Paton has painted her luminous *Windows in the West*, in which a handsome freestanding tenement in the West End of Glasgow is the principal subject, not just as a splendid building, but as a living, organic home for the multitude of people who live there. The artist's concision, warmth and directness have made poster-sized reproductions of her work immensely popular. We are bordering now on the invidious, but talent evidently abounds.

But the public desire for the work of Jack Hoggan, who has become better known as Jack Vettriano, has amazed – if not silenced – his many critics. If Cézanne was the primitive of a new sensibility, Vettriano has shown himself to be the sophisticate of an old, some would say worn-out, one. His work is little enjoyed by artists or museum directors, but this has not stopped him being reproduced more than any other living artist. Perhaps his romanticism-with-a-strong-hint of innuendo is the principal reason for his appeal. Certainly, the crowd at the 2010 retrospective of his paintings in Kirkcaldy gave every sign of being entranced.

It would be nice to think that the adjacent rooms and the fine collection of Scottish paintings in them also had their admirers.

PORTRAITURE AND LANDSCAPE IN EDINBURGH

When Queen Victoria came to the throne in 1837, certain artistic bodies were beginning to place in Edinburgh's possession facilities for the nurture of the fine arts which were markedly superior to anything that had previously existed north of the Border, and which for several decades represented the best available outside London. The recent past had produced Sir Henry Raeburn, Alexander Nasmyth, and Sir David Wilkie, the last two still living, from whom Scottish Victorian portraiture, landscape and genre received their first impetus. Fortunately, the rising generation of painters at this period included a wider cross-section of talented artists than any earlier group in Scotland, although this talent was perhaps more remarkable for variety than depth and no artist of the stature of Raeburn or Wilkie emerged. Of the painters born in the first decade of the century, only David Scott and William Dyce come within measurable distance, but their contemporaries included several notable artists, among them the portraitists Sir Francis Grant and Sir Daniel Macnee, the landscapists Horatio McCulloch and James Giles, and the figure painters Sir George Harvey, Robert Scott Lauder, and Thomas Duncan, all of whom were by 1837 regular exhibitors at the Scottish Academy.

Scottish artists of the earlier Victorian period are clearly divided into two groups by their training. The majority were trained at home and painted for the provincial taste of Edinburgh, of which the upper-middle-class membership of the Royal Association for the Promotion of the Fine Arts in Scotland, founded soon after the beginning of the new reign, was most evidently if not most actually representative. The many volumes of engravings after paintings by local artists published by the Association throughout the century give a good indication of staple Edinburgh fare in pictures: landscape with a strong topographical bent and figure painting which leant heavily towards illustration, preferably of Scottish history, or of the works of Burns or Scott. A few painters, on the other hand, including Dyce, David Scott, and Robert Scott Lauder, were powerfully influenced by visits they had made to Rome and as a result of their broader training were more sympathetic to the standards and ideals of what was called High Art – a peculiarly Victorian concept which contains a number of meanings. These painters are set apart from the less ambitious concerns of their contemporaries in two important respects: their subject-matter tends to be of a morally elevated character, and their experience of Italian art is reflected in a more adventurous use of colour.

Regarding colour, the stay-at-homes were almost all influenced by the tenebrous later manner of Wilkie, and tacitly shared his opinion that 'depth, and not brightness, is what is required in our *materia medica*; and as richness is the object to be aimed at in all systems of colouring, a dark brown may be a useful colour'. Sir William Allan, Harvey, early Scott Lauder, and in the next generation the young John Phillip followed Wilkie in their fondness for a brown tonality, and for a time Harvey and Lauder emulated him in the treacherous use of asphaltum black which, hallowed by Wilkie's example, caused the speedy cracking of many an early Victorian painting including Lauder's *The Trial of Effie Deans* (1842: Hospitalfield House) and several of Harvey's early convenanting scenes. Yet despite its provincial character, perhaps because of it, there is much in the work of the early Edinburgh Victorian portraitists, landscapists, and genre painters that merits more than its present neglect. First, however, it is necessary to outline some of the main developments which formed a background to it.

The Scottish Academy was founded in Edinburgh in 1826 and held its first exhibition in the following year. At the outset its prospects of continued survival were delicately balanced, but it tenaciously resisted and eventually defeated the attempts of a rival body, the Institution for the Encouragement of the Fine Arts in Scotland, to outdo it in attracting the best local artists and the public of Edinburgh to its exhibitions. The Institution (not to be confused with the Royal Association for the Promotion of the Fine Arts in Scotland already referred to) had been founded in 1819 on the initiative of one of the greatest collectors of the age, Lord Elgin, and other nobles and gentlemen, with the object of improving the standards of taste among artists and public alike by arranging loan exhibitions of old masters. Latterly contemporary artists, including Wilkie in London, had also been invited to exhibit. But they were denied any effective part in the affairs of the Institution, and the terms of the Royal Charter of Incorporation granted in 1827 to the Institution and denied until

1838 to the Academy, omitted all reference to the artist associates of the Institution, exacerbating their discontent. In 1829 they petitioned the Academy for admission, and were admitted as soon as the necessary constitutional amendments had been made. The membership of the Academy was broadly representative of painting in Scotland from that date until the eighties.

By 1835, the main agencies in Scotland for collecting important pictures, for exhibiting and selling modern art, and for teaching young artists had been physically brought together in a prestigious new building in the heart of Scotland's capital, although they remained under separate administrations. This building, called the Royal Institution (it is now the Royal Scottish Academy), was completed to William Playfair's design in 1826 and extended to its present plan in 1835 with funds controlled by the oddly titled Board of Trustees for Improving Fisheries and Manufactures in Scotland. From 1835 to 1855 the Academy held its exhibitions in the building, moving next door to the National Gallery of Scotland in 1855 until 1911, when it returned to its earlier home which it has occupied ever since. The Trustees of the Board of Manufactures, as their main function, administered an art school, the Trustees' Academy, which was founded in 1760 and was also housed in the Royal Institution building from 1826. The Scottish Academy likewise offered instruction to young artists, which it was able to reinforce by purchasing what were considered exemplary works of modern art, notably the five large history paintings by William Etty acquired between 1827 and 1831 now in the NGS. Following the secession of its artist members in 1829, the Royal Institution devoted its energies to the purchase of old masters and prints. By the time of its virtual demise in 1859, it had made some notable purchases for the Scottish national collection, owing much to the connoisseurship of Andrew Wilson, and had seen them housed in Playfair's National Gallery. The foundation stone for this was laid on 30 August 1850 by the Prince Consort on a splendid site made available by the City of Edinburgh immediately to the south of the existing Royal Institution by the same architect, the newer building providing a graceful Ionic foil to its earlier neighbour's Doric.

The portraitist Sir Henry Raeburn, for so long the cynosure of the community of artists in Edinburgh, had died in 1823. His knighthood, conferred in the previous year, was the first since the Union of Parliaments granted to a painter resident outside London. A contemporary of Sir Thomas Lawrence, Raeburn possessed a style which in its way was as complete as that of the virtuoso President of the Royal Academy. While it lacked nothing in subtlety, it was more powerfully masculine in its candid presentation of character and in its direct handling of the pigment. He had no rival in Scotland in his own lifetime as the painter of the men and women who were prominent personalities in the vigorous Scottish society of his day, but inevitably he had many imitators. Colvin Smith (1795-1875) was perhaps the most faithful and certainly one of the most pedestrian of them, but no established Scottish portraitist of the post-Raeburn generation was untouched by the master's influence which is felt even in the splendid early *Self-Portrait* (NGS) by Wilkie. John Graham-Gilbert (1794-1866) practised in Glasgow, where he was a leading light in local art affairs, being the first and last president of the short-lived West of Scotland Academy from 1841 to 1853, and his collection of pictures, including Rembrandt's *Man in Armour,* was bequeathed to Glasgow Art Gallery by his widow in 1877. He and his Edinburgh rival Sir John Watson Gordon (1788-1864) tended to be at their highly competent but not particularly inspired best in single male figures. Wilkie's friend, Andrew Geddes (1738-1844), a more distinguished artist, whose career after a late start was spent in London, showed a vivid natural talent of which *Summer* (exhibited 1828: NGS), probably representing Charlotte Nasmyth and based on the *Chapeau de Faille* by Rubens, is a good example. Tentative in conception (he was a frequent *pasticheur* of Old Masters) Geddes's work at its best is confident and attractive in execution. That of the *petit-maître* William Yellowlees (1796-1856) – 'Raeburn in little' as he was known to his contemporaries – combines a delicate painterliness with a sympathetic intimacy of characterization which is more appropriate to the invariably small scale of his portraits. The dainty art of the miniature itself was practised most notably in this period by the Aberdeen-born pupil of Nasmyth, Andrew Robertson (1777-1845), whose *Letters and Papers* published by his daughter offer fascinating insights into the life of a portrait artist in London and Scotland in his day; and his pupil Sir William Charles Ross (1794-1860), whose brilliantly baroque style led to commissions from the Queen and the royal family and a successful career in the English capital.

William Dyce, too, was capable of a more intimate style of portraiture, of which the best-known example is the sensitive child portrait of *Harriet Maconochie* (exhibited 1832: private collection). However, his portraiture mostly belongs to his early Edinburgh period, during which he was forced to paint over a hundred portraits for a livelihood despite his many other interests. As a result many of them are potboilers totally lacking the extraordinary technical qualities for which he was later admired by Ruskin. Dyce was among the new wave of figure painters who were still young at the start of the reign. The portraiture of his contemporaries Thomas Duncan, Scott Lauder and David Scott was of an occasional nature and forms a better-integrated part of their work, which is discussed in the next chapters. Sir Francis Grant (1803-78) and Sir Daniel Macnee (1806-82) were the most important Scottish portraitists among Dyce's contemporaries. Their contributions

to the Paris International Exhibition of 1855 earned them praise as the best portraitists of the British school in a review written by Théophile Gautier, and Macnee's *Lady in Grey,* painted four years later, which is probably his masterpiece, shows precisely the enamelled surface which one might expect the author of *Émaux et camées* to have appreciated. In reality it is painted directly in a manner which still shows Raeburnesque influence, although the camera-like variations of focus bespeak a later age, and above all, its high key and harmony of cool colours seem closer to *Le Déjeuner sur L'Herbe* than to the romantic world of Raeburn's outdoor portraits. Macnee studied under John Knox in Glasgow with Horatio McCulloch and William Leighton Leitch, gradually increasing his share in what had been Graham-Gilbert's monopoly of Glasgow patronage, until he moved to Edinburgh in 1876 on his election to the presidency of the Royal Scottish Academy.

Macnee's humble beginnings contrast markedly with those of Grant, the spendthrift fourth son of a Renfrewshire laird, who saw portrait painting as a lucrative profession which would enable him to recoup the large inheritance which had rapidly run through his fingers on the hunting field. Grant had a natural facility and an elegant manner which quickly ensured his success, especially after his transfer to London in 1834, the year his famous picture *The Melton Hunt Breakfast* (Earl of Cromer) was exhibited. His work really falls into two categories, one being portraiture proper, the other sporting pictures in which the animals and the landscape are as much the object of attention as the riders or sportsmen. A picture like *Master James Keith Fraser on his Pony* (exhibited 1845: Mr and Mrs Paul Mellon) comes somewhere between these categories and reveals his essential qualities, which have often been belittled. It is a genuinely swagger equestrian portrait which suggests the gentle breeding of the young rider and his mount through their composed bearing and curiously self-regarding expressions. The eye is the window on the character of each subject; their demeanour indicates an aristocratic self-containment in contrast with the baroque animation of the composition as a whole. A similar expression of aristocratic refinement captured in the languorous gazes of a pair of society beauties, *The Countess of Chesterfield and the Hon. Mrs Anson* (private collection), results in fashionable portraiture of a sheer stylishness which can have left little to be desired by its feminine subjects, and is exceptional in Scottish painting. In *Golf at North Berwick* (private collection) and *A Hill Run with the Duke of Buccleuch's Hounds (*Bowhill*),* the actions of the participants and the terrain itself are conveyed with the excited accuracy of the aficionado. Grant's work may have been mannered, but it was also well mannered, and its popular success in its own day is easy to understand. In 1866 he became President of

the Royal Academy, and is the only Scot to have held the office.

Although David Octavius Hill (1802-70) was familiar to the RSA exhibitions as a prolific but rather uninspired landscapist, his real achievement lay in photography, especially in the large series of calotypes, many of them portraits, made in collaboration with Robert Adamson (1821-48). But his *magnum opus*, begun in 1843 and finished in 1866, was the large painting of *The First General Assembly of the Free Church of Scotland* (General Trustees of the Free Church of Scotland), which records the central event of the Disruption of 1843, the signing of the Deed of Demission by which the Free Church came into being. This is commemorative group portraiture at once on the largest and most minute scale; there are above four hundred and fifty portraits, many of which were painted from calotype studies. It would be hard to imagine a more detailed piece of reportage, but the herculean labour of its execution robs the painting of any element of life or drama. Hill's industry was extraordinary even for Victorian times. He worked tirelessly as secretary of the RSA from 1830 to 1869 and is credited with having suggested the idea upon which the Royal Association for the Promotion of the Fine Arts in Scotland was based.

Such faith in institutions is characteristic of the age. A high proportion of the best Scottish painters born in the 1800s did service in various official or academic capacities: Sir Daniel Macnee and Sir George Harvey as President of the RSA, Sir Francis Grant as President of the Royal Academy; Thomas Duncan and Robert Scott Lauder became Masters of the Trustees' Academy, where David Scott was a Visitor; and William Dyce, the most obvious example, devoted years to the reform of the national system of art education as Secretary of the new School at Somerset House, having briefly been master of the Trustees' Academy. As these names and their concomitant titles indicate, portraiture and figure painting were regarded by many Victorians as more serious pursuits than landscape painting. However, in 1837 the *éminence grise* among painters in Scotland was a landscapist, Alexander Nasmyth (1758-1840). Although he was two years Raeburn's junior, Nasmyth belonged to a more old-fashioned classical tradition. His portraits show little of the training he had received in Allan Ramsay's studio in London. They range from stiff Zoffany-like conversation pieces such as *The Erskine Family* (Christie's 1974) of 1780 to the famous but unremarkable portrait of *Robert Burns* (1787:SNPG). His landscapes, after a sojourn (1783-85) in Italy, adhere to a Claudian ideal transposed to a Scottish setting. But although Nasmyth's style was quickly superseded, he has a strong claim to have been the originator of the nineteenth-century vogue for Scottish landscape views. Writing from Seville in 1828, Wilkie addresses Nasmyth as 'you whose taste has drawn so much from Italy and whose genius has made Scotland so

much the theme and the school of the landscape painting of our day'. John Ruskin, whose father received lessons from Nasmyth, himself owned to Nasmyth's influence on him in his young years. Nasmyth's theatre sets excited at least as much contemporary admiration as his easel painting but they can unfortunately no longer be judged, except in drawings. His younger contemporaries David Roberts (1796-1864) and William Leighton Leitch (1804-83) were rapturous in their praise of them. Roberts wrote of them as 'beautfiul works of art' and remarked, 'These productions I studied incessantly, and on them my style, if I have any, was originally formed.' A drop-scene by Nasmyth for the Theatre Royal in Glasgow, then one of the best theatres in Britain, was described by Leitch as 'a magnificent work of art and justly renowned as a masterpiece'. However, the work of these admirers of Nasmyth, and that of his son Patrick Nasmyth, 'the English Hobbema' as he has been confusingly and confusedly called, had little effect on Scottish painting, as their careers were passed chiefly in London. Roberts

achieved great success as an architectural painter there, specializing in Mediterranean and Middle-Eastern subjects, and Leitch, who as a watercolourist was influenced by Samuel Prout, became Queen Victoria's drawing-master.

Although he moved to London in 1822, Roberts retained close links with Scotland, exhibiting from time to time at the RSA and visiting his friends on an annual basis until 1863, the penultimate year of his life. In 1858 he received the Freedom of the City of Edinburgh – the first artist to receive this honour. Starting as a scene-painter at the Theatre Royal. Glasgow, and (with Clarkson Stanfield) at the Pantheon Theatre, Edinburgh, which was managed by William Henry Murray, brother of Harriet Siddons, Roberts first went to London in 1822 at the suggestion of Murray, where his talents as a designer and painter of theatrical flats quickly found employment, notably in the first English production of Mozart's *Il Seraglio* at Covent Garden in 1826, for which Roberts produced sets for all seventeen scenes. By 1830 Roberts, having sold all the pictures he had sent to

6 Alexander Nasmyth
Distant View of Stirling
Exhibited at the Royal Institution, Edinburgh, in 1827
Oil on canvas, 83.90 x 116.90 cm
National Gallery of Scotland

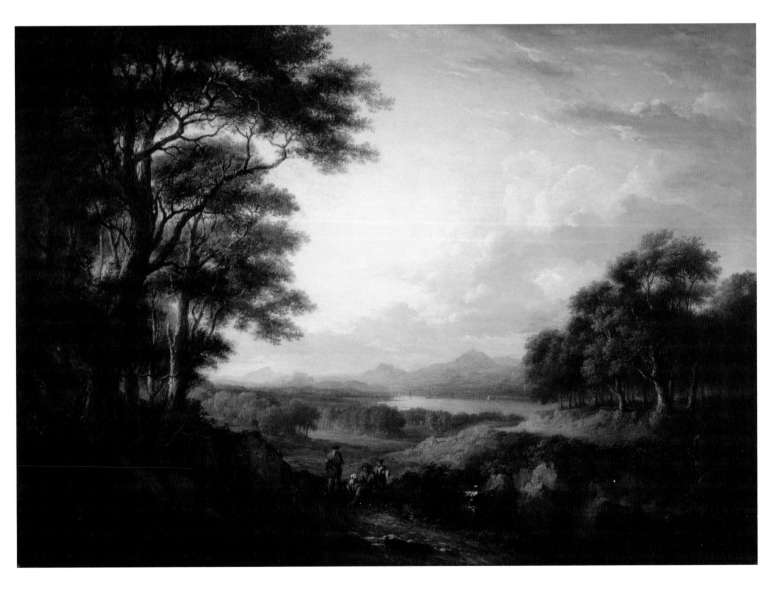

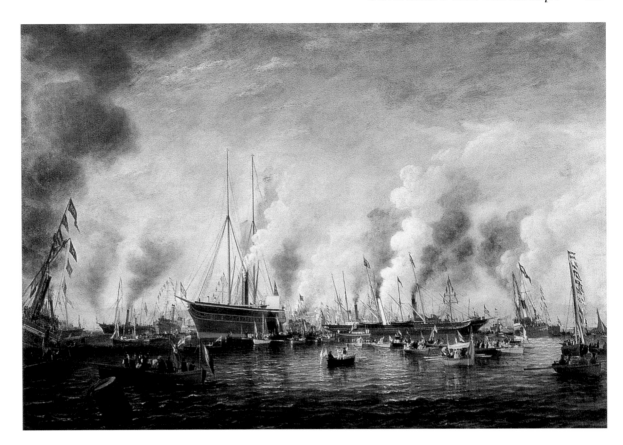

7 William Clark of Greenock
The Queen's Visit to the Clyde, 17th August 1847
1848
Oil, 77 x 112 cm
McLean Museum and Art Gallery (Inverclyde Council)
Queen Victoria, on her third visit to Scotland, and accompanied by Prince Albert and the royal children, is seen here transferring from the RY *Victoria and Albert* to the tender *Fairy*.

the Royal Academy – including the huge, imaginative and positively de Mille-like *Departure of the Israelites* (1829: private collection), sold to his early supporter Lord Northcliffe – was confident enough to give up his theatre work and devote himself entirely to his chosen branch of art. Like his friend J.F. Lewis and his compatriot Wilkie, Roberts made extensive journeys, which are well documented in his letters and diaries, through Spain and the Holy Land, as well as (unlike them) to Egypt, Syria, and North Africa in search of fresh material, in his case scenes of architectural and archaeological interest. The resulting images of Spain (visited in 1832) and more especially of Egypt and the Holy Land (1838-39) – the latter published as a collection of lithographs in six volumes – were extremely popular and established Roberts as one of the most celebrated British artists of the day. It is not hard to understand their success, for Roberts, having with considerable foresight chosen subject-matter which itself made an exotic and even romantic appeal, was able to match the grandeur and novelty of his subjects with a consummate ability to suggest their power without omitting relevant archaeological detail or an architect's sense of the structure underlying form. His architectural studies combine admirable scholarship and grasp both of scale and detail with a compositional sweep which transforms them into works of art. Indeed, a relatively rare flight of fancy such as *A Recollection of the Desert on the Approach of the Simoon* (1850: private collection), based of course on

actual experience but revealing a strain of romantic poetry worthy of Delacroix, indicates that Roberts possessed an imagination which was the equal of his remarkable powers of description. This painting was presented by the artist to his friend the novelist Charles Dickens.

The most outstanding of Nasmyth's many pupils the Reverend John Thomson (1778-1840), a gifted amateur landscapist and friend of Sir Walter Scott, effected the transition in Scotland to a romantic landscape type, with solitary castles, often ruined, sometimes perched on cliffs whose perspective is exaggeratedly steep, dimly seen through a misty atmosphere. If one compares master and pupil in two pictures now in the National Gallery of Scotland, Nasmyth's *Distant View of Stirling* (exhibited in 1827) and Thomson's *Fast Castle from Below* circa 1824), the dainty and almost brittle formality of Nasmyth presents a marked contrast with the more subjective painterliness of Thomson. The latter's typical golden-brown tone, however, is reminiscent of the current admiration for Claude indicated for example in the *Noctes Ambrosianae*, published in *Blackwood's Magazine* between 1825 and 1835, and probably represents an attempt to reproduce what was then misguidedly thought to be a Claudian effect. Thomson's freer style and, for a time, his mannered use of almost monochromatic colour influenced later landscapists such as Horatio McCulloch. On the other hand, the Nasmyth tradition of panoramic views of Scotland ended with the career of

his pupil John Knox (1778-1845), whose views of *Old Glasgow Bridge* and *The Clyde at Glasgow Green* (GAG), peopled with many small figures, make him seem a kind of Glasgow Carlevaris. Knox was at his most naively personal in his street scenes; despite its up-to-date-sounding title, *The First Steam Boat on the Clyde* is still heavily dependent on the classical convention. Equally faithful to a different seventeenth-century convention, that of the minor Dutch marine painters, were the contemporaries of Thomson and Knox, John Wilson (1774-1855) and J.W. Ewbank (1799-1847) – the latter another Nasmyth pupil – who were frequent exhibitors at the Academy in Edinburgh. At the same time there exists a veritable school of artists, mostly unsung, who painted local views for a local clientele. Two may here stand for the many: George MacGillivray of Dundee and William Clark of Greenock (1803-83). Dundee Art Gallery possesses all that is known of the former's work, which includes the naive but attractive and historically interesting *The Opening of the Dundee-Arbroath Railway* (1838), and the more accomplished view of *The Union Hall, Dundee* (1847). Clark of Greenock's masterpiece is assuredly the large *The Queen's Visit to the Clyde, 17th August* 1847. Clark was a marine specialist for whom anatomical accuracy in the delineation of sailing ship subjects was a matter of course, but he was much more than a quayside painter of ship-portraits; his regatta and racing scenes possess a vivid sense of colour, of weather, of movement, and in this case even of pageant.

Among the early Victorians, some of the most distinguished work in landscape was done by painters not normally thought of as landscapists, especially David Scott and William Dyce, who are considered in the next chapter. The mountain views and ruined castles of the most interesting of the landscape specialists of their generation, Horatio McCulloch (1805-67), have a homespun look when compared with the exuberant colour and romantic imagination of Scott's *Puck Fleeing before the Dawn* (1837: NGS) or the Pre-Raphaelite botanical precision of Dyce's *Titian Preparing to Make His First Essay in Colouring* (1857: AAG). McCulloch trained in Glasgow under John Knox and belongs, like most of his contemporaries in this category, to the tradition of the landscape-topographer. On one occasion he was called upon to advise on the landscaping of the new railway line passing through the estate of Castle Semple, just as Alexander Nasmyth before him gave advice on projects like the laying out of the gardens at Culzean, and of the siting and design of St. Bernard's Well in Edinburgh. But McCulloch's large paintings have a compositional sweep and a nostalgic quality which are authentically romantic and place him on a higher level than his more humdrum contemporaries and fellow-academicians, William Simpson (1800-41) and Edmund Thornton Crawford (1806-85). His *Inverlochy Castle* (1857: NGS)

and *A Border Keep* (n.d.: DAG) successfully evoke the wildness of an untamed landscape in which once-mighty fortresses stand as ruins. Much of his work, however, suggests a rather mundane sensibility: *Glencoe* (1861: GAG) has little to add to what had been said for once and for all ten years earlier in Landseer's *Monarch of the Glen*. This is a fault which is most serious in his use of colour, which tended to a monochromatic brown or green. His pictures are really decorative pieces, although his brushwork is vigorous and represents a development of the painterliness of John Thomson, and he is as capable of painting with sensitivity on an impressively large canvas – *Loch Awe with a View of Kilchurn Castle* (Western Club, Glasgow), is a splendid example, as is his *River Clyde from Dalnoltar Hill* (circa 1859: Clydesdale Bank) – as equally on work of sketch dimensions.

Less subjective than McCulloch, the Aberdeen painter James Giles (1801-70), who advised many of the Aberdeenshire gentry on the planning of their gardens, was influenced as a topographer by his Italian journey (1824-26). The eerie romanticism or *The Weird Wife* (1832) is a rare excursion from the placid norm of his usual style, although the inclusion of Pictish standing stones of a type found in North-East Scotland echoes the interest in Scotland's ancient ruins which had been reawakened by Scott's novels.

The next wave of landscapists, who were in their thirties by mid-century, marks a transition to a more naturalistic, less interpretative mode from the subjective romanticism of McCulloch, who worshipped Wordsworth as 'Claude and Turner and Stanfield and Linnell all in one' according to his *Art Journal* obituarist. Landscape subjects came to be chosen less for their romantic or historical associations than for a tamer type of picturesqueness. The difference in treatment is even more pronounced, reaching a logical conclusion in the descriptive precision of Noel Paton and William Dyce, and resulting among landscape specialists like Arthur Perigal (1816-84), James Cassie (1819-79), and J. Miln Donald (1819-66) in a more factual approach, which in their hands veers dangerously close to the pedestrian. Their slightly younger contemporaries are more interesting: Sam Bough (1822-78), J.C. Wintour (1825-82), and James Docharty (1829-78) in particular managed to infuse an element of poetic drama into their own distinct styles. The enormously prolific Bough was clearly considerably under the influence of early Turner, but more detailed and circumstantial than that master, the busy facility of his drawing not always disguising a certain poverty of content and an apparent indifference to colour. Too often his would-be animation lapses into mere restlessness and a relentless cataloguing of incident weakens the unity of his compositions, but at its best his work possesses undeniable verve. But are we today in possession of the evidence necessary to a balanced evaluation of

OPPOSITE
8 William Dyce
Titian Preparing to Make His First Essay in Colouring
1856-57
Oil, 91 x 71 cm
Aberdeen Art Gallery and Museums Collections

Bough, whose centenary has passed without notice, who emerges so engagingly from the pages of the Gilpin biography (published posthumously as late as 1905) and who clearly was regarded by all his contemporaries as the giant of Scottish landscape painting of the mid-nineteenth century? Few indeed of the 224 works exhibited by him at the Royal Scottish Academy in the years 1844-78 are known today. One such is *Newhaven Harbour during the Herring Fishing*, offered in 1856 for £30, a large-scale composition full of detailed observation and an almost Boudin-like lightness of palette. Another picture shown in the previous year, and now lost, of the Iron Shipyard at Dumbarton, was priced at £100; as it cannot have been three-and-a-third times bigger, was it three-and-a-third times better? A second example of Bough's power in large-scale composition to appear recently in the Scottish art market has been the great *Peel Harbour in a Storm*, exhibited at the RSA in 1875 with a price of £472 10s. This beautifully suggested, elemental work seems to justify the artist's estimation of it as the highest-priced picture he ever showed in Scotland, and its undeniable authority suggests that a re-examination of this neglected artist is overdue, preferably in the form of a large-scale exhibition which would bring his mostly hidden work back into public view.

Totally different in mood, Wintour's earlier work, influenced by Constable, reveals a richer and more simplified sense of colour and composition, as in *A Woodland Well* (1857: Orchar Collection, DAG). A lingering sense of romantic nostalgia is especially apparent in the landscapes of the last twelve years of Wintour's life after he had freed himself from Constable's influence around 1870. *A Border Castle* (1872: NGS), painted for a patron who refused it on the grounds of the liberties taken with the topo-graphy, is a hauntingly evocative work which shows something of that Corot-like serenity and painterly brushwork which commended Wintour to the land-scapists of the later Glasgow School. James Docharty was a more severe artist; his descriptive *Loch Achray* (1866: AAG) and *Morning – Mist Clearing off the Hills* (1876: ibid.) suggest Courbet rather than Corot, but his seeming preference for the gloomier moods of landscape makes him difficult to enjoy, despite a photo-impressionistic concern with effects of atmosphere and light.

Landscape painting had in fact reached a low ebb with the generation of painters who separate the romanticism of Horatio McCulloch from the impressionism of William McTaggart. The slightly younger Alexander Fraser (1827-79), who worked in the open air in Cadzow Forest with Sam Bough and William Fettes Douglas, and had by his early twenties arrived at the style which he was to employ for the rest of his career, summed the matter up with remarkable candour: 'I have followed certain rules and modes of procedure, chosen certain views and used certain colours. Success would lead to repetition, failure to trying another process, but the quantity of mere repetition is not to be denied. What then? Is not all life a repetition?' Fraser was predictably successful, repetitious, and prolific, but a certain responsiveness to the *genius loci* and to nature in her calmest moods gives life to the otherwise mechanical perfection of his style. His timid use of colour was also elucidated by himself in the *Notes* partly published by Pinnington: 'Working with one tint only should not be allowed to fall entirely into disuse. Like a solo on the drums, it may be made a very effective performance.' An infinitely richer orchestration of landscape was to be demonstrated by William McTaggart from the mid-1860s.

HIGH ART

The first fifteen years of Victoria's reign – which embrace Sir William Allan's election as President of the Scottish Academy in 1837 and the appointment of Robert Scott Lauder as Headmaster of the Trustees' Academy in 1852 – were particularly eventful ones for figure painting in Scotland. The new wave of young Scottish figure painters who came into prominence in the 1830s, born mostly in the first decade of the century, divided into two distinct groups, one concentrating on religious, allegorical, or mythological subjects, the other on genre scenes or episodes from Scottish history or romance. The second group absorbed a Scottish vernacular style mediated by Sir William Allan (1782-1850), under whom they studied at the Trustees' Academy. However, the slightly older members of that generation, including William Dyce, David Scott and Robert Scott Lauder, were among the last students taught at the Trustees' Academy by the outgoing Master, the landscapist and connoisseur Andrew Wilson (1780-1848). Wilson was an Italianist (once a pupil of the Italianate Alexander Nasmyth) who was Master at the Trustees' Academy from 1818 until 1826, when he was succeeded by Sir William Allan. Wilson's pupils Dyce, Scott and Scott Lauder (and to a lesser extent the precocious later figure of Sir Joseph Noel Paton) are effectively separated from their Scottish contemporaries by their Italianizing tendencies and their elevated conception of subject-matter. However, in the cases of Scott and Paton this did not preclude successful excursions into the field of fairy painting or imaginative fantasy, with themes from *Paradise Lost*, *A Midsummer Night's Dream*, or *The Tempest*.

Their extended Italian visits, which profoundly affected the work of Dyce, Scott and Lauder, increased the stylistic distance between them and their Scottish colleagues. Dyce had especially wide sympathies, and his friendship with the German Nazarenes in Rome enabled him to anticipate aspects of Pre-Raphaelitism and to play an important role in the triumph of the German style favoured by Prince Albert for the scheme to decorate the new Parliament buildings. He seems less a Scottish than a London figure – an impression heightened by his participation in the ecclesiological controversies of the age, by his preoccupation with matters of High Church liturgy and music, and by a close involvement with art education after his appointment in 1838 as Superintendent of the Schools of Design at Somerset House. Despite the prodigal dispersion of his talents and time, he painted several of the most interesting pictures of the Victorian era, and his work, like that of his fellow expatriate Scott Lauder, continued to be occasionally seen at the annual exhibitions of the RSA.

Born in 1806 in Aberdeen, William Dyce gave early proof of intellectual versatility. In 1829 he published a prize-winning essay on *The Relations between Electricity and Magnetism* and in 1833 a paper on *The Jesuits* which resulted in correspondence with the future Cardinal Wiseman. At the same time he furthered his development as an artist with visits to Italy in 1825, 1827 and 1833 which brought him into contact with the Nazarenes. His introductory remarks to the treatise on electromagnetism give clear notice not only of the future polymath, but of the future eclectic as well:

> The boundaries of separate branches in philosophy . . . have become so undefined that we, loaded with the accumulated weight of experience, must acknowledge that our thorough understanding of even a single natural phenomenon has thus been made to depend upon our ability, with one comprehensive grasp, to apprehend the contexture of the whole system.

This suggests that his many-sidedness in fact resulted from deep conviction rather than, as has often been said, from the lack of it. Unfortunately it led him to enter into certain commitments, such as the directorship of the Schools of Design, which turned out to be enormously time-consuming, consequently restricting his output as a painter.

The brothers Redgrave saw Dyce's work as 'learned more than original', yet he was perhaps the first artist in Britain to appreciate early Italian art and to apply its lessons to his own style. In this respect he appears as a forerunner of the Pre-Raphaelites, whose early work he was one of the first to understand. Ruskin, quoted by Ernest Chesneau in 1882, recalled that his introduction to the Pre-Raphaelite School was by Dyce, 'who dragged me, literally, up to the Millais picture of "The Carpenter's Shop", which I had passed disdainfully, and forced me to look for its merits'. Dyce's own best

work has about it a certain Pre-Raphaelite intensity of mood as well as of observation, to a degree which seemed uncomfortable even in 1881 to the RSA Council, owners of Dyce's most important picture in his early Scottish period, *Francesca da Rimini*. The Council ordered that the 'objectionable' left-hand side of the picture should be cut, removing the figure of Francesca's deformed husband Gianciotto, who was shown advancing with murderous intent upon the unsuspecting lovers, dagger in hand. This and other subjects from Dante were to be treated many times by Rossetti, just as the Arthurian theme suggested by Dyce to the Prince Consort as a suitably patriotic alternative to the *Nibelungenlied* for the frescoes in the Queen's Robing Room at Westminster Palace, commissioned in 1847, again anticipated a fashion.

After his appointment to Somerset House in 1838, art education was only one of the onerous official concerns which Dyce added to his studies of church architecture, music and liturgy, and of the technique of fresco painting, in which he became the foremost expert in Britain. It is then perhaps not surprising that certain of his pictures, like the *Christabel* (1855: GAG) described by Ruskin as an example of 'one of the false branches of Pre-Raphaelitism consisting in an imitation of the old-religious masters', appear to have little more to recommend them than a certain agreeable sweetness which borders on vapidity. Other examples in this Peruginesque style are the *Madonna and Child* of 1845 bought by Prince Albert for the royal residence at Osborne, where Dyce

painted a fresco, *Neptune Resigning his Empire to Britannia*, and the *Omnia Vanitas*, presented to the RSA Diploma Collection in 1848. What is more remarkable in these circumstances is the taut control of a figure painting such as *Jacob and Rachel* (1853: Kunsthalle, Hamburg; version at Leicester Art Gallery), a very Nazarene work based on a composition of Führich, or the boldly simplified *Joash Shooting the Arrow of Deliverance* of 1844. This is an astringent design of real tonic vitality, described by the artist as symbolizing 'the arm of secular power directed by the Church', but which may well have had a private meaning for him as an allegory of self-liberation. The later landscapes possess an even more impressive meditative concentration. The anguished agitation of the figure of Christ in *Gethsemane* contrasts powerfully with the repose of the carefully observed Scottish Highland setting. Painted in 1850, this is the first of a small group of meticulously descriptive landscapes containing diminutive figures and preoccupied with the rendering of light and atmosphere in a final logical extension of the artist's love for the Umbrian painters of the *quattrocento*.

Ruskin wrote to Dyce in 1857 'to congratulate you on your wonderful picture' – *Titian Preparing to Make His First Essay in Colouring* – adding, 'you have beat everybody this time in thoroughness', but the picture, painted in 1859 and shown at the RA in 1860, is an even more extraordinary *tour de force*. This is the haunting *Pegwell Bay – A Recollection of October 5th, 1858*. Here, in

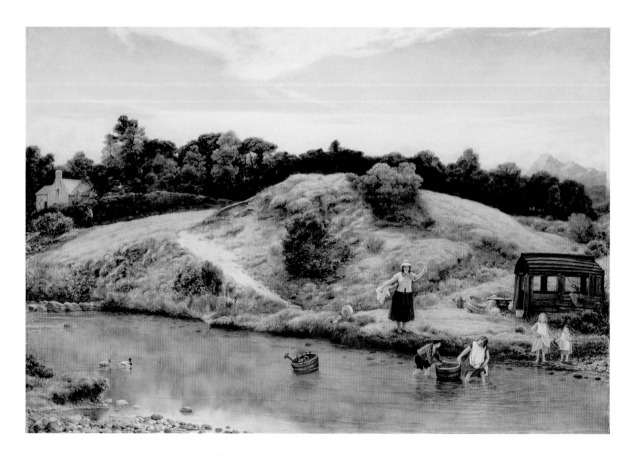

9 William Dyce
A Scene in Arran
1859
Oil on panel, 35 x 51 cm
Aberdeen Art Gallery and
Museums Collections
A rare excursion into narrative
painting, dating from a family
holiday.

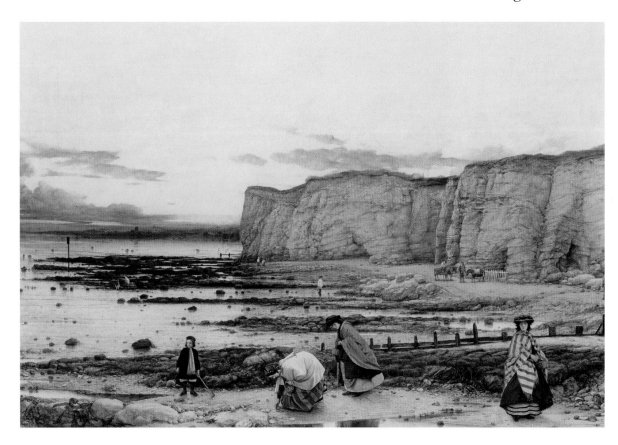

10 William Dyce
Pegwell Bay: A Recollection of October 5th, 1858
1860
Oil, 73.70 x 88.90 cm
© Tate, London, 2010
The figures represented are the painter's wife and her sisters, Grace and Isabella Brand, with the artist and one of his sons.

a landscape littered with rocks, elegantly costumed figures (members of the artist's family) ignore the presence in the sky of another, more spectacular piece of geological debris – Donati's Comet of 1858 – and instead stand irresolutely like exotic birds of passage in an unfamiliar and inhospitable terrain. The picture lacks the incident of Frith's *Ramsgate Sands* (1854) and the social message of Brett's famous *Stonebreaker* (1858), but an impression of mysterious significance is created by the almost surreal intensity of the obsessively rendered detail and the infinitely subtle modulations of a cool harmony of colours. *Pegwell Bay* remained until 1894 in the collection of the artist's father-in-law, James Brand, who also owned *Titian Preparing to Make His First Essay in Colouring. A Scene in Arran*, showing a more informal Dyce family outing in 1859, the year of *Pegwell Bay*, was painted for Mr Brand and not apparently intended for exhibition. It possesses a charmingly intimate quality in addition to its remarkable truth to natural phenomena. A similarly lyrical view of verdant nature is revealed in Dyce's last important work, *George Herbert at Bemerton* (1861: Guildhall Art Gallery), a subject taken from Walton's *The Compleat Angler* where Piscator quotes to Venator the following lines of Herbert:

> Sweet day, so calm, so cool, so bright,
> The Bridal of the earth and sky,
> The dew shall weep thy fall tonight
> For thou must die.

Dyce was fifty-seven when he died three years later in 1864. His career was acknowledged to have been a brilliant one, but somehow incomplete despite, perhaps because of, the variety of his achievements, of which his contribution to Victorian painting was by no means the least significant.

Like William Dyce, but with different results, the brothers Robert and James Lauder (born in 1803 and 1811 respectively) spent years in Rome studying Italian painting, but both brothers also showed a keen interest in the new genre style for which the novels of Sir Walter Scott had done so much to create a demand in Scotland. Prior to his departure to the Continent in 1833, Robert Scott Lauder's work was chiefly in portraiture, of which the *Henry Lauder* (NGS) and *Mrs Duncan* (DAG) are good painterly examples, with an isolated excursion into Scott in the style of Sir William Allan, the now bituminized *Bride of Lammermoor* (DAG). The five-year tour which took Lauder to Rome, Florence, Bologna, and Venice did not quench his enthusiasm for Scott, and his then greatly celebrated *The Trial of Effie Deans* (now at Hospitalfield House but ruined by the effects of bitumen) was begun in Scotland, taken to the Continent, and completed in London, where the artist took up residence on his return in 1838. This is an ambitiously conceived work in which an animated crowd of large-scale figures is skilfully handled, while in terms of colour and the rendering of light the picture represents a great advance on *The Bride of Lammermoor*. Other less ambitious illustrations to

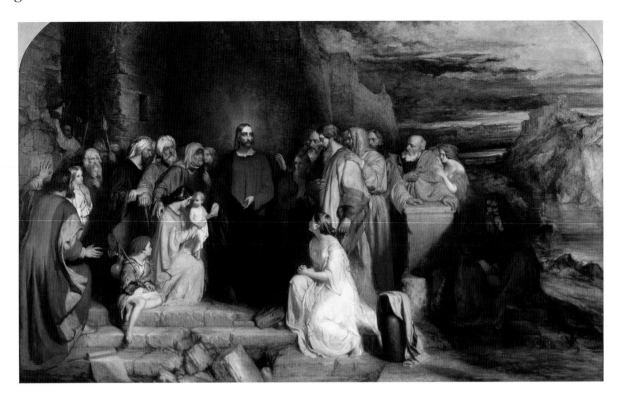

11 Robert Scott Lauder
Christ Teacheth Humility
1848
Oil on canvas, 234 x 328 cm
National Gallery of Scotland

Scott followed, showing a preoccupation with a certain type of female beauty of which two graceful examples were predictably engraved for the Association for the Promotion of the Fine Arts in Scotland: *The Gleemaiden* (private collection) and *The Fair Maid and Louise Listening at the Dungeon Wall* (untraced), both from *The Fair Maid of Perth*, exhibited at the RSA in 1842 and 1848 respectively.

Scott Lauder's more obviously Italian-influenced religious works began with *Ruth* (untraced) of 1843. Unfortunately, pieces like *Christ on the Way to Emmaus* (DAG) and *Christ Walking on the Sea* (FAS), both exhibited in 1850, have a static and somewhat anodyne quality which contrasts unfavourably with the urgency of Dyce's *Gethsemane* of the same year. The use of deep Venetian reds and blues is confident enough, although rather low-keyed. *Christ Teacheth Humility*, measuring 234 cm x 328 cm in the largest version, which was purchased by the Association, is the most impressive of these later essays and reveals an undeniable unity of light and grouping, while the architectural and landscape background is painted with notable breadth and transparency. The landscape passage in this picture drew from Caw a comparison with Delacroix which might more justly have been applied to the small oil sketch for it (NGS), in which the lights are largely painted in primary colours. But the main importance of Robert Scott Lauder to Scottish painting derives not from his own work, but from that of the pupils whom he influenced after his appointment as Master of the Trustees' Academy in 1852.

James Eckford Lauder (1811-69), who returned to Edinburgh while his brother stayed in London after

their Continental tour, is known today only as the painter of *Bailie McWheeble at Breakfast* (1854: NGS) from a passage in *Waverley*, but was a prolific exhibitor at the RSA and the *McWheeble*, a cabinet piece with much emphasis on still life, demonstrates more than average competence. Yet the artist's obituarist in *The Art Journal* of 1869 remarks sadly that 'neglect . . . it is scarcely too much to say . . . hastened his end'. In 1847 he had succeeded in winning a 200 guinea premium for his entry to the Westminster Hall competition, *The Parable of Forgiveness* (WAG), a well-organized, somewhat Poussinesque work of requisitely large size (198 cm x 313 cm). Separated by only seven years, these two paintings seem poles apart and illustrate the dichotomy that existed in the minds of many people in the late 1840s and 1850s and even later between the styles that were deemed appropriate for various levels of subject, with religious themes tending to appear as inflated academic compositions, humble domestic subjects receiving much more realistically descriptive treatment, and literary or historical painting occupying the middle ground. The dilemma produced by the conflicting demands of modern realism and the formal expressiveness of the Italian tradition was convincingly resolved in England by the Pre-Raphaelites, but their Scottish contemporaries were less systematic.

Sir Joseph Noel Paton (1821-1901), a Dunfermline-born painter, was an early and close friend of Millais in London and might have become a member of the Pre-Raphaelite Brotherhood had he not elected to return to Scotland in 1844. He was widely regarded in his own day (though not by Ruskin) as the

foremost religious painter in the land, together with Holman Hunt. Today this aspect of his work finds no favour, and with its overscaled, bland designs and undernourished pigment is hardly likely to do so again. But it was not until about 1870 that Noel Paton became almost exclusively a religious painter; in his early days he attempted a remarkable variety of themes ranging from fairy pictures and subjects from Dante, Malory, Keats and Coleridge, to modern subjects such as the Indian Mutiny and the Crimean War. Like Eckford Lauder, Paton was a prizewinner in the Westminster Hall competitions (in 1845 and 1847), but he enjoyed much greater success than Lauder. He numbered among his admirers Queen Victoria, who commissioned a replica of *Home from the Crimea* in 1856 and in 1864 the memorial picture *Queen Victoria in the Death Chamber of the Prince Consort*.

Home from the Crimea, exhibited in 1856, described by Ruskin as 'a most pathetic and precious picture', depicted the return to the bosom of his family of a soldier who sits wearily at last by his own fireside, embraced by his wife and mother, who abandon themselves to their painfully mixed emotions, for he has been severely wounded. Even in reproduction the image is arresting and conveys feelings which we know to have been genuine: Paton in the previous year had produced a drawing titled *Commander-in-Chief of the Crimea*, showing a skeleton holding a baton marked 'routine' riding a skeletal charger over the bodies of men and horses. *In Memoriam*, shown in 1858 at the Royal Academy to a public still stunned by the massacre at Cawnpore,

touched an exposed nerve and had to be changed from its first design, which showed sepoys advancing on a huddled group of English women and children, to the more comforting later version which substituted rescuing Highlanders for the sepoys and was called *The Rescue* (untraced), representing the relief of Lucknow. (Queen Victoria expressed her approval of the change.) *Dawn: Luther at Erfurt* (1861: NGS), unlike the two modern subjects just discussed, is not sustained by any topicality of content; it is inwardly rather than outwardly dramatic and thus a more strictly Pre-Raphaelite work, showing some influence of Holman Hunt in particular, but of the Brethren in general, in its meticulous drawing and strong colour. The picture combines historical verisimilitude with circumstantial realism; there is much antiquarian detail and the head of Luther was studied from a contemporary portrait, although the eyes were those of the artist's wife, 'the look of strain in them induced by a judicious application of onions'.

Noel Paton is best remembered today, however, as the painter of the fairy pictures of *The Quarrel of Oberon and Titania* and *The Reconciliation of Oberon and Titania* and *The Fairy Raid*, not surprisingly, as they show him at his best in terms of technique and invention. Painted while he was still in his twenties, the two *Oberon and Titiania* pictures (NGS) possess a degree of elaboration remarkable even by Victorian standards and not again attempted by the artist. Lewis Carroll saw *The Quarrel of Oberon and Titania* in the Scottish National Gallery in 1857 and wrote delightedly in his diary: 'We counted 165 fairies!' Noel Paton's talent for minute

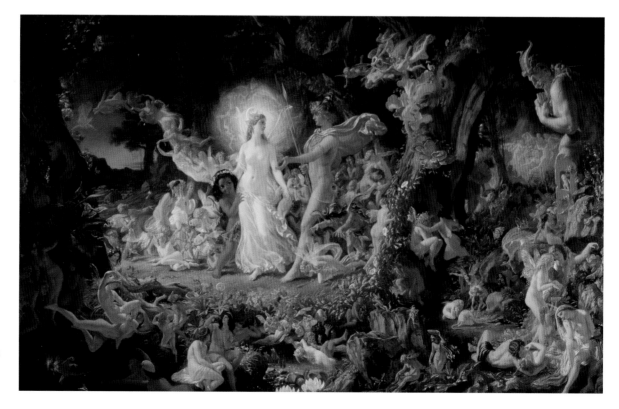

12 Sir Joseph Noel Paton
The Quarrel of Oberon and Titania
1849
Oil on canvas, 99 x 152 cm
National Gallery of Scotland

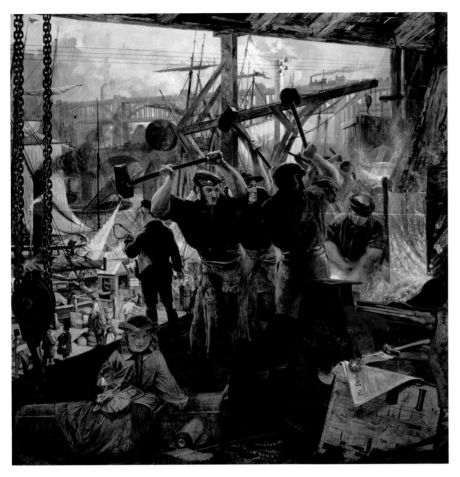

13 William Bell Scott
Iron and Coal on Tyneside in the Nineteenth Century
1856-61
Oil, 185.40 x 185.40 cm
Wallington Hall, the Trevelyan Collection (The National Trust)
© NTPL/Derrick E. Witty

finish, bright colours, and microscopic detail, together with a teeming cornucopia of chastely erotic life studies. Its myriad figures engaged in a multitude of actions quite incidental to the main drama are conceived with great vitality and much play on scale, and placed in a woodland glade rendered with the minute, loving precision of the botanical draughtsman. All these characteristics make the pictures widely and instantly accessible, and they are evident masterpieces in the fairy genre.

The *horror vacui* of the *Oberon and Titania* pictures, and their great variety of facial expressions, may have influenced Richard Dadd (1817-77), whose celebrated *The Fairy-Feller's Master Stroke* (1855-64) contains in the central figure of the anguished old man what appears to be a type taken from *The Quarrel of Oberon and Titania*. Dadd earlier was almost certainly an influence on Noel Paton: his *Come unto these Yellow Sands* (an illustration to *The Tempest*) was shown at the RA in 1842, when the twenty-one-year-old Noel Paton was attending classes there, and its numerous nude and semi-nude figures and lightness of design must have made an impression on the younger painter. *The Fairy Raid* of 1867, in contrast with the hard outlines visible in earlier pictures, displays a much greater concern with the evocation of an atmosphere of mystery, and its haunting rendering of a moonlit midsummer eve is full of poetry. To this later type also belongs *Fact and Fancy* (1863: private collection), a charming fantasy showing the artist's three-year-old son in conversation with fairies he has encountered at the bottom of the garden. *I Wonder Who Lived In There* (1865: private collection) shows the same child gazing into the opened vizor of a helmet drawn from Noel Paton's famous collection of armour.

Noel Paton the popular moralist is already apparent in the early *The Pursuit of Pleasure* (1855: engraved). The allegory shows a butterfly-winged girl flying away from a motley throng of pursuers, whom she contrives to entice despite her inane smirk. They are evidently having difficulty in staying the pace, and the winged Nemesis looming over them unnoticed, sword in hand, about to punish them for the pleasure they want to enjoy but can't, is a similar conception to the Spirit of the Cape, Adamastor, in David's Scott's *The Discoverer of the Passage to India Passing the Cape of Good Hope* (1841: Trinity House, Leith) and to the figure of Kühleborn in Maclise's *Undine* (1843: H.M. The Queen) which are clearly related and may have a common German origin. The earlier Scott version is the one more likely to have been known to Noel Paton. Already, we are far from the playfully amoral fairy pictures of the late forties and Noel Paton's claim to our attention as a painter – but not his hold on the Victorian public – declined with his growing adoption of didactic themes. In later life, when he had become in Ruskin's words 'the Genius of Edinburgh, more of a thinking

observation and rendering of detail was exactly suited to such a subject, which was dear, no doubt, to his highly developed sense of the supernatural; very young visitors to Ardmay, the Noel Patons' holiday house on Loch Long, would be taken on expeditions to look for fairies which, as his granddaughter tells us, had been one of the pastimes of the painter's own childhood at Dunfermline. The early fairy pictures were painted long before his marriage in 1858; later, as the father of eleven children, he showed himself intensely sympathetic to the imaginative fantasies of childhood. Lewis Carroll asked him to illustrate his *Through the Looking-Glass,* but the invitation was declined by Noel Paton, who said that Tenniel 'was still the man'. Dated studies in the RSA Diploma Collection and at Glasgow Art Gallery show that both the *Oberon and Titania* pictures were conceived at the significantly early date of 1846. *The Reconciliation of Oberon and Titania* was painted first and exhibited at the RSA in 1847, winning a government prize at the Westminster Hall competition in the same year, and bought by the RSA in 1848 – a remarkable honour for its twenty-seven-year-old author. *The Quarrel of Oberon and Titania,* shown at the RSA in 1850, was bought by the Royal Association for the Promotion of the Fine Arts for the NGS in the same year for £700, by far their most expensive purchase. This was recognition indeed, and it is not hard to explain. The painting has a high

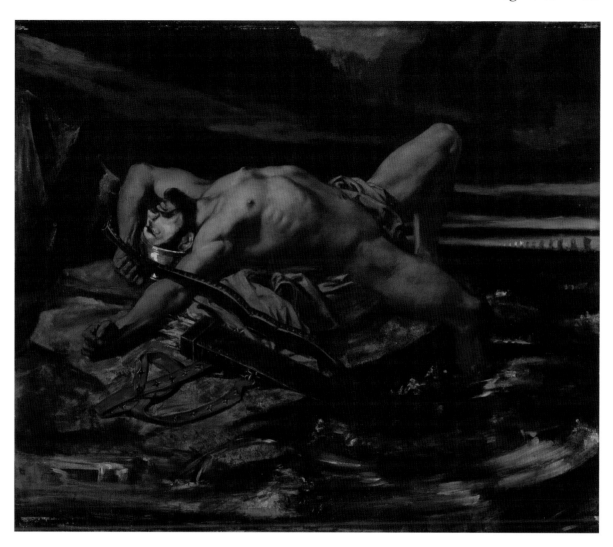

14 David Scott
*Philoctetes left on the Isle of
Lemnos by the Greeks on their
passage towards Troy*
Exhibited at the Royal Scottish
Academy in 1840
Oil on canvas, 101 x 119.40 cm
National Gallery of Scotland

and feeling man than a painter', his alertness to new ideas deserted him, and later work like the *Beati Mundo Corde (How an Angel Rowed Sir Galahad over Dern Mere)* (1890: DAG) combined heavy literary bias with an almost total disregard of plastic qualities. In 1892 *Ezekiel in the Valley of Dry Bones: de Profundis* (1891: private collection) was seen by 30,000 people when put on view in Edinburgh, although the artist had feared that he 'could not afford to paint it – it would not sell'. Part of the preparation for this work, and for others of an historical or Biblical type, was in the reading of relevant literature; in this case, Layard's *Nineveh*.

William Bell Scott (1811-90), like Noel Paton, was a poet-painter. Today he is more often invoked, probably, as a poet or as the author of *Autobiographical Notes* (1842) and of the *Memoir* (1850) of his elder brother, David Scott, than as the painter of the mural cycles at Wallington Hall (1857-58) for Sir Walter Trevelyan and at Penkill Castle (1865-68) for Alice Boyd. He was in fact a minor member of the Pre-Raphaelite movement, contributing to *The Germ* in 1850, advising the Newcastle business man James Leathart on his collection of Pre-Raphaelite paintings after his appointment as Master of the School of

Design at Newcastle-upon-Tyne in 1843, and a neighbour of his friend Rossetti in Chelsea after his return to London in 1864. His painting *Albrecht Dürer of Nürnberg* (1854: NGS), which was actually painted from the balcony of Dürer's house, shows Pre-Raphaelite detail combined with the trivial circumstantiality of genre, and derives from Bell Scott's pioneering advocacy of early German art. The picture also indicates that archaeologizing tendency which found its ideal outlet at Wallington Hall, where he painted eight scenes from Northumbrian history on canvas. These were designed to fit blind arcades of an Italian courtyard with a glass roof which had been built at Ruskin's suggestion in the centre of the house. Painted in a light key which suits the well-lit interior, the Wallington Hall series, still in fresh condition, is a remarkably successful solution to a difficult brief, perhaps the best being those which include luminous passages of landscape, *The Building of the Roman Wall, St. Cuthbert, The Descent of the Danes, Grace Darling* and *Iron and Coal on Tyneside in the Nineteenth Century* the last of the series. As a piece of industrial realism the last-named is only paralleled by Ford Madox Brown's celebrated *Work* (1852-65: MAG) in England. No other Scottish

painter had attempted a subject like this paean to commercial, industrial, and scientific progress. It shows the heir to Wallington as one of the three brawny 'strikers' hammering the red-hot iron beside a huge chain pulley, a marine air pump, an Armstrong shell and great gun, and a large anchor, with fisher-folk, a milk girl, a pit boy, and a photographer among the recognizable figures in the background.

David Scott (1806-49), while much less versatile than his brother and the unfortunate inheritor of the perhaps psychotic melancholy which pervaded the family home in Edinburgh, was the more considerable artist of the two. Rossetti regarded him as 'the painter most nearly fulfilling the highest requirements for historic art ... who has appeared among us from Hogarth's time to his own'. After returning to Edinburgh in 1834 from an eighteen-month stay in Rome, Scott spent the remaining fifteen years of his life in the Scottish capital. Despite discouragement and neglect, his output was large and dominates by sheer force of individuality the first twelve years of Victorian painting in Scotland until his death. A dignified but embittered figure, he was the solitary protagonist in Edinburgh of the difficult ideals of the Grand Manner. 'He never looked on Art but as another Literature – able to address the age through history, poetry and morals', wrote W. Bell Scott in his *Memoir of David Scott* of 1850. But the themes which Scott chose were often stern and unfamiliar, even deliberately obscure: *Philoctetes left on the Isle of Lemnos, Paracelsus, Vasco de Gama Encountering the Spirit of the Cape, The Russians Burying their Dead.* Although he craved the acclaim which was always denied him (except by his artist colleagues, who admitted him to membership of the Scottish Academy in 1829 at the age of twenty-three), Scott refused to ingratiate himself with the buying public. He clung steadfastly to his view that:

the art of painting . . . strives to create a world recognizable by the sense of sight, which will present things, or more properly, mental impressions, divested of those circumstances, which link with purposes aside from their more important or ultimate end – resting upon that alone which is most valuable in relation to mind.

Such an ideal was unlikely to be popular; even today the neglect of Scott continues and many of his pictures are lost. Yet his style is often far from austere and shows great dramatic invention and a powerfully pictorial sense of composition and colour.

In Italy in 1833-34, at the same time as William Dyce and Scott Lauder, David Scott's preferences among the works of the old masters seem a little old-fashioned in relation to contemporary taste. His chief admiration was reserved for the masters of the Roman *cinquecento* and *seicento* – Michelangelo, Caravaggio, Reni – although Caravaggio he grouped with Rembrandt and the author of the hellenistic *Laocoon*, that paradigm of Neo-classical perfection, as 'three of the most forcible minds that have been exerted in art'. This contrasts markedly with Dyce's quattrocentist and Lauder's Venetian tastes. Scott was evidently seeking models for a monumental style, although the mention of Rembrandt shows that painterly qualities also weighed with him.

Although Scott's style varies from picture to picture there is little development as such, and it comes as something of a shock to realize that the Daumier-like expressiveness of *Russians Burying their Dead* of 1832 precedes the *Sappho and Anacreon* painted in Italy in 1833 and partially influenced by Guido Reni. The serene *Vintager*, also of 1833, shows how much a colourist Scott could be; but such moments of lyrical repose are rare in his work. As soon as he had seen Caravaggio's *Entomb-*

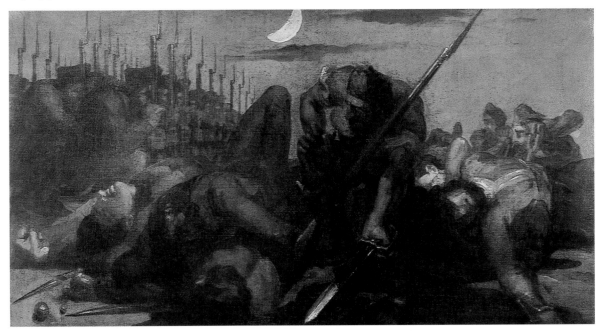

15 David Scott
The Russians Burying their Dead
1832
Oil, 49 x 91 cm
© Hunterian Museum and Art
Gallery, University of Glasgow

ment in Rome, he declared himself ashamed of my own prettiness in *Sappho'* – on which he was then engaged – and the philosopher-painter quickly re-emerged in his next Roman work, *The Agony of Discord, or The Household Gods Destroyed* (engraved, but present whereabouts unknown). This contrived composition, in which the artist's admiration for the *Laocoon* and also for Etty's *The Combat* (by then in Edinburgh) is plainly visible, is a moral allegory on the passions which destroy family unity and by extension society itself. The protagonists' expressions of hatred, despair, and shame – as instantly legible as masks in a treatise on physiognomy – imply their opposites, the love, hope, and happiness whose destruction has turned harmony to discord. Scott wrote gloomily of this work in his journal for 10 October 1833, his twenty-seventh birthday: 'It will be my final effort for notice . . . I know what its fate will be; my acquaintances will be timid; a few foreigners may come to see it; it will be rolled up and follow me to Scotland.' In fact, the picture remained unsold at the time of his death.

Undeterred by his failure to win a following in Edinburgh, Scott continued to produce his large compositions on a wide variety of themes. The best of them are those which make their effect through striking simplifications of form – such as the rhythmical repetition of the distantly receding ships (*Philoctetes*, 1840), the teeth of the portcullis (*The Traitor's Gate*, 1842), or the moonlit bayonets (*Russians Burying their Dead*, 1832) – allied to a dramatic use of light; in other words relying more on pictorial form than on narrative content. These powerful designs have the additional merit of being couched in a painterly language of bold brushwork and imaginatively used colour. Scott was a pioneer in a number of ways. His fairy paintings, *Puck Fleeing before the Dawn*, *Ariel and Caliban* (both 1837: NGS), and *The Belated Peasant* (1843: NGS), anticipate a Victorian fashion; the *Paracelsus* (1838: NGS) sets a precedent for Sir William Fettes Douglas's *The Spell* of 1880 (NGS) and *The Dead Sarpedon* (1831: NGS) for the Edinburgh Symbolists of the 1890s and for Henry Lintott's *Avatar* (RSA Diploma Collection). Scott's painterliness, too, set an important example in an age of high finish and 'correct' drawing.

In his *Memoir of David Scott*, W.B. Scott alludes to

the truth – that in the present age and in this country, especially in the limited sphere of Edinburgh, high art of an original kind, and on an adequate scale, is not required by any desire in the public mind – that pictures take their value nearly

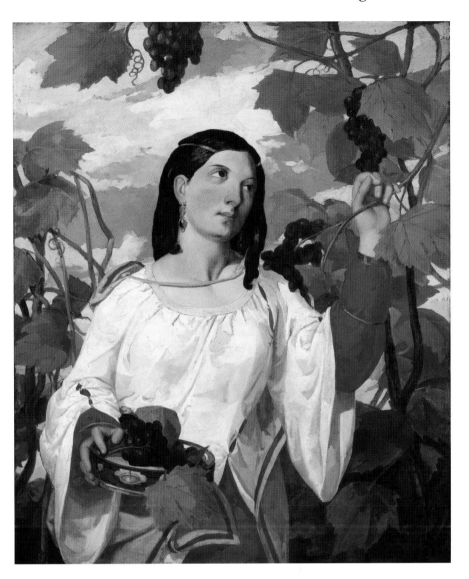

16 David Scott
Vintager
Exhibited at the Royal Scottish Academy in 1835
Oil on canvas, 116.90 x 97.20 cm
National Gallery of Scotland
The first sketch was made in Rome from the model, La Fornarina, in April 1833.

in proportion to their workmanship and scarcely ever by their intellectual expression.

It is certainly true that while David Scott found little support for his lonely endeavours in Edinburgh, the genre painters (one of whom, Thomas Duncan, was given the Chair of the Antique at the Trustees' Academy in preference to Scott in 1844) tended to be popular and successful. The appeal of genre lay not only in its familiar, accessible subject-matter but also in its adaptability to a wide range of moods and themes. It had special relevance to the new humanism of the nineteenth century. Here, the versatile David Wilkie had given the lead. This development is considered in the next chapter.

3 DOMESTIC AND HISTORICAL GENRE

'The taste for art in our isle is of a domestic rather than a historical character,' wrote Sir David Wilkie (1785-1841). No one, perhaps, had done more than Wilkie himself to bring this about. When he died in 1841 his work enjoyed, in the words of his fellow Royal Academicians' letter of condolence to his relatives, 'a celebrity unsurpassed in modern times'. A still more splendid tribute came from J.M.W. Turner, whose *Peace: Burial at Sea* was painted to commemorate Wilkie's death, which occurred on board ship during his return voyage from the Holy Land. From his début at the Royal Academy in 1806 until the change of style which followed from his travels in Italy, Saxony, Bavaria, and Spain in 1825-28, Wilkie's art was universal in its appeal, and was

admired alike by his royal patrons, by the ordinary people who thronged his exhibited paintings or bought the immensely popular steel engravings made after them, and by his fellow artists, including Delacroix and Gericault, who saw his work during visits to England. In his earlier manner, Wilkie was really the perfecter rather than the inventor of a genre type which was partly of Scottish origin and later developed strong Scottish associations through his own and his followers' work. This tendency, curiously enough, became endemic to London with the migration to the capital of Wilkie himself and of such later Scottish artists as John Phillip, Erskine Nicol, the brothers Thomas and John Faed, and John and Alexander Burr. Even Landseer's brilliant gifts

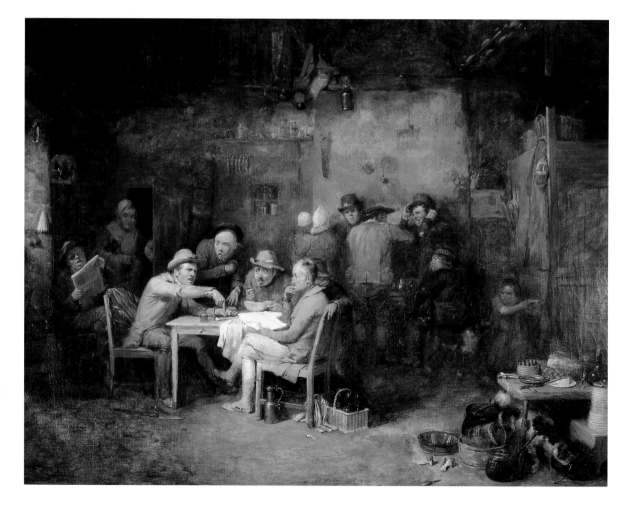

17 Sir David Wilkie
The Village Politicians: vide
Scotland's Skaith
1806
Oil, 57.20 x 75 cm
From the collection of The Earl of Mansefield, Scone Palace, Perth
Painted in London for Lord Mansefield, and based on an earlier version done in Scotland.
'Scotland's Skaith' is a poem by Hector McNeill, illustrating the dangers of addiction to political discussion and whisky.

were more than once deployed on Wilkiesque themes such as *The Highland Shepherd's Home*, exhibited in 1842 at the Royal Academy.

The story of Wilkie's rise to fame as a painter of genre is well known. In 1806 at the age of twenty he exhibited at the Royal Academy the small painting *The Village Politicians* (Earl of Mansfield) which instantly made his reputation. Its success was due to a delicacy of touch, simple and well-observed subject-matter, and its humour. Cunningham relates that on seeing this picture Sir George Beaumont, who was to become Wilkie's lifelong friend and influential ally, presented the young artist with the mahlstick which had once belonged to Hogarth, which Beaumont had kept until he should find a painter worthy of possessing it. A series of similar subjects followed, sometimes drawn from the life of the Scottish peasantry Wilkie had known as a son of the manse in Fife.

A limited precedent had been created for this type of subject in Scotland by David Allan (1744-96), whose pioneering genre scenes and street cries were influenced by the *bamboccisti* whose work he had encountered in Rome. The poet Burns wrote of himself and Allan as 'the only genuine and real painters of Scottish costume in the world', and Wilkie's *The Penny Wedding* of 1819 painted for the Prince Regent contains a reminiscence – but nothing more – of Allan's *Penny Wedding* (NGS), which had been engraved in 1803. David Allan's genre work was mostly in watercolour. That of his pupil Alexander Carse, who died in 1843 (the date recently established in Lindsay Errington's valuable study), was in oils and had perhaps some early influence on Wilkie, whom he followed to London in 1812, the year of Carse's masterpiece, *The Visit of the Country Relations* (Bowhill), whose brittle delicacy of theme and treatment shows real independence. Wilkie's *Pitlessie Fair* (begun 1804: NGS) is perhaps the clearest example of the younger artist's debt to Carse – specifically, to the composition *Oldhamstocks Fair* (1896: NGS and GAG) – but beside the Wilkie version Carse's own later *Mauchline Holy Fair* (1816: private collection) appears wooden. Carse's wittily titled *The New Web* (NGS), which was exhibited in Edinburgh in 1813, showing a tailor's apprentice kissing a servant-girl behind her master's back, although adding nothing to the Wilkie canon, does reveal an admiration for Netherlandish painters of domestic genre like Ostade and Teniers which was certainly shared by Wilkie, whose *Letter of Introduction* (1813: NGS) is based on a composition of Ter Borch. Again, however, the qualities exemplified in this latter, partly autobiographical work inspired by a visit made by the aspiring young artist to the influential London connoisseur Caleb Whitefoord – the subtle and sympathetic characterization which at once individualizes and links the three participants, man, youth, and dog; the beautiful drawing, delicate finish, and gently understated humour – remained

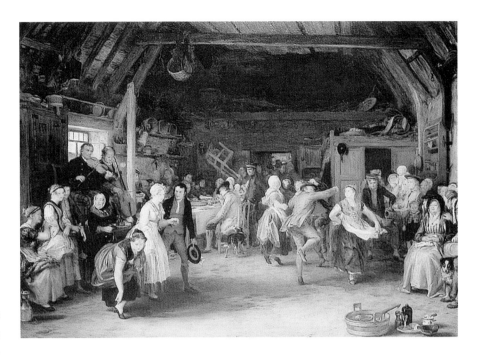

always beyond the reach of Wilkie's rivals and followers. The parallelism in subject-matter between the two artists interweaves closely in Carse's London years (until circa 1821) with subjects such as *The Pedlar* (Yale Center for British Art) or scenes from Burns's *Duncan Gray*, culminating in *The Penny Wedding* by both artists in 1819. But whereas the Wilkie wedding picture (H.M. The Queen) is nostalgically set in the costume of an earlier age, the Carse version (private collection) robustly portrays a contemporary scene in all its vigorous immediacy. It is no small tribute to Carse that he is able to emerge with credit from the comparison.

In Scotland the painters most immediately influenced by Wilkie were four of his former classmates at the Trustees' Academy in Edinburgh, William Home Lizars (1788-1859), Alexander Fraser (1786-1865), John Burnet (1784-1868), and Sir William Allan (1782-1850). These artists had studied at the Trustees' Academy under its sixth Master, the history painter John Graham (1754 or 1755-1817), one of whose sponsors to the post was the same Caleb Whitefoord immortalized by Wilkie. Graham, rescued from oblivion by Hamish Miles's recent study, was only a mediocre painter who nevertheless, as Miles points out, can be credited with the blossoming of the Trustees' Academy as a painting school in Edinburgh during the rise of the crucial generation of painters which included Walter Geikie and Sir John Watson Gordon, as well as the names mentioned above. Of these, Burnet is now chiefly remembered as Wilkie's engraver. *A Scotch Wedding* and *Reading the Will* (both 1811: NGS), the two best-known works of Lizars, who in 1812 virtually gave up painting while still in his mid-twenties to devote his energies to the family engraving business, foreshadow Wilkie in their subjects but show his

influence in treatment. Fraser's *The St. Andrews Fair* (1834: DAG) on the other hand clearly follows in the master's footsteps in subject as well, but here, as with Sir William Allan's *The Shepherd's Grace* (1835: RA Diploma Collection), any comparison with Wilkie is inevitably unflattering to his imitators. Of these, only two further names require mention here: William Bonnar (1800-1853) and Alexander Johnston (1815-91). Johnston studied initially at the Trustees' Academy in Edinburgh before moving to London and enrolling at the Royal Academy schools. His work is now rarely seen but suggests an artist deeply influenced by Wilkie in subject-matter, colouring, and treatment, who nevertheless was a draughtsman of real individuality. Bonnar (whose short career was spent in Scotland and whose pictures are equally rare) was perhaps a more subtle and more painterly artist. The quiet arcadian poetry of *Roger, Jenny and Peggy – a Scene from 'The Gentle Shepherd'* (1829: private collection) exemplifies the very real charm of what Sickert was pleased to call 'the old Scotch school', those 'descendants of Rubens, through Wilkie' whom

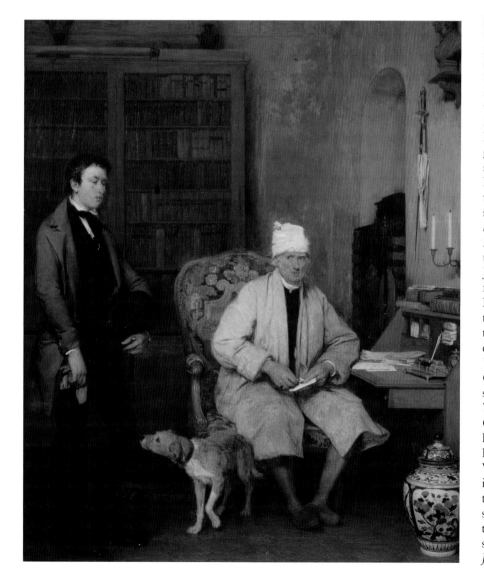

19 Sir David Wilkie
The Letter of Introduction
1813
Oil on panel, 61 x 50.20 cm
National Gallery of Scotland

Sickert had 'always loved and admired', whose vernacular style at once created and satisfied a demand for fine painting among the connoisseurs and collectors of early nineteenth-century Scotland.

Wilkie gradually became dissatisfied with the limitations of domestic genre and evolved his own distinctive version of historical genre, frequently turning to contemporary events for his themes. Later in life he also changed certain technical aspects of his style, above all painting with a much greater breadth virtually imposed by the greatly increased scale of his compositions. As early as 1814, after seeing the Rubens *Medici* cycle in the Luxembourg Palace for the first time, he reported in his journal, 'They grew upon me amazingly, and before I left the room, I could not help being convinced that, with all his faults, Rubens is one of the greatest painters that ever existed'. Wilkie was then still painting in his meticulously finished earlier style and was not technically prepared to absorb the lessons of Rubens immediately, but it was perhaps inevitable in his search for a more monumental, broader style that Wilkie should turn to Rubens, just as his desire for greater depth and sonority of colour eventually led him to the two earlier Spanish masters who were also painters of the life of their own day, Velazquez and Murillo. *Chelsea Pensioners Reading the Gazette of the Battle of Waterloo* (1822: Apsley House), *The Entry of George IV into Holyrood House*, and the vast Rembrandtesque *General Sir David Baird Discovering the Body of Sultan Tippoo Sahib* (1838: Edinburgh Castle) show three clear stages in Wilkie's gradual progress towards a grander manner and subjects of greater or more overt historical moment. Past history also began to receive his attention at the end of his career. He painted two Napoleonic subjects, *Napoleon and Pope Pius IV at Fontainebleau* (1836) and *The Empress Josephine and the Fortune-Teller* (1838: NGS), which retained a measure of topicality, and two pictures of the reformer John Knox which, painted in the years immediately following Catholic Emancipation and preceding the Disruption, may have been of more urgent significance to their own day than we at first suppose. In the year of the Act of Emancipation, 1829, Wilkie exhibited *Cardinals, Priests and Roman Citizens Washing the Pilgrims' Feet* and *Baptism in the Church of Scotland*, which ought to have been satisfactory to both sides. The earlier composition, *The Preaching of Knox Before the Lords of the Congregation* (1832: TG, versions at Petworth House and NGS) was commissioned by the Earl of Liverpool, but eventually bought by Sir Robert Peel. Wilkie spared no pains to achieve historical accuracy in this painting, and it is worth recalling that it was to Robert Peel that Wilkie wrote soon before he died stressing the importance of travel in the Near East to the authentic rendering of religious subjects. The second Knox picture, which was never finished, was *John Knox Administering the Sacrament* (begun 1839),

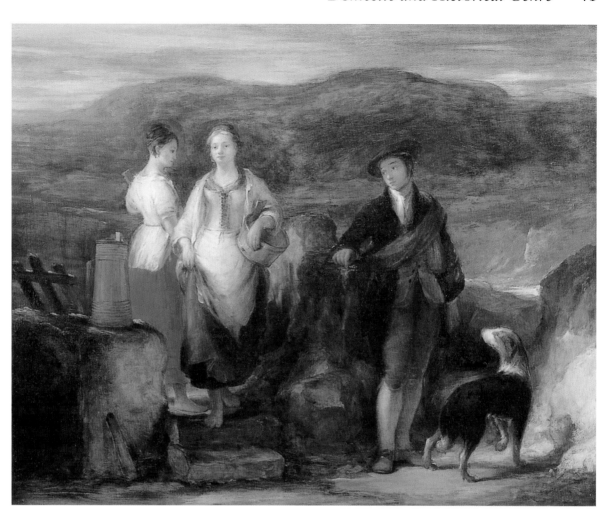

20 William Bonnar
Roger, Jenny and Peggy
1829
Oil on panel, 41.90 x 52 cm
Private collection
A scene from Allan Ramsay's *The Gentle Shepherd*.

the large version of which was bought by the RSA at the Wilkie Sale in 1842. This latter picture became well known to the younger Edinburgh painters, and William Dyce, Thomas Duncan, James Drummond, and W.Q. Orchardson produced works based on it.

Wilkie's contemporary and erstwhile fellow student at the Trustees' Academy, Sir William Allan, was by the beginning of Victoria's reign established in Edinburgh in the highly influential positions of Master of the Trustees' Academy (from 1826) and President of the Royal Scottish Academy (from 1837). Like Wilkie, Allan had studied under John Graham in Edinburgh. Although Wilkie tended to discount what he had learned in Scotland and called William Allan 'Allan the First' in disparagement of David Allan, the admittedly scanty available evidence suggests that John Graham was a not unworthy master of the two Scots, who were in 1837 still among the most prominent figure painters in London and Edinburgh. Graham's *Othello and Desdemona* (lost; engraved), painted for the Boydell Shakespeare Gallery, is a confidently dramatic costume piece, but it looks forward more obviously to the interest of Sir William Allan and his Edinburgh pupils in illustration and costume genre than to the naturalism of Wilkie.

Allan spent the years 1805-14 in Russia painting romantic studies of Tartars and Circassian brigands. 'Do not forget to embellish your landscape with fine figures. You know that nature is like a desert to me if it doesn't contain brave men and fair women,' wrote a St. Petersburg patron to Allan in 1808 (the original letter, in the NLS, is in French). This advice appears to have been taken to heart and Sir William Allan's Russian pictures contain their full complement of the brave and the fair, or at least of the picturesque. But Allan found on returning to Edinburgh in 1814 that Russian subjects did not have a ready market, and on the advice of his friend Sir Walter Scott he turned to historical romance, with subjects taken from Scottish history and literature, and especially from Scott's own works. In this field he became a specialist, the Scottish brave and fair replacing the Russian, and his example was largely responsible for the predominance of specifically Scottish themes in the work of the rising generation of painters in early Victorian Edinburgh. But the nationalism of a large painting of 1840, *Heroism and Humanity* (GAG), representing an incident in the life of Robert the Bruce, appears rather rhetorical when compared with Wilkie's festive *Entry of King George IV into Holyrood House*, a much subtler expression of patriotism, which reticently

introduces the newly rediscovered Honours of Scotland, the Scottish royal palace itself, and, in the large version in the Royal Collection, the figure of Sir Walter Scott as subordinate elements in what is essentially a state portrait. Allan, although generally independent and even original in his choice of subjects, was influenced by the later manner of Wilkie and transmitted to his pupils not only the broader execution which was one of its chief features but also, less happily, a prevalent use of brown which could only have meaning in the hands of an artist possessing Wilkie's mastery of tone. The ruinous effects of the use of asphaltum *à la* Wilkie can also be seen in several of the earlier works of Sir George Harvey, Robert Scott Lauder, and Thomas Duncan.

Sir William Allan's pupils, like their master, have fallen into an oblivion which seems unmerited, and since only a small proportion of their exhibited output can now be traced it is difficult to arrive at a satisfactory judgement of their achievements. Sir George Harvey, Thomas Duncan, and James Drummond were successful and popular artists during their own lifetimes, particularly Harvey, who became President of the RSA in 1864 and was knighted three years later. As the excellent reproductions in the revealingly titled volume *Harvey's Celebrated Paintings* of 1870 show, Harvey was an engaging and versatile artist. Unlike his contemporary David Scott, he never ventured beyond the limitations of his own technique, but displayed considerable inventiveness on a less grandiose plane. His first success came in 1830, with *Covenanters Preaching*, the first of several treatments of this aspect of Scottish history from which popular engravings were made. The awkward groupings and articulations in these compositions lend them an almost primitive air, yet this is curiously apt where the subject is, as here, austere and even stern, and they have a refreshing vitality. This latter quality appears to great advantage in *The Curlers* (1835), which also shows increased confidence in the handling of space and is part sporting picture and part landscape. Its sequel was *The Bowlers* (NGS), which was shown at the RA in 1850. *Drumclog* (1836: GAG) continued the series of Covenanting scenes, perhaps influenced by the battle scenes of Jacopo Cortese.

The series was interrupted by several not altogether successful 'histories': *Shakespeare before Sir Thomas Lucy* (1837: RSA), *John Bunyan in Bedford Gaol* (1838), *Argyle an Hour before his Execution* (1842), *An Incident in the Life of Napoleon* (1845), and in the same year *Mungo Park and the Little Flower* and *Dawn Revealing the New World to Columbus* (1855: all untraced). Perhaps the most important of these history paintings was *The First Reading of the Bible in the Crypt of St. Paul's*, painted in 1839-42. This picture was bought by the Liverpool collector John Clow and may have had some influence on the Liverpool artist W.L. Windus before he fell under the spell of the Pre-Raphaelites.

In 1859 the Association published Robert Burns's *Auld Lang Syne* with illustrations by Harvey, and in the following year four paintings each illustrating a line from the poem were sent by Harvey to the RSA. Two of them are particularly memorable images: 'But seas between us braid ha'e roared', which shows a sailor perched high aloft among the rigging of a sailing ship and is seen from his viewpoint, and 'We twa ha'e paidl't in the burn', which shows two young boys playing on a grassy hill, a simple and nostalgic treatment of the outdoor pleasures of childhood.

On occasion Harvey showed himself to be an excellent and sympathetic recorder of contemporary life. *A Schule Skailin'* (1846: NGS) – translated as *School Dismissing* when lent to the RA in 1871 – and *Quitting the Manse* (1848: NGS), which deals with the situation of many parish ministers who resigned their charges at the Disruption and consequently found themselves and their families homeless, were both in their own day extremely well-known examples of this side of his work. Wilkie's influence is evident in these relatively early works by Harvey, but in *Sheep Shearing* (1859: SAG) it is no longer so. Caw wrote of this painting that it possessed a 'truth and subtlety of aerial effect new in Scottish Art', and of Harvey's landscape work in general that 'he realised the pensive charm and pastoral melancholy of the Highland straths and the Lowland hills with an insight and sympathy which make recollection of his landscape a precious possession'. Approximately thirty landscapes appear to have been exhibited at the RSA by Harvey between 1859 and his death in 1876, but most of these pictures, constituting the major part of the artist's later work, are now lost. One of the few traceable examples, *Holy Isle, Arran* (1873: DAG), is painted with a freedom and tonal control which would not have looked out of place on the other side of the Channel, although its colour scheme is still based on a harmony of browns. It is in its way an impressive and beautiful work, and supports Caw's suggestion that Harvey is to be seen at his best in the late landscapes.

Thomas Duncan (1807-45) was a year younger than Harvey but died more than thirty years before him. In the seventeen years from 1828 when he first exhibited at the Scottish Academy until his death, he was represented at the RSA by nearly 100 canvases, of which approximately two-thirds were portraits. Yet despite the success in that field suggested by the rank of his sitters it was as a genre painter with an evident predilection for subjects inspired by Sir Walter Scott and Shakespeare that he achieved his considerable reputation among his contemporaries. He was an Associate of the early Scottish Academy by the age of twenty-two and fourteen years later, in 1843, of the Royal Academy. In 1844 he succeeded his own teacher, Sir William Allan, as Headmaster of the Trustees' Academy, but was dead the following year. Today he is virtually forgotten and most of his

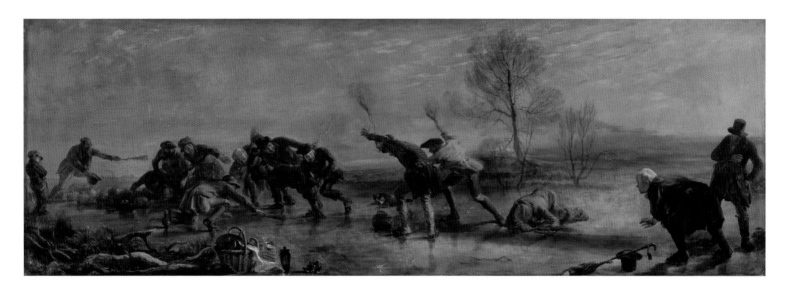

21 Sir George Harvey
The Curlers
1835
Oil on panel, 55.80 x 167.70 cm
National Gallery of Scotland

recorded work has vanished. The recently redisplayed *Anne Page and Slender* (1836: NGS), regarded by Caw and earlier writers as his most characteristic work, is a piece of Shakespearian whimsy with an emphasis on period costume and theatrical gesture which looks forward to Fettes Douglas, Orchardson, and Pettie. Its use of richer colour than was usual in Scottish painting of this date indicates the considerable Venetian influence which Duncan's early copies (now in the NGS) from Titian and Veronese might lead us to expect. Somewhat more surprisingly and a little incongruously, there is a Dutch motif recalling Brouwer or Ostade in the faces of Falstaff and an elderly companion framed in a window casement as the unseen witnesses of the comic encounter of the principal figures. These secondary personages are painted in glazed browns in contrast to the impasted lights of the main figures. Transitional and inconsistent though this work appears in its use of colour when compared with the confident colourism of Robert Scott Lauder's sketch for *Christ Teacheth Humility* of twelve years later, it nevertheless looks forward more clearly than any of Lauder's work to the more robust use of colour and well-nourished pigment which became a hallmark of later Scottish painting.

The effects of Duncan's training under Sir William Allan are evident in the bituminized *Catherine Glover and Father Clement* (PAG), which is brownish and insubstantial. His later, more painterly approach may well have been learned from the Raeburnesque portraitists, and perhaps especially from John Graham-Gilbert, whose *Love Letters* of 1829 mixes genre with portraiture and shows the solid paint surface and glowing internal lighting which appear in the later Duncan, most notably and completely in the large *Prince Charles Edward Asleep in a Cave* of 1843 (Castlemilk). It is also likely that the example of Etty's smooth modelling of the figure has some bearing here. However, a further reminder of the Raeburn portrait tradition occurs in Duncan's portrait (n.d. illustrated RSA 1926) of his friend Professor John Wilson (the pseudonymous 'Christopher North' of the *Noctes Ambrosianae)*, whose composition is indebted to Raeburn's grandly romantic *Colonel Alastair McDonnell of Glengarry*.

James Drummond (1816-77) gave an antiquarian turn to the interest in historical genre with a national emphasis which is characteristic of Allan's pupils. He was born in John Knox's House in Edinburgh's Royal Mile and his father, himself an historian of Old Edinburgh, inculcated in the son a love of the study of Scottish antiquity. This was to bear fruit in a book on the Celtic sculptured stones of the west Highlands and a series of drawings of Edinburgh streets executed between 1848 and 1867 with the object of recording the vanishing face of the ancient capital. Drummond's *George Wishart on His Way to Execution Administering the Sacrament for the First Time in the Protestant Form* (1845: DAG) is an early attempt at that species of archaeological reconstruction whose prototype was Wilkie's unfinished *John Knox Administering the Sacrament at Calder House*. It was followed by a series of paintings which either evoked the Scottish past and its notables, as in *Blind Harry the Minstrel Reciting the Adventures of Sir William Wallace* (1846), *James I of Scotland Sees His Future Queen* (1852), and *Ben Jonson's Visit to Hawthornden 1618* (1867: all untraced), or depicted the old architecture and

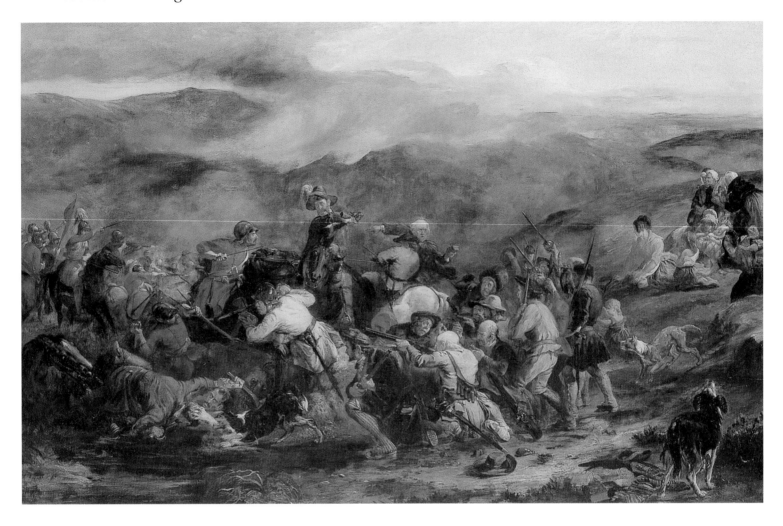

22 Sir George Harvey
Drumclog
1836
Oil on panel, 100.9 x 159.2 cm
Kelvingrove Art Gallery and
Museum
© Culture and Sport Glasgow
(Museums)

historic streets of the Scottish burghs, particularly of Edinburgh. A picture purchased for the national collection by the Royal Association for the Promotion of the Fine Arts in Scotland, *The Porteous Mob* (1855: NGS), combines these two elements in a satisfactory way. It portrays a dramatic night scene described in *The Heart of Midlothian,* and shows as a backdrop for this a reconstructed Candlemaker Row and Grassmarket, depicted with a wealth of incident and historical detail made palatable by subordination to an architectural framework which contributes to the impression of authenticity. Drummond's treatment in this as in the *George Wishart* picture is redeemed from the meretriciousness to which this type of genre was all too prone by a certain scholarly integrity which triumphs over his graceless drawing and almost total eschewal of colour.

By mid-century the never very clearly defined boundary between High Art – historical and religious painting and the illustration of the heavier classics of literature – and genre was blurred still further. Sir George Harvey and Thomas Duncan had narrowed the idea of history painting down to the painting of historical narrative; Drummond merely continued this tendency towards the particular and the real as opposed to the universal and the ideal, and towards a would-be factual rather than an imaginative reconstruction of events of the past. We have already seen how the realism of James Eckford Lauder's *Bailie McWheeble at Breakfast* and Noel Paton's *Dawn: Luther at Erfurt* represents a departure from the art of ideas to which David Scott alone in Scotland remained faithful. Yet even Scott in his *Paracelsus Lecturing on the Elixir Vitae* (1838: NGS) displayed an interest in the past for the sake of its curious lore, presenting in that work a disturbing gallery of bizarre characters in quaint dress: whispering conspirators, indolent courtiers, sullen priests, and venal ladies portrayed for their individual idiosyncrasy as much as for conformity to type. Throughout the 1850s, works by Millais and Holman Hunt were lent to the annual exhibitions of the RSA, providing an inescapable challenge to artists in Edinburgh, and above all accelerating the progress of realism. *Bailie McWheeble* and *Dawn: Luther at Erfurt* reflect this influence. William Fettes Douglas's portrait of a celebrated Edinburgh bibliophile and antiquarian, *David Laing and His Household Gods* (1862: NGS), notwithstanding a difference of subject-matter more in degree than in kind, shares with these two earlier pictures a common preoccupation with antiquarian staffage and with individual character. It is perhaps

the most satisfying work of the three because rather than strain after literary interpretation or religious expression, the artist has here found a subject in which the man and the milieu are one, and has deployed his remarkable skill on rendering with exquisite minuteness (hardly paralleled in any Scottish painting since Wilkie's *The Letter of Introduction*) the sitter's 'household gods', which are an extension of his own personality.

Sir William Fettes Douglas (1822-91) was a self-taught painter of exceptional gifts who became President of the RSA in 1882. The letters he wrote to David Laing from Italy in 1865 reveal him as a collector and learned antiquary, but are full of a feeling of *déjà vu* indicative of a fastidious temperament at once easily sated and wary of novelty. He writes: 'nature retains its beauty but the works of man seem poorer and falser the more they are studied. St. Peter's seems to me now neither so fair nor even so large as it did eight years ago, and not one picture, not one work of art of any kind repeats or revives the pleasure it afforded in former days', and elsewhere, 'I am so utterly sick of this idle wandering life that there is little likelihood of my going to Greece.' Perhaps the art galleries of Holland and Belgium which Fettes Douglas visited in 1878 gave him more pleasure. As an artist his affinities were above all with the Dutch and Flemish still life painters, and his paintings of astrologers, alchemists, and philosophers are in reality cabinet pieces, conceived on a larger scale, but akin in spirit to those of David Teniers, redolent of the arcane atmosphere of the study or laboratory and containing marvellously painted passages of still life. Several works painted in the 1860s demonstrate a delicate, rather dry virtuosity – *The Moneylender* (1861), *David Laing* (1862), and *The Spell* (1864: NGS). Their subtlety of colour and certainty of touch achieve a kind of minor perfection, more proper to the applied arts than to painting, satisfying the eye but leaving the mind and emotions untouched, and seeming to aspire to the material preciousness of the *objets d'art* shown in many of the paintings lovingly painted by an evident connoisseur. His disregard of the dictates of fashion is suggested by his later reversion to a Wilkie-like brown colour scheme from the conspicuously high key of *The Spell* to *The Antiquary* of 1875 (DAG). In the same year he began to turn his attention to landscape, which increasingly preoccupied him until his death. *Stonehaven Harbour* (1876: NGS) is the best-known example. It exploits the steep perspective provided by a viewpoint high on the hill behind the harbour, so that the surface of the water beyond, on which are dotted sailing boats returning in the early morning light after a night's fishing, rises in a flat vertical composition reminiscent of oriental art.

Among the more important Scottish genre painters born in the 1820s, Fettes Douglas was virtually the only one who did not spend his career in London, although his principal pictures were frequently sent first to the Royal Academy, and then to the RSA. This isolation created a refreshing independence, but at the same time his conservative temperament prevented him from contributing to new developments in the subject picture of the High Victorian period. As a result his own work has a slightly archaic air.

Fettes Douglas was a member of an Edinburgh sketching club called The Smashers, founded in 1848 and consisting originally of Douglas himself, John Ballantyne (1815-97), William Crawford (1811-69), the brothers John (1820-1902) and Thomas Faed, (1826-1900) and James Archer (1823-1904). While not exactly redolent of the revolutionary iconoclasm suggested by the club's title, these names severally indicate the transition that was taking place in the concept of genre from the earlier sometimes stern 'histories' of Sir William Allan, Sir George Harvey, and James Drummond (with their themes of murder, battle, and martyrdom, and events on a high level of historical significance), to the more human, more subjectively emotional, and later frankly sentimental, approach introduced especially by Tom Faed on a simple realistic plane in the early 1850s. In particular Faed depicted the agrarian population accepting its humble, sometimes deprived lot with resignation. Successful London Scots have never been prone to rock the boat and there is no hint of social criticism in Faed's work. By mid-century, in Scotland as in England, genre painting had become a medium of mass entertainment akin to the popular novel and its aspirations to profundity were generally no greater. In Fettes Douglas's *The Recusant's Concealment Discovered* (1859: GAG) a Pre-Raphaelite theme of religious persecution is reduced to a game of hide-and-seek, prettily coloured. In contrast Noel Paton, in a somewhat similar work, *The Bluidie Tryste* (1855: GAG), shows again that he understood the aims of the Pre-Raphaelites more clearly than any of his Scottish contemporaries, capturing and vulgarizing in a few paintings such as this something of the movement's intensity, in addition to the meticulous drawing and use of strong colour which were all that Fettes Douglas had absorbed. It is fair to add that Millais's *The Proscribed Royalist* of 1853 already shows a slackening of the Brotherhood's own early impetus.

James Archer, another member of The Smashers, was a portraitist in pastels who became a minor late follower of the Pre-Raphaelites, notably in a rather insipid Arthurian series painted in the 1860s, of which *The Death of Arthur* (1861: MAG), with its Tennysonian vein of sweet melancholy, is one of the better examples. Soon after his transfer to London in 1862 we find Archer a member of a London sketching club called the Auld Lang Syne, which was founded in 1863 and was in fact The Smashers reconstituted now that Archer and the Faed brothers were resident in London, where Tom Faed had in fact lived since 1852. Erskine Nicol (1825-1904), another

London Scot, was a member of the Auld Lang Syne, and three younger Edinburgh-trained painters who were soon to make their mark in the capital were frequently welcomed as guests: Pettie, Orchardson, and Peter Graham. Somewhat later, these younger artists formed a club of their own in London, known simply as The Sketching Club, which included virtually all the Edinburgh-trained artists of Pettie's generation resident in London.

These sketching clubs, with their lively and informal atmosphere, their competitions on suggested themes, and their cultivation of narrative inventiveness and rapidity of execution, were a common factor in the development of these Scottish artists in London. At the same time they were fertile forcing-houses of ideas for pictures planned on a very different basis from the high seriousness of a David Scott or the sensitive observation and careful calculation of a Wilkie. Martin Hardie, in the Pettie book, tells us that the subject for one evening's meeting was 'destruction', which was illustrated by C.E. Johnson by a shipwreck, while MacWhirter depicted a burning castle – 'the dark mass of ruins and some withered trees against the lurid glare of the sky, making a fine piece of composition and colour', while 'in Pettie's case the subject inspired a powerful drawing of Palissy seated despondently before his furnace door with his pottery lying in shattered fragments on the ground'. Several paintings shown at

the Royal Academy by members of the Club originated from rapid sketches made at one or other such meeting, including the famous *Funeral of the First-Born* (1876: DAG) by Frank Holl, one of the few English members of The Sketching Club. Martin Hardie tells a story which amusingly reveals the fertile and melodramatic habits of imagination formed by this type of approach: as a schoolboy he was to make a drawing of a pistol for a school prize and told Pettie (who was his uncle), who instantly suggested that the picture's title should be *The Suicide's Weapon* and that a smoking weapon should be shown beside a prostrate body. In a sense, this kind of slightly dubious ingenuity had its origin in Wilkie's much pilloried apophthegm that 'to know the taste of the public is to the artist the most valuable of all knowledge' (although Wilkie's early popularity has been achieved almost by accident and he actually defied popular opinion with his later change of style and subject), a remark which was only too prophetic, had he but realized it, of the desperate efforts of his own followers to palliate that taste. About 1868 one of the most successful and most talented of these followers, Tom Faed, most of whose career was spent in London, described himself in a letter to W. Hepworth Dixon as a 'slave to the Academy'.

The kind of over-production, in terms of number and scale, enjoined on successful artists by the Royal

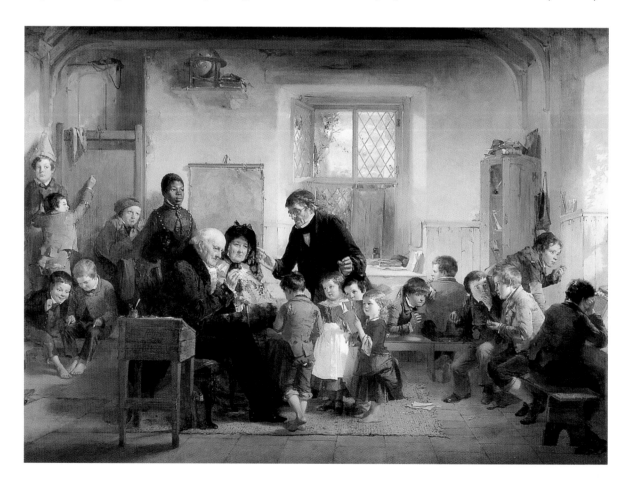

23 Thomas Faed
Visit of the Patron and Patroness of the Village School
1851
Oil on panel, 96.50 x 132.10 cm
The McManus: Dundee's Art Gallery and Museum
Dundee Art Galleries and Museums (Dundee City Council)

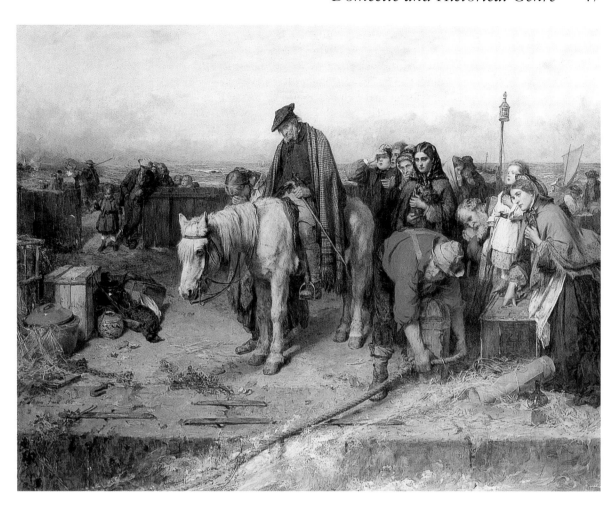

24 Thomas Faed
The Last of the Clan
1865
Oil, 144.80 x 182.90 cm
Kelvingrove Art Gallery and
Museum
© Culture and Sport Glasgow
(Museums)

Academy system, must have been a chronic problem for a painter of Faed's painstaking methods and laborious execution. The large and elaborately finished *Visit of the Patron and Patroness to the Village School* (1851: DAG), actually exhibited at the RA during the first year of Faed's residence in London, 1852, shows his remarkable manipulative skill (the enamel-like surface of the paint is still in beautiful condition), and a sensitive treatment of light which imparts a fine luminosity to the muted harmony of ochres and greys. In its subject of the pastimes and pains of young life the picture owes an obvious debt to Scottish predecessors like *The Village School* or *The Cut Finger* by Wilkie or Harvey's recent *A Schule Skailin'*, and it shares something of their robust humour. Several of the small figures are charmingly sympathetic studies, but by no means all: on the right the face of the boy about to steal the apples wears an ugly expression of stupidity and greed; and the boy adopting a pugilistic stance behind the back of the negro boy servant (whose features are elsewhere being caricatured by another miscreant) will seem more alarming than amusing to those for whom the child is father to the man. This astringent element, inherited from early Wilkie, but added to an ingredient of social comment which reminds us of Faed's link with the circle of the

philanthropist Angela Burdett-Coutts in Highgate, is seen to best advantage in *The Mitherless Bairn* (1855: National Gallery of Victoria, Melbourne), upon which Faed's reputation in London as a painter of Scottish genre was founded. Here, the artist contrasts an unfortunate orphan with a horrible little bully in a way which is far removed from sentimentality. Faed according to McKerrow attributed the inspiration of the painting to a poem of the same name by William Thom, and the same writer tells us that Angela Burdett-Coutts liked the picture so much that she asked Thomas to paint a similar one for her (the less successful *Home and the Homeless*: 1856). An element of realism is also apparent in *The Last of the Clan* (1865: GAG), showing those left behind, perhaps on some Hebridean island, after the departure of emigrants from the community. But although Faed's later pictures retain the careful rendering of still life and costume in humble surroundings which makes them fascinating as social history, they are filleted performances in which the human content lacks any urgency, lacks indeed any real point. The large, beautifully painted *Where's My Good Little Girl?* (1822: GAG) is indeterminate in subject – a child is apparently being consoled with the gift of an apple, perhaps for a broken doll which lies on the floor, by her mother and older sister – but the focus

of the picture is the child's expression, which registers a hard-won victory over tears. To enjoy this painting and others like it, it is not absolutely necessary to like children, but it does help.

A parallel development in Tom Faed's career, aside from the elaborately executed subject pictures just discussed, is a small series showing the single figure of an attractive young woman in a landscape setting, with a title sometimes giving a literary reference as in *Evangeline* (n.d.: MAG), *Highland Mary* (1857: AAG), and *The Reaper* (1863: ibid.), with their respective overtones of Longfellow, Burns and Wordsworth. A sickle in the latter picture, and the titles of the others, are indispensable pointers to their literary origin, which would not otherwise be apparent. They are essentially fully clothed pin-ups as devoid of intrinsic meaning as another of the series, A *Seaside Toilet* (1862: AAG), which depicts a comely wench fastening or unfastening her bodice by the seashore, but which like the others is innocent (or nearly innocent) of erotic implications. In fairness to all concerned it should be mentioned that Longfellow himself wrote to Tom Faed in terms which appear to go far beyond mere politeness in thanking the artist for a sympathetic visual interpretation of the poem: 'The landscape, the melancholy seashore, the face and attitude of Evangeline, so full of sorrow and patience, tell the whole story with great power and truth. It is very beautiful and very pathetic.' In each of these pictures the landscape backgrounds are handled with greater breadth and spontaneity than is usual in Faed's work. In the case of *Highland Mary* there appears to be a debt, extending even to the facial type, to Millais's celebrated *The Blind Girl*. An associative title, in such pictures, is clearly an important part of the Faed armoury.

We have seen Tom Faed treat aspects of contemporary reality – the plight of the orphan and of the Highland emigrant, the provision of education in poor or country communities – and *From Hand to Mouth – He was one of the Few that would not beg* of 1879 (Wadsworth Athenaeum) reverts to the theme of destitution amid plenty, here the poverty and scarcity of employment which oblige a poor but honest old soldier to take his weary children with him as he plays for pennies in the street, while the pretty lady in her elaborate dress attended by her black boy servant, possessive terrier and sheltered child arrives after a day of idleness to the certainty of a respectful reception from the hardheaded shop-owner, who is clearly not about to extend credit to his poorer customer – or is he? Sentimental the treatment may seem to us to be, but this large picture is oddly compelling (it measures 148 cm x 207 cm and is wonderfully painted), and enshrines the Victorian artist's optimism regarding the future of a society which believed itself to be perfectible. Here everyone (including the concerned artist and the sympathetic viewer) is seen in an excellent light – the lady alone may be open to criticism, but perhaps she will

intercede for the war veteran, and she is very pretty – and perhaps we should acknowledge that in a less cynical age sentiment could not only soften hearts, but also bring about a climate of concerned philanthropy. The picture's purchaser from the RA was in fact a Member of Parliament, Angus later Lord Holden. That the social problem of mendicancy among old soldiers was a topical one has recently been demonstrated by Hichberger.

John Faed (1819-1902), less well-known in his own day and in ours than his younger brother Tom, was also an artist of great technical ability and was more versatile, but less popular in his choice of subject-matter. His early extensive practice as a basically self-taught but very accomplished miniaturist in Edinburgh may be represented by *The Evening Hour* (watercolour on ivory, 1847: NGS), which shows the children of Dr Archibald Bennie as musicians portrayed with an almost startling perfection of finish and a photographic precision which recall Ingres on the one hand, and on the other the contemporary calotypes of Hill and Adamson. In 1853 John Faed was commissioned to provide a series of illustrations to Burns's *The Cottar's Saturday Night* by the Royal Association for the Promotion of the Fine Arts in Scotland. The resulting engravings, published in the Association's edition of the poem, employ an appropriate Wilkiesque idiom as convincingly as Tom Faed's work of this date, suggesting that perhaps the most significant difference between the brothers lay in Tom's more inventive approach to subject-matter. This appears to be confirmed when we find as late as 1871 John Faed's *The Statute Fair* (Wolverhampton Art Gallery) – a subject associated with the earlier painters Sir David Allan, Wilkie, Carse and Walter Geikie – was exhibited at Brooks's Scotch Gallery in Pall Mall, and some of John's excursions into literary genre, like *The Death of Burd Ellen* (n.d., probably 1860s: Kelvingrove) and *Catherine Seyton and Roland Graeme* (1863: Wolverhampton Art Gallery) from Scott's *The Abbot* exploit a by now somewhat depleted seam, although full of passages of fine painting. Yet it fell to John Faed to paint what is certainly one of the great documentary paintings of the nineteenth century, *A Wappenschaw* (1861: The National Trust for Scotland), a canvas measuring 148 cm x 246 cm and containing over forty individual portraits as satisfyingly united compositionally as they were, no doubt, in real life – for here we have the tenantry of a country laird gathered for the traditional shooting competition, a ruined fifteenth-century keep in the background serving as a reminder of the historical origin of the event in the decree of James I obliging the crown vassals – the lairds – to muster with their men and their weapons four times a year in satisfaction of their fief.

Of the other genre painters born in the 1820s, only three are of note: Erskine Nicol (1825-1904), Robert Herdman (1829-88), and Robert Gavin (1827-83),

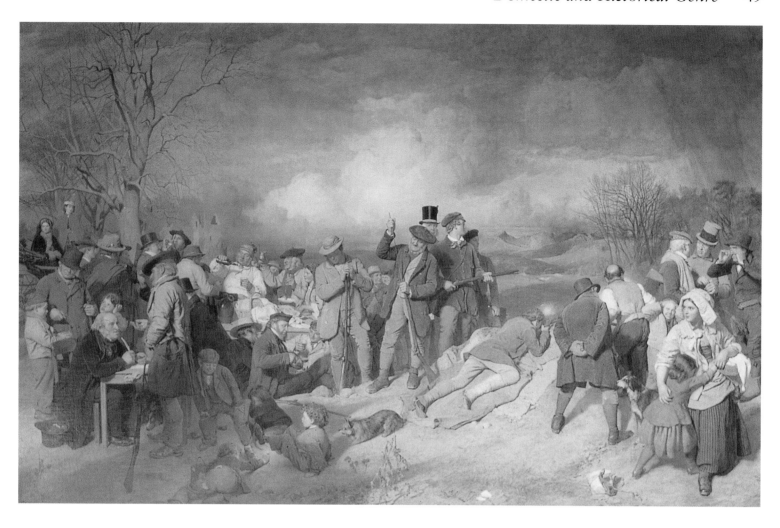

25 John Faed
A Wappenschaw
1861
Oil, 149 x 236 cm
The National Trust for Scotland

each an accomplished but not very brilliant personality. Nicol was part of the wave of Scottish artists who descended on London in the early 1860s, and after 1863 his entire career was spent in the south. He specialized in Irish subjects which he is said to have derived from a four-year stay in Dublin begun in 1846 and which exhibit a relentless coarse humour which perhaps no longer amuses quite as it once did. These paintings bear titles like *They Talk a Power of Our Drinking but Never Think of Our Drought* (RSA 1862: sketch in DAG), *Toothache!* (1862: lost), A *Doubtfu' Saxpence* (1874: private collection), and *Steady, Johnnie, Steady!* (1870: DAG) in which a young angler is intently playing a trout under the eye of an experienced old ghillie. Nevertheless, the latter work indicates an ample measure of the ability to draw expressions which is essential to this type of painting, and the landscape background is handled with a breadth and a sensitivity which almost redeem the picture as a whole.

Robert Herdman spent his entire career in Edinburgh, apart from a visit as a student to Italy in 1855, where he divided his time between portraiture and genre, showing a particular bent for scenes from Scottish history. He is another example of a painter of sound and agreeable technical quality whose

notion of subject-matter finds little sympathy today. He learnedly reconstructed historical scenes like *The Execution of Mary, Queen of Scots* (1867: GAG), *After the Battle* (1871: NGS) which was engraved by Frank Holl for the Royal Association in Scotland, and seems to owe something to Henry Wallis's *The Death of Chatterton* (1856: TG), *The First Conference between Mary Stuart and John Knox: Holyrood 1561* (1876: PAG) and *Saint Columba Rescuing a Captive* (1833: PAG). These now look academic and unconvincing, as if the characters were playing charades. His group portrait of the children of Patrick Fraser (1866: lost but photographed) *Dressing for the Charade* exploits an evident knowledge of period costume less pretentiously, and a little picture *Wae's Me* (1879: DAG) refers in a manner akin to the single female studies of Tom Faed to a literary source, in this case Lady Anne Barnard's well-known 'Auld Robin Gray'. This poem, which is about a girl who believes her sweetheart to have perished at sea and marries her elderly suitor only to find that her Jamie is alive after all, provides a subject potentially full of an almost Rossettian kind of anguish which in the hands of a better painter would have been made more explicit. A slightly earlier picture also using a literary prop is *The Quadroon*

Girl (1872: DAG) by Robert Gavin, which shows a semi-nude quadroon girl standing in the gaze of two seated men, and illustrates Longfellow's poem of the same name at the passage where her master is deciding whether to sell her to a slave-trader. Caw states that during Gavin's visit to the United States about 1860, 'he was struck by the pictorial possibilities of plantation life, and for a number of years painted the negro at work and play, principally the latter'. In 1874 his address in the RSA catalogue is Tangiers, and subsequently a number of North African subjects appear under his name. As none of these works can now be traced, their value as records of foreign places and people must remain an open question. A portrait of two unknown local sitters, both girls in their teens (n.d.: recently Maas Gallery), a direct luminous work, was fresh and attractive enough to make one regret the nearly complete disappearance of his work.

The last artist to be considered in this section, John Phillip (1817-67), was the most forward-looking of the Scottish genre painters of the post-Wilkie generation, although he was slightly older than those just discussed. In a few pictures produced in the 1860s, at the end of his career, he perceptibly enlarged the boundaries of the High Victorian subject picture in his painterly use of colour and in his ability to convey a wide gamut of human emotion. In both respects he looks forward to the work of those pupils of Scott Lauder who, like himself, passed the major part of their careers in London, particularly Orchardson and Pettie.

Although he was born in Aberdeen, Phillip's early training was in London, where he had become a pupil of T.M. Joy by 1836, and in 1837 was admitted to the schools of the Royal Academy, along with Richard Dadd and W.P. Frith, who became his friends. With these artists he became a founder-member of a sketching club called The Clique which contained, in addition to the three already mentioned, Henry Nelson O'Neil, Augustus Leopold Egg, Edward Matthew Ward and Alfred Elmore. Phillip returned to Aberdeen by the time The Clique ceased to meet, in 1841, where he was engaged on painting portraits and figure subjects. Writing in *The Art Journal* in 1898, John Imray recalled that the young Phillip was ambitious to paint incidents in the lives of famous persons. A large group portrait, commissioned by Queen Victoria in 1858, of *The Marriage of the Princess to Prince Frederick William of Prussia* (1860: H.M. The Queen) might well come into that category, but it is unlikely to have been the kind of thing the young Phillip originally had in mind during the period of The Clique. In more general terms, however, the stimulus provided by that talented company fostered an individuality which gradually emerged in his work, and which was eventually to make him one of the most successful of all Victorian artists. When he died in 1867, the value of his portrait commissions left uncompleted stood at twenty thousand pounds. It is for his subject pictures that he is remembered now, not for his portraits, but the royal portrait mentioned here, exhibited at the RA in 1860, is a masterly performance containing over forty heads, grouped with no sense of strain in a lucid composition on a large scale (the picture is 102cm x 183cm), with an admirable execution reminiscent of the cameo-like smooth modelling of flesh and precise draughtsmanship of Daniel Maclise. Several single-figure studies, too, show great sensitivity in the perception of character and, latterly, an almost *alla prima* 'attack' in their painterly brushwork. Of the former, *The Spinning Wheel* (1859: GAG), strictly speaking a genre subject, is a very beautiful example which does full justice to a particularly lovely model; and the unfinished *Woman with Guitar* (undated late work: Nottingham Art Gallery) demonstrates that Phillip's discovery of Velazquez in the later part of his career was a revelation fully absorbed by the Scottish artist in its implications for late nineteenth-century painting, with its twin evils of starved surfaces and excessive anecdotal bias. Runs of paint rapidly and confidently applied in this study remind us that 'Spanish' Phillip's debt was as much to Spanish painting as to Spanish local colour, and it has a modern appearance akin to Manet's Spanish subjects or Whistler's treatment of the single figure in the *Sarasate* portrait.

Unlike the painters already discussed who were influenced by Wilkie, Phillip did not spend his entire career under the shadow of the earlier master and his is a comparatively rare case in the mid-nineteenth century of late development. However, it should be added that in his travels to Spain (initially in 1851 under doctor's orders, and again in 1856-57 and 1860-61) which were of such importance to the revitalization of his style, he was only following in Wilkie's footsteps. The early pictures reveal the all-persuasive influence of Wilkie in theme, treatment and handling. A *Presbyterian Catechising* (1847: NGS), relating to an old custom in the Church of Scotland, shows a good-humoured but attentive gathering of village folk grouped round the seated minister and the standing girl who is being asked questions about her religious faith. The picture is brownish in colour but without the transparency that Wilkie could achieve. A *Scotch Fair* (1848: AAG) and the full-scale drawing for it (DAG) are humdrum in execution and in the interpretation of a theme which Wilkie had made so much his own; they give little enough indication that their creator possessed other than ordinary talent. *Drawing for the Militia* (1849: Bury Art Gallery) is a more humorous subject, showing a rather stout recruit being measured for his uniform; both this picture and the sketch (WAG) show how heavily dependent Phillip was on Wilkie at this stage in his career, even when he attempted subjects that had not been touched by the master. The sketch (1850: Orchar Collection, DAG) for *Baptism in Scotland*, however, though in other

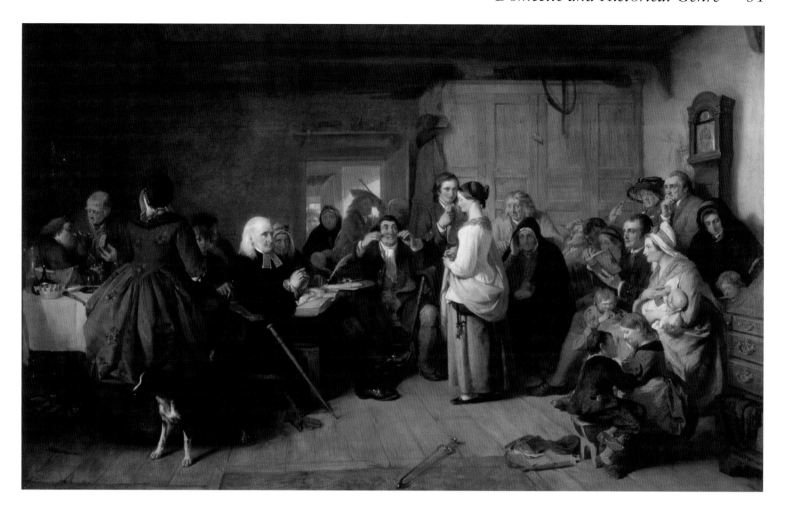

26 John Phillip
A Presbyterian Catechising
1847
Oil on canvas, 100.60 x 156 cm
National Gallery of Scotland
A country minister tests his
charges' knowledge of the
Scriptures.

respects it could be taken at first glance for a work by Wilkie, is preoccupied with an almost Rembrandt chiaroscuro effect.

It is in the pictures painted on his visits to Spain that Phillip emerges, with gradually increasing power, as an original artist. The works of the first two visits were those which appealed especially to Prince Albert and to Queen Victoria, whose attention had been drawn to Phillip by Landseer and who is said to have given Phillip his brevet 'of Spain'. They still show the influence of Wilkie in their subject-matter, as in *The Letter-Writer of Seville* (1853: H.M. The Queen), given to Queen Victoria by Prince Albert at Christmas 1852, which derives from *The Letter-Writer, Constantinople,* and *The Dying Contrabandista* (1858: H.M. The Queen), which is related to *Peep O'Day Boy's Cabin,* and was given to the Prince Consort by Queen Victoria at Christmas 1858. However, both paintings employ a light tonality which is quite unlike Wilkie. A perceptible difference in emotional atmosphere too, begins to differentiate the generally euphoric Spanish subjects from his other, less flamboyant works. In the *Lady Playing the Mandolin* (1854: WAG), a languid Victorian beauty – Phillip had a better eye for models than many of his contemporaries – reclines in a deeply upholstered chair, stunningly gowned and

accessoried, the embroidery on her knees suggesting a convalescence that is being whiled away. In complete contrast, *Gypsy Musicians of Spain* (1855: AAG) shows two dark-eyed, assertively smiling girls under a trellis of vine, making music with guitar and tambourine as loud, no doubt, as the colours of their clothes. One obvious contrast such as this should not be forced into a general rule, since there are serious and even melancholy subjects like *Spanish Peasants – the Wayside in Andalusia* (the animals and landscape painted by Richard Ansdell, Phillip's travelling companion in 1856, completed 1863: AAG), in which a girl on the donkey plays her guitar with the wistful concentration of Wilkie's *Pifferari,* while *Collecting the Offerings in a Scottish Kirk* (York Art Gallery; exhibited at the RA in 1855 with the subtitle 'Give and ye shall receive') has a vein of quiet humour. Nevertheless, it is broadly true that Phillip found in Spanish life the vivid contrasts which enabled him to deliver his anecdotes with greater pointedness than before. This applies particularly to the paintings that date from the last Spanish visit (1860-61) and after, notably *La Bomba* (1863: AAG), *'La Gloria' – A Spanish Wake* (1864: NGS), and *A Chat round the Brasero* (1866: Guildhall Art Gallery). These and other works of this last period are astonishingly bold in their use of powerful colour

and handling. They reveal that Phillip was studying Velazquez with particular attention at this point (his splendid copy of *Las Lanzas* is in the RSA collection). The subject, too, of his masterpiece '*La Gloria*', unites in one composition the opposite extremes of a gamut of emotion, paralleled by the picture's abrupt division into two halves, light and dark. Here, the inconsolable mother of the dead child seen in the dark extreme left of the painting is being persuaded in vain by her husband and a friend to join the dancers at the wake, who uninhibitedly and even flirtatiously desport themselves in the bright sunshine beyond to the accompaniment of guitars and castanets. The picture was exhibited at the RA with the note that 'In Spain, when a child dies, it is firmly believed that it is spared the pains of purgatory and goes direct to heaven. The neighbours consequently assemble at the house of death, and celebrate the event by dancing and feasting'. As a symbol of this (less obtrusive in the picture than it sounds to describe) the child's pet bird, freed from its cage, is seen flying off against a blue sky.

27 John Phillip
Gypsy Musicians of Spain
1855
Oil, 65 x 54.50 cm
Aberdeen Art Gallery and Museums Collections
A memory of the artist's seven-month stay in Seville in 1851.

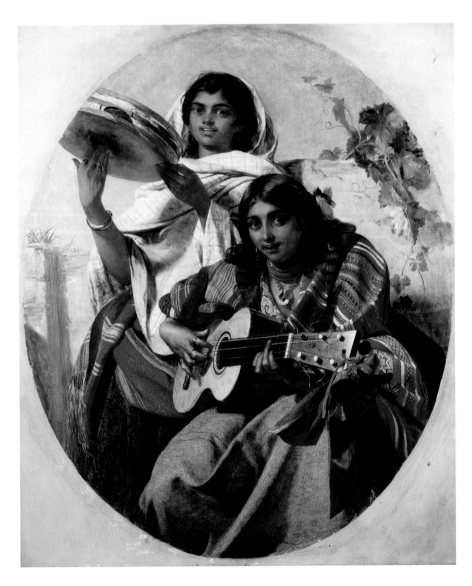

Several of the other late works show similar, if less extreme contrasts in emotion. In the large *La Loteria Nacional – Reading the Numbers* (n.d: AAG) the influence of Wilkie's *Chelsea Pensioners Reading the Gazette of the Battle of Waterloo* is still relevant. It appears again, somewhat more subtly, in *The Early Career of Murillo, 1634* (1865: Forbes Magazine Collection, U.S.A.), exhibited with a lengthy quotation from Stirling-Maxwell's *Annals of the Artists of Spain*, and showing 'the unknown youth' standing 'among the gipsies, muleteers and mendicant friars, selling for a few *reals* those productions of his early pencil for which royal collectors are now ready to contend'. Here, the contrast in types and expressions is explicit. In *La Bomba*, (DAG) which is one of Phillip's most monumentally simple compositions, there is an implicit contrast between the gaiety of the toreador and the girl who fills his glass, and the dangers of his vocation.

Phillip seems never to have been robust and died at the age of fifty-nine in 1867. Despite the attention that has been paid to his work, he himself remains a surprisingly little-known figure. His first visit to Spain was made under doctor's orders, for an unspecified, perhaps nervous illness. It may be guessed that the colour, music, and continuous fiesta which are almost exclusively what he shows us of Spanish life had a particular attraction for an invalid. Graham Reynolds has plausibly suggested that 'the degree of his conversion to the choice of Spanish themes is one more example of the complete way in which the warm South can take hold of the scions of the North', and one certainly feels that this was what Phillip wanted us to believe. *The Evil Eye* (1858: Hospitalfield House; versions at Kelvingrove and Smith Institute, Stirling) contains a self-portrait of the artist as a genial tourist sketching with avuncular amusement the shrinking figure of the Spanish peasant woman who superstitiously turns away from her portrayer but cannot resist fearfully looking back over her shoulder at him. Neither the patronizing air of the painter, nor the woman's discomfiture, are in any way played down, and the heartless humour which results has a painful quality. Has the artist revealed a disturbing truth deliberately or unconsciously? Either way, the picture presents the artist as a crass intruder upon a life in which he has no part. Recent research has shown that the benign artistic *persona* which Phillip also projected as a man – 'delightful, warm-hearted, generous to a fault, single and simple-minded . . . he had a large share of that quiet humour which his countrymen seldom lack', as Walter Armstrong wrote – can have owed little to his personal circumstances. Although less closely involved in the events surrounding Dadd's murder of his own father in 1843 than David Roberts (to whom Stephen Dadd immediately wrote a distraught account of the calamity), Phillip had been close to Dadd and must have been deeply affected. Shortly after his return to London from

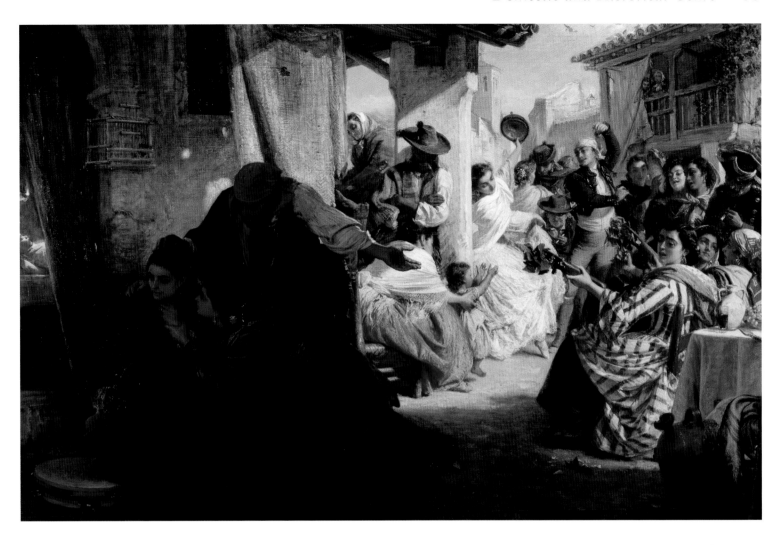

28 John Phillip
'La Gloria' – A Spanish Wake
1864
Oil on canvas, 145.40 x 219.20 cm
National Gallery of Scotland
The principal of some twenty
pictures painted or begun during a
last visit to Spain during 1860-61.

Aberdeen in 1846, he married Dadd's youngest sister Maria, but within ten years she too had become insane, and there is a contemporary account of her marriage with Phillip which related that at an unknown date she attempted to strangle one of their children before being committed to an asylum in Aberdeen in 1863, where she died thirty years later, twenty-six years after Phillip himself. From this unhappy tale, which has never been taken account of in any discussion of Phillip's mature works, we may at least suspect that the apparent hedonism of the Spanish pictures may conceal an almost desperate element of escapism, and that a full interpretation of the artist's masterpiece, '*La Gloria*', for example, may not be possible until we know more exactly how it related to the circumstances of the painter's life.

What is certain is that '*La Gloria*' introduces a frisson which we recognize now as belonging peculiarly to the High Victorian subject picture, in which emotionalism is allowed free play and the artist conveys subjective feelings which are not related to a moral or a literary theme. Phillip's painterly use of strong colour and generous brushwork are the other aspects of his late work which contribute something new to British painting in the 1860s. Regularly seen at the RSA Exhibitions, Phillip's work was widely admired in his native Scotland by artists and collectors.

4 PUPILS OF ROBERT SCOTT LAUDER IN LONDON

Robert Scott Lauder was appointed Headmaster and Director of the Antique, Life, and Colour classes at the Trustees' Academy in 1852, and his influence acted as a catalyst on the group of young painters who were his pupils in Edinburgh until his enforced retirement through paralysis in 1861. It was as a teacher and personality rather than as an artist that he most affected them. The rising generation of students included William McTaggart (1835-1910), Hugh Cameron (1835-1918) and George Paul Chalmers (1835-78), whose careers were spent almost entirely in Scotland. National fame was denied to them, but McTaggart's influence on subsequent painting north of the Border was to be greater than that of his fellows in London. Sir William Orchardson (1832-1910), John Pettie (1839-93), Tom Graham (1840-1906), John MacWhirter (1839-1911), John Burr (1831-93) and his brother Alexander Hohenlohe Burr (1835-99), and Peter Graham (1836-1921) were among the students of Lauder who as expatriates and close friends in London from the early 1860s made a considerable impact on the artistic life of the metropolis. With the exception of the Burrs and Tom Graham all these artists became full members of the Royal Academy. Peter Graham (a great favourite of Queen Victoria) and John MacWhirter (who was appreciated by Ruskin, if not as a landscapist, at least as a sketcher from nature) specialized in the popular commodity of wild, usually Highland mountain landscapes. Graham's titles such as *Caledonia Stern and Wild* and MacWhirter's such as *The Sleep that is among the Lonely Hills* indicate rather conventional sensibilities. The Burrs purveyed native genre with a Faed-like emphasis on child subjects; Tom Graham, a more reticent artist who sometimes touches a note of quiet poetry, was mainly a genre painter; and Orchardson and Pettie, whose work was most frequently linked and even mistaken for one another's by contemporary commentators in London, began their careers as painters mainly of historical genre.

Despite their evident involvement with subject, all these painters have, at their best, one saving grace in common. If their imagery lacks the peculiar intensity of the best work of the Pre-Raphaelites, some compensation is provided by their painterly qualities. These Scottish painters share a technical approach which goes far beyond the careful addition of colour to drawing. In general, their brushwork has an attractive freedom which stands in considerable contrast to the niggling finish of much contemporary work, and this broader approach to colour no longer applied in flat fields (a feature even of the method of John Phillip) can be attributed to the influence of Scott Lauder's teaching.

No full account of the methods or the content of Lauder's teaching exists, but some of his ideas can be inferred from the work produced by students at the Trustees' Academy soon after his arrival. Orchardson's student years bridge the years immediately prior to, and following on, Lauder's appointment in 1852. Such was the prestige of Lauder's name in Edinburgh that Orchardson had returned to the classes of the Academy in order to benefit from his teaching. Two pictures shortly thereafter show a considerable change from the almost monochromatic grey or brown of Orchardson's very earliest work, which is succeeded by a chromatically richer Venetian style very much in line with Lauder's known and practised Venetian enthusiasms. They are the very striking, already rather manneredly posed, little *Self-Portrait* (probably 1853: Orchar Collection, DAG), and *Wishart's Last Exhortation in the Castle of St. Andrews* (1853: University of St. Andrews). The latter picture, painted when Orchardson had studied under Lauder for about six months, is compositionally much in advance of all his earlier work: the figures are grouped expressively, and painted in a higher key, and with more control of tone, than its predecessors. This picture bears out the account of Lauder's teaching method given by Martin Hardie, whose uncle John Pettie had been one of Lauder's pupils:

> Lauder set himself to teach his pupils how to see. In the Antique Class, for instance, he did not place a single figure, but a whole group of casts before him. He insisted on a grasp of the model as a whole ... Thus he taught his pupils that power of grouping, of seeing things broadly ... which is one common characteristic of their work. But he appears to have followed no cut-and-dried system, and to have made no attempt to mould his students into any uniformity.

A letter of 1858 from Pettie to McTaggart shows clearly that Lauder was the odd man out at the

29 Tom Graham
Alone in London
No date but probably painted
shortly after the artist's move to
London in 1863
Oil, 54.60 x 88.90 cm
Reproduced by kind permission
of Perth Museum and Art Gallery
(Perth and Kinross Council,
Scotland)

Academy in attaching as much importance to colour as to drawing in the curriculum: 'Lauder is wild at the new system which they [James Drummond, Noel Paton, and James Archer] are going to begin in the Life Class . . . He feels that their rigorous drawing and inattention, in the meantime, to colour, imply that his system had been all wrong'.

Lauder's nine years in charge of the Trustees' Academy clearly mark a watershed in Scottish painting, and his influence may be measured by comparing the work of his students with the immediately preceding generation of Edinburgh-trained artists, such as the Faeds, Erskine Nicol, James Archer and Alexander Fraser, all of whom employed a technique in which colour was subservient to drawing. A comparison of Orchardson's *Wishart* picture of 1853 with the same subject (1845: DAG) by James Drummond, one of the three drawing-masters with whom Lauder disagreed, illustrates the beginning of the effort by the next generation to supersede the drier style of their predecessors. Yet it would be wrong to pretend that emancipation was swift and total, especially in the case of the later genre painters like Orchardson and Pettie who were as preoccupied with subject-matter as Wilkie and Sir William Allan before them had been. The main purpose of the sketching clubs was, as we have seen,

to foster this side of an artist's talent. The fact of the matter was that in the High Victorian period any figure painter remaining inside the academic estab-lishment, as all the pupils of Lauder did, almost inevitably cast himself in the role of public enter-tainer; the public, in this case, who attended the annual exhibitions of the RA or the RSA. Only landscape painters were not expected to amuse, elevate, instruct or titillate, and this was to give William McTaggart a considerable advantage over his colleagues in his exploration of the possiblities of a painterly evocation of the visible world.

The brothers John and Alexander Hohenlohe Burr were the first of the artists of the Scott Lauder group to go to London, in 1861. Although plainly minor figures, they perhaps do not wholly deserve their present neglect, since each was aware of his own limitations and stayed within them. They painted small-scale canvases on childhood themes which remain within the territory conquered by Tom Faed, although the Burrs seem not to have had Faed's proneness to sentimentality. Thanks to their contact with the Lauder circle, they were able to add an element of colour which provides an apt setting for their cheerful art, although it is neither refined nor rich. The little *Grandfather's Return* (n.d., perhaps an early work: NGS) by John Burr is charming.

straightforward, and provincial in the best meaning of the word, and another version of a similar theme, *The New Toy* (n.d.: DAG) is equally, and as unostentatiously, full of life, amusingly capturing grandfatherly as well as infant glee. *The Careless Nurse* (1877: DAG) casts a level and wry glance at the domestic chaos resulting from the short absence of a mother whom we are relieved to see returning to wake up her young daughter who has fallen asleep despite the squalls of the baby in its cot. A.H. Burr is even less familiar a figure, but *Wild Flowers* (n.d.: DAG) has a title which perhaps conveys the artist's empathy with the children who are the subject of the picture, out picking flowers in a pleasantly painted landscape.

Orchardson and Pettie followed the Burrs in moving to London and, in 1863, when they had been there a year, they were joined by Tom Graham. Graham resembles the Burrs in his unassuming attitude to subject, and in the fact that he was evidently more at ease on a smaller scale. He was, however, a more original artist, and while the routine works from his hand are quite dull enough to make his comparative lack of success readily understandable, a small number show a real talent which never seems to have developed consistently. *A Young Bohemian* (1864: NGS), once owned by Sargent, suggests the influence of John Phillip in its subject of a young girl musician in a deliciously painted folk

costume with roses round the skirt, but its colour is cool and refined, and the figure suggests shyness and reserve. A presumably later work, *Alone in London* (PAG), is a remarkably freely painted view of the Thames at the Victoria Embankment in early morning haze, the pavement deserted except for the solitary figure of a young woman wrapped in a Scots plaid who looks out over the balustrade. The picture is not a tract in the style of Egg's *Past and Present, No. 3*, where an unfaithful wife and her child are seen alone under a bridge near the Strand as a consequence of her infidelity, and in fact we are not told what she is doing there, but the still cityscape is pervaded with a sense of homesickness sensitively captured. Like Robert Gavin (perhaps with him) he went to Tangier; a small painting of an Algerian woman sitting on a prayer rug (n.d.: Orchar Collection, DAG) delicately renders the luminous atmosphere of North Africa. Graham's best-known work, however, is the convincingly impressionistic *The Landing Stage* (n.d.: V&A), admirable alike in composition, observation and handling, and probably showing the Clyde at Craigendorran, looking towards Greenock. This is *au revoir* (rather than the often-painted *adieux* of conscription or emigration), a tender but informal farewell before the anticipated pleasure of a windy crossing on the river.

A large factor in John Pettie's decision to move to London in 1862, a few months after Orchardson,

30 James Archer
Summertime, Gloucestershire
1860
Oil on canvas, 76.40 x 106 cm
National Gallery of Scotland
After 1862, Archer's career was spent in London. This luminous landscape shows the influence of Millais, which is also visible in early McTaggart (cf. *Spring*, 1864, page 56).

was the removal by the periodical *Good Words* from its headquarters in Edinburgh to London in the same year. Apart from Pettie himself, contributors of illustrations to *Good Words* included Millais, Holman Hunt, Whistler, Arthur Boyd Houghton and Fred Walker, as well as a Scots contingent of Orchardson, McTaggart, Tom Graham and Mac-Whirter. But Pettie did not have to rely for long on black and white illustration for income; in just four years he had become an Associate of the Royal Academy, and his biographer tells us that he had been earning over a thousand pounds per annum from his pictures for some years before he was thirty. Pettie's success then, and any claim he has now to our attention, rest on the vigorous work done when he was still in his twenties and early thirties. Unlike Orchardson, who was later to score an even greater popular success, Pettie's work shows little or no development in subject or technique from quite an early stage; and in his later years portraiture was to occupy an increasing proportion of his time.

An interesting glimpse into the characters and, to some extent, the *credo* of Pettie, Orchardson, and Tom Graham around 1863 is provided by Clarence Dobell, the brother-in-law of Briton Riviere. Dobell was invited to dinner by James Archer and his wife to meet the three Scottish painters, and later remembered:

> . . . the brilliant conversation of Orchardson, the strong sense of Pettie, and the calm confidence of Tom Graham delighted and astonished me
>
> They spoke in the coolest manner of the weakness of the Art leaders of London and were clearly well satisfied that their own school of art was certain to be welcomed by the picture-dealers and the public.
>
> The young English painters of that day were so anxious to crowd all that they could into a little space in order to have a better chance of being hung on the line, that they deemed it a sign of exceptional skill to arrange a group so that the heads nearly touched the top of the picture and the feet stood on the lower edge of the frame, while the background was crowded into the intermediate spaces. The Scotchmen laughed at these artifices and liked to surround their figures with illimitable spaces and boldly declared that the RAs dared not reject them; and to our amazement they were right. The pictures were hung, and not only hung but sold, and the dealers clamoured for more. In a single season Orchardson and Pettie were marked men and made men.

Fittingly, Pettie's decision to become a painter had received early support from James Drummond, who stood sponsor to the young artist's entry to the Trustees' Academy at the age of seventeen. Although in some ways a painter's painter, Pettie at the same time had Drummond's leanings towards historical subjects and had antiquarian interests, particularly (like Noel Paton) in armour. The kernel of his work lies almost exclusively in the subject, which is usually set in the past of history or romantic literature. We know that Pettie considered modern male attire drab and disliked painting it, so much so that his portrait of the novelist William Black (to take only one instance) was posed in Venetian costume. The prime function of Pettie's rapid brushwork, warm colour and sprightly drawing is to enhance the vividness of the tale. 'Significant form' would have meant little to him; and it is not altogether surprising that he considered Rembrandt's skill, which he admired, 'wasted' on his 'beef-steaks'.

For all his painterliness, drama for Pettie was inherent in the subject and not in the treatment, and no Rembrandtesque suggestion of mortal clay apprehended through the earth colours of the palette ever appears in his work. This division between subject and treatment often emphasizes the faults of each, exposing a *belle facture* applied as automatically as a sauce concocted by a chef, but not in itself able to compensate for an inadequate dish. The Edwardian view of Pettie's style expressed by Martin Hardie, however, was probably shared by the vast majority of visitors to the Royal Academy in Pettie's own day, and is understandable in the context of the Academy's continuing function as a provider of mass entertainment. Discussing *Treason* (1867: Mappin Art Gallery, Sheffield) and *The Sally* (1870: ibid.), he writes that 'they are both great pictures – great in the purely pictorial elements of line, form, colour and illumination. That they thrill, not only as a piece of painting, but for the story they tell, makes them greater pictures still'. In reality, Pettie's best pictures are those in which form and content, vehicle and tenor, are intrinsically related; in the two examples quoted, the vitality of the treatment – vivid colour, nervous drawing, and dramatic composition – contributes everything to the final atmosphere of dangerous suspense.

It is, however, extremely unlikely that such historical reconstructions will ever again seem as thrilling as they evidently did to the Victorians who bought them. Hollywood has added motion and a cast of thousands, on which there is no going back; but Pettie would surely have had a good eye for cinematic essentials; for cutting (the elimination of inessentials), camera angle, lighting, make-up and wardrobe.

Pettie's contribution to the developing use of colour among the pupils of Scott Lauder becomes clear when one compares him with his slightly older Scottish contemporaries: Drummond, Archer, the later Noel Paton, the Faeds, and Erskine Nicol. An Edinburgh pamphleteer of 1860 was still able to write of Pettie and of Lauder's other pupils: 'Their pictures want finish and they are objectionable in colour. The love of grey and grey-green exhibited by the school is ridiculous. It is their regulation colour. Their harmony of harmonies is grey agreeing with itself. Orchardson, Hugh Cameron and George Paul

Chalmers retained a muted approach to colour throughout their careers with an emphasis on half-tones; McTaggart and Pettie on the other hand experimented more boldly and became more powerful colourists. Pettie himself said of his earliest period: 'I felt about colour then, like a boy looking at all the bright bottles in a sweetie-shop window, that it was something to be bought when I had saved up a pennyworth of drawing'. An early work such as *Alice in Wonderland* (Orchar Collection, DAG) – *Alice* was first published in 1865 – shows the quiet tonal style criticized by the writer just quoted, as well as the illustrative bias which informs Pettie's *oeuvre* from the beginning, with its preponderance of scenes from Scott, Sheridan, Shakespeare (especially from the history plays), and occasionally from historians like Macaulay and Lawrie. *The Drumhead Court Martial* (1865: MAG) was Pettie's first major success at the Royal Academy, paving the way for a whole series of similarly military scenes, very often set in the seventeenth century. The treatment of colour here, with its bold, high-keyed contrast of scarlets and off-white, marks an obvious advance on the other work, and Pettie always retained a preference for colours at the warm end of the spectrum, with notes of white or blue added for contrast. It cannot be said that he was a subtle colourist, but it was in itself a noteworthy achievement in his day to use such full-blooded colour orchestration as he did, with a sense of dynamics usually remaining within the range of *forte* to *fortissimo*.

Aside from the 'blood and thunder' scenes from the Civil War, the War of the Roses, and from the Jacobite rebellions with which his name is most often associated – *The Drumhead Court Martial, Treason, The Flag of Truce, Disbanded, A State Secret, Sword-*

31 Sir William Quiller Orchardson
The Last Dance
Begun 1905, unfinished
Oil, 96.50 x 142.50 cm
Private collection
The dramatis personae include Orchardson's daughter, Hilda, who regarded the picture as the artist's farewell on the eve of her permanent departure for South Africa. It also offers enigmatic comment on Edwardian sexual mores.

and-Dagger Fight and *A Highland Outpost* make a typical but far from exhaustive list – Pettie also painted a few pieces of humorous genre. In some cases these drew on Sheridan or Shakespeare, and in others on his own invention, like *Pax Vobiscum* which shows a friar blessing a mouse. *The Doctor's Visit* is one such humorous painting; it is a Burr-like subject although the humour is rather contrived, with a droll old doctor offering a shy little girl an apple to the amusement of her grandmother. As a raconteur of historical scenes, Pettie is as racy as any schoolboy could wish; as a humorist he tends to laugh so much at his own jokes that he forgets the punch line.

Sir William Quiller Orchardson, on the other hand, was truly versatile in his subject-matter, while at the same time the individuality of his technique was recognized, deprecatingly at first, from an early stage in his career. Discussing Orchardson's contributions to the Royal Academy exhibition in 1879 *The Art Journal* commented: 'The theme is by no means original, but its manner of treatment is so; and that is the only kind of originality which can now be claimed for the works even of the mightiest of men.' Anecdotal ingenuity was the rage at the Academy, and *recherché* subject-matter the norm; and Orchardson, although without cynicism, undoubtedly had a happy knack of choosing tales which pleased his audience. For this, posterity has not forgiven him, and he has been remembered only as a painter of genre or (perhaps worse) of *chic*. In fact his subject-matter, despite its obvious diversity of period and theme, has a certain underlying unity which comes from the artist's preoccupation with moments of psychological drama (quite different from the external drama of Pettie), often set in luxurious surroundings which imprison the *dramatis personae* and whose calm atmosphere is momentarily troubled by their mental agitation. The paintings show a steady increase in the subtlety of Orchardson's approach to such subjects: *The Last Dance* (1905: private collection) has a poignancy not to be found in the Shakespearian pictures of the sixties and early seventies.

In his own lifetime, Orchardson achieved great popularity in both Britain and France, and his career is a paradigm of Victorian artistic success, rising in steady progress from provincial obscurity to Academic recognition, public honours, and a commission to paint the Queen's portrait. The real fascination of this career, however, lies in the fact that like another characteristic figure of the period, the architect R. Norman Shaw, who was a year older than Orchardson, and like him was born in Edinburgh, Orchardson contrived to work in a manner which satisfied his own standards of excellence while at the same time making a strong appeal to contemporary taste. Both men were unable to break the conventions of their period, but the new life they gave to stylistic modes derived from the past suggested possibilities later to be realized by younger practitioners. Orchardson

was, we know, admired not only by his own contemporaries during his student years in Edinburgh but also by the young Glasgow painters of the next generation, including Sir D.Y. Cameron; *mutatis mutandis*, Norman Shaw stands in a similar relationship to Charles Rennie Mackintosh.

Although not prolific by Victorian standards Orchardson was able for the last thirty years of his life to maintain a good address in London and a house in the country out of income from pictures and reproduction rights. When the Tate Gallery acquired *On Board H.M.S. Bellerophon* in 1880, the price paid out of the Chantrey Bequest was £2000: twice the figure paid for Poynter's *A Visit to Aesculapius* in the same year. Although it came late and as something of an anti-climax in 1907, his knighthood was in the expected order of things, and, although the presidency of the Royal Academy was not to be his, he was a candidate in the elections of 1896, when Poynter succeeded Millais to what du Maurier called the 'Lord Mayorship of all the Plastic Arts'. Orchardson was also made a chevalier of the Légion d'Honneur in 1895, when the French ambassador's diplomacy carried him so far as to describe Orchardson as 'the greatest artist in England'. The key to this success story was the anecdotal element in Orchardson's work, which he himself took very seriously. Even at the end of his career we know that among the projected works which were never begun were pictures with titles such as *By Order of the Executors, The Burning of the Sarah Sands, Beethoven,* and *Nelson.* Orchardson insisted on choosing his own subjects, and appears to have sold his pictures to a mainly middle-class clientèle of industrialists and professional men. Many of his patrons were Scots, including John Aird and George McCulloch in London, whose collections, published in *The Art Journal* in 1891 and 1909 respectively, reveal an orthodox taste for anecdotal painting. Aberdeen collectors such as James Ogston, Alexander Macdonald, and Sir James Murray bought important paintings from Orchardson, while Dundee (especially the fashionable neighbouring burgh of Broughty Ferry), which has been such a fruitful source of revenue for the artist nicknamed 'the Laird' in *Trilby,* lived up to this fictional reputation for munificence. James Orchar, John M. Keiller, and G.B. Simpson in particular, bought several important paintings, including in Keiller's case two key works, *St. Helena 1816: Napoleon Dictating his Memoirs* (1892: The Lady Lever Art Gallery, Port Sunlight) and *Mariage de Convenance – After!* (1886: AAG), one of three *Mariage de Convenance* pictures. In Glasgow, James Donald and Sir Thomas Glen Coats, and in London Sir Henry Tate and his adviser Humphrey Roberts, Sir Walter Gilbey, and Lord Blyth were among Orchardson's most faithful patrons. Orchard-son's pictures were thus collected in the main by wealthy men of rather conventional taste, but two exceptions to that general rule stand out. J.G. Orchar's purchases were almost exclusively from the

Scott Lauder group, with the significant qualification that he owned not only an impressive collection of Whistler's etchings, many of them in states not recorded by Kennedy, but also an oil by Whistler, *Nocturne in Grey and Silver: Chelsea Embankment.* Another adventurous collector who bought from Orchardson was the Aberdonian John Forbes White, who was one of the first British owners of a work by Corot (the *Souvenir d'Italie,* bought in 1873, now GAG).

Orchardson's patrons were clearly engrossed by the anecdotal element in his work. But a significant minority among his contemporaries admired him chiefly for his powers as an executant. He was one of the exceedingly few British artists of the day whom Whistler found himself able to admire. The Pennell biography quotes Harper Pennington, who had gone with Whistler to the Royal Academy exhibition of 1887, recording Whistler as standing before one of Orchardson's modern interiors 'for which he had expressed the most sincere admiration' and finally pointing to a particular passage with the words, "It would have been nice to have painted that," almost as if he had thought aloud'. In the 1860s, when Whistler was still sending to the Royal Academy, *The Art Journal* critic on several occasions bracketed the two artists together. From Sickert we learn that Edgar Degas also appreciated Orchardson, as Sickert himself did. Sickert regarded Orchardson and Pettie as 'descendants of Rubens, through Wilkie', adding 'I have always loved and appreciated them'; a tribute which demonstrates that to a painter of the generation that came to prominence in the early 1880s, to which the Glasgow School also belonged, there was no contradiction in liking Orchardson's and Pettie's work while at the same time being alive to more contemporary developments.

Orchardson reciprocated Whistler's admiration and felt that recognition of his work in England had been unduly delayed, writing in 1889 (in accepting an invitation to speak at the dinner given in Whistler's honour at the Criterion), 'I am in entire sympathy with any proposal that will do honour to J. McNeill Whistler. The occasion . . . is I agree a good one, though perhaps late in the day – but it is never too late to mend and when we have a great painter to recognise we must do it while we can'. In the late 1890s Orchardson wrote to his daughter that he knew Whistler's paintings 'by heart'. Temperamentally the two artists were not dissimilar, both possessing a fastidiousness which was both a strength and a weakness. The close-knit and introverted family circle which provided Orchardson with the right surroundings for his work was a kind of Mayfair equivalent to the no less rarefied but more unconventional atmosphere of the Whistler establishments in Chelsea. Orchardson is reported as a witty talker and his keen interest in military matters parallels Whistler's infatuation with West Point: but they supported opposite sides during the Boer War,

32 Sir William Quiller Orchardson
Mariage de Convenance
1883
Oil, 104.80 x 153 cm
Kelvingrove Art Gallery and
Museum
© Culture and Sport Glasgow
(Museums)
'The multifarious qualities,
didactic and otherwise, with
which it has been invested
by critics, are significant of
its powerful attraction.' (The
Magazine of Art review of the
1884 Royal Academy exhibition.)
Tom Graham was the model for
the husband.

Whistler ardently taking the part of the Boers, while Orchardson grew exasperated with the incompetence of the British handling of the campaign. Orchardson's preferred old masters were Titian and Rembrandt, and his warmest admiration seems to have been reserved for Gainsborough. Among his contemporaries he appears to have been indifferent to French painting, with the possible exception of Fantin-Latour, and of the Pre-Raphaelites he predictably felt that they were 'too minute', adding the now rather surprising rider 'but it was a good training, and see what it led to in Millais'. Sargent he judged to be 'magnificently effective in the distance – but not finished'.

Orchardson left the Trustees' Academy in 1855 but continued to live in Edinburgh until his departure for London early in 1862. During these years he began to adopt literary as opposed to historical themes, using Scott, Dickens and Harriet Beecher Stowe as his originals. In 1856 he exhibited as the RSA a picture called *Claudio and Isabella* (now lost), three years after Holman Hunt's picture of the same name was seen at the Royal Academy. It is about this time that the influence of Pre-Raphaelitism becomes

evident in Orchardson's work, though in a diluted form. Between 1852 and 1860 eleven pictures by Millais were exhibited as the RSA including *Ophelia* (in 1853), *The Return of the Dove to the Ark* (in 1854), *The Blind Girl* and *Autumn Leaves* (in 1858), and *The Rescue* (in 1859, when Millais was living at Bower's Well in Perthshire). In 1860 Orchardson made an excursion into the field of illustration proper with the publications of six of his drawings in *Good Words,* to which Millais and Holman Hunt later also contributed.

Orchardson's work in London from 1862 until 1870, in common with English painters like Calderon and Yeames in the same period, shows a continuing influence of Pre-Raphaelitism both in subject and, to a lesser extent, in treatment. A series of pictures on Shakespearian themes painted at this time are an obvious case in point. In *Hamlet and Ophelia* (1865: private collection) the theme of cruelly disappointed love and the detailed treatment of the costumes are Pre-Raphaelite in derivation, as is the realism which allows Hamlet to appear with cross-garters undone, and shows him so much an anti-hero that, as a critic wrote in 1870, 'Hamlet

does not come up to our ideal of the Hamlet of Shakespeare in his self-assumed mental distraction'. At the same time, the stage-like setting, and the large flat areas of very broadly handled tertiary colour are entirely personal to Orchardson, whose colour-schemes at this period were likened by the French critic Ernest Chesneau to 'the back of an old tapestry'.

Similar evidence of Orchardson's early independence is provided by other pictures of this period which owe an apparent debt to Pre-Raphaelitism. The very title of *The Broken Tryst* (1868: AAG) suggests a Pre-Raphaelite subject, but its thin, transparent brushwork and subdued colouring are at a far remove from the enamelled surfaces and bright colours of the Brotherhood, whose work Ruskin described as 'like so much stained glass'. On the other hand, when one compares *The Flowers of the Forest* (1864: Southampton Art Gallery) with an example of the early work of another of Scott Lauder's pupils, profound similarities emerge. *Spring* (1864: NGS) by William McTaggart is particularly close to this work in subject, treatment, and mood. In the same way, comparing Orchardson's *Casus Belli* (1872: GAG) with any of Pettie's pictures on a similar theme at this period – such as *A Sword-and-Dagger Fight* (1877: Mappin Art Gallery, Sheffield) – the resemblances are so striking as to suggest that the continued association of these painters during the earlier part of their careers had at least as much influence on the formation of their respective styles as any outside influence. There are numerous examples of nearly identical themes, for example, Pettie's *The Gambler's Victim* (1868: FAS) and Orchardson's *Hard Hit* (1879: private collection, U.S.A.), Orchardson's *The Story of a Life* (1866: private collection) and Pettie's *Sanctuary* (1872: sketch in AAG), Orchardson's *Toilers of the Sea* (1870: AAG), and McTaggart's *Through Wind and Rain* (1874: Orchar Collection, DAG). Moreover, both Pettie and Orchardson moved from the Jacobean subjects of the 1860s to the Regency or Empire set-pieces of the 1870s and 1880s. But whereas Pettie always retained his illustrator's instinct for a good story clearly told, Orchardson's work was often found baffling because of its enigmatic content and he had to wait until 1868 – four years later than Pettie – before being elected to an associateship of the Royal Academy. Full academic honours came in 1877. Orchardson's main picture for that year was *The Queen of the Swords* (1877: NGS), which was the last of the series of literary subjects based on Walter Scott and Shakespeare. In that respect, it sums up the earlier part of Orchardson's career, but it also looks forward to the later scenes of domestic and social life in which Orchardson appears as the successor of Tissot.

The remaining thirty and more years of Orchardson's life were the years of such characteristically High Victorian pictures, famous in their own day, as *On Board H.M.S. Bellerophon* (1880: National Maritime Museum), *Voltaire* (1883; NGS), *Mariage de Convenance* (1883: GAG) and its two sequels, and *The Borgia* (1902: AAG). In these later works, Orchardson's craft reaches its zenith, and his very last pictures show undiminished mastery. During this period his circle of friends widened to include many eminent figures of the day, including W.S. Gilbert, Sir J.M. Barrie, and the scientist James Dewar, who received a knighthood with Orchardson in 1907, and whose *Portrait* by Orchardson (1894) is in Peterhouse, Cambridge. A certain cult of dilettantism characterized these friendships: 'shop' seems to have been taboo, and when Dewar wrote to Orchardson to tell him of his latest scientific discovery, his intention was obviously to amuse rather than to edify. Like other Academicians of his day, Orchardson was a frequent attender at dinners and a theatregoer, but his family and home were the real centre of his life. His daughter Hilda regarded the pictures which show domestic strife – the *Mariage de Convenance* pictures and *The First Cloud* for example – as attempts by Orchardson to imagine the converse of his own happily married life. Orchardson greatly valued the calm refinement of his domestic surroundings and it is easily supposed that any disruption of it would appear to him as a form of nightmare. His fears were perhaps those of a common Victorian species of which he was an example: the self-made man. We know that he had a medically unjustified dread of weakening sight because 'then we shall all starve'. His close attachment to his daughter Hilda, born in 1875, may well have provided the emotional *raison d'être* for later pictures such as *Her First Dance* (1884: TG) and *The Last Dance*. Hilda herself seems to have regarded the latter picture, which shows her leaving the room with her fiancé, as the artist's farewell to her on her departure in 1905 for South Africa, from which she never returned. Be that as it may, two developments are conspicuous in Orchardson's later subjects: a growing preoccupation with a late-Victorian and Edwardian dream of material elegance, on the one hand; and, on the other, an increased empathy with the inhabitants of the gilded cage.

The later portraits – which Sickert especially admired – benefit strikingly from this increased psychological penetration. In his earlier years Orchardson placed portraiture and subject-painting in two very separate compartments, employing a near-caricatural rendering of 'character' in the early costume pictures while at the same time producing such soberly observed speaking likenesses as *John Hutchinson* (circa 1854: RSA) and *Mrs John Pettie* (1865: MAG). Later, when he began to deal with modern themes, the divergence in treatment becomes less marked. Orchardson's subdued palette suited male Victorian attire better than Pettie's, and the transparency of his thinly applied pigment imparted a luminous quality to the predominant browns and blacks. His portraits of his wife in a black dress with

their baby son Gordon, *Master Baby* (1886: NGS), of the architect *Alfred Waterhouse* (1892: RIBA), the Dundee manufacturer *Henry Balfour Fergusson* (1896: DAG), and the physicist *Lord Kelvin* (1899: SNPG) are, for all their reticence, masterpieces of late Victorian portraiture.

Portraiture aside, the development in Orchardson's subject-matter in his later years is matched by an increased technical subtlety. In a sense, the lighter touch of his later manner provides an apt vehicle for his more rarefied subject-matter, the tremulous poise of his brushwork and composition well suited to expressing the delicate anguish of *The Morning Call* (1883: private collection), *The Feather Boa* (1896 or 1897: Orchar Collection, DAG), *The Lyric* (1904: ibid.), and *Solitude*. The individuality of his style had always attracted as much attention as his subjects. Orchardson invariably used the traditional earth

33 Sir William Quiller Orchardson
The Morning Call
1883
Oil, 81.50 x 62 cm
Private collection

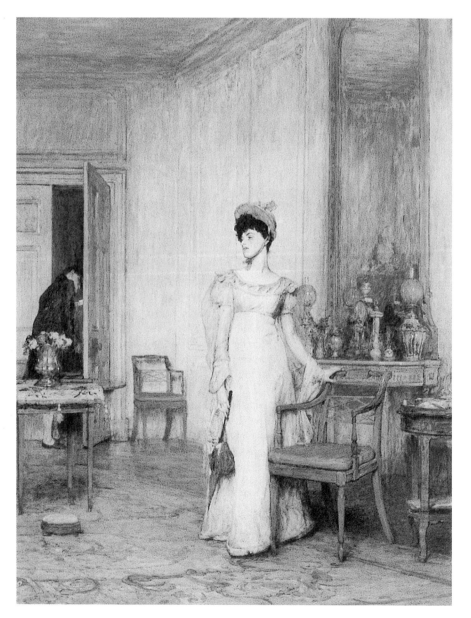

colours, never experimenting with the more brilliant but unstable new aniline colours. Nor did he ever paint on to a wet white ground; his method of achieving luminosity was to apply oil colour direct on a dry white ground. In the earlier pictures he began his work on the canvas with a pencil drawing, which closely followed a fully elaborated working drawing. This done, he would begin to paint. His earlier pictures often betray their linear origins in the outlining surrounding the figures. Later, however, he was able to dispense with the aid of the pencil underdrawing, and painted directly on to the ground. Thus his later pictures tend to have a more painterly quality, and his preparatory studies too become more painterly as Orchardson's technique matures. The drawing for *Mariage de Convenance* is a striking example of this, and the directional brushwork noticeable in the background of the picture follows the soft diagonal hatchings visible in the drawing: a point of style which one also finds in Pettie and, less expectedly, in William McTaggart. This charcoal drawing, which does not even include a figure of the wife, who is so essential to the tale, suggests that Orchardson was concerned to capture a certain effect of light. An equally pictorial sense of placing is also evident in his work: a small drawing for *Her First Dance* (RA) indicates in a flurry of barely decipherable lines the dispositions of the main groups in the picture. In an era of crowded compositions, his use of empty spaces is refreshing.

A rapid glance at the names of the more prominent subject-painters who had studied under Lauder and stayed at home in Scotland suffices to indicate that London had the best of the bargain. Unimaginative competence reigns supreme in the *longueurs* of J.B. Macdonald (1829-1901) – notwithstanding the continuing popularity of his *Lochaber No More* (1863: DAG) – and his pupil W.E. Lockhart (1846-1932). Equally literary in approach was George Hay (1831-1912), who dressed the comic situations so beloved of the age in eighteenth-century costume, as in *An Alarm* (1890: Orchar Collection, DAG), which shows an overheard conspiracy. Although belonging to a later generation, George Ogilvie Reid (1851-1928) unabashedly continued the tradition of costume genre into the twentieth century, without any hint of the perception of mood and character or the painterly qualities found in the best of Orchardson's work.

As we have seen, Orchardson and Tom Graham occasionally painted landscape, and with enough success to make one regret that they did not do so more often; but only modified enthusiasm can be felt for the leading landscape specialists among this generation of expatriate Scots: Peter Graham (1836-1921, in London from 1866) and John MacWhirter (1839-1911, in London from 1869), who both attained full membership of the Royal Academy. Although they had been pupils of Lauder, his influence upon their work is hard to distinguish.

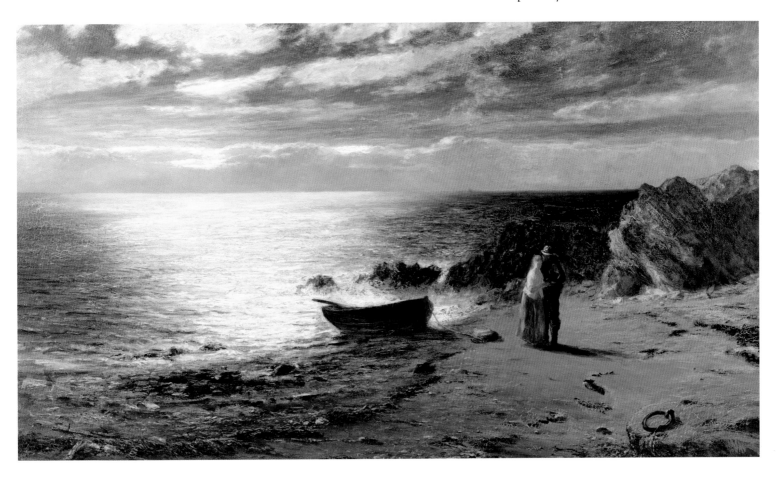

34 John MacWhirter
Night, Most Glorious Night, Thou Wert Not Made for Slumber
1874
Oil on canvas, 99 x 165 cm
© Royal Holloway and Bedford New College, Surrey, UK and The Bridgeman Art Library

There is every indication that Lauder himself viewed landscape as justifying a freer approach than figure painting, as the landscapes in his own figure paintings tend to be treated with the breadth which seems to extend to his approach to landscape proper, if *The Cobbler, Loch Long* (n.d.: FAS) is anything to go by. This work is much more freely and transparently handled than anything by Graham, whose style too often comes close to a meretricious virtuosity, and can be opaque and glib like imitation Ruisdael. *The Spate* (1866: untraced) was his first picture to appear at the Royal Academy, and its success brought the accolade of a commission from the Queen, for *Bowman's Pass: Balmoral Forest* (1868: HM The Queen). This painting included Highland cattle in a wild landscape and suggests the romantic influence of Horatio McCulloch, and of Landseer and his successor as Animal Painter to Her Majesty for Scotland, Gourlay Steell (1819-94). *Wandering Shadows* (1878: formerly Chrystal collection), a large work measuring 129 cm x 180 cm, is typical of Graham's later style, showing dappled sunlight on bracken-clad hills which are partly hidden by wisps of cloud. *Moorland and Mist* (1893: DAG) equally large, exploits the same effect, although the Highland cattle (doubtless painted from the live specimens which Graham kept at his Buckinghamshire studio) loom larger in the whole composition, their shaggy coats have a soft, fluffy

appearance as if recently shampooed. *Sea-Girt Cliffs* (untraced), presumably belongs to the group painted from studies made on the island of Handa, off the Sutherland coast.

Graham taught Joseph Farquharson (1846-1935), who painted almost nothing but snow scenes in the Highlands, often with effects of cloud or mist. That this rather bleak view of the Highlands of Scotland was for some reason a widely desired commodity in the south is suggested by the fact that Farquharson too became a member of the Royal Academy. MacWhirter was no less a purveyor of 'local colour': his pictures at the Royal Academy in 1875 included two with the titles *Land of the Mountain and the Flood* and *Nemo me impune lacessit*, the latter prominently featuring a group of thistles, the Scottish emblem. MacWhirter was a more adventurous colourist than either Graham or Farquharson, although sometimes in striving for a Turneresque intensity he would lapse into rather lurid purples and reds. His widow tells us that 'he gradually developed a habit of making a rapid sketch of anything that interested him while travelling by steamer or rail, and colouring it later from memory'. His devotion to and study of nature is not open to question, and Herkomer's portrait of him shows a keen gaze and sensitive face, but the task that he and other late romantics like Peter Graham set themselves, which was to capture and suggest the ineffable grandeur of

the world, was one suited to rarer and more heroic temperaments. Skye, the Alps, Norway (where he painted watercolour flower studies which were bought by Ruskin for his School of Art at Oxford), the Austrian Tyrol, and Sicily were all included in his travels for subjects, although he always spent autumn in Scotland, on the island of Arran, or in the Trossachs, at Aviemore in the Cairngorms, or near Glen Affric. All these places are spectacularly picturesque, and it is only rarely that MacWhirter includes human figures in his work as he does in *Night – Most Glorious Night, Thou Wert Not Made for Slumber* (1874: Royal Holloway College). Usually the landscape is allowed to speak for itself, or it dwarfs humanity, as in the Tate Gallery's *June in the Tyrol* (1892), or in *A Sermon by the Sea* (Orchar Collection, DAG). Otherwise it includes animal figures which only emphasize the vastness or the solitude of nature, as in *The Falls of Tummel* (1870s: DAG) or *A Donkey in Snow* (n.d.: ibid.).

David Farquharson (1839-1907) had a career spent mostly south of the Border and painted landscape in the Home Counties and Holland as well as in Scotland. Caw is rather dismissive of his work, but remarks that he 'brought a more instinctive feeling for tone . . . and much greater facility of handling to bear upon the imitative faculty which he shared to some extent with his more widely-known namesake', adding that 'as facility of execution in itself holds no very lasting satisfaction, and David Farquharson's sense of the life and beauty of landscape was rather superficial and his design was wanting in true significance, his art is of less significance than appears on first acquaintance'. Had one been able to point to other examples to match the fine, sweeping *The Herring Fleet leaving the Dee* (1888: AAG) which shows much more than technical fluency and whose high viewpoint and unusual, silvery tonality seem very modern, Caw's strictures, written the year after Farquharson's death, could have been dismissed out of hand.

W.M. Gilbert's monograph of 1899 on Peter Graham quotes two letters which Graham wrote in 1870 to P.G. Hamerton, who later became a prolific writer on contemporary art, but was then struggling to become a landscape painter. Hamerton had asked for Graham's advice, and the latter's painstaking replies give a useful insight into his own methods. Graham begins encouragingly by listing the 'high

qualifications' for landscape painting which Hamerton 'obviously has': 'a sensitively impressionable nature, a strong loving admiration for whatever in heaven or earth is beautiful or grand in form, colour or effect', and finally 'the faculty of observation'. He then expatiates on his own practice. 'My method of getting memoranda . . . is to study as closely as I can; to watch and observe, and make notes and drawings, also studies in colour,' and he adds, 'I believe I am much indebted to my long education as a figure painter for any little ability I may have in rendering the material of nature . . . Continued study from the nude in a life class gives, or ought to give, an acquaintance with light and shadow which to a landscape painter is invaluable – nature affects our feelings so much in landscape by light and shadow'. Here Graham is, of course, referring to Lauder's teaching but in a context which might well have surprised Lauder. Graham remarks of the Antique Class at the Trustees' Academy:

I shall never forget the exquisite beauty of the middle tint or overshadowing which the statues had which were placed between the windows; those which were immediately underneath them were of course in a blaze of light, and we had all gradations of light, middle tint, and shadow. When I came to study clouds, and skies, I recognised the enchantment of effect to be caused by the same old laws of light I had tried to get acquainted with at the Academy.

The emphasis on the beautiful and the grand in nature, the method of working in the studio from annotated drawings, and the chiaroscuro treatment of light, inevitably deprive the work of Graham and his numerous kind of immediacy and directness. However, Graham enjoyed immense success, which demonstrates how well the resulting *grandes machines,* in Gilbert's words, 'impressively brought home to prince and peasant, and to the merchant overburdened with the bustle of city life' the romantic commonplaces of landscape. But the most fruitful developments in Scottish landscape painting of the period were the result of the very different approach and methods north of the Border by William McTaggart, George Paul Chalmers and Hugh Cameron, who had all been pupils of Scott Lauder, and by George Reid, who had studied in Edinburgh, Utrecht, and Paris.

WILLIAM McTAGGART AND HIS CONTEMPORARIES IN SCOTLAND

William McTaggart (1835-1910) was the most gifted, the most prolific, and the most single-minded of the landscapists who remained in Scotland and who first made their mark in the 1860s. Two other pupils of Scott Lauder who distinguished themselves as landscapists, or more properly as painters of rustic or pastoral genre, were George Paul Chalmers (1833-78) and Hugh Cameron (1835-1918). Chalmers's early death and perfectionist approach prevented him from developing his powers to their fullest extent; Cameron made a speciality of the childhood subjects which are ubiquitous but less emphasized in the work

of his two colleagues. As with Orchardson and Pettie, it can happen that the work of each of these painters closely resembles that of the others, although McTaggart was the dominant personality. Cameron's seashore pictures with children playing at the water's edge or *The Italian Image Seller* (1862) – a subject treated by several of the Lauder pupils no doubt as a reminiscence of the 'whole group of casts' which would confront the student in Lauder's Antique Class – or (a rarer example) Chalmers's *Girl in a Boat* (begun 1867: Orchar Collection, DAG) look much like works by McTaggart. But basically the three

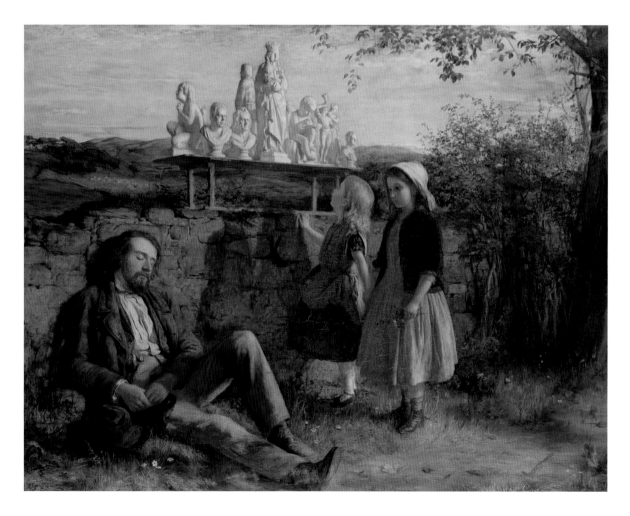

35 Hugh Cameron
The Italian Image Seller
1862
Oil, 82.50 x 111 cm
Private collection
Image courtesy of The
Bridgeman Art Library

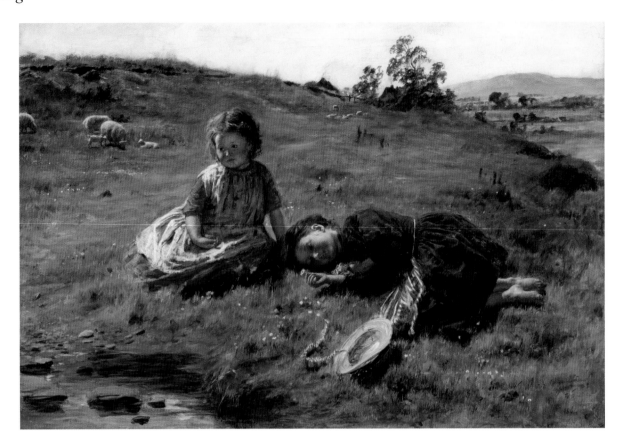

36 William McTaggart
Spring
1864
Oil on canvas, 45.10 x 60.40 cm
National Gallery of Scotland
See page 69.

artists were individuals and their work can be taken as representative of the three main channels along which landscape painting developed in Scotland from about 1865 until 1885 and later.

McTaggart represents the 'purest' landscape type of the three; although only a few of his pictures are devoid of figures – *The Wave* (1880: KAG) is an early example – the landscape or seascape is always the main motive. In his definitive biography of the artist, Caw tells us that 'from the very beginning McTaggart had painted much out-of-doors, but prior to 1883 the larger pictures were frequently begun in the studio from sketches, and when considerably advanced were taken to the country to be worked on there'; and after 1883 even the largest pictures (unless dependent on earlier works) were painted in the open air. This differs radically from what we have seen of the method of Peter Graham and John MacWhirter, who were studio-bound landscapists who only sketched from nature. Another major difference between the two groups lies in the fact that human presence and human scale are much more to the fore in the work of the Scottish-based land-scapists of this generation, McTaggart included, than in that of the London Scots, Graham and Mac-Whirter. But although figures, usually children, are almost always present in his work and frequently occupy the foreground, from a quite early point in his career McTaggart removes emphasis from them. As a result, in the pictures dating from after 1880 one sometimes has to look hard to find them or to distinguish their actions, so completely are they integrated into the overall scheme. To most people today McTaggart gives pleasure in direct proportion to his success in integrating figures and landscape; when he fails to do this, his work comes uncomfortably close to sentimental genre. In his best work, the figures provide human content rather than subject-matter as such.

Chalmers and Cameron usually give the figure much greater prominence. Chalmers, like the Aberdonian landscapist George Reid, was a close friend of one of the most enlightened amateurs and collectors in Scotland, the Aberdeen mill-owner John Forbes White (1831-1904), whose circle of acquaintances included several of the Hague School painters and also Daniel Cottier, one of the most enterprising of all British art dealers. Forbes White collected the modern painters who were being handled by Cottier – mainly the Dutch Impressionists and the Barbizon School – and both Chalmers and George Reid reflect a similiar taste in their own work, from which a consciousness of Dutch Impressionism in particular is never far distant. Both Reid and Chalmers are extremely limited as colourists, being much more concerned with tonal values and chiaroscuro. Cameron, on the other hand, shares something of McTaggart's interest in colour in a light key, but his principal motive is an idyllist's view of the innocent joys of childhood – a subject equally dear to several of his near-contemporaries in Scotland, like George Manson and Robert McGregor.

Writing in 1937, Sir James Caw, McTaggart's son-in-law and biographer and Director of the National Galleries of Scotland, expressed a view of McTaggart's work which contains a grain of truth although it now seems hyperbolical: 'In the gradual yet impassioned growth of McTaggart's art the whole evolution of modern painting from Pre-Raphaelitism to Impressionism, and even farther, is epitomised'. The remark suggests a limited appreciation of both movements, as well as ignorance of Post-Impressionism. On the other hand, it is undeniable that, of all the Scottish Victorians, McTaggart today looks the most modern, and his best work shows a freshness of vision, an exuberance of handling, and a timelessness very different from the modishness of Orchardson, the sentimentality of Tom Faed, or the melodrama of Peter Graham and John MacWhirter. The outwardly uneventful life which McTaggart led facilitated the steady development of his style, which quite quickly found a sufficient public to free the artist from the necessity of illustration or portraiture, upon which he at first relied for income.

His slow but consistent development embraces an early Pre-Raphaelite phase showing some influence of the minutely observed landscape of Holman Hunt and Millais, a middle 'Impressionist' phase (datable roughly to the 1870s and 1880s) which shows an increasing preoccupation with the effect of light on the appearance of objects in the open air and with the surrounding envelope of atmosphere which modifies colour and form, and finally a late phase which may be called expressionist, in which the artist's view of nature takes on a rapturous subjectivity expressed in the title of a work of 1902, *All the Choral Waters Sang* (Orchar Collection, DAG) and in an *alla prima* freedom of handling. The young McTaggart was influenced, then, by Pre-Raphaelite landscape painting and went on to create an impressionism of his own, by all accounts unaware of French Impressionism. Perhaps the most striking aspect of his career is the calm independence with which he made a virtue of his provincial isolation. He painted the fields at Broomieknowe, the Atlantic and Kilbrannan Sound shores of his native Mull of Kintyre, and the North Sea at Carnoustie as concentratedly as Monet at Argenteuil or Etretat, but never ventured into the urban scene as Monet did. His humility before what he called 'the miracle of everyday life' was an emotional rather than a rigorously visual, rational or intellectual response. Yet his painterly instincts led him to develop an instrument capable of recording the most delicate perceptions with no corresponding sacrifice of power. The subjective nature of his aesthetic made it inevitable that his later style should derive from his own *facture* rather than from a considered redeployment of the elements of colour and form, since his increasingly rapid execution was peculiarly suited to rendering the flux and change of nature which became a central concern in his work.

Having been urged by Daniel Macnee, the foremost painter in Glasgow, to study in Edinburgh rather than Glasgow, the young McTaggart was enrolled as a student at the Trustees' Academy in 1852, joining Orchardson, Hugh Cameron, Peter Graham and John MacWhirter who were already students there under Scott Lauder. Chalmers, Tom Graham and John Pettie were to join the Trustees' Academy as students within the next three years, and McTaggart became their close friend. In 1857 he accompanied Chalmers to Manchester to see the great Art Treasures exhibition, where it can be imagined that two of the early triumphs of Pre-Raphaelite landscape painting, *Valentine Rescuing Sylvia from Proteus* (1851: BAG) and, also by Holman Hunt, *The Hireling Shepherd* (1851: MAG), must have particularly impressed McTaggart by their faithful transcription of detail illuminated by bright daylight. By Hunt's own later account his 'first subject' had been to paint 'not Dresden china *bergers*, but a real shepherd, and a real shepherdess, and a landscape in full sunlight, without the faintest fear of the precedents of any landscape painters who had rendered Nature before'. This realism was to some extent at odds with the teaching of Scott Lauder, whose 'reiterated injunction to look for the greys in colour' (the words are those of McTaggart's biographer and seem likely to have been suggested by McTaggart's own account of Lauder's instruction) at first encouraged his students to adopt a rather low-key approach to colour, with an emphasis on tonal unity considerably different from the bolder chromaticism of the Pre-Raphaelites. Hunt's precise draughtsmanship, too, is at variance with the more painterly approach of all the Lauder pupils, but his realistic treatment of subject-matter may well have been noted with approval by McTaggart. In the following year, 1858, a further group of Pre-Raphaelite master-pieces made their appearance at the Spring Exhibition of the RSA which can only have made a strong impression on the young Scottish landscapist. These included Millais' *Autumn Leaves* (1856: MAG) and *The Blind Girl* (1856: BAG), and Dyce's *Titian Preparing to Make his First Essay in Colouring* (1856-57: AAG). At least one local landscapist, Waller Hugh Paton (1828-95), brother of Noel, was clearly influenced by the Pre-Raphaelite works seen in Edinburgh in the 1850s, as his *Highland Cottages, Arran* (1856) shows.

The tension implicit in the divergent influences on McTaggart in his early years was not fully resolved until his *Spring* of 1864. In the interim, McTaggart had been elected to an Associateship of the RSA in 1859 at the early age of twenty-four, and in company with Pettie and Tom Graham he went to Paris in 1860, with the unrealized aim of seeing the Salon, which he caught up with on his next visit in 1876 on the way to the Riviera, and saw again on his last journey abroad in 1882. Caw's biography records that McTaggart did not see a Monet until 1902 when

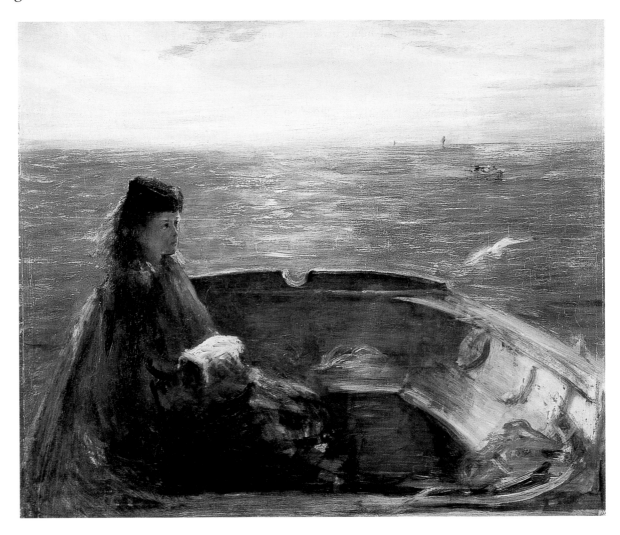

37 George Paul Chalmers
Girl in a Boat
Begun 1867
Oil, 55 x 65 cm
The McManus: Dundee's Art
Gallery and Museum
Dundee Art Galleries and
Museums (Dundee City Council)

two canvases by Monet were included in the exhibition of the Society of Scottish Artists in Edinburgh. This implies that he did not go to the Monet exhibition of 1889 at Goupil's, or the London exhibitions of Impressionist pictures held at Durand-Ruel's in the 1870s and 1880s, or for that matter at Reid's in Glasgow during the last decade of the century. If one is to speak, as some have done, of McTaggart's work as 'Scottish Impressionism', the term is justified at least in the national sense that outside influences which might have operated on McTaggart seem in fact to have had very little bearing on his work; he demonstrated an almost complete indifference to contemporary developments abroad. McTaggart's pictures in the 1860s frequently show an illustrative bias: *The Wreck of the Hesperus* (1861: private collection) is from Longfellow. *Willie Baird* (untraced) commissioned in 1865 by the Dundee collector J.C. Bell, was based on the sentimental 'A Winter Idyll' by the 'kailyard' poet Robert Buchanan and particularly on the lines:

> Then with a look that made your eyes grow dim,
> Clasping his wee white hands round Donald's neck,
> 'Do doggies gang to heaven?' he would ask.

Enoch Arden (1867) and *Dora* (1868: RSA Diploma Collection) are both Tennysonian subjects. McTaggart was active as an illustrator (contributing, as we have seen, to *Good Words*). Like his friends at the Trustees' Academy he was a member of a sketching club called The Consolidated in Edinburgh during the earliest part of his career, and the literary and anecdotal bias of his early work is shared by his contemporaries. A very early work, *The Past and the Present* (1860: private collection) which shows five young children playing on the grass in an old graveyard overlooking Kilbrannan Sound, invites comparison with a Pre-Raphaelite masterpiece on a related theme, Arthur Hughes's *Home from Sea* (first exhibited 1857 as *A Mother's Grave*, altered 1863: Ashmolean Museum). In the latter picture, the effect depends on details like the young boy's sailor costume which explains an absence long enough to have allowed the grass to grow over the grave, and on the beautifully drawn faces, with the eloquently restrained expressions. McTaggart aims at a much more indeterminate pathos. Similarily, in *The Old Pathway* (1861: Orchar Collection, DAG) the familiar sentimental theme of the soldier's return to his home and family, who are still unaware of his

uniformed figure arriving at the gate, is treated by McTaggart with considerable understatement, the landscape, illuminated by dappled sunlight, appearing as the chief motive for the picture. *Spring* (1864: NGS) is without a subject as such; two little girls, symbols of spring, muse on a grassy hillside where sheep graze with their lambs. The elder girl completes a daisy chain. Beyond that there is no incident, no story to distract from the main point of the picture, which is a startlingly faithful rendering of a fresh spring day. The lighting in this picture is brighter and more uniform than in any of its predecessors. The few shadows are luminous and painted with evident observation; the landscape, which as a whole is apparently full of detail and highly finished, is in reality transparently and openly handled. In adopting the precise vision of the Pre-Raphaelite landscapists, McTaggart has avoided the concomitant dangers of over-labouring. He was never again to produce a work in this style, despite the fact that even his most devoted patrons at this period (J.C. Bell, G.B. Simpson, W. Ritchie) were wont to comment on what seemed to them the unfinished state of his completed works. As early as *Dora,* the broad impasto and light palette characteristic of his mature style are apparent in the field of yellow barley which forms the background to the principal figure group. This picture was originally given evening lighting, but was changed by McTaggart in 1869 to the effect of broad daylight it now has.

Dora was McTaggart's last work conceived as illustration, apart from a small group painted in 1896-98 to illustrate an unpublished volume of stories by J.G. Orchar. Henceforward he treated the figure in landscape with an increasing concern for its unity with the landscape's own harmonies of colour and form, and beyond that, with the picture surface itself as a pattern of brushstrokes of a deliberately chosen weight, scale and rhythm. The artist's progress in this direction was gradual but decisive and can be seen clearly in the key works of the seventies and early eighties. *On the White Sands* (1870: Orchar Collection, DAG) with its unusually sharp contrast of bright sunshine and shadow, shows a boy and a girl prominently placed in the foreground, so that it is their actions which register first on the spectator as in a genre painting, but the figures are as broadly brushed as the landscape. An element of genre persists in *Something out of the Sea* (1873: ibid.) – also the subject, more than coincidentally, of a lost painting exhibited by Orchardson at the RA in 1876, *Flotsam and Jetsam,* for which a drawing survives (NGS). Here three children, excited by the crash of the breakers, run towards us (one of them having fallen on the sand) pulling on a rope which leads into the water. They are seen from a high viewpoint which allows the foreground surf and the distant horizon to appear to rise above them in such a way that the sea occupies the main part of the composition and dwarfs the figures. *Something out*

of the Sea is a particularly beautiful example of McTaggart's subtlety as a colourist: characteristically, the light is not the strongest sunlight, but a diffused brightness which is represented in modulated dove-greys, blues, and pale lilacs. But perhaps, the masterpiece of the seventies, painted in 1874, the *annus mirabilis* of the first Impressionist exhibition in Paris, is *Through Wind and Rain* (Orchar Collection, DAG). It shows very different weather conditions from *Something out of the Sea:* a mist of rain and a full force six driving the green sea through which a small boat charges, heavily reefed. This work suggests the action of the vessel in the water, the scudding sails in the background, and the dynamic effect of wind on water as realistically as the excitement of the young crew and the concentration of the older helmsman. However, an imaginative elimination of inessentials reduces the figures to little more than ciphers while the straining sails make a dramatic *leitmotiv* fully developed only later in the century by a very different artist, the American visionary Pinkham Ryder, who visited Scotland in 1882. McTaggart, however, unlike Pinkham Ryder, painted no nocturnal seascapes, and never fully exploited the formal possibilities of the dramatic silhouette suggested in *Through Wind and Rain.* McTaggart's was an opposite type of art, rooted in realism and devoted to an ideal of truth to appearances, that is, the appearances revealed by light – to McTaggart 'the most beautiful thing in the world'. 'No amount of finish would ever make a lie a truth', he is recorded as saying on one occasion, and on another:

> To draw a few boats carefully is to get some knowledge of their build and form; but it does not enable one to give an impression of their actual sailing, and of the play of light on them, which sometimes gives them an appearance quite different from what close examination would reveal. You must trust to your observation and give a frank rendering of what you see. Sometimes a glint of sunshine will so modify the appearance of a boat or a group of distant sails that it becomes difficult to say what the actual form is, but one accepts that in nature for what it suggests, and in rendering it in a picture one should do the same.

These statements have more than a little in common with Impressionist theory, as far as they go, but it is noticeable that McTaggart seems to attach importance to the idea of movement, to the 'actual sailing' of the boats rather than to the frozen instant of time of Impressionism. In contrast with his French contemporaries, McTaggart frequently delights in turbulent weather conditions which set the northern land or seascape in motion. With its long rhythmical brushstrokes, his technique was evolved to suggest the continuity of this motion as well as the instantaneity of a single impression. Therefore, whereas the later Monet painted static subjects in the series of

38 William McTaggart
The Sailing of the Emigrant Ship
1895
Oil on canvas, 77 x 87.50 cm
National Gallery of Scotland
Given to the National Gallery of
Scotland in 1931 by the artist's
biographer and son-in-law, Sir
James Caw. Noel Paton's diary for
11 August 1882 records the singing
of 'Auld Lang Syne' to the 800
passengers on an emigrant ship in
Lamlash Bay before she headed
south past the Mull of Kintyre – like
this ship, bound for America.

pictures of haystacks, of Rouen cathedral, and of waterlilies at Giverny, later McTaggart is concerned with moving things, clouds, waves, sailing boats, human figures. The dissolution of form which characterizes both artists' development is in fact the result of very different aims.

We have the evidence of McTaggart's biographer than he was a painstaking 'lifelong student' of nature. A deliberate cultivation of his own perceptions underlies the delicate nuances of colour of his carefully restrained early manner and the exuberant abandon of the late works. Gradually the human figure appears less *découpé* and is subordinated to the atmospheric and tonal unity of the whole even when shown full length. In a number of later canvases of which *The Wave* (1881: KAG) is the forerunner, the sea is painted – under what influence, of Whistler, whom McTaggart admired, or of Courbet, it is not known – without the addition of figures, as a living entity absorbing or reflecting the light of the sky, an apparently plane surface constantly changing its shape, or becoming formless as it turns to surf crashing on the shore, and whose

colours too, change through the constant agency of light sparkling on its surface or illuminating its depths. *The Paps of Jura* (1902: GAG) and *All the Choral Waters Sang* (1902: Orchar Collection, DAG) – the title is from Swinburne – are among the largest and most successful of this type. The former work was perhaps painted first; it derives from *The Sound of Jura* (1895: untraced) and was painted, leaving out the figures, in the studio, perhaps in order that the experiment would benefit from controlled conditions. *Choral Waters* however was painted in the open at Machrihanish where the Atlantic rollers encounter the first land for nearly three thousand miles and the surf is nearly always present. The rapidity of McTaggart's later technique – a painting would often take only a day to finish – here produces an almost gestural shorthand, the flickering notations of colour registering the artist's physical, kinetic, muscular response to the moving image before him, providing a visible record of the movements of his hand across the surface of the picture. There is a photograph of McTaggart painting at Machrihanish in 1898 a large canvas on an easel –

perhaps the seven-foot *Machrihanish Bay* – supported by guy ropes attached to boulders, which shows the sixty-three-year-old artist standing at the canvas which is at right angles to the shore line, his body taut as he looks intently at the sea before adding the brushstrokes which his outstretched arm is poised to make. Such close and immediate contact amounting almost to identification with the motif gives McTaggart's work its chief strength and freshness. These late pictures are among the artist's largest. 'Arguing that the impression of grandeur and vastness, which Machrihanish produces on the mind, was in no small degree due to its airy spaciousness, McTaggart believed that to suggest these qualities pictorially, size was . . . highly desirable,' Caw explains.

Of course, McTaggart, who visited the Vaughan collection of Turner watercolours annually in January when they went on display in the National Gallery of Scotland, was as aware as anyone of the fact that a sense of space in painting is not dependent on size. This is amply demonstrated by a small Turneresque watercolour of his (1889), showing a *Sunset* over water, with a large flight of gulls so distant as to appear as mere specks, but clearly only occupying the nearer part of the middle ground. His large late pictures seem to have an incipient mural intention or function, but without the muralist's sense of the flat wall plane. Illusionism demands the retention of the compositionally uninteresting parallel bands of sea and sky, separated by the line of the horizon. Colour, too, is used not decoratively but descriptively, with unmodulated pure white frequently occurring – an obvious sacrifice of the more nuanced earlier approach, which for these reasons may be preferred. But the work, which relates McTaggart distantly but recognizably to a line of thought which passes through Giverny (where Monet painted the first of the *Nymphéas* series in 1899) and culminates in the action painting of Jackson Pollock, exhibits a confidence in powerfully handled oil paint as a vehicle of expression which can make all McTaggart's British contemporaries seem timid or tame.

It is arguable that the germ of all later McTaggart, and the essence of his work is to be found in a few paintings of the early 1880s, beginning with *The Wave* of 1881, the forerunner of the group of late seascapes. *Away to the West as the Sun went down* (1881: untraced) requires only that the foreground should be reduced in importance and that the small sloops in the distance should be replaced by a dramatically lit large square-rigged ship to acquire a Claude-like suggestion of the magical potential of a

39 William McTaggart
The Coming of Saint Columba
1895
Oil on canvas, 131 x 206 cm
National Gallery of Scotland
Painted at the Cauldrons near
Machrihanish, on the west side
of the Mull of Kintyre, in June as
the 13th centenary of the death
of the Saint (8 June 597) was
being celebrated in Iona – 'he felt
drawn to paint a picture which
would be connected . . . with the
advent of Christianity in Scotland'
(Caw, *McTaggart*).

40 Sir William McTaggart
The Storm
1890
Oil on canvas, 122 x 183 cm
National Gallery of Scotland

voyage just begun, as in *The Sailing of the Emigrant Ship* (1895: NGS), a subject which McTaggart also painted in 1891 and 1893. Similarly, a change of emphasis and title leads from *Daybreak, Kilbrannan Sound* (1893: untraced), which shows a small boat with young children and their father returning from a night's herring fishing to a very different marine arrival in *The Coming of Saint Columba* (1895: NGS). This was painted in Kintyre in the year when the thirteenth centenary of the death of St. Columba was being celebrated on the nearby island of Iona, where the saint had landed in 597 on his mission to convert Britain to Christianity. That McTaggart was affected by the idea of suggesting a landing of special significance and that this could be achieved through the medium of the seascape itself, is indicated by Caw's reminiscence that when McTaggart looked at the picture with anyone, he would murmur softly 'What a day for such a mission'. Two paintings of 1883 may finally be mentioned, both of which were the basis of later versions. Dundee's *Wind and Rain, Carradale* perfectly blends the figures into the landscape, although allowing them their substantiality. A storm is brewing, and boats are seen running for the shelter of the anchorage, where other small craft are

safely at their moorings. This is an example of the sparing use of human incident which characterizes McTaggart at his best, and it is at the same time unusually considered as a composition, while its restrained harmony of lavender, slate, and lilac shows the greatest refinement. *The Storm* (KAG; later versions NGS and Orchar Collection, DAG, both 1890), fully matched to its elemental theme, has a northern, expressionistic air which clearly looks forward to the late period, but still contains those delicate and transient effects 'not too tightly grasped' as McTaggart himself said, which reveal a highly developed art of suggestion. The small oil in the Orchar Collection is exquisite in its pearly colour and rich, enamelled surface (it is painted on wood) and in the extraordinary vitality of its brushwork. The largest version of the three, which used to be owned by Andrew Carnegie, was developed in the studio from the 1883 picture, which was painted in the open air at Carradale. The Edinburgh picture makes a powerful impression and vindicates McTaggart's belief in the advantages of greater scale to his later style.

It is as a painter of the sea and shore that McTaggart excels, perhaps, above all, and works in

this vein predominate numerically in his *oeuvre*, as well as in public collections. Generally speaking the figure subject appears more dominant in landscape proper, as already discussed in two works of the 1860s, *Spring* and *Dora,* and the actions of the figures of more central importance to the theme, as many titles indicate: *Half Way Home* (1869), *Village Connoisseurs* (1870), *The Dominie's Favourite* (1873), *At the Fair* (1874), *Fern Gatherers* (1875), *The Blackbird's Nest* (1887), *Caller Oo!* (1894). Even a late work such as *The Soldier's Return* (1898: PAG), as ambitiously large (134 cm x 206 cm) as the big seascapes of the same period and equally concerned with a suggestion of movement, is slightly marred by an insistent element of genre. The main pivot of the composition is an awkwardly drawn figure of a running soldier. Somewhat more successful is another large work of the same year *The Lilies,* (KAG), which shows two groups of children dancing in a ring in the artist's garden at Broomieknowe round a bed of tall lilies in bloom. Here the figure drawing is less eccentric and the lyrical impulse which suggested the picture's full title *The Lilies – Consider the Lilies* is carried through convincingly.

Two Scottish painters who became well known in London as painters of the west coast of Scotland, Colin Hunter (1841-1904) and Hamilton Macallum (1841-96), frequently painted in company with McTaggart at Tarbert during the summer, and their work show his influence. Both, however, have faults which may be taken to stem at least in part from the need to specialize in a certain recognizable landscape type which was more necessary to survival in the larger exhibition of the south. Colin Hunter, who became an Associate of the Royal Academy, was the more painterly artist, and an early work, *On the West Coast of Scotland* (1879: Orchar Collection, DAG) need only be compared with Harvey's work of this time to show the younger generation's much freer confidence as colourists. Yet his technique often degenerated into slickness. Even his sketches, painted with considerable freedom and breadth, too often have a meretricious look, using unmixed ultramarine or cobalt to gain an immediate effect. Although less gifted technically, Macallum was perhaps a more genuine artist. In his hands the genre element, which in the minds of the public at large was one of the attractions of landscape, is soberly and objectively treated. *Haymaking in the Highlands* (1878: GAG) shows the new hay being loaded onto a boat on one of the Hebridean islands. This type of documentary transcript of life in the remoter parts of Scotland was appreciated more as social history than as art. J. Dafforne learnedly advised the readers of *The Art Journal* when describing *Shearing Wraick in the Sound of Harris* (untraced) of the value of this industry to the Highlands (£200,000) and on the soda, potash, iodine and bromine and other 'substances used largely in manufacture' which could be extracted from seaweed. Macallum settled in London

in 1865, and used broad Scots in his titles like *A Wee before the Sun Ga'ed doon*, less as a means of communication than as an advertisement of national subject-matter.

McTaggart had numerous followers in Scotland. Joseph Henderson (1832-1908), an almost exact contemporary of McTaggart who became his father-in-law when his daughter became the latter's second wife, was the most prominent artist in Glasgow of his generation. He exhibits similar interests to Macallum in *Kelp Burning* (Orchar Collection, DAG), and comes very close to McTaggart in *The Flowing Tide* (1897: GAG), yet his approach is workmanlike and rather pedestrian. He never became a member of the RSA, indicating the difficulty Glasgow painters had in the later decades of the century in having their claims to academic recognition heard. Sir James Lawton Wingate (1846-1923) was born in Glasgow but trained in Edinburgh, where he lived after 1871, ultimately becoming President of the RSA. His work, too, records without comment life on the land at its most placid. His figures are generally engaged in the unchanging work of the country, pausing only, one presumes, to discuss the weather, as in Dundee's *Watering Horses* (1885), exhibited at the RSA in 1887. Although an agreeable work, it cannot compare with the educated vision and subtly modulated colour of McTaggart's work of similar date. Like others, Wingate was more timid than McTaggart in his handling of paint. At his best he possesses an individual delicacy of brush-work and colour, but McTaggart's weakness in composition (which sometimes had to be made good by augmenting an already painted canvas with additions which were stitched on) is sometimes exaggerated to the point of formlessness in Lawton Wingate's later seascapes.

Even more dependent on McTaggart, to the extent of working at his favourite locations at Carnoustie and Machrihanish, Robert Gemmell Hutchison (1855-1936) concentrated almost exclusively, in the later part of his career, on one area of McTaggart's subject-matter – small children playing at the seashore – but was influenced in his treatment of the figures by the nineteenth-century Hague School. For all his considerable popularity and a long and productive career, Gemmell Hutchison has remained a surprisingly little-studied artist and a chronology of his work is difficult to establish precisely as few of his pictures are dated. However, a tentative dating to the 1880s and 1890s seems appropriate for a series of little works often measuring a mere six by eight inches more often than not showing children either alone or in groups, or perhaps a baby with its older sister by whom it is being spoonfed or told a story in the humble familiarity of a cottage interior. These modest compositions frequently demonstrate the most delicious painterly quality on a small scale, together with a genuinely sympathetic treatment of the lives of the very young; they have always been more prized by collectors than appreciated by art

historians. Tom McEwan in Glasgow frequented similar territory; his domestic interiors are stiffer and less natural, but also more detailed in terms of dress and furniture. Gemmell Hutchison's later and probably better-known seashore paintings retain a charming freshness and spontaneity and are often handled with impressive freedom. *Shifting Shadows* (exhibited 1913: RSA Diploma Collection), which is very large and shows a buxom young wife hanging out the washing on a windy day, is untypical in size and subject and suggests that in his usual smaller pieces he was deliberately reining-in an exuberant talent.

Two later artists whose work bears a family resemblance to that of Gemmell Hutchison are Jessie McGeehan who concentrated on Dutch children playing at the water's edge or in small boats; and John McGhie (1867-1952), who seems to have drawn all his subjects from the ancient Fife fishing village of Pittenweem where he lived when he was not working in his Charing Cross studio in Glasgow. A typical subject will show a handsome young woman mending nets, gathering shellfish, or simply waiting for the arrival of the fishing boats, against the ever-present background of a North Sea as blue as her eyes.

A major influence on artists from the north-east in the last quarter of the nineteenth century was the Aberdeen collector John Forbes White. He was a polymath of advanced tastes, with particular enthusiasm for the Dutch Impressionists and the Barbizon School and a classicist who would typically delight in recounting how on a journey by coach from Stettin to Danzig he talked Latin for hours with a Polish professor of mathematics. He founded the Homeric Society of Dundee, and in 1889 gave a lecture there on the newly discovered Tanagra figurines. He was in addition a pioneer photographer, and knowledgeable enough about Rembrandt and Velazquez to write *Encyclopaedia Britannica* articles on them. A wide circle of artists visited his house as their friend and patron, including the Scots Arthur Melville, Hugh Cameron, Orchardson and Daniel Cottier (whose firm in 1863 installed nineteen stained-glass windows of Cottier's design in Seaton Cottage, White's retreat on the Don), as well as George Paul Chalmers and Sir George Reid. The English painters William Stott of Oldham and Paul Falconer Poole were also occasional guests, as was Josef Israels, who contributed to the joint portrait of himself now in Aberdeen Art Gallery and inscribed '*à notre ami White*'. White bought Mollinger's *Drenthe* from the International Exhibition in London in 1862, and secured an introduction to the young Utrecht artist, with whom he developed a friendship. When Mollinger died, White took responsibility for disposing of the contents of his studio on behalf of the family. Through Cottier and Mollinger, White met Arzt, Maris, and Bosboom and bought their pictures. He bought the Corot *Souvenir d'Italie* (GAG) in 1873 for £600

('Maister White, are ye mad?' said his father's old head clerk), selling it again in 1892 for £4000.

Their contact with White was a decisive factor in the development of the painters George Reid, who was also an Aberdonian, and George Paul Chalmers, who came from nearby Montrose, and led them in a more conspicuously European direction than McTaggart. McTaggart's three-week tour of European galleries in 1882, made in company with J.G Orchar, included a visit to Israels at The Hague, but although McTaggart admired the Dutch painter, there is no sign that he was influenced by him. The opposite is true of Chalmers, who first met Israels at White's Seaton Cottage, and then renewed his acquaintance when he visited Paris and the Low Countries in 1874. And when George Reid went to Holland in 1866 it was to study under Mollinger, apparently with financial support from White. Mollinger's *Drenthe* is a clear influence on Reid's *Montrose* (1889: AAG), just as White's large Corot inspired Chalmers' *Autumn Morning* (late work: untraced).

Reid and Chalmers were only occasional landscapists. Chalmers also painted genre, and both were exceptionally accomplished portraitists. Yet it is their landscape work, and in Chalmers' case, a handful of the genre pictures, which are of chief interest today. They show a consciousness of atmosphere as a diaphanous element interposed between the seer and the seen, altering the appearance of things far more subtly than the dense mists and 'effects' of artists like Joseph Farquharson. Chalmers studied under Lauder at the Trustees' Academy for only two and a half years, and it is possible that this short training, which contrasts markedly with McTaggart's seven-year apprenticeship, was a considerable factor in Chalmers' extremely hesitant production, forcing an undue reliance on his undoubted natural gifts in the absence of a clearly identified aesthetic. There was a good deal of head-shaking at Chalmers' want of determination and habit of rising late, but he clearly enjoyed a good reputation among his contemporaries. However, it rested upon an extraordinarily small output, much of which has now vanished, although just enough remains to demonstrate his quality. There are the portraits proper, of which perhaps the most important are *John Charles Bell* (1875: DAG) and the unidentified *Portrait* (n.d. MacDougall Art Gallery, Christchurch, N.Z.) which show a Rembrandtesque sense of contrast, although in colour they are closer to Velazquez's use of black and white. In both works the chiaroscuro effect is handled with extreme delicacy, and there is real sympathy with the serenity of old age. The Drumlanrig *Old Woman Reading* by Rembrandt was an obvious influence on a little portrait of a sitter of similar age in the Orchar Collection. That Chalmers could also paint a sympathetic study of a very young sitter is demonstrated by his portrait of Forbes White's daughter *Aitchie* (exhibited 1874: AAG).

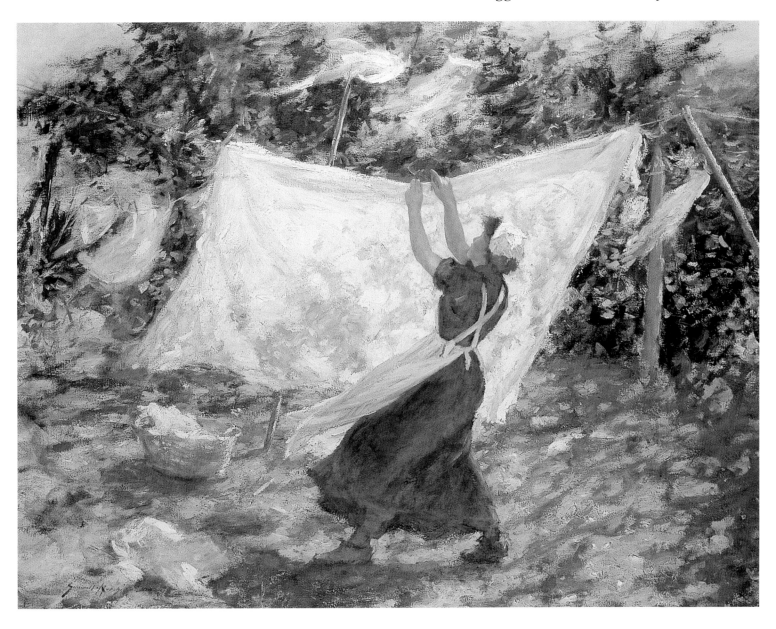

41 Robert Gemmell Hutchison
Shifting Shadows
c. 1912
Oil, 116.80 x 149.90 cm
Royal Scottish Academy
(Diploma Collection)

Chalmers comes closest to his admired Dutch contemporaries in a few paintings which show a domestic interior with figures, usually including children. *Prayer* (1870: untraced but reproduced in Caw) shows a young girl kneeling beside an old woman who holds a Bible on her lap and the relationship between the two figures is tenderly conveyed. *The Lesson* (n.d.: Orchar Collection, DAG) shows a similar contrast of youth and age. His most ambitious work of this kind was *The Legend* (circa 1864-67: NGS) which shows a group of children gathered round an old lady who is telling them a story. The room is filled with a grey-blue light which is rendered with the greatest delicacy and was the main cause of the trouble which this composition caused the artist. Alexander Gibson tells us that 'Chalmers rarely kept to the original conception of his picture, but was continually being led astray by new ideas or by passages of colour, which were beautiful in themselves, but which involved a rearrangement of the whole picture; and then, when the process went on for a while, he lost the fresh feeling with which he began the work, grew sick of it and finished it as a piece of disagreeable taskwork'. In 1865 the unfor-tunate artist wrote to G.B. Simpson, who had commissioned the picture, 'I have wrought harder this year than ever I did and have completed nothing', and in a subsequent letter tells his correspondent with understandable wryness of a painting by Orchardson (whose London career was just beginning) that had been sold to a dealer for £400, and resold 'immediately for twice that figure; painted in five weeks!' Generally, Lauder's other pupils developed an ability to exploit not only the freshness but also the rapidity of the sketch aesthetic. Chalmer's adherence to Old Master models made this an impossibility for him, despite that fact that 'his sketches, if he intended them to be merely

sketches, were done with extreme facility and pleasure'. It is perhaps for this reason that his very rare landscapes are perhaps the most satisfying of all his works.

At the End of the Day (private collection) is set in the flat countryside of the artist's native Montrose, and shows a luminous evening sky reflected on a wet road. Its technique completely eschews the expressive brushwork typical of Lauder's pupils, but instead provides infinitely subtle gradations of tone, with no trace of the movement of the brush over the surface of the picture. This work probably dates from the period 1872-75, when he spent some months in summer and autumn at the village of Edzell painting from nature. Chalmers appears to have approached the problems of painting in the open with the excessive conscientiousness which he brought to portraiture (on one occasion a portrait required ninety sittings), but the large *Running Water* (untraced) was finished, together with numerous sketches. The pains which Chalmers took to achieve the maximum truth to appearances – 'the detail always emerging into prominence and having to be beaten back into mystery' – indicate a predominantly realistic concern which could only be reconciled with Chalmers's technique with the greatest difficulty. For the main aim of that technique was to suggest the most ethereal and evanescent effects, paradoxically, through a high finish which would have the immediacy of an apparent sketch, but not its material flimsiness. When Chalmers succeeded in achieving this as he did in *The Head of Loch Lomond* (Orchar

Collection, DAG) and *The Ferry* (ibid.), he appears as one of the most poetic and delicate of landscapists, especially in his use of a range of colour which is much wider than is seen in his studio paintings.

In 1876 Chalmers went to Skye. *Rain in Sligachan* (untraced) has the same atmospheric transparency and depth as the two pictures in the Orchar Collection, suggesting that the enthusiasm for Corot that Chalmers was heard to express on the night before his mysterious death was to some extent that of a disciple of the French painter.

The very extensive correspondence of Sir George Reid (as he became) and James Forbes White contains a number of clues concerning the painter's views on landscape painting and certain of its practitioners which are more of interest for the light they shed on his early views than instructive regarding his own work. From Paris, where he studied under Yvon, he writes, 'I cannot but feel sorry that Gérôme's star is so much in the ascendant here – he is exercising a strong and very hurtful influence upon many of the young fellows, both in regard to choice of subject and manner of painting . . . Jules Breton and Daubigny have their worshippers too – but their numbers are few.' In the same letter Reid describes his impression of Veronese's use of light in *The Marriage at Cana* (Louvre): one group of columns in the picture has, he observes, 'only the borrowed light from the blue sky above. You can feel the blue of the sky repeated over their surface like a kind of glossy skin'. The same letter states that Reid's friend the Dutch artist Artz is to arrange for Reid to

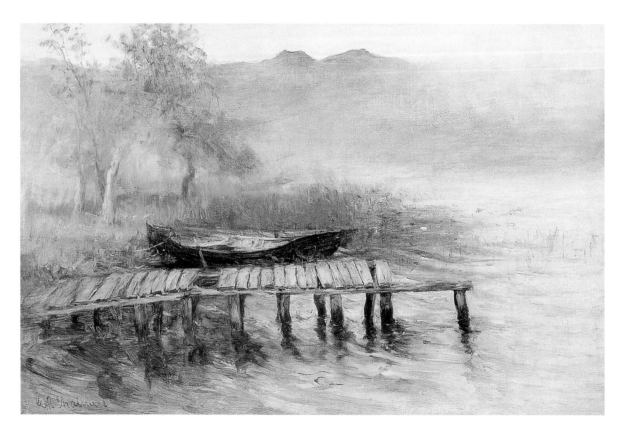

42 George Paul Chalmers
The Head of Loch Lomond
No date
Oil, 26.60 x 43.80 cm
The McManus: Dundee's Art Gallery and Museum
Dundee Art Galleries and Museums (Dundee City Council)

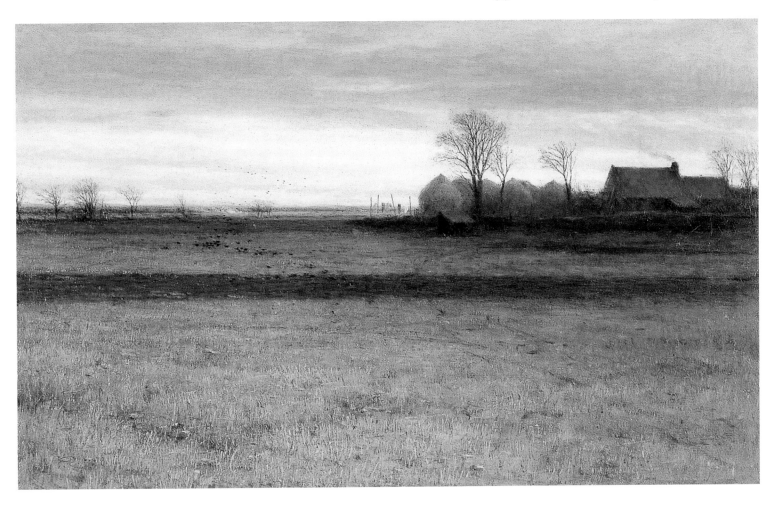

43 Sir George Reid
Evening
1873
Oil, 42.50 x 69 cm
The McManus: Dundee's Art
Gallery and Museum
Dundee Art Galleries and
Museums (Dundee City Council)

meet Daubigny through a mutual friend. Although it is not known whether this meeting did in fact take place, the correspondence reveals that Daubigny was, with Jules Breton, the artist whom Reid most admired in Paris in 1869.

It is probably unfortunate that Reid did not remain a landscapist and that his considerable technical skill was of a kind which could be and very quickly was pressed into what the later Victorians sometimes called the 'sin of commission' portraiture. Reid had the same view of the respective merits of portraiture and landscape painting as Gainsborough, but despite this and the very real gift, nourished by the perceptive intelligence which shows itself in the young artist's reactions to current painting in Paris, and demonstrated in the Orchar Collection's *Evening* (1873), he painted very few landscapes and concentrated from an early point on portraiture. His neat draughtsmanship also led to many commissions as an illustrator. The Reid-White letters reveal a rather dry temperament – 'fou' o' seriousness', as he says himself – which borders on aridity. At the end of his career, as President of the RSA (1891-1902) he came to represent to the younger generation of painters of the Glasgow School all that was reactionary in the academic system that then prevailed in Edinburgh, and his tenure of the presidency was an uneasy one.

In 1893 Reid attacked *ex cathedra* the young painters of the Glasgow School in an article in the *Westminster Gazette*. The wheel had turned full circle for the young Scot in Paris who criticized the *pompier* influence of Gérôme and briefly indicated his own awareness of new developments as the painter of *Evening*.

George Smith (1870-1934) was another artist from the north-east who went abroad to train, in his case with Verlat in Antwerp, who had been the teacher of Hornel and his friends of the Kirkcudbright School, Mouncey and MacGeorge. Like these landscapists, Smith demonstrates the influence of the watered-down impressionism which was becoming endemic in some of the Continental schools in the 1890s, together with the rudely vigorous handling of paint which Verlat seems to have inculcated and which is appropriate to the bucolic scenes of farm and field favoured by Smith.

Hugh Cameron (1835-1918) has been mentioned as representing a third strand of development in the landscape painting of the later Victorian period, namely the taste, almost amounting to obsession, for paintings of children. To some extent this identification is artificial since all the pupils of Scott Lauder treated this theme. Our more cynical age regards the subject as sentimental and escapist, but for the

Victorians, with their positivistic belief in the perfectibility of man and society, it to some extent represented the more pleasant of the two possible reactions to the inescapable inference that if man and society are perfectible in the future, they must at present be imperfect. One of the reactions is to criticize society and the vices of man, either by ridicule and caricature or by objective description of what is wrong. *Punch* (which had no specifically Scottish equivalent) exercised this function, as did the graphic work of the Scottish artist William 'Crimean' Simpson (1823-99). The other possibility is to emphasize what is good in existing society, as William Bell Scott believed he was doing in *Iron and Coal*. The Victorians saw childhood as a time of innocence. This appears clearly in Cameron's work and in that of a slightly later group of artists in Scotland whose work began to appear in the 1870s. It presents a Scottish parallel to the shortlived contemporary English development which was led by George Mason, Fred Walker, G.J. Pinwell and Arthur Boyd Houghton.

The Edinburgh-trained R.W. Macbeth (1848-1910), the son of the genre painter Norman Macbeth, became an illustrator for *The Graphic* and moved to London in 1870, becoming an Associate of the Royal Academy in 1883. His work as a painter was thereafter little seen in Scotland, but as the engraver of Walker's *Bathers* and *The Plough*, of

Pinwell's *Elixir of Love* and of Mason's *Pastoral Symphony* Macbeth played a crucial role in the taste of the day for idyllic pastoral subjects. As an engraver he was outstanding; his large plate of Titian's *Bacchus and Ariadne* is a *tour-de-force*.

Hugh Cameron, George Manson and Robert McGregor were the most interesting of the Scottish-based adherents of the new movement, which influenced such artists as the short-lived P.W. Nicholson, John Reid, J.C. Noble and A.M. Macdonald. Cameron's work, especially when it is on a small scale, has a tender lyrical quality seen at its best in a small oil *The Swing* (Macfarlane Collection), rather than in a large exhibition piece such as *The Funeral of a Little Girl on the Riviera* (1881: DAG). Both pictures convey a convincing sense of the open air, as we might expect from an artist who was a contemporary and friend of McTaggart, but Cameron's elongated and wistful figures, which can be charming on a small scale, seem mannered or simply inept when enlarged. Or is it possible that the emotionalism implicit in the heart-rending subject of infant mortality requires the powerful colour and forceful composition which Phillip had employed in 'La Gloria'? Cameron's use of colour is restricted to pale harmonies of blue and green appropriate to his gentle style. What is known of George Manson (1850-76) comes from the well-produced illustrated memorial volume of 1879. His early death prevented

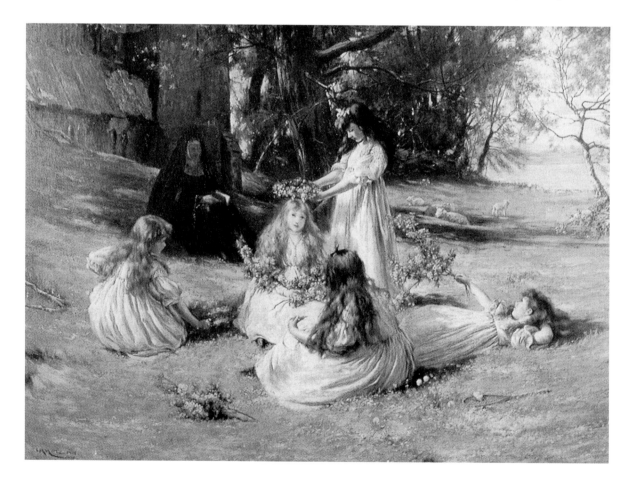

44 Charles Martin Hardie
An Unrecorded Coronation
1888
Private collection
The Royal Scottish Academy catalogue of 1889 adds, ' "The Isle of Rest", A.D. 1548' to the title.

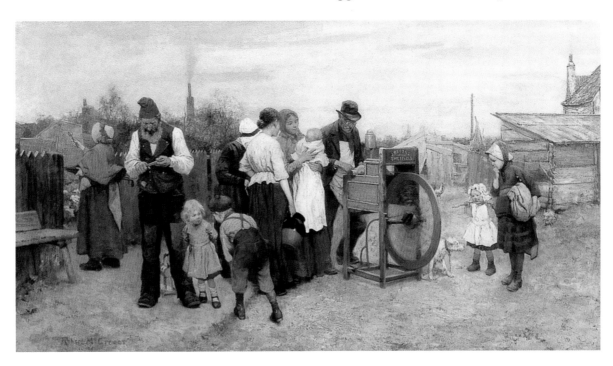

45 Robert McGregor
The Knife Grinder
1878
Oil, 76.20 x 137.80 cm
The McManus: Dundee's Art
Gallery and Museum
Dundee Art Galleries and
Museums (Dundee City Council)

the development of a sensitive artist whose precocious talent as a watercolourist can be seen in the early two examples of his work in a public collection, *The Cottage Door* (1871-73: Orchar Collection, DAG) and *What is It?* (1873: ibid.).

John Henry Lorimer (1856-1936), brother of the architect Sir Robert Lorimer, trained in the RSA schools under McTaggart and Chalmers prior to a period in the atelier of Carolus-Duran in Paris. His work as a flower painter can seem wonderfully showy and exotic. As a subject-painter, Caw writes of him: 'None except Sir W.Q. Orchardson . . . had painted the more refined and cultured side of modern society, until Lorimer took up figure subjects and gave delightful glimpses of life as it passes in many a Scottish home.' Many of these include the children of the household as the main protagonists, with titles such as *Sweet Roses*, *Winding Wool*, *Lullaby*, and *Grandmother's Birthday – Saying Grace*, all from the 1890s; perhaps the best known of all is the late work, *The Flight of the Swallow*, purchased by the Scottish Modern Arts Association in 1908, a charming Edwardian group with a mother and three pretty daughters (one of them in tears) watching the departure of a flight of swallows at the end of summer. Charles Martin Hardie (1858-1916), similarly, studied at the RSA schools and absorbed (as far as can be judged from the little that has appeared

of his work in recent years) a fresh and pleasing technique seen to considerable advantage in one of his best-known works, *An Unrecorded Coronation* (1888 – how academic such a work appears in comparison with the Glasgow School at the same date!), where, watched by a patient old nun, the four young Marys who were the companions of Mary, Queen of Scots during her sequestration on Inchmaholm Priory in 1547 surround her on the summer sward and one of them 'crowns' her with a daisy chain. Equally wedded to childhood subjects, but of considerably greater talent and originality, Robert McGregor (1847-1922) was born in Yorkshire and worked with his father as a designer of damasks at Dunfermline before joining the Life Class of the RSA. He seems at some unknown date to have worked in Brittany, but of his life and training surprisingly little is known. In any event, his style seems more French than Scottish; more than any artist before Guthrie or the Newlyn School he appears either to have absorbed the lessons of Bastien-Lepage, or to have arrived independently at a similar *plein-airisme*. Two large early works at Dundee Art Gallery, *The Knife Grinder* (1878) and *Great Expectations* (1880) show that in his vigorous handling of paint and concern with rich, low-keyed colour, he prefigures the early work of the Glasgow School painters James Guthrie and E.A. Walton.

THE GLASGOW SCHOOL AND SOME CONTEMPORARIES

A remarkable burst of creative vitality in the visual arts took place in Glasgow in the last two decades of the nineteenth century. The Second City of the Empire (by 1890 just ahead of Melbourne in terms of rateable value) had owed its recent rapid growth to shipbuilding, the locomotive and heavy machinery industries, and (assisted by vast local reserves of coal) the production of iron, reaching at one stage a third of Great Britain's output. When steel took the place of iron, Glasgow's steel production was increased nearly twenty-five fold in twenty years, to reach a million tons by 1900. Despite the bank failure of 1878 – which immediately gave a splendid excuse to provide employment by the expediently labour-intensive erection of a palatial City Chambers – at the end of the century the city rode on the crest of a wave of confidence and prosperity which was reflected in more widespread and gradually more discerning patronage. The 'beautiful little city' admired by Daniel Defoe on his visit in 1715 with its venerable Cathedral and ancient University, its merchant city thriving on the American tobacco and cotton trades, prettily situated on the banks on the Clyde, had by the end of the nineteenth century become an international manufacturing and trading giant successfully selling its goods to the world.

In the *Notes* written in 1891 Macaulay Stevenson, pointing out that the Glasgow School artists 'did not seek the name and were but a dozen or so in all' (a total he later increased to twenty-three in a letter to T.J. Honeyman in 1941), estimated that there were about one hundred and fifty professional artists working in the city. But painting did not exist in a vacuum and the burgeoning of the visual arts in Glasgow at the end of the century has three main aspects: architecture, design and painting. First, in addition to its strong local architectural tradition, which bore the very personal impress of Alexander 'Greek' Thomson (1817-75) and of Charles Wilson (1810-63) and others, late-Victorian Glasgow boasted a number of accomplished and original architects. The most eminent of these was Sir J.J. Burnet (1857-1938) whose Glasgow work dates from his return in 1878 from a period of training at the Ecole des Beaux-Arts in Paris. In a long series of buildings he developed an approach to architectural design which showed historicism applied with unpedantic inventiveness to contemporary urban requirements, from the skilful, witty addition to the Glasgow Stock Exchange (1849) in Venetian Gothic to the Sullivanesque McGeoch's warehouse (1905). Burnet's Glasgow contemporaries included William Leiper (1839-1916), designer of a delicious Venetian Gothic extravaganza in polychrome brick and tile known as Templeton's Carpet Factory (1889), James Salmon II (1874-1924), and J. Gaff Gillespie (d. 1926) whose paths away from historicism led them to an Art Nouveau architecture. Outside the old city, with its handsome new banks, insurance offices, churches and terraces, new communities sprang up in the pleasant green acres of Cathcart, Bridgeton and Pollokshields, along Great Western Road and out to the Clyde resorts like Helensburgh, where the newly-rich merchant class built themselves imposing stone mansions which provide a domestic counterpart to the public architecture of the Victorian city. Bare walls in many a grand drawing-room simply cried out for pictures.

Art Nouveau in Glasgow in the 1890s is the second important aspect of late nineteenth-century style in the city. With it came a revival in the decorative arts of furniture, metalwork, and stained glass which gives Glasgow its own equivalent of the Arts and Crafts Movement, although the English movement regarded its Scottish counterpart with active distaste. Although it owes something to the purifying influences of Christopher Dresser, E.W. Godwin, Thomas Jekyll and Whistler, this Glasgow movement was above all impelled by the protean originality of Charles Rennie Mackintosh (1868-1928), a designer of genius whose earlier work, culminating in the first part of the Glasgow School of Art (built 1897-99) and containing many Art Nouveau elements, further added to the international standing so recently and so surprisingly achieved by its school of painters. These young Turks of Scottish painting form the third section of our triptych. Collectively known as 'The Glasgow School' – unconnected with the Glasgow School of Art – they provide a slightly earlier background to the esoteric *fin-de-siècle* movement of Mackintosh and his friends. The first mature works by these young artists – the 'Glasgow Boys' – appeared in the middle 1880s, but their creative impulse slackened after 1896. This third aspect of the flourishing visual arts in Glasgow sprang from a happy combination of favourable economic

conditions and a new consciousness on the part of the Glasgow public of the art of painting. The evolution of that taste requires a brief description here.

Through the decades preceding 1880 Glasgow had developed a fine tradition in the appreciation of good pictures. The city's artistic independence may be said to date from the foundation in 1753 of the Foulis Academy within the University for the training of painters, sculptors, and engravers. This brave new enterprise was the brainchild of the brothers Robert and Andrew Foulis, printers to the University, and Robert, in McLaren Young's words 'an ardent if somewhat gullible collector', accumulated a collection of 450 mostly spurious 'Old Masters' for teaching purposes. The Academy produced the medallionist James Tassie (1735-99) and the genre painter David Allan, one of several students who visited the Glasgow alumnus Gavin Hamilton on the obligatory visit to Rome. It closed when Andrew Foulis died in 1775. After over thirty years, in 1808, the Hunterian Museum at the University was opened – the second public museum in Britain after the Ashmolean – with its excellent examples of Rembrandt, Koninck, Chardin, Stubbs and Ramsay, and much else besides, left to the University by a collector of a very different stamp, the pioneer obstetrician, friend of Reynolds and connoisseur William Hunter. A variety of Glasgow exhibition societies had existed from the earlier nineteenth century, notably the Dilettante Society (begun in 1825) and the West of Scotland Academy, which lasted from 1841-53. By the middle of the nineteenth century the taste of two widely travelled Glaswegians, the art dealer William Buchanan – a student at the University during the Foulis years – and the master coachbuilder and collector Archibald McLellan, had made a considerable impact on public collections in both Glasgow and London. Buchanan was responsible for bringing many important Old Master paintings to Britain, including Titian's *Bacchus and Ariadne* and *The Toilet of Venus* by Velazquez, both now in the National Gallery. He may have acted as adviser to Archibald McLellan, who in 1853 left to the City of Glasgow an Art Gallery and a large collection of paintings including Giorgione's *The Adultress Brought before Christ* (GAG). The landscape background of this famous picture seems to have influenced the early Glasgow School painters.

In the 1860s two institutions were founded which were to have an immediate bearing on the development of the Glasgow School of painters – the Fine Art Institute (later the Royal Glasgow Institute of the Fine Arts) in 1861, and the Glasgow Art Club in 1867. The early exhibitions of the Fine Art Institute were held in the McLellan Galleries at 254-290 Sauchiehall Street, and there is no clearer indication of the Glasgow's public's interest in art at the time than the Institute's decision in 1879 to provide itself with sumptuous new premises at 171 Sauchiehall Street, merely a year after the crash of the City of Glasgow Bank had brought financial ruin to many of its shareholders and had caused a short-term cash crisis in the city. The new Fine Art Institute, designed by Sir J.J. Burnet, had an elaborate sculptured frieze by John Mossman (1817-90), who was the teacher of Pittendrigh Macgillivray (1856-1938), the only sculptor to be associated with the Glasgow group. The importance of the annual exhibitions held at the Glasgow Institute in the 1870s and 1880s was twofold. First, an outlet was provided for the products of artists living in Glasgow and the west of Scotland who found themselves tacitly debarred from membership of the RSA in Edinburgh; in the second place, the Loan Sections of these exhibitions began to reflect the taste of the more advanced collectors in Scotland for the works of the Barbizon School, Bastien-Lepage, and the Hague School. In the middle eighties, works by Monticelli, Whistler, Rossetti, Burne-Jones and William Stott of Oldham began to appear. The Glasgow Art Club's exhibitions were less ambitious, having more the role of a market for the work of members of the Club. This was a necessary economic function, but it may be supposed that much of whatever lustre the Club possessed must have departed when two of its most distinguished members, Daniel Macnee and the landscapist David Murray (both later knighted), moved to Edinburgh and London in 1876 and 1883 respectively. In the early eighties, therefore, the situation in Glasgow was such as to provoke in any young artist of talent and originality a sense of frustration at the prospect of long years of exclusion from the RSA establishment in Edinburgh, and an awareness of the superiority of the works of the foreign schools which were represented in the annual exhibitions of the Glasgow Institute. Added to that was a feeling of disgust at the frank commercialism and sub-Wilkie sentimental and ancedotal approach of the so-called 'Gluepots', who formed the majority of the membership of the Glasgow Art Club and whose use of heavy brown megilp varnish earned them that unflattering but apt sobriquet.

The MS *Notes* on the history of the Glasgow School written by Macaulay Stevenson in 1891-92 and apparently revised by his wife in 1895 (until recently in the possession of the artist's daughter) trenchantly underscore the views of the younger generation of Glasgow painters who were still struggling to make their way against public apathy or official benightedness. Stevenson castigates the preference of the selection committee of the RSA for anecdotal painting, commenting 'Alas poor Edinburgh! It was left to live on traditions. The life of the community is fettered by the effete conventions of a faded gentility and eaten into by the dry rot of an exclusive and self-sufficing "culture" '. Praising the great display of modern French and Dutch masterpieces assembled by T. Hamilton Bruce for the Loan Section of the Edinburgh International Exhibition of 1886, Stevenson describes the Barbizon School as

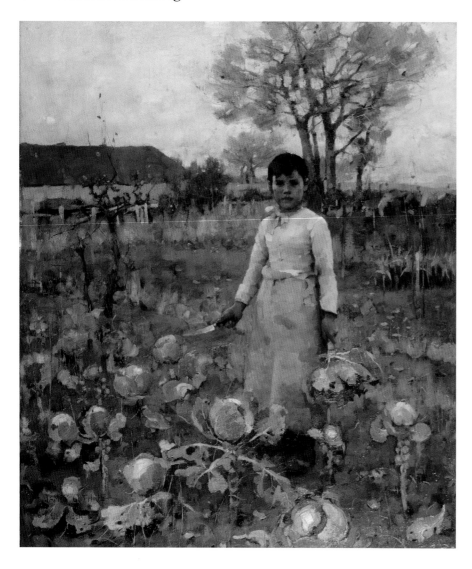

46 Sir James Guthrie
A Hind's Daughter
1883
Oil on canvas, 91.50 x 76.20 cm
National Gallery of Scotland

'the greatest event that had occurred in art since Rembrandt'. He then emphasizes the important role of the Glasgow Institute in bringing in annually to Scotland excellent examples of the work of the Barbizon and the Hague School artists and of Bastien-Lepage, praises the fact that these borrowed works were often instructively hung in juxtaposition with works by local young artists, and emphasizes that the Institute was 'the real school – not Paris.' Stevenson, ever the controversialist, actually goes out of his way to dismiss suggestions of French influence: 'Even in W.E. Henley's brilliant paper *The National Observer* in which appear the most capable art critiques in the country the whole group are to this day blunderingly described as the Scoto-French school – much to the amusement of the men themselves'.

The enlightened activity of a small number of collectors and dealers in Scotland, especially in Glasgow, provided a further stimulus for the revolt of the young painters who were to form themselves into the Glasgow School. The culmination of this activity was, of course, reached in the last years of the

nineteenth century and the first decades of the twentieth with the dealing of Alexander Reid (1854-1928) and with the formation of Sir William Burrell's vast collections. Reid's Glasgow firm La Société des Beaux-Arts was started in 1889. He supported the young Glasgow painters from the early eighties, and until 1892, when Reid held his first exhibition to include French Impressionist paintings in Glasgow, he seems to have concentrated on the Barbizon painters and the Hague School. He was on friendly terms with Fantin-Latour and showed him in Glasgow first in 1897. Reid knew Van Gogh with whom he shared lodgings in 1886 in Paris and who painted his portrait (GAG). A note by Mrs S.J. Peploe (Peploe MSS) mentions that Reid also knew Gauguin, but Reid did not buy examples of his work until well after 1900.

As early as 1874, the Glasgow dealer Craibe Angus (1830-99) had opened a gallery in Glasgow, and he seems to have introduced paintings by Corot, Diaz, Rousseau, Bosboom, the brothers Maris, Israels and Anton Mauve to Glasgow, although unfortunately he was unsuccessful in selling the great J.F. Millet's *The Sower* to a Glasgow client, bringing it briefly to the city at an unknown date. One of his principal Glasgow customers was the collector James Donald. Angus's son-in-law, the Dutch dealer Van Wisselingh, handled Courbet, and the family connection is a likely factor in the early arrival of paintings by the French Realist in Glasgow. Angus, furthermore, acted as the Glasgow agent of the Aberdeen-born dealer Daniel Cottier (1839-91) who had galleries in London and New York and was the first to introduce paintings by Monticelli into Scotland. The Cottier Sale in Paris included no fewer than twenty-five paintings by Monticelli – a total approached by the sixteen in W.A. Coats's collection (which also contained thirteen by Corot). John Reid of Glasgow had seven Corots and eleven pictures by Josef Israels. Among other important collectors at this period were T. Hamilton Bruce in Edinburgh (noted above in connection with the French and Dutch Loan Section of the Edinburgh International Exhibition of 1886) and A.J. Kirkpatrick of Glasgow, whose collection included works by the Hague and Barbizon painters, and Courbet. As we have seen, the Aberdeen collector John Forbes White had been to Paris in 1873 and had bought the large Corot *Souvenir d'Italie* (GAG) in the same year. His collection also included a Courbet and works by the Dutch Impressionists, some of whom he knew personally.

The most vital period of the Glasgow School lasted from approximately 1885 until 1896. This period encompasses early groupings based on close friendships and artistic congeniality which formed, initially as separate entities, around Sir James Guthrie (who was mainly self-taught), W.Y. Macgregor (Slade-trained), and Sir John Lavery (who studied at Julian's in Paris). It includes the eighteen monthly issues of the *Scottish Art Review* (1888-89), the organ of the

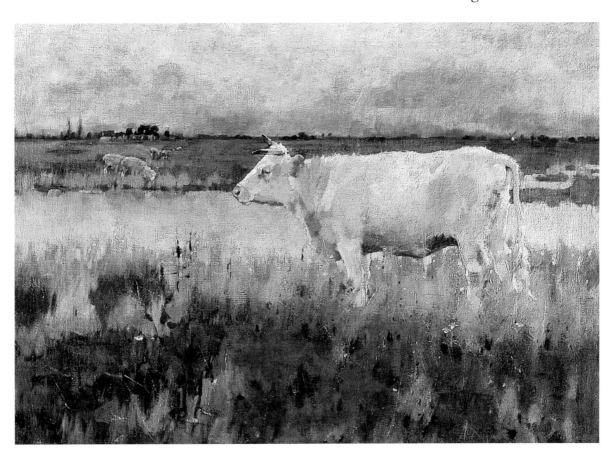

47 Joseph Crawhall
A Lincolnshire Pasture
c. 1882
Oil, 91.40 x 127 cm
The McManus: Dundee's Art
Gallery and Museum
Dundee Art Galleries and
Museums (Dundee City Council)

School, and ends shortly after the return of E.A. Hornel (who had trained in Antwerp) and the Glasgow-trained George Henry from their visit to Japan in 1893-4. Initially, the work produced during this period stemmed from a rejection of the academic finish and sentimental narrative style, which were the stock-in-trade of the majority of contemporary painters, together with a wholehearted adoption of realism in subject and style. The main sources of this early realism were Bastien-Lepage, the Hague School, Courbet, and the Barbizon painters. In the later 1880s, a decorative tendency began to appear in the work of the School. This later development promised well, and a number of works of real originality were produced, notably by Arthur Melville, George Henry, E.A. Hornel, Stuart Park, Joseph Crawhall, Alexander Roche and W.Y. Macgregor. A highly successful exhibition at the Grosvenor Gallery introduced this Scottish phenomenon to a London audience and led to exposure at the Munich Secession and large sales throughout Europe, North America and elsewhere. However, the vitality of this later impulse seems to have evaporated shortly after 1895, when commercial and other considerations began to tame the vigour of most of these artists. The Glasgow School is thus almost exactly contemporary with the New English Art Club, which several of the Glasgow painters joined at its foundation in 1886, and acted as a rallying point for young artists in rebellion against academic standards and anecdotal painting.

The Glasgow School's origins may be traced to 1878 and two friendships. In that year W.Y. Macgregor (1885-1923) – 'the father of the Glasgow School' – and James Paterson (1854-1932) were painting together at St. Andrews. Also in 1878 Sir James Guthrie (1859-1930) and E.A. Walton (1860-1922) met and became friends. By then Walton's brother Richard had married one of the sisters of Joseph Crawhall (1861-1913) and this relationship resulted in Crawhall's first visit to Scotland in the summer of 1879, when he is found painting with Guthrie and Walton at Rosneath in Garelochside, some twenty miles from Glasgow. Very few paintings from before 1880 by these five artists can now be traced, but Caw's opinion, based on acquaintance with many of the Glasgow painters, that Macgregor and Paterson were the first exponents of the early realism of the School, must carry some weight. In the autumn of 1879, Guthrie and his mother were living in London, where Crawhall stayed with them. At this time Guthrie was receiving advice and encouragement from Orchardson and Pettie and at the latter's suggestion stayed in Britain instead of going to France to train as he had originally intended. Caw tells us that Guthrie 'always spoke with respect of Pettie and Orchardson'. In 1880 Guthrie and Crawhall exhibited a joint work, *Bolted*, in an exhibition in Newcastle, and in the summer of that year, were painting with E.A. Walton in the open air at Brig O'Turk in Perthshire, where in the following year

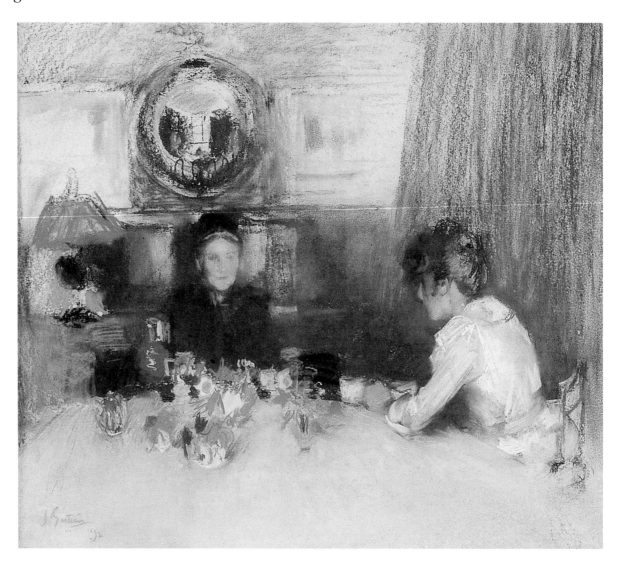

48 Sir James Guthrie
Causerie
1892
Pastel, 50.50 x 57 cm
© Hunterian Museum and Art
Gallery, University of Glasgow

they were joined by George Henry (1858-1943) and others. The slightly older Edinburgh artist Robert McGregor was then also painting in the village.

The winter life classes in W.Y. Macgregor's Glasgow studio seem to have been started in 1881. By all accounts these were of great importance in the development of the Glasgow style in encouraging artists to reject anecdotal subjects and to use a freer technique and bolder colour. By 1885 these winter classes were attended by James Paterson, T. Corsan Morton, Alexander Roche, John Lavery, E.A. Hornel and Thomas Millie Dow. They were also attended by Henry, Walton, and Crawhall, who during these years painted in the summer with Guthrie (who never attended the classes in Macgregor's studio) at the newly discovered Cockburnspath in Berwickshire, where Arthur Melville (1855-1904) was also working in 1883-84. A rare photograph (Walton family collection) from this period shows Walton and his brother, the designer George Walton, with Guthrie, Crawhall and Whitelaw Hamilton at Cockburnspath and conveys the *joie-de-vivre* of the young artists; another slightly later photograph from

the same collection records the little bohemia of Walton's studio at Cambuskenneth near Stirling in 1888, the mantel decorated with four Japanese colour prints and with what appears to be a palm fan or perhaps an easel decorated in Whistler fashion with a Japanese motif. The sense of a youth movement, strong in these rare records, is further conveyed in Macaulay Stevenson's *Notes*, in a passage written circa 1892: '. . . so great were the difficulties of some in getting the bare means of subsistence and of carrying on their work that one or two of the largest earners among them seriously proposed having a common purse, as the only means of meeting the case . . . the common purse has practically existed during all these years and exists still'.

These groupings of artists still in their early twenties had a stimulating effect on their development, and several works dating from this first phase of the Glasgow School until about 1885 show real accomplishment and originality. Visiting Guthrie at Cockburnspath in 1884, Caw formed the impression that at that stage Guthrie was the mainstay of the group – an impression confirmed by the rapid

progress of his style in the space of a few short years, and independently corroborated by the fact that two works by Guthrie acted as the magnet which drew the charismatic figure of Arthur Melville to the Glasgow group and persuaded the brilliant John Lavery to return to Glasgow instead of to London at the end of his period of study in Paris. In 1882, at the age of twenty-three, Guthrie painted *A Highland Funeral* (GAG) inspired by a funeral he had witnessed at Brig O'Turk. This ambitious work, measuring 129 cm x 193 cm, is a vigorous if somewhat clumsy piece of realism which probably owes both its bold handling and its subject to Courbet, and it marks a complete break from the influence Pettie had on Guthrie's early work. On seeing this painting exhibited at the Glasgow Institute Arthur Melville, himself at that date working along similar realist lines, asked for an introduction to the artist. Guthrie seems (according to the Stevenson *Notes*) to have visited Paris for a few days in 1880, and to have made another short visit in 1882. It is therefore entirely possible (*pace* Billcliffe) that he would have been aware of the *Burial at Ornans* (finally accepted by the Louvre in March of 1883 and immediately the object of renewed controversy) and perhaps also further works by Jules Bastien-Lepage, who is usually mentioned in connection with Guthrie's next ambitious work, *To Pastures New* (1883: AAG). This large picture represents a consid-erable advance and shows great assurance in handling and colour, although it should be added that *A Highland Funeral* had originally been painted in a higher key and had only been darkened at Walton's suggestion. *To Pastures New* still appears notably light in key, and a certain element of the 'Kodak' realism of Bastien-Lepage is tempered by the chromatic delicacy of the work, which is tenderly coloured in harmonies of white quite unlike the predominant browns and greys of the French painter, and at the same time has a considerable richness of surface. This was the work which persuaded Lavery to return to Glasgow. It more than holds its own with another important Glasgow School painting of the same date also produced in all probability at Crowland: *A Lincolnshire Pasture* (1882-83: DAG) by Joseph Crawhall. This was possibly painted in Guthrie's company, and is dependent to some extent on Jacob Maris but already reveals the peculiarly vivid draughtsmanship which makes Crawhall unique among animal-painters of any period. Two other notable pictures by Guthrie in 1883 indicate an effervescent talent. *Hard at It* (GAG), painted in the same harmony of pale blue and white as *To Pastures New,* shows a fluidity of handling worthy of early Peploe. *A Hind's Daughter* (1883: NGS) adds a powerful but controlled impasto (laid on with the palette knife) to a sympathetically rendered theme of country-style young girlhood, akin in feeling to the work of Robert McGregor, but more general and less anecdotal. In its powerful handling, rich tonality

and sense of childhood at one with nature, this work anticipated an important aspect of the early Glasgow School (particularly what might be described as its Kirkcudbright offshoot, the work of Henry and Hornel and to some extent Bessie MacNicol). *Schoolmates* (1884: Museum of Fine Arts, Ghent) shows Guthrie in what may seem to be a Bastien-Lepage vein, but actually it again bears more resemblance to such earlier works of Robert McGregor as *The Knife Grinder* and *Great Expectations* (both DAG). With the heads much more minutely modelled than any other area of the composition, the finish of *Schoolmates* is treated discrepantly, as is another childhood subject *In the Orchard* of 1885 (private collection) although here the trees, foliage, and grass are painted with a breadth of expression which produces a generalized and decorative effect. A similar tendency appears in E.A. Walton's rare early figure subjects. The impasted colour of Walton's portrait of *Joseph Crawhall* (1884: SNPG) which, were the picture not

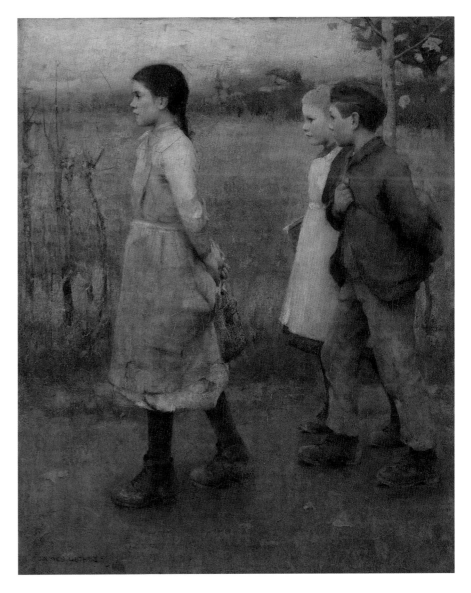

49 Sir James Guthrie
Schoolmates
1884
Oil, 137 x 101.50 cm
Museum of Fine Arts, Ghent
Image © Lukas-Art in Flanders
VZW

dated, would cause one to place it ten years later, is succeeded in Walton's most important work in the following year, the wistful *A Daydream* (NGS), by a subdued tonality and inconsistencies of handling as between the flesh tones and the draperies and landscape. It is as if Guthrie and Walton had taken to heart Ruskin's stricture on John Phillip's treatment of detail: 'It is indeed quite right to elaborate detail but not the ignoblest details first'. Realism posed a problem for these painters in their treatment of the human figure in landscape, and their eventual specializations in portraiture and landscape evaded the problem by dealing with its parts. However, Guthrie, made a successful attempt to solve it in the years 1888-92 with two series of pastels of domestic subjects, of which *Causerie* (1892: HAG) is a fine example. Indeed, Guthrie's pastels with their subtle, intimist approach and delicate evocations of light – qualities which he seems only on one occasion to have attempted to translate into oils in his Diploma work at the RSA, the impressionistic *Midsummer* (1892) – crown and effectively terminate an impressive decade of artistic progress. Guthrie had received a gold medal at the Munich Exhibition of 1890, not, as his friends had hoped, for *In the Orchard*, but for a portrait of the

Reverend Andrew Gardiner. It seems likely that this was the beginning of his successful career as a portraitist of many of the notables of the day, culminating in the herculean *The Statesmen of the Great War* (1930: NPG). A clear debt to Whistler's *Miss Cicely Alexander* appears in Guthrie's *Miss Jeanie Martin* (1896), but for the most part his later work – much interrupted by his long tenure of the presidency of the RSA – deals with male sitters.

Guthrie's great friends and brother artists Edward Arthur Walton and Joseph Crawhall each made profound – and profoundly different – contributions to the School in its early realist phase. The portrait of *Joseph Crawhall* by Walton was originally inscribed 'Joe Crawhall, The Impressionist, by E.A. Walton, The Realist', an affectionate joke between two young artists which contains more than a grain of truth Although both practised in oils, Crawhall is usually thought of as a master of drawing and watercolour, and some of Walton's most significant works from his early maturity are in small-format watercolour. Walton's *In Grandfather's Garden* (1884), *En Plein Air* (1885), *The Herd Boy* (1886) and *The Game-keeper's Daughter* (1886: GAG), particularly the two latter, are sensitive and contemplative works which achieve poetic stature. Walton exhibited a few other

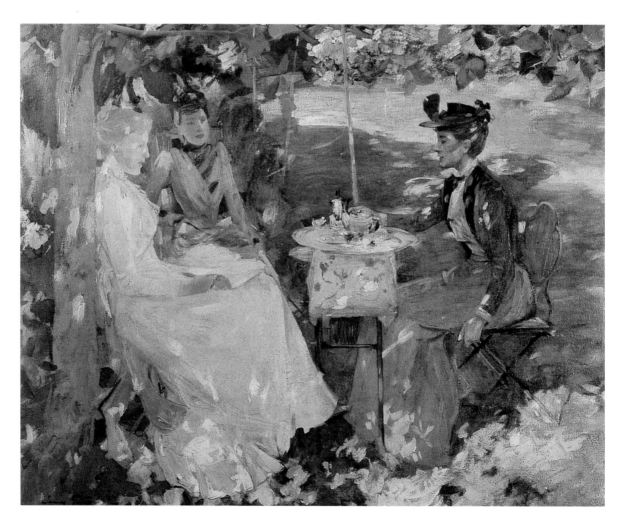

50 Sir James Guthrie
Midsummer
1892
Oil, 99 x 124.50 cm
Royal Scottish Academy
(Diploma Collection)

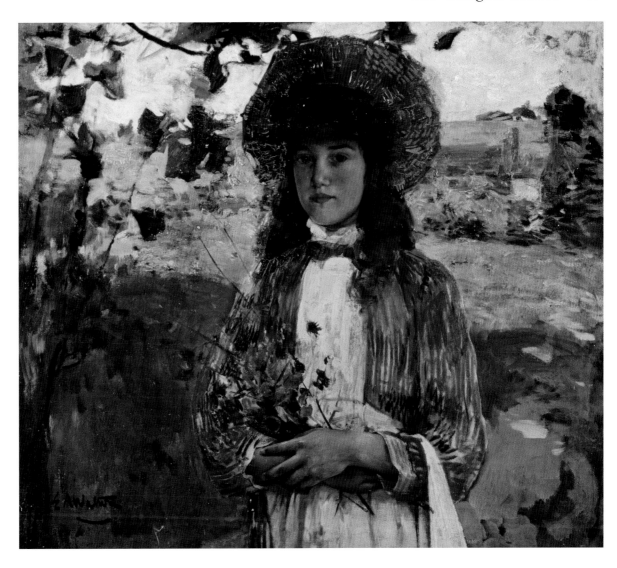

51 Edward Arthur Walton
Bluette
1891
Oil on canvas, 76.20 x 87.60 cm
National Gallery of Scotland

watercolours of this type of subject, but these examples of his talent in the lighter medium are rare, although he was throughout his life a frequent and distinguished landscapist in watercolour. Rather later than these, probably, is his undated oil *Bluette* (1891: NGS), which shows a young girl as pretty as her name holding blue flowers, against a freely painted landscape background. This charming picture is an early example of Walton's skill as a portraitist, a field in which he was increasingly engaged after his removal to London in 1894 where Whistler, a friend since the successful 1891 campaign orchestrated by Walton to have the *Carlyle* portrait purchased by Glasgow Art Gallery, became a neighbour in Cheyne Walk. In 1899, Walton was one of four artists – the others were Lavery, Henry and Roche – involved in a major project to provide mural decorations for the Banqueting Hall in Glasgow City Chambers, where the results can still be seen in the extremely imposing room reached by two sumptuous flights of marble staircase. Walton's contribution rises to the challenge of the very large scale with a depiction of a medieval fair on Glasgow Green;

Roche and Henry are somewhat less successful, and Lavery departs altogether from the medievalizing brief in a rare essay in modern industrial realism, *Shipbuilding on the Clyde*, which is not unreminiscent of William Bell Scott's work at Wallington Hall. In 1903 Walton was persuaded by his friend Guthrie (who had been elected President of the Royal Scottish Academy in the previous year) to return to Edinburgh. Here he specialized in portraiture, numbering *Andrew Carnegie* (1911: University of St. Andrews) among his sitters.

Walton referred to his friend Crawhall as 'the Impressionist'. An enigmatic and taciturn man whose circumstances allowed him to paint purely for his own amusement, Crawhall was also called 'the Great Silence' by his friend and fellow member of the Tangier Hunt, R.B. Cunninghame-Graham, with whom Crawhall shared a passion for horses. A brilliant horseman whose favourite pastime was riding to hounds, Crawhall might have stepped from the pages of *Memoirs of a Fox-Hunting Man*. His two short months of training in Paris under Aimé Morot in 1882 were clearly of much less importance

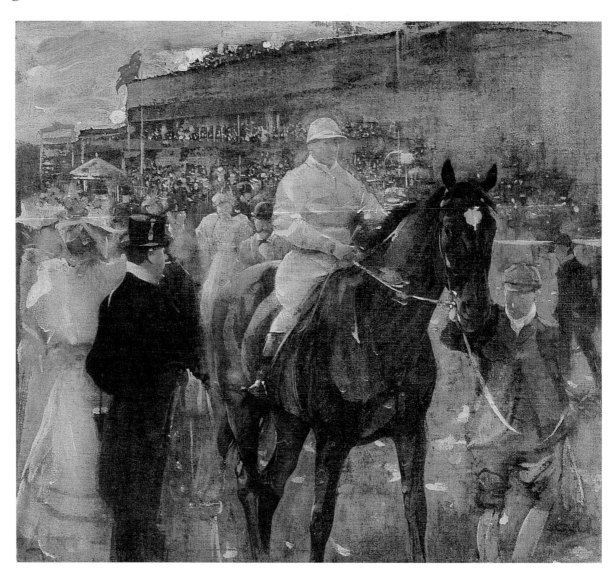

52 Joseph Crawhall
The Racecourse
c. 1894-1900
Gouache on holland,
29.30 x 32 cm
Kelvingrove Art Gallery and
Museum
© Culture and Sport Glasgow
(Museums)

to his development as an artist than the sympathetic encouragement and sound practical advice of his father, an inventive gentleman-artist who taught his son to draw from memory. Crawhall heeded the advice and cultivated a phenomenal visual memory which enabled him to reduce to a rapid shorthand an exquisite, vibrant technique as a draughtsman and to capture the most fleeting appearance, above all of animals and birds in motion. His production was small; most of it was collected immediately by two main supporters, William Burrell and T.H. Coats, and a few other connoisseurs. With Crawhall, technique was always subordinate to observation and design; the resulting portrayals of horses or birds combine the spontaneity of an instant's impression with the truth to type of *animalier* or sporting art. This is done with a consummate economy of means in such celebrated masterpieces as *The White Drake* (circa 1890, painted in gouache on brown holland), *The Pigeon* (Burrell Collection) or *The Jackdaw* (circa 1900: National Gallery of Victoria, Melbourne). As single studies of birds these examples

represent a pinnacle of perfection even by Crawhall's ruthlessly self-critical standards and show a developing sophistication in the elimination of all inessential detail and indeed of all hesitancy in line or weight of brushstroke which would retard the effortless fluency and immediacy of the final effect. In an earlier *tour de force, The Aviary* (1888: Burrell Collection), which showed the fashionably dressed sisters of Crawhall and Guthrie dwarfed perspectively by the other gaudily feathered occupants of the parrot-house, Crawhall stretches the conventional medium of watercolour (mixed apparently with a little Chinese white) to the limits of its capacity. The result is brilliant indeed, but the discrepancies of handling or surface which have been noted with regard to the 'Kodak' realism of Guthrie and Walton are also evident here, in the sense that the tiny human figures which are 'in focus' are treated with more 'finish' than their surroundings. Crawhall himself, according to Bury, was dissatisfied with this work and had to be restrained from consigning it to the usual fate of anything which did not meet his exacting standards,

summary destruction. It seems to have been approximately at this period that Crawhall began the fruitful experimentation with a fine-woven textile support – brown holland – which became the preferred ground for the decoratively simplified works of his maturity.

Crawhall's precise chronology has never been satisfactorily established, but three very beautiful equestrian subjects, all in the Burrell Collection, suggest a clear line of development. Each is painted in gouache on holland. *The Racecourse* is an immensely complex composition – the wonderful racehorse, jockey up, led by the stable lad and watched by the owner and his fashionable lady all in the foreground and, in the background, the stand full of hundreds of spectators painted in Melvillesque shorthand – which has slightly experimental awkwardness, just as the technical difficulties of applying gouache to textile result in a somewhat uneven handling of the pigment. *The Flower Shop*, partly through the selection of a simpler subject, achieves a more satisfactory unity of style – the dark form of the horse silhouetted against the bright flowers in the shop window – while the perhaps slightly later *The Farmer's Boy*, articulated by a series of gently curving lines which proclaim the 1890s, finally resolves surface and design in effortless unity. The absorbency of the textile support requires a more loaded brush and the greater weight of pigment in turn confers a more solid and less flickering and variegated effect, while the brown colour of the holland contributes to the tonal unity of

the picture, just as its fine weave helps unify its surface. The way was now clear for the consciously decorative single studies of birds mentioned above, which miraculously blend spontaneity of application and instantaneity of vision with the most exquisitely balanced effects of bold colour and *mise-en-page*.

The pictorial evidence in support of William York Macgregor and James Paterson as the originators of the early realism of the Glasgow School makes up in quality what it lacks in quantity. Painting did not come easily to Macgregor, as we learn in Paterson's *Memoir*, and ill-health and the necessity of foreign travel further combined to reduce his output. *Crail* (1883: Smith Art Gallery & Museum, Stirling) and *A Cottage Garden, Crail* (1833: private collection) are unadorned, masculine works of obvious integrity but hardly prepare us for the artist's masterpiece of the following year. In 1884 Macgregor, who had trained under Legros at the Slade, painted several big canvases of vegetables, of which only one, *The Vegetable Stall* (1884: NGS) can now be traced. This picture marks the climax of the first phase of the Glasgow School's development. Whereas the early work of Guthrie, Crawhall and Walton indicates mastery of an existing idiom, *The Vegetable Stall* is a picture which it is impossible to ascribe to any outside influence, and its bold realism and confident handling are equally astonishing. Cursiter describes how Oskar Kokoschka, seeing this picture in the National Galleries of Scotland for the first time,

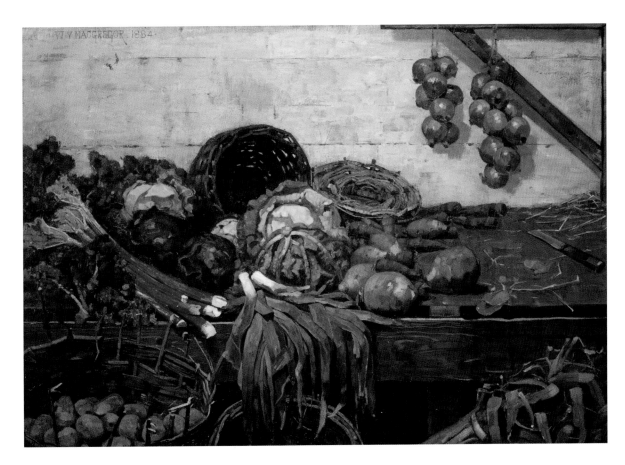

53 William York Macgregor
The Vegetable Stall
1884
Oil on canvas, 106.70 x 153 cm
National Gallery of Scotland

exclaimed, 'To think that the picture was painted before I was born – and I never knew!' The work demonstrated in convincing fashion that the imitative truth or realism of *plein-air* painting might be of secondary value to the truth of reality reconstructed in terms of the artist's vocabulary of form and colour, with the brushstroke as the smallest unit of the composition. In other words, reality is rendered in a painterly style which does not at the same time lose its own integrity.

The Vegetable Stall was to be Macgregor's masterpiece; ill-health forced him to leave Glasgow in 1886 for the cleaner air of Bridge of Allan, and then for South Africa in 1888-90, and when he returned the more progressive 'Boys' had overtaken him. However, a later work like *A Rocky Solitude* (exhibited 1896: NGS) shows that Macgregor retained something of the virile, austere quality of his earlier period later in life, when we find him exhibiting in Edinburgh with the much younger artists of the Society of Eight and expressing admiration for the paintings by Gauguin shown at the SSA Exhibition of 1913 (Paterson MS).

James Paterson (1854-1932), who had known Macgregor since school days and remained a close associate, and whose correspondence with Macgregor is our main source of information concerning him, had studied in Paris during the years 1874-76 and 1879-83 and in an account of those years in the fifth number of the *Scottish Art Review* recalled the emphasis his French masters had placed on tonal values in painting. Paterson's *Moniaive* (1885: private collection) is a thoughtful and competent application of the system of tonal unification Paterson had learned in France; it has a smoother and more assured, less experimental appearance than the other Glasgow School landscapes by Crawhall, Guthrie, and Walton which have just been mentioned. Paterson was never one of the front runners in the rapidly changing succession of leaders of the Glasgow School.

In the early 1880s the Glasgow School was slowly coalescing in Scotland through the gradual amalgamation of the two groups of painters who surrounded Guthrie in summer and Macgregor in

54 James Paterson
Moniaive
1885
Oil, 107.30 x 152.40 cm
© Hunterian Museum and Art Gallery, University of Glasgow

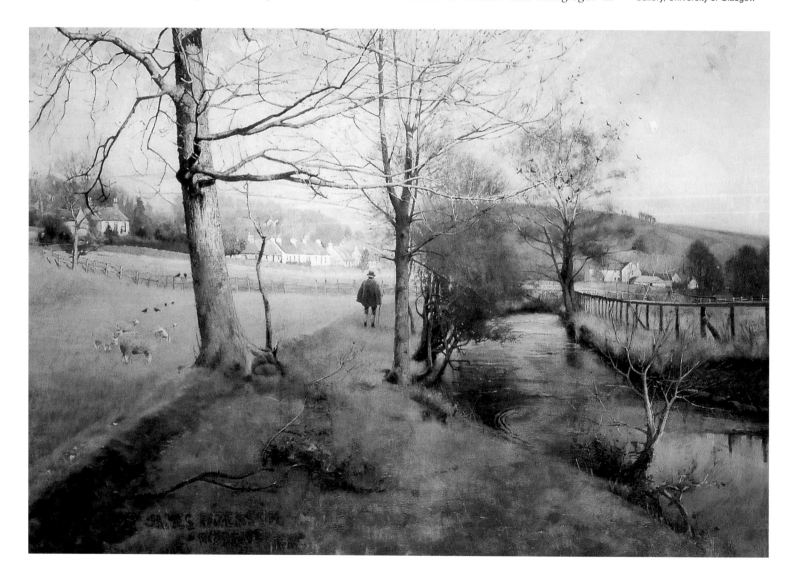

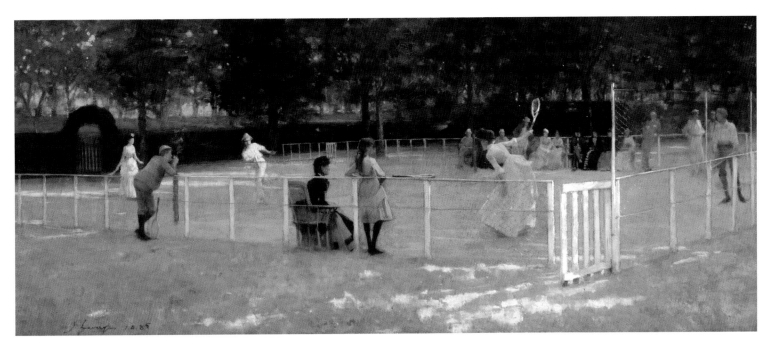

55 Sir John Lavery
The Tennis Party
1885
Oil, 71.10 x 182.20 cm
Aberdeen Art Gallery and
Museums Collections
By courtesy of Felix Rosenstiel's
Widow and Son Ltd, London on
behalf of the Estate of Sir John
Lavery

winter. At this time a third group was studying and painting in France. Sir John Lavery (1856-1941), Alexander Roche (1861-1921), William Kennedy (1859-1918), and Thomas Millie Dow (1848-1919) painted outdoors at Grez-sur-Loing, where they were joined by William Stott of Oldham, and the critic R.A.M. Stevenson, adding to the small colony of British artists and writers who had recently included Stevenson's cousin Robert Louis Stevenson. The composer Frederick Delius was also resident at Grez at the same time as the Glasgow painters, but Lavery's autobiography gives no indication that there was any real contact between them. Lavery's work at Grez is exemplified by *The Cherry Tree* (1884: Ulster Museum), which bears a considerable general resemblance in its unified tonality to Paterson's Moniaive picture, with the significant difference that Lavery shows great confidence in introducing human figures on a quite large scale into his tonal scheme, without any discrepancies of handling. The chief influence on Lavery during his French stay, however, was not his older contemporaries, the Impressionists, but their chief 'vulgarizer' (as Lucien Pissarro called him), Jules Bastien-Lepage. Lavery had known Marie Bashkirtseff, Bastien-Lepage's disciple, and had encountered and received advice from Bastien-Lepage himself in Paris. Lavery followed Lepage briefly as a practitioner of his 'gray impressionism', but the influence of the later Manet rapidly began to assert itself in Lavery's work, paradoxically after he had returned to Britain in 1884. The Manet memorial exhibition was held in Paris in January 1884, and it is at least probable that Lavery visited it.

Lavery tells us that his decision to settle in Glasgow rather than London was made in 1883 when he saw Guthrie's *To Pastures New* at the Glasgow Institute. In 1885 he painted and exhibited at the Institute a canvas which sums up most

completely his early, French-derived realism. *The Tennis Party* (AAG). In it he seems to put into practice Bastien-Lepage's advice on capturing the human figure in action. Lavery remembered this as: 'Always carry a sketch-book. Select a person – watch him – then put down as much as you remember. Never look twice.' Lavery's comment was that from that day on he became 'obsessed by figures in movement, which resulted in *The Tennis Party*'. This picture immediately stamps Lavery as possessing greater natural dexterity than any of the other Glasgow painters, and it is not spoiled by the over-facile virtuosity which creeps into his later work. Fittingly, it was awarded a Gold Medal at the Paris Salon of 1888. It is arguable that Lavery was at his best in the 1880s. A series of fifty small canvases depicting the events of the Glasgow International Exhibition of 1888 are as impressionist in the French sense of the word as perhaps any work by a British painter at this date. A *plein-air* example like *The Musical Ride of the 15th Hussars during the Military Tournament at the Glasgow International Exhibition* (DAG) or an interior such as T*he Dutch Coffee House* (NGS) show a complete assimilation of the French style, although the nocturnal scenes, painted with equal brilliance, seem indebted to Whistler, whose *Sarasate* portrait provided clear inspiration for Lavery's portrait of *R.B. Cunninghame Graham* (1893: GAG). The same International Exhibition gave Lavery his first important portrait commission – to paint the *State Visit of Queen Victoria to the City of Glasgow, 1888* (1890: GAG). As a direct result of its success much of Lavery's later work belongs to one of the less interesting manifestations of painting in his own period – fashionable portraiture – a field in which he was surpassed probably only by Sargent and Orpen, and in which he achieved success on a transatlantic scale. He was to number Shirley

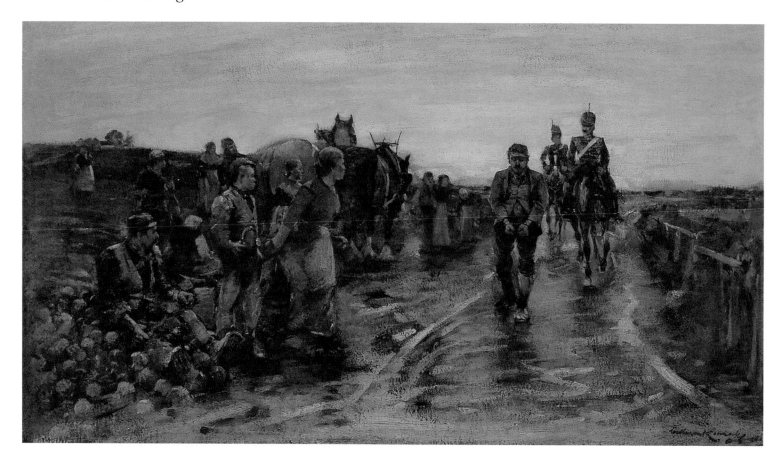

Temple, Pavlova, Lady Diana Duff Cooper, Lloyd George and his friend and pupil Winston Churchill among his sitters.

Lavery moved to London in 1896 and in 1898 became Vice-President of the International Society of Painters, Sculptors and Gravers, of which Whistler was president. When Whistler died in 1903, Macaulay Stevenson wrote Lavery a letter (Tate Gallery Archive) which typically combines the zealotry of Stevenson as the prophet of the gospel of modern art with his usual impish irreverence and is worth quoting *in extenso*.

> To you it will be a more personal loss than to some of us who are nevertheless all at one in appreciation of his transcendent genius and admiration for his inimitable personality. He held the torch for Europe and indeed the world when even Japan was infected with the evils of the accursed Protestant movement – every man doing what was right in his own eyes – which was usually very far wrong – no authority no noble tradition – the R.A. and the Salon all in their anecdotage . . . I was immensely tickled at that International meeting to see you in the chair. You did it so delightfully badly. Worse even that Henry . . . that's why you're the right man for the job. [Stevenson concludes ringingly:] Landscape art will yet write the Bible of His Revelation for the Common people.

Stevenson studied at the Beaux-Arts in Paris, and although his nocturnal landscapes show the inevitable influence of Whistler, his chief inspiration seems to have been Corot. On their return from Paris Lavery's friends William Kennedy, Alexander Roche, and Thomas Millie Dow painted several pictures which show French inspiration. These artists, like many of the Glasgow School painters, are minor figures who briefly demonstrate the catalytic effect which the movement had on its members. Kennedy (regarded by Macaulay Stevenson as one of the more important members of the early group) began robustly as a powerful and accomplished realist, attested by the interesting group of his early water-colours, mostly of military subjects now in Stirling Castle Museum. *The Deserter* (1888: GAG), a subject which might have appealed to Daumier, is not only convincing in its monumental treatment of the working-class central figure, but shows mastery of tonal unity and draughtsmanship of a high order. Similarily, *The Harvesters* (Paisley Art Gallery) and the masterly pastel study for it reveal Kennedy's technical sophistication in an unorthodox composition which looks very French. Kennedy painted *Stirling Station* (circa 1888: private collection) in an evening light which shows less of the influence of Monet than might have been expected from the subject, and more than a little of Whistler's.

The glowing lights and the cloud of steam produce a decorative as well as realistic effect. In fact the

picture belongs to a Glasgow School group of nocturnal subject-paintings which begin to appear at about this point in the group's developments, in the hands particularly of Roche, Guthrie, Henry and Hornel. At least one of the series Lavery painted during the Glasgow International Exhibition shows a night scene lit by bright lanterns (1888: private collection). Kennedy, however, did not move forward from the territory he had convincingly conquered in *Stirling Station*, and *The Fur Boa* (circa 1892: GAG), though a vivacious portrait, harks back to the realism of Bastien-Lepage, just as *Homewards* (circa 1892: GAG) relates (as Elizabeth Bird has shown) to a picture by Anton Mauve then in the collection of T. Hamilton Bruce in Edinburgh, and which appeared in the International Exhibtion of 1886. Nevertheless, the latter work with its impasted colour and lyrical celebration of an orchard in blossom, indicates a genuine response to the beauty of a bright spring day, as *The Harvest Moon* (circa 1890: untraced), illustrated in Martin's book of 1897, is suggestive of the mystery of a moonlit autumn dusk. But Kennedy's later military and North African subjects (he went to live in Tangiers in his later years) show diminished originality, and are almost uniformly a bore.

Thomas Millie Dow began to exhibit regularly at the Glasgow Institute in 1880, and lived in the city from 1887 to 1895 before moving to St. Ives. He was a close friend of William Stott of Oldham and shared with Stott a concern for tonal values and a silken finish which is at odds with the general tendency of the Glasgow School artists towards vigorous handling. His early flower pieces seem all to have disappeared, surprisingly, as his gifts were those of a decorator and the flower subjects look well in the period journals. On the other hand, his rather static or stiff figure drawing made him less well suited to the kind of allegorical figure painting represented by two large works in the Dundee Gallery, *The Herald of Winter* (1894), which represented Dow in Martin's book, and *Sirens of the North* (1895). *The Herald of Winter* shows a winged figure in a white robe standing on the crest of a hill sounding a horn, while migrating geese fly past. The picture owes something to the mural style of Puvis de Chavannes and is not far in concept from John Duncan's slightly later work in a similar vein. *Sirens of the North*, too, is a faintly comical treatment of the theme of the *femme fatale* dear to the Symbolists of the 1890s, where woman often appears as sphinx, harpy, or here, as mermaid, representing a threat to men as the hesitant oarsman, who approaches in his eminently sinkable skiff, appears to be fully aware. *The Hudson River* (1885: GAG) is a much more prepossessing work; partly because it is less pretentious but not less ambitious, and adopts the same tonal approach as Paterson's *Moniaive* already discussed, but using a lighter palette.

Few works of the 1880s, however, are more quintessentially of the Glasgow School style than Alexander Roche's *Good King Wenceslas* (1887:

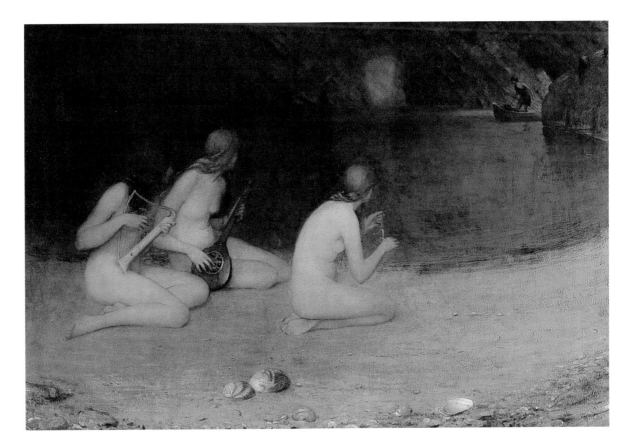

57 Thomas Millie Dow
Sirens of the North
1895
107.90 x 152.40 cm
The McManus: Dundee's Art
Gallery and Museum
Dundee Art Galleries and
Museums (Dundee City Council)

private collection), which shows the page following the king through snow and uses gold leaf to indicate Wenceslas's sainthood. The subject is one that might have appealed to the democratic humanitarianism of Whitman or Thoreau whom the 'Boys' admired, but it is treated without bombast, and the page is the main figure in the composition. The decorative gold nimbus in the background adds an element of mystery and spiritual significance to the winter landscape, and is in a sense repeated in the incised Japanese seals with which the frame is decorated, making a contrast with the very boldly painted snow-scape. Roche's later career was devoted almost exclusively to portraiture. *Miss Loo* (1889: private collection) is an unusually well-composed example, but it does not possess the originality of *Good King Wenceslas,* which appears to be unique in Roche's *oeuvre.*

Arthur Melville (1855-1904), who asked for an introduction to Guthrie when the latter's *A High-land Funeral* was first exhibited at the Glasgow Institute in 1883, was like W.Y. Macgregor sufficiently senior in age and experience to the 'Boys' to be something of an elder brother to them. By the time of his first visits to Cockburnspath with Guthrie, Walton and Crawhall, Melville had received training first in Edinburgh and then at Julian's in Paris and had completed a two-year painting tour from Karachi to Baghdad, crossing Asia Minor on horse-back (one wonders whether Crawhall and Melville ever found time to discuss anything as mundane as watercolour painting) with a series of adventures and narrow escapes which rival David Roberts's and make him seem, with his 'big, handsome, courageous cavalryman presence' like a character from the romances of Robert Louis Stevenson, whom he met at Grez in 1878. Melville in fact, came not from the west of Scotland, but from Angus in the north-east of the country. He was the first of the group to be elected an Associate of the RSA in 1886.

Melville therefore had a considerable body of work to his credit by the time of his first encounter with Guthrie and the others. *The Cabbage Garden* (1877: NGS), a small work, emerges from the rurual realism practised by W.D. McKay (1844-1924) and associated with the Lothians. It prefigures much work typical of the Glasgow School in a similiar vein – for example Walton's *A Berwickshire Fieldworker* (1844: TG) or Henry's *A Cottar's Garden* (watercolour, 1855: NTS) – in its painterly vigour. *Paysanne à Grez,* dated 1880 (private collection), like the earlier work, unsentimentally gives equal importance to both the landscape and the figure subject, and marks a further advance in decorative terms, with its strong colour and painterly surface. Painting of this stength

58 Alexander Roche
Good King Wenceslas
1887
Oil, 50.80 x 76.20 cm
Private collection

cannot have failed to capture the imagination of the Cockburnspath group. *Audrey and her Goats* (begun 1882: TG), a Shakespearian subject which Macaulay Stevenson tell us 'cost the artist an infinity of time and trouble' over several years, has an inchoate quality which is surprising in an artist of Melville's very real virtuosity as a watercolourist. It is clear that for Melville as for Guthrie, at this stage a struggle was taking place, the very birth-pangs of a new style. In the same year that Guthrie triumphantly brought *In the Orchard* to a successful conclusion, 1885, Melville also produced one of the most original works by any member of the Glasgow School up to this point, the brilliant and bold *Red Poppies* (private collection). Although the *Portrait of Mrs Sanderson* exhibited at the New Gallery in London in 1889 – and pronounced by Whistler the best portrait shown in London that year – in Macaulay Stevenson's words was 'attempted on no less than three separate canvases and carried each a long way towards completion ere he reached the fine expressive result which the finished picture shews', no such hesitancy troubled the artist at least in two major landscapes with figures dating from his trip to Spain with Frank Brangwyn in 1892.

A Spanish Sunday: Going to the Bullfight (Dundee University) and *The Contrabandista* (private collection) infuse into the more intractable oil medium the vitality and spontaneity of Melville's highly individual watercolour style, although his oil technique is quite different. *A Spanish Sunday* shows Melville using long sweeping brushstrokes which impart movement to the whole work, in such a way that the brushstroke is simultaneously descriptive and frankly decorative. The artist's harmonic knowledge is evident in the single bold accents of colour placed at telling intervals in the design, in unexpected touches of lemon yellow or bright red, while over the whole composition there hangs a realistic suggestion of the faint haze of a very hot day in a terrain where the dusty earth reflects back the sun's glare. *The Contrabandista* is an equally original work. Here, shadows cast on a hill by poplars which are not shown but understood to be behind the spectator, are bluer than the sky itself, and the white cloud in the sky is as solid as the hill down which a mule train descends in a cloud of fine dust. The composition is of a consciously decorative flatness and the shapes and colours schematic in a way that recalls Monet's series of poplars on the Epte of similar date. From the same period also come a small group of landscape panels which show even greater confidence in the abstract possibilities of form and colour, fully realized finally on a large scale in *The Chalk Cutting* (private collection) dated by Mackay to 1898. The richly decorative, large-scale portrait of 1897, *The White Piano* (Harris Museum, Preston), resolves the conflict between realism and decoration as successfully as any Glasgow School portrait.

Melville, however, is best known as a watercolourist, and with a good reason, for this was his preferred medium in which he developed a highly individual virtuosity. *The Turkish Bath* (Paris, 1891: Keith Collection) may remind one of Gérôme in its exoticism and use of an elaborately architectural interior as the *Arab Interior* (NGS: oils, also 1891) is reminiscent of J.F. Lewis, an obvious model for such a subject; but the two works are fascinating as demonstrating the ease with which Melville adopted and as quickly abandoned two contrasting styles – beaux-arts and English romanticism – at this early stage. *The Call to Prayer; Midan Mosque, Baghdad* (1882: private collection) exemplifies one of the two main types among the watercolours which originate from Melville's two-year painting tour of North Africa and the Middle East. It has an architectural background and an amazingly numerous group of figures wearing the colourful jellabah. While the architectural subject, the sky and foreground are painted with flat washes, the crowd is suggested in passages of heavily worked pigment which has been wiped, sponged, run and dripped onto the page. The busy crowd scene thus provides an exciting staccato counterpoint to the legato of the rest. In terms of colour Melville can seem surprisingly subdued in these earlier works, which retain a tonal reticence much in contrast with his later style. The second of the two types of watercolour mentioned comprises the interior scenes which tend to be broader in treatment: *A Cairo Bazaar* (1883: GAG) is an example. Here, the figures are much larger in the overall composition, the colour is warmer and the brush-work more conventional.

59 Arthur Melville
A Spanish Sunday: Going to the Bullfight
1892
Oil, 81.30 x 99.10 cm
University of Dundee Museum Services

60 George Henry
A Galloway Landscape
1889
Oil, 122 x152 cm
Kelvingrove Art Gallery and
Museum
© Culture and Sport Glasgow
(Museums)

Melville's full tessitura – to continue the musical analogy – is revealed in the mid-eighties, and announced by the astonishing *Awaiting an Audience with the Pasha* (1887: private collection). This large watercolour allies the formal counterpoint analysed above, to a daring chromaticism of hot colours and technically (in terms of beautiful draughtsmanship and unbelievably intricate brush-work) probably surpasses anything ever done by Melville. It prepares the way for such remarkable examples of decorative pyrotechnics, full of realistic suggestion, as *Bravo Toro!* (exhibited 1899: V & A) and *Banderilleros à Pied* (1890: AAG). He was resident in London after 1889, but died prematurely in 1904 from typhoid contracted on a visit to Spain. Writing in 1891, Macaulay Stevenson commented justly that 'the value of such a personality to the young Scottish School has been incalculable'.

Melville was evidently an influence on the style of the more mysterious J.W. Herald (1859-1914), who also studied at Herkomer's school at Bushey and lived in Croydon until 1899 when he returned to live in his native Angus. Erratic, a recluse who disposed carelessly of his best completed work, Herald possesses a haunting style very different from the vigorous Melville, although technically there are considerable affinities between the two. *The Portico* (circa 1898: private collection), however, suggests the influence of Conder rather than Melville in its delicate use of colour.

A new phase in the development of the School began in 1885 with the return of Edward Atkinson Hornel (1864-1933) from his studies in Antwerp and the beginning of his friendship with George Henry, whom he met in Kirkcudbright in the same year. George Henry had been with Walton and Guthrie at

Brig O'Turk in 1881 and exhibited two small pictures painted there at the Glasgow Institute in the following year. He was in Eyemouth in 1883, near Cockburnspath, where Guthrie and Walton were to be found, and in the winter of that year worked in W.Y. Macgregor's Glasgow studio, accompanying Macgregor on a painting trip to Dunbar in the following spring. Billcliffe convincingly traces the influence of Guthrie on Henry's early work. A comparison of Henry's *Noon* (1885: private collection) with Guthrie's *In the Orchard* of 1885-86 reveals similarities in subject, colouring and technique, with the Henry picture if anything slightly ahead in its progress from Realism towards Symbolism: in *Noon* the girl in her peasant's apron stands in flattened profile in the shade of an equally flattened tree trunk, while the shaded ground and the sunlit field beyond halve the composition into two horizontal bands of colour. Henry's grasp of style seems the firmer. Hornel's teacher Verlat taught his pupils to handle paint vigorously 'so that one was painting and drawing at the same time', as Hornel later said. This Belgian influence is visible in an impressive, if conventional, early work called *The Bellringer* (1886: private collection), which shows Kirkcudbright's 'town crier', Winefield Nellens, in a

composition and pose strongly dependent on two very similar paintings of elderly men in uniform which Hornel painted in Antwerp (both 1885: Nottingham Art Gallery and NTS [gift of Mrs L. Walmsley]). Hornel's *Resting* (1885: private collection), exhibited at the Glasgow Institute in the same year, so resembles the Henry *Noon* that an indebtedness of the former to the latter seems clear, as the Hornel picture is comparatively tentative in handling. Again, measuring the progress of the two friends by comparing two works of 1887, Hornel's *In Mine Own Back Garden* (HAG) and Henry's *Sundown* (ibid.), the conscious decorativeness of the Henry picture stands in marked contrast with the early realism of the Hornel. Another Henry work of 1887, *Gathering Mushrooms* (private collection) – which Henry thought enough of to send to the Munich exhibition of 1890 – is a daringly Symbolist concept both in its schematic design and in its rather fey subject (to Victorian eyes) of a girl gathering mushrooms by the light of the full moon, although its handling is almost crude. Henry's *Autumn* (1888: GAG) is a woodland scene in which the figure of a girl can be inferred, her face only being clearly discernible, among a pattern of leaves and slender tree trunks, painted with masterly variations of

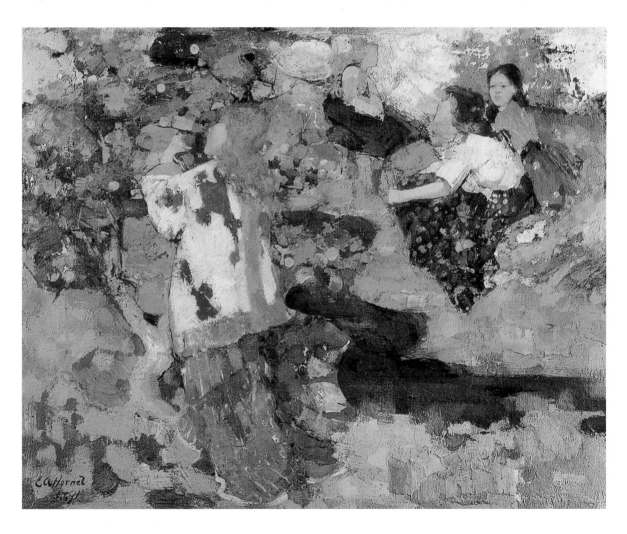

61 Edward Atkinson Hornel
The Brook
1891
Oil, 40.60 x 51 cm
© Hunterian Museum and Art
Gallery, University of Glasgow

handling from palette knife to delicate brushwork. Not by coincidence, Hornel's most ambitious work of 1888 has the same title of *Autumn* (private collection); this is a ravishingly painted small picture in which the boldness of the application with the palette knife is matched by the poetic subject which suggests a mystical connection between the girl and the tree with its apples. The progress of the two artists to this point tends to support the contemporary view of Macaulay Stevenson that Henry, on meeting Hornel in Kirkcudbright, offered friendly practical criticism of the younger artist's work by showing him his own, and that Henry's at that early

62 Edward Atkinson Hornel
The Dance of Spring
c. 1891
Oil, 142.60 x 95.30 cm
Kelvingrove Art Gallery and Museum
© Culture and Sport Glasgow (Museums)

stage was 'the original mind', although he qualifies this by adding that Hornel's 'is no secondary mind'. The *Notes* of 1891 add of Henry that 'In any walk of life he would be a remarkable man . . . Not a little of what is best in the work of some of [the others' work] is at least partly due to Henry's generous help – both the help of actually working on some of the pictures and the more intangible yet nonetheless real influence of his stimulating personality.'

It remains a matter of conjecture whether Hornel met James Ensor during his stay in Belgium but certainly in 1893 Hornel sent to the final exhibition of the Groupe des XX – of which Ensor was a founder – and at least one work of Hornel resembles that of the Belgian master in its macabre subject-matter: *The Brownie of Blednoch* (1889: GAG), an apparition which in turn prefigures the 'spooks' which came to haunt some artists of the 1890s. Also in 1889 Hornel painted a beautiful little picture titled *The Goatherd* (private collection) which takes one stage further the tendency to represent landscape as a decoratively flat pattern united by strong colour and a richly nourished and increasingly fragmented surface. Hornel and George Henry shared a studio in Glasgow and painted in the country around Kirkcudbright where Hornel had been brought up and where he had ancient family roots; and, as Stevenson asserts, even painted on each other's pictures. Two large pictures, *The Druids – Bringing in the Mistletoe* (1890) and its companion *The Star in the East* (1890: both GAG) are the best-known examples of their collaboration. Hornel brought his considerable antiquarian knowledge to bear on *The Druids* which is full of Pictish symbolism and interestingly anticipates something of the Celticism of the later nineties. The decorative approach to painting evolved by Hornel and Henry in the late eighties had its most remarkable result however in Henry's *Galloway Landscape* (1889: GAG). In his book *A Painter's Pilgrimage* A.S. Hartrick, who had known Gauguin at Pont-Aven and even painted a picture of Gauguin's house there (1886: private collection), wrote of Henry's picture: 'I have seen the spot where it was painted, a very ordinary field with a hill in it; but Henry introduced a blue burn, painted with a palette knife, around it; then put a stain over all, and it became an object of derision for the man in the street as well as for the Glue Pot School, but an ineffaceable memory for any artist who has ever seen it'. (The Stevenson *Notes* agree that 'It is almost a literal transcript of a particular scene.') The emphasis on arabesque and flat colour pattern in this painting represents a complete departure from the realistic descriptiveness of earlier Glasgow School landscapes. In the wider context of British painting, the *Galloway Landscape* is an extraordinarily advanced work for 1889, and in the light of Mrs S.J. Peploe's assertion that the Glasgow dealer Alexander Reid (who was Henry's dealer) had known Gauguin in Paris – no doubt during his spell with Boussod and Valadon (formerly

63 George Henry
Blowing Dandelions
1891
Oil, 49.50 x 59.70 cm
Yale Centre for British Art, Paul
Mellon Fund

Goupil) in Paris in 1887 – it seems at least to be a reasonable hypothesis to link its novelty directly to Gauguin.

Both artists now embarked on a period of consolidation in a series of paintings which represent a high point in the achievement of the Glasgow School. Hornel's *The Brook* (1891: MacFie Collection, HAG) resembles the *Galloway Landscape* but unlike it contains human figures unorthodoxly posed against the landscape, or rather within it, so that they form with the landscape a pattern of rich colour in which the individual elements are difficult to distinguish from each other. The relevance of Monticelli to this kind of painting is clear. Equally decorative is *A Galloway Idyll* (1890: private collection). These are small pictures. Hornel's confidence in his new manner is demonstrated in two large paintings in the following year: *The Dance of Spring* (1891: GAG), which resembles Ensor in its exuberant impasto and truculent vitality; and the powerfully painted *Summer* (Walker Art Gallery, Liverpool) which was the first picture by any of the young Glasgow artists to be acquired by a public museum. The latter work is tightly composed in a swirling circle of movement. Henry's work in the same period lacks the raw

vitality of Hornel's but is increasingly concerned with static decoration as in *Blowing Dandelions* 1891: YCBA) and *Through the Woods* (1891: FAS). *Poppies* (1891: ECAC) unusually shows only the heads of four pretty girls among the flowers; this is a Symbolist treatment of the subject which distinctly anticipates the Art Nouveau. A little landscape, *Barr, Ayrshire* (1891: NGS) is as fresh and modern looking as a Peploe, while *The Fruiterer* (1894: private collection), painted in a light key, is as sophisticated with its off-centre design as the other is artless.

When he went to Japan with Hornel in 1893 Henry produced much less than Hornel during their eighteen-month stay, and many of his Japanese pictures are in media other than oil. They consist in the main of delicate drawings and sensitive pastels which hark back to Sir James Guthrie's pastels of 1888 and 1890, and of watercolours which seem indebted to the watercolours produced by Sir Alfred East in Japan and seen in the Glasgow International Exhibition of 1888, as well as in the pages of the *Scottish Art Review* in the same year. The rather rare examples of Henry's work in oils from the Japanese visit are of fine quality and the ruin of a quantity of them on the return journey from Japan is a matter of

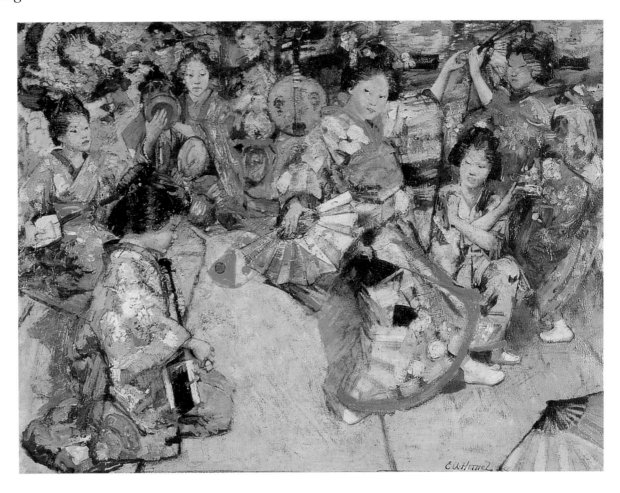

64 Edward Atkinson Hornel
Japanese Dancing Girls
1894
Oil, 71.10 x 91.40 cm
Private collection

real regret; but they seem to add little in stylistic terms to what Henry had already achieved. It was left to Hornel to add an impetus of his own to the momentum of the decorative style which these two artists had initiated. Hornel's Japanese paintings are among the most exciting of all the pictures produced by the Glasgow School. It does not detract from their originality to say that Monticelli's formal diffuseness and rich colour (which Hornel must have noted in the great International Exhibitions of 1886 and 1888 in Edinburgh and Glasgow, which included several Monticellis) are important elements in Hornel's style of the middle nineties. Such a work as *The Japanese Garden* (1894: private collection) is very nearly *sui generis*, and the repetition over the whole surface of the canvas of the formal *leitmotiv* of the flashing smile that is the focal point of the design is a sophisticated device. About forty paintings from his Japanese tour were assembled by Hornel for an exhibition in the Glasgow gallery of Alexander Reid, who had been the main sponsor of the expedition. The exhibition received enthusiastic reviews and nearly every picture was sold.

Alexander Reid's exhibition of Hornel's 'Japanese' paintings in the galleries of the Société des Beaux-Arts marks the climax of Hornel's association with Glasgow and the Glasgow School. The assurance and originality of these paintings must have appeared to many to mark the rise of a new leader of the 'School'. However, by 1895 Hornel had become permanently resident in Kirkcudbright, and had began to do all his painting in the studio in the High Street there, and although there was no abrupt cessation of good relations between Hornel and the other members of the School (Hornel continued to exhibit at the Glasgow Institute every year), there seems to have been a gradual weakening of ties. Hornel refused an associateship of the Royal Scottish Academy in 1901, to the annoyance of friends who had supported his nomination. In a letter to his friend the publisher Thomas Fraser (NTS) he wrote:

> Many thanks for your letter of congratulation. It will not surprise you to learn that I have declined the honour of Associateship. I am very happy as plain Hornel and I mean to remain such, as far as these trumpery affairs are concerned. I am not built right someway for wearing purple and fine linen. This decision will no doubt surprise some, gratify others, and disappoint few. I am quite indifferent . . .

George Henry was made a full member of the RSA in the following year.

As early as 1892, as a brief correspondence between Macaulay Stevenson and James Paterson shows (Stevenson MS), an amusing altercation had

taken place involving two factions which, independently of each other, had attempted to set themselves up as the 'official' Glasgow School of painters. This piece of 'Glasgow schoolboyishness', as Stevenson called it, symptomizes a malaise within the movement, and it comes as no surprise to find Hornel, in a letter to Stevenson of 13 August 1905 (ibid.) referring to the 'brotherhood' as something of the past. But the parting of the ways was certainly very much of Hornel's choosing. In 1901 he removed from his studio to Broughton House, also in the High Street in Kirkcudbright and now open to the public under the auspices of the National Trust for Scotland, and thereafter his time appears to have been equally divided between painting, and other occupations connected with the fine seventeenth-century mansion that was his new home. A considerable proportion of the correspondence with Thomas Fraser, which spans twenty-three years, is devoted to talk of gardening and the purchase of books for the library in Broughton House. It is obvious that Hornel gave a great deal of thought to the planning of his remarkable Japanese garden, and with Fraser's help he built up an excellent library which contains a unique collection of Burns editions, a manuscript collection, which includes items by Bishop Percy, Scott and Carlyle, and a comprehensive Galloway collection including works on local Dark Age archaeology. Hornel added a studio to Broughton House, and a gallery whose furnishings (including a huge Renaissance mantelpiece by his friend John Keppie of Honeyman, Keppie and Mackintosh, and a plaster cast by John Henning of the Parthenon frieze) are in markedly Victorian taste. In a word, then, Hornel's isolation from Glasgow and its 'School' was partly due to that movement's increasing debility, and partly to the fact that Hornel had formed other interests which tied him to Kirkcudbright.

The paintings produced by Hornel between 1895 and 1907 reflect changes just described in his personal circumstances and in his relationship to the Glasgow group. These were the crucial years which saw the power and audacity of the thirty-year-old's style give way to the prolix and mannered charm of the middle-aged and elderly Hornel. They were also the years in which Hornel became the leader of a small group of Kirkcudbright painters, among them Bessie MacNicol (1869-1904), who painted a powerful portrait of Hornel shortly after his return from Japan (1896: NTS), W.S. MacGeorge (who had studied with Hornel in Antwerp), and William Mouncey, Hornel's brother-in-law. Thomas Bromley Blacklock (1863-1903) trained in Edinburgh, but the influences on his work were his fellow Kirkcudbright artists E.A. Hornel and Jessie M. King, whose very different styles are reconciled in Blacklock's attractive painterliness, which resembles Hornel's, while his subject matter resembles Jessie M. King's: Caw lists *Red Riding Hood, Bo-Peep* and *Snowdrop,* as well as several other titles in which 'children and fairies and

the creatures of the wilds and the sea-shore live on terms of intimate companionship in an enchanted land.'

After 1895, Hornel's Monticelli-based handling and lighter palette (which never returned to the earlier rather sombre 'Glasgow School' richness) were a major influence on these artists. After Hornel's return from Japan, says Sir James Caw, 'for some years he seemed to be in a cul-de-sac and made little or no progress. The large painting *The See-Saw* (1896) shown at the Glasgow Institute in 1897, although it has all the old exuberance – a quality that was soon to disappear from Hornel's work – is (as far as one can judge from a photograph) badly drawn and badly composed. After the successes of the Japanese period, such uncertainty comes as an anti-climax, and Hornel seems to have been content until about the turn of the century to produce atmospheric colour schemes whose rich impasto and formal diffuseness recall Monticelli. The Kelvingrove *Fair Maids of February* (1899) is an exception however. As a contemporary writer noted it had 'much more precision than is usually observed by the painter' and with its fine quality of paint and conventional drawing this work seems to foreshadow the insistence on *belle matière* which became so characteristic an aspect of Hornel's later style. The little girls who populate Hornel's pictures after 1900 are increasingly well-behaved and do the things that little girls were supposed to do: catch butterflies, pick flowers, and play ring-o'-roses, unlike their tomboy sisters in the earlier pictures. It is hard to agree with a Studio critic of 1907 according to whom Hornel 'paints the gamins of Kirkcudbright as Murillo painted those of Seville, with the uncompromising fidelity not of the satirist but of the true nature-lover, for whom the unkempt, ragged urchin engaged in the manufacture of mud pies is lovelier than the daintiest suburban miss in pink muslin . . .' Mud pies and unkempt ragged urchins are conspicuously absent from Hornel's work after 1900. The fact that shortly after 1900 Hornel used photography for his figures provides proof, if any were needed, of his predominantly decorative intention; he was not remotely interested in psychological portraiture. According to the late Mrs E. Johnstone, who 'sat' for Hornel as a little girl and whom I interviewed in 1967, the models were grouped and posed by Hornel, photographed by a professional photographer, and then added as figures to a backcloth of flowers which Hornel painted *sur le motif*. Some of the Japanese photographs in Broughton House are beautiful in their own right.

Photography led Hornel to the practice of painting several versions of the same pose or grouping which were differentiated only by size or colour. But the later treatment of flowers is often magnificently rich and lyrical, and shows an interest in pattern making (with the petals of the flower species in question providing a kind of modulus for the whole surface of

the painting) which may owe something to Hornel's admiration for the Pre-Raphaelites. He was recorded in 1905 as saying that Madox Brown was 'the greatest modern British colourist' and he especially admired Madox Brown's Manchester Town Hall frescoes (1879-93), but the last word may be left with an old friend of Hornel's, the late Owen Bowen, who wrote to me in 1967 that Hornel 'treasured an old Paisley shawl, this he took with him when painting in the open, as an inspiration for a colour scheme'.

In connection with the later decorative phase of the School, another name must be singled out – Stuart Park (1862-1933). Park's whole claim to attention as one of the important members of the School rests on a small number of paintings of flowers produced in 1888-89. These paintings reveal a highly original use of simplified planes to denote surface and volume and their colour is most subtle, although the later examples have the cardboard appearance of an exhausted formula, for all their ingenuity. As a

65 James Stuart Park
Girl with Poppies
c. 1892
Oil, 51.10 x 41 cm
The McManus: Dundee's Art Gallery and Museum
Dundee Art Galleries and Museums (Dundee City Council)

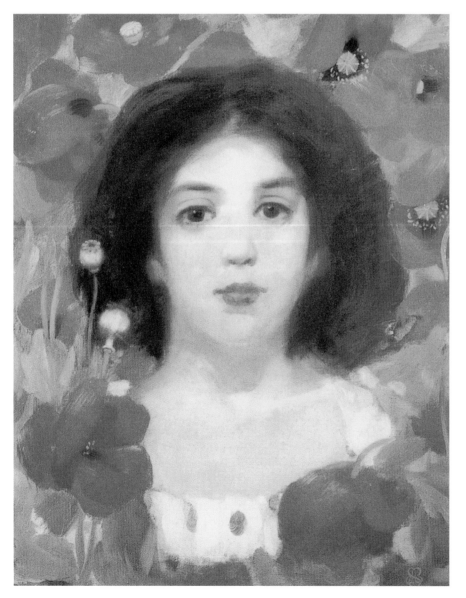

slightly later development on the theme of the flowers, Park painted several single head-and-shoulder studies of pretty girls surrounded by flowers. Only one is known – the *Girl with Poppies* (DAG) – probably because these confections must have been highly saleable in their day and are presumably still in private collections. These must be dated slightly later than the series just referred to, as they lack the rigorous draughtsmanship of the 1888-90 pictures, but they are lusciously painted and amusingly comment on sensual temptation: one wonders if the Dundee girl has been eating the poppies. Park was a genuinely individual colourist and developed a swift and sure painterly dexterity which can pall; but his flower paintings, which were sold in a popular one-man exhibition held every February in the McLellan Galleries and also abroad, preferably in their opulent Italian carved giltwood or feigned-oval ebonized frames, can be wonderfully decorative. Each flower petal is formed by a single stroke, often with striking contrasts of dark flowers against a light background or *vice versa*.

As Art Nouveau is essentially a linear rather than a painterly style, and broad handling of paint is strongly characteristic of all Glasgow School painting, there is little of the Art Nouveau style *per se* even in the later paintings of the Glasgow group who were its immediate forerunners. An exception however is provided by the early work of David Gauld (1865-1936), who was one of the younger members of the group. Gauld was a friend of Mackintosh (who in 1893 gave Gauld a set of bedroom furniture as a wedding present), and Gauld's *Saint Agnes* of 1889, perhaps inspired by Keats's poem or the Christmas carol 'Good King Wenceslas' which had in 1887 provided Roche with the theme for his most successful picture, and depicting the village of Cambuskenneth on the Forth in the background, is pervaded with *fin-de-siècle* feeling – more than ten years before the end of the century. The Stevenson *Notes* describe Gauld in glowing terms: 'The youngest of them all . . . his work simply burns with spiritual power.' A smaller work, *Music* (1889: private collection), is very similar in style and contains the same ingredients as the *Saint Agnes* picture: a form of Cloisonnism which makes both pictures look as if they had been conceived as stained glass; a division of the landscape background into parallel bands of colour; and the foreground figures ('dressed in the aesthetic garb of the nineties with a hint of Japanese influence') symbolizing the presence of saints and angels on the earth with which they blend so harmoniously. The static decorative style of Burne-Jones is a distant influence on *Saint Agnes*, and this is also evident in the stained-glass designs which Gauld produced for Guthrie and Wells from about 1891, which include a lyrical three-window triptych installed at Montgomerie Quadrant, based on *Music*. Perhaps *Saint Agnes* was similarly realized in stained glass. In one of the most curious of these designs – Gauld's

stained-glass windows for the proto-Art Nouveau house Rosehaugh (circa 1893) on the Black Isle – a free adaption was made of the composition of *The Druids* by Henry and Hornel. Gauld's largest commission as a designer of stained glass was for a series of windows for the Scottish Church of St. Andrew in Buenos Aires, made and assembled by Guthrie and Wells over most of the decade before 1910. This work seems to have preoccupied Gauld virtually to the exclusion of all else during that time. Partly as a result, Gauld's work as an innovative painter ceased, and he became well known and widely collected in Scotland as a painter of calves in landscape. Two little early landscapes at Sorn, and *Homeward* (circa 1891: private collection), which Elizabeth Bird has shown to derive from Matthew Maris, indicate Gauld's return to a more conventional style; one ought to add that repetitious though this became, Gauld's painterly touch never seems to have deserted him. He did paint a delightful *Head of a Girl* (circa 1893: Private collection), with the head showing the influence of Bastien-Lepage surrounded by boldly painted foliage, which one may guess to have been his own epithalamium, and a few watercolours in a similar style have appeared in the salerooms. Few artists base a secure place in the history of the Glasgow School on such a tiny handful of pictures.

Sir D.Y. Cameron (1865-1945), who remained on the periphery of the Glasgow School, with his sister Kate Cameron (1874-1965) contributed to the *Yellow Book* (making a rare link with London aestheticism, but looking a little out of their depth). D.Y. Cameron's *The White Butterfly* (circa 1892: FAS) influenced by Matthew Maris, has a decorative emphasis rare in his work, which tends to severity, a quality shared with the more dramatic James Pryde, with whom Cameron had trained at the Trustees' Academy in Edinburgh. Pryde, as one half of the Beggarstaff Brothers, made an important contribution to illustration and poster design in the nineties, but his career was entirely spent in London.

The Beggarstaff Brothers' collaboration lasted from 1894 to 1896 and although the easily printed, flattened outline style of their lithographs became fashionable and produced some of the most characteristic images of London in the 1890s, it did not earn much for the two young artists, Pryde and Nicholson. James Pryde (1866-1941), after study at the Trustees' Academy, moved permanently to London in 1890, following his sister Mabel who, at the age of seventeen, had run off to study painting in the metropolis, where she was to meet and marry the painter William Nicholson. Pryde's memories of Edinburgh, which he called 'the most romantic city in the world', were to inform his painting: the formal grandeur of the New Town; the monumental architecture of the Old Town; the romance of Holyroodhouse with its great bed of Mary, Queen of Scots, which inspired a series of twelve paintings. As he said, 'A bed is an

66 David Gauld
Saint Agnes
1889-90
Oil on canvas, 61.30 x 35.80 cm
National Gallery of Scotland,
Purchased with the aid of the Art
Fund 1999

important idea. Look what happens on it and how much time we spend on it.' The similarities between the early work of Pryde and D.Y. Cameron are obvious, and must stem from their common training. Both display an interest in rather austere architectural subject matter which is in each case matched by a restrained use of colour – sepia, ochre, burnt sienna. But an influence other than Edinburgh's imposing buildings operated from the beginning on Pryde. His parents were great lovers of the theatre and included Henry Irving and Ellen Terry among their friends. Ellen Terry's son Edward Gordon Craig became a close friend of Pryde in London and even put several small touring parts his way when income from painting was insufficient for basic requirements. There is a good deal of common ground between Craig's dramatic designs for theatre sets, with their sense of scale and chiaroscuro, and Pryde's style as a painter. *The Unknown Corner* (1912) is reminiscent of Edinburgh's Cowgate with its huge subterranean arches, while the little figures dwarfed by the great wall behind them are simultaneously a memory of the strolling players and human flotsam of Edinburgh's Old Town, and of the seventeenth-century mannerist figures which inhabit the etchings of Bellange and Callot. In this typical work there is indeed a strong sense of the theatre, of the way in which the players are dwarfed by the vast height of the backdrop, and also of the intensely dramatic, artificial quality of stage lighting.

Perhaps no twentieth century artist before Utrillo could invest a blank wall with as much significance as Pryde. *The House* (1914) presents a single architectural elevation without depth, exactly like a stage flat; but the windows which penetrate this surface hint at a mysterious interior with glimpses of figures and drapes. The surface of the wall is weathered; the building possesses a mysterious life and is somehow animated, just as the sky beyond is also dramatically alive, each rendered by a painterly, scumbled technique. The artist's horror at the destruction of war is conveyed most powerfully in *The Monument* (1916-17). Before a desolate landscape under a lowering sky, a huge statue in a shattered architectural niche appears to bleed. Pryde's dramatic qualities as an artist attracted the patronage of Lady Cowdray, who commissioned twelve large works for the Library at Dunecht; other commissions followed, including several for portraits – his sitters included Lady Ottoline Morrell and his parents' friends Ellen Terry and Henry Irving – and a period of success and acclaim from about 1905 until 1925 preceded a sad final period of decline and neglect. An exhibition at the Redfern Gallery in 1988 did much to recall this important artist to our attention.

Like James Pryde, James Watterston Herald (1859-1914) studied at Herkomer's school at Bushey (he enrolled in 1891) where Pryde's work impressed him and is perhaps behind the sophisticated *mise-en-page* which characterizes Herald as a composer: a tiny watercolour, *Femme assise au Café* (FAS) could indeed have come straight from the pages of *La Revue blanche*, although no connection can be demonstrated between Herald and Paris beyond his admiration for the Beggarstaff Brothers' French-inspired work. As already noted, the no less modernistic style of Arthur Melville, who like Herald was native to Angus in the east of Scotland, and of whose work he would have been well aware if only from the Glasgow International Exhibition which Herald visited in 1888, was equally a determining influence in his style as a watercolourist. For Herald was a true artist, brilliantly gifted as draughtsman and the most poetic watercolourist of his day, who was keenly interested in the new style of the nineties despite his voluntary rustication after 1901 in the old and historic burgh of Forfar where his roots were, where he felt comfortable with his drinking cronies or among his musical friends for whom he played the violin and who bought his watercolours, and where a drawing was acceptable tender for many a bill.

Although David Gauld, George Henry and E.A. Hornel's work of the nineties betrays many of the characteristics of the new style, they are part of the history of the Glasgow School, while in the same city J.Q. Pringle, quintessentally a painter of the nineties, is no less part of Glasgow's *fin-de-siècle* efflorescence. It may smack of truism to say that Bessie MacNicol, like Pringle, was not one of the Glasgow Boys; but as the most accomplished of a remarkable group of women artists, who in those separatist days exhibited under the auspices of the Glasgow Lady Artists' Club at their elegant premises in Blythswood Square, where her contemporaries included the painters Stansmore Deans, Robertson, and the illustrators Olive Carlton Smythe, De Courcy Lethwaite Dewar, Annie French and Jessie King, Bessie MacNicol seems to belong with a small and select group of Scottish artists whose intimist, tender and reflective styles as easel painters working in oils stamps them as children of the nineties. Other names that immediately occur in this context are W.J. Yule (1869-1900), who was a contemporary of George Dutch Davidson and John Duncan in the Dundee Graphic Arts Association, and studied under Professor Fred Brown at the Westminster School before being taught by Jean-Pierre Laurens in Paris; Robert Brough (1872-1905) who came from Aberdeen and studied under Laurens and Constant in Paris; and Beatrice How (1867-1932), who seems to have attended Herkomer's school at Bushey at the same time as Herald and the Beggarstaffs, and was then trained at the Académie Delecluse in Paris, where she lived in the same street as J.D. Fergusson, rue Notre-Dame-des-Champs.

Bessie MacNicol's work is rather rare and infrequently dated. There seem to have been three main phases in her style: a tonal manner using a dark palette deployed in vivacious portrait studies (e.g. *A*

French Girl) often in semi-profile or *profil perdu*; a more open manner employing a lighter palette in *maternités* of great intimacy and delicacy which inevitably recall Berthe Morisot or Mary Cassatt, of whose work she was surely aware; and what one might term a Kirkcudbright style exemplified in her painterly portrait of Hornel. The work of Beatrice How exemplarily revived by the Fine Art Society in 1979, is more delicate still. The absence of dates makes a chronology difficult, but again we are in the presence of an artist of impressively consistent quality whose subtle intimacy in studies of mothers and babies and in portraiture makes her a worthy contemporary of the Nabis and above all of her friend Albert Besnard.

Robert Brough and William Yule share an east coast background and a Paris training – and the special qualities of delicacy, intimacy and tenderness which mark them out as paragons of the nineties. The present state of knowledge of both artists is again scanty. Yule is best documented in Messrs Geering and Colyer's sale catalogue of 22 September 1982, where his brilliancy with the pencil in a style very close to that of Herald, and his incisiveness as a portraitist are much in evidence. Brough we know to have specialized in portraiture after his return from Paris in 1897, when he spent three years in Aberdeen before removing to London where he become Sargent's neighbour and friend and enjoyed tremendous success, Caw tell us, until his premature death – the norm for this little constellation of artists – in a train crash in 1905.

Some of the key Glasgow School painters became members of the New English Art Club on or shortly after its foundation in 1886. Lavery and Alexander Mann were founder members and J.E. Christie (a Paisley artist who moved to London in 1885), Guthrie, Henry, W.Y. Macgregor, Paterson, Roche, Crawhall and Walton together with two other Scottish artists, J. Cadenhead and Maurice Greiffenhagen, became members or sent pictures in the years immediately following. By then the Scottish contingent were fully-fledged exponents of the new Realism and would have little to learn from their English contemporaries, but recognition in the metropolis was, as ever, important, and Henry, Lavery and Walton were soon to pursue their careers in London.

The Glasgow School's representation was at its most numerous in 1890, but they resigned almost as a body in 1892 due to what they saw as a political rejection of a Scottish picture by the London Impressionist group who were attempting to dominate the Club. The Scots must have felt encouraged by the reception accorded to their exhibition at the Grosvenor Gallery in the summer of 1890, to which the most important of these artists, with the addition of Thomas Millie Dow, William Kennedy, Thomas Corsan Morton, and George Pirie, sent some of their strongest works. This exposure in London and the

68 John Quinton Pringle
Muslin Street, Bridgeton
1895-96
Oil, 35.90 x 41.20 cm
City Art Centre, Edinburgh
© City of Edinburgh Council

resulting *succès d'estime et de scandale* led directly to the invitation from Herren Firle and Paulus to exhibit with the Munich Secession at the Glaspalast later that same year, which was the beginning of international recognition and the first of many exhibitions and sales abroad, both in Europe and in North America. The critic of the *Muenchener Neueste Nachrichten,* Fritz von Ostini, wrote in unequivocal terms of admiration:

> . . . a Glasgow School really does exist! It is not merely that a score or so of painters have established their studios in Glasgow and now happen all to paint good pictures. They form an organic whole, heterogeneous as they may be; they are united by one aim, one spirit, one power, they all spring from the same soil. This spontaneous growth of a school of painters of such importance is perhaps without parallel in the history of art . . .

Although not one of the Glasgow Boys – he never took part in their exhibitions and was only an artist in the time he could spare from his practice as a optician – John Quinton Pringle (1864-1925) was in some ways the most gifted of all his contemporaries in Scotland. His associations are entirely with Glasgow, where he was born. He studied at the Glasgow School of Art's evening and early-morning classes from 1885-95 and in 1899-1900, all the while uninterruptedly pursuing his daytime profession of practising optician at his shop in the Saltmarket near Glasgow Cross (where the television pioneer John Logie Baird and the playwright James Bridie were among his clients). He was thus a most thoroughly trained artist but never a professional in the financial sense and to this independence and the consequent lack of temptation to over-produce can be attributed the smallness of his output, his extreme consistency of quality and his individuality of style. Technically his work possesses a degree of refinement unique in the Scottish and indeed in the British context of the day. It is an astonishing fact that he seems to have had very little contact with the Glasgow School artists who were constantly in the local news; his artistic mentor and encourager was Fra Newbery, the far-sighted head of the Art School, and there exists a fascinating photograph which shows him in the company of his contemporary at Glasgow School of Art, Charles Rennie Mackintosh, at Gladsmuir,

William Davidson's house at Kilmacolm. He created works of consistent quality that can be both dreamily poetic and painstakingly observant. In his choice of subject-matter, however, he departs little from his precursors of the Glasgow School.

Pringle's earlier pictures exhibit the most fastidious and detailed realism allied to the most minute execution and it is not surprising that he later painted a number of portrait miniatures on ivory (of which Sir James Guthrie possessed two examples). Two early portraits in oils, of himself and his brother Christopher Pringle, *Artist with Palette* (circa 1886: GAG) and *Portrait of the Artist's Elder Brother* (circa 1890: TG), are painted with relative freedom and are sensitive studies of their subjects reminiscent of E.A. Walton's early watercolours. From the same period date several delicate and subtle views of Glasgow back-court scenes – *Old Houses, Bridgeton* (1890: formerly Davidson Collection), *Back Court with Figures* (1890: private collection), *Old Houses, Parkhead, Glasgow* (1893: private collection) – the last-named having a special meaning for the artist as his mother was born in one of the houses, and died in it in the year the picture was painted. The culmination of this group is the remarkable *Muslin Street, Bridgeton* (1895-96: ECAC), the artist's own

favourite of which he commented, 'There will never be another *Muslin Street* – quite apart from the skill no-one could afford to spend the time on it'. Yet despite its minuteness of execution, the painting has a fresh immediacy and a sense of scale which belie its small size. Here too, Glasgow School precedents exist in the Glasgow Street scenes painted a little earlier by James Nairn – *West Regent Street* (1884: untraced) and Thomas Corsan Morton – *St. Vincent Street* (1887: private collection), which both adopt the high viewpoint also employed by Pringle. Pringle here uses a noticeably tonal palette with infinite variations on a narrow range of blue-grey enlivened only by the inclusion of passages of rust-red. A similarly restricted palette is visible in another realist *tour de force*, *The Loom* (1891: ECAC), a composition of immense spatial complexity with every detail sharply articulated yet retaining a sense of air and atmosphere, each surface painted with infinite variations of brushstroke in such a way that it is simultaneously described and illuminated by the light in the room. Meldrum records that this canvas, measuring nine by eleven inches, took three summer months to complete, during which Pringle devoted two hours to it every morning before setting out for the shop. In a slightly later group of pictures

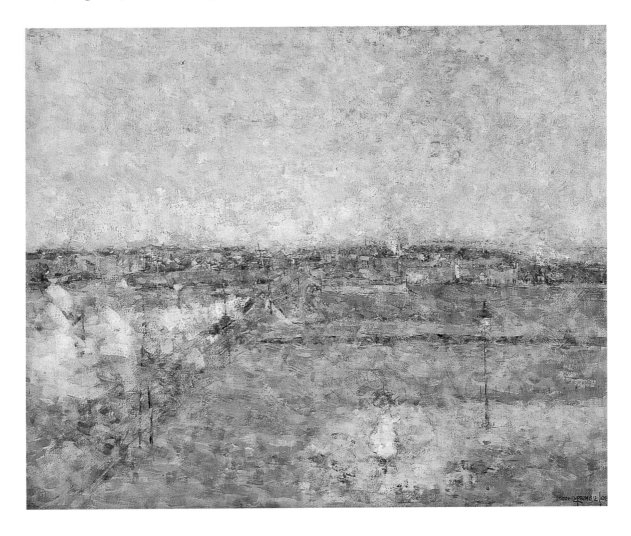

69 John Quinton Pringle
Tollcross, Glasgow
1908
Oil, 42.50 x 52 cm
© Hunterian Museum and Art
Gallery, University of Glasgow

painted between 1903 and 1908, a more poetic conception of subject-matter is evident – *Girls at Play* (1905: HAG) – and a more open, transparent execution which is intriguingly close to the pointillism of the Neo-Impressionists whose work Pringle is most unlikely to have known at this stage in his career, as Meldrum has emphasized, *pace* Buchanan who claims to see the influence of Henri Le Sidaner. These works are in fact astonishingly original in technique, the subject emerging through a mesh of tiny brush strokes of colour which form the bejewelled surface of the painting and at the same time suggest the surrounding atmosphere which diffracts the colours perceived within the three dimensions of the picture space. The most consistently divisionist work in his *oeuvre*, probably, is *Tollcross, Glasgow* (1908: HAG), which on examination turns out not to be a pointillist work at all – the paint is applied transparently with a square brush in overlapping layers of pure colour or, to be exact four colours: a dominant primary, blue, with its complementary, orange; and the remaining secondary colours green and lilac, with white. This phase Pringle referred to as his 'very extreme' style in a letter (Meldrum Trustees). Tantalizingly of this very rare artist, it is known that a Continental dealer bought several canvases from him at around this time, although it was not Pringle's normal practice to dispose of his pictures outside the small circle of his family and friends. Two other important works date from this middle period: *Two Figures and a Fence* (1904: GAG) may be unmatched in Pringle's work for its sheer exquisiteness of technique, although it has an indeterminate, dreamlike quality also visible in Pringle's largest canvas, *Poultry Yard, Gartcosh* (1906: SNGMA), which so poetically transforms a prosaic theme. A visit to Caudebec in Normandy in 1910 (his only excursion abroad; he never realized his ambition to take his paintbrushes to Japan) resulted in four oils which were to be the last in that medium for over a decade. It seems likely that the increasingly onerous demands of the shop on his time, and the discouraging climate of the war years, rendered the relative speed of watercolour attractive to the artist. The most important of these is the delicate landscape *On the River Sainte-Gertrude, Caudebec*, which interestingly once belonged to an early collector of C.R. Mackintosh, David Turnbull, who was a partner in Templeton's carpet factory.

The Curing Station at Whalsay (1921: AAG) dates from Pringle's last period and marks a return to oil, after a decade of painting only in watercolour. The legacy of painting in the more fluid medium is visible in the increased transparency and fluidity of *The Curing Station*. The return to oil painting caused Pringle no difficulty and he wrote happily in a letter of this time from Whalsay, where he was staying with his friend Dr. Wilson '. . . my hand is as light as a feather, no difficulty in what I want . . .', adding that his new Orkney pictures were *not* of the 'extreme school' – a view with which we would now concur. The pictures painted in Orkney only a year or so before the onset of the artist's final illness, show that Pringle's limpid style had lost nothing with the passing of a decade.

At the same time as international acclaim was being granted the School began to disintegrate. In a postcript dated 1895 to the MS *Notes* written in 1891-92, Macaulay Stevenson describes how they gradually separated, owing to marriage, honours and success, which prejudiced the School's spiritual force, so that 'a sort of apostolate . . . now got broken up into a number of individuals with at most a grouping into twos and twos, with perhaps a third in occasional sympathy'. Stevenson concludes, 'This fair bud of promise put out by Nature came too early in the still tarrying springtime of human progress and the frosts of the winter from which our civilisation has not yet emerged have nipped it'. Between 1887 and 1892 there appear to have been various attempts to formalize the *de facto* existence of the Glasgow School but rather than unifying the group these appear only to have succeeded in ruffling the feelings of various individuals, and the Glasgow School was a spent force by the later 1890s, although its work continued to be seen in special exhibitions all over Europe and America. On two occasions Diaghilev borrowed Glasgow School pictures for exhibitions in St. Petersburg in the late 1890s.

The significance of the School for subsequent Scottish painting lies in its rejection of academic values and its return to the expressive qualities of colour and the vigorous handling of paint. Its impact on contemporary English painting, except in the single case of Frank Brangwyn, was negligible, but in Scotland it had considerable influence on the next generation of painters.

FIN DE SIÈCLE: A NEW ART

Scotland made a distinctive contribution to the international Art Nouveau in the last years of the nineteenth century. In the Scottish context, the exquisiteness, not to say preciousness, of Art Nouveau and its linear nature are at variance with the painterly characteristics we have seen grow up in Scottish easel painting in the latter half of the nineteenth century. The essence of Art Nouveau is its intense inwardness, its emphasis on mental intuition rather than sense-perception. Paintings by the younger members of the Glasgow School around 1890, such as Hornel's *Young Girl* (1888: private collection), Henry's *Sundown* (1887: HAG), *Gathering Mushrooms* (1888: private collection) and *Galloway Landscape* (1889: GAG), and above all *Saint Agnes* by C.R. Mackintosh's friend David Gauld, one of the earliest of all Art Nouveau images, prepared the way in Scotland for a style which would concentrate on spiritual essences rather than on visual impressions of the material world. This contrasted with the evolving interpretation of realism which had provided the stylistic connections throughout the nineteenth century. The prophetic *Saint Agnes* (1889: exhibited in Munich, 1890), painted in a *cloisonniste* style related to Gauld's very similar stained-glass designs for the Glasgow firm of Guthrie and Wells, demonstrates the elongations, the formalization, the pensive wistfulness, and even the interest in vernacular architecture (in this case, that of Cambuskenneth, one of the Glasgow Boys' favourite painting locations) so characteristic of the new movement in Scotland.

In Glasgow alone, however, more exotic contemporary influences were at work and Jessie Newbery, writing in 1933, recollected the importance to Charles Rennie Mackintosh and his friends of 'contact, through the medium of *The Studio*, with the work of the following artists: Aubrey Beardsley (his illustration to the play *Salomé* by Oscar Wilde); illustrations to Zola's *Le Rêve* by Carlos Schwabe; reproductions of some pictures of Toorop – a Dutch artist; and the work, architectural and decorative, of C.F.A. Voysey. These artists gave an impetus and a direction to the work of "The Four"'.

Glasgow, Edinburgh and Dundee were each in turn the centre of creative activities which are surprisingly little related. Gauld's *Saint Agnes*, as already noted, is dated 1889. In 1891 the French-trained Edinburgh artist Robert Burns (1869-1941)

produced the perhaps de Feure-inspired drawing *Natura Naturans* (dated 1891 but only published as a wood-block engraving in *The Evergreen* in 1895), which at this early date confidently exploits the whiplash curve which became the movement's hall-mark. French inspiration and an illustrative bias inform the graphic work of the main contributors – Burns himself, Charles Mackie and John Duncan – to *The Evergreen*, whose four numbers appeared in Edinburgh in the years 1895-97. Duncan was the foremost of the Celtic revivalists, with the designer-ceramicist Phoebe Traquair in Edinburgh, which also boasted two interesting disciples of Morris among its architects, Sir James Gowans and F.T. Pilkington, whose Bruntisfield Church is the epitome of picturesque illustration in architecture.

But the main direction of the style in Scotland in the early nineties is determined by Mackintosh and

70 Robert Burns
Natura Naturans
1891
Printed in the Spring Edition of
The Evergreen, 1895
Wood engraving by Augustus
Hare

71 George Dutch Davidson
Abstract
1898
Watercolour, 35.60 x 25.40 cm
The McManus: Dundee's Art
Gallery and Museum
Dundee Art Galleries and
Museums (Dundee City Council)

In the realm of the applied arts Glasgow witnessed an immensely rich flowering of talent, partly inspired by the ever-encouraging presence at the Glasgow School of Art of Fra Newbery as Director. Apart from the 'The Four' there are the major furniture designers George Walton, Jane Fonie, E.A. Taylor, and George Logan, the two last named producing many designs for the Glasgow firm of Wylie & Lochhead; in metalwork Peter Wylie Davidson and many others; in stained glass, Oscar Paterson and Alf Webster; in embroidery and dress design, Jessie Newbery née Rowat, Ann Macbeth and a host of feminine talent; in glasswork, the Clutha glassworks; in pottery, the Allander kilns. And finally, third in chronological order after Glasgow and Edinburgh, Dundee requires mention in any survey of Art Nouveau in Scotland because of the brief incandescence of George Dutch Davidson's career in the north-eastern city.

In terms of painting Art Nouveau was an interlude which passed without sequel, vanishing as suddenly as it had appeared, leaving behind a handful of enigmatic watercolours by 'The Four' and by G.D. Davidson which hint at the world of Munch, Klee and Kandinsky, together with a much larger body of decorative work whose period charm has experienced a nostalgic contemporary revival. Its more lasting influence was in architecture, the applied arts and graphic design; and the dominant figure in each field was Charles Rennie Mackintosh (1868-1928. The international significance of his architecture and design, particularly to the Vienna School, but also in Germany and Holland and from thence to the Bauhaus is well documented. In Mackintosh's hands the new style evolved as an instrument of purification capable of great expressive power and never threatened merely to replace the old historicism with a new mannerism.

Yet pioneer as he was, Mackintosh was not alone. In the 1893 lecture on 'Architecture' he names to his Glasgow audience several precursors in England who 'are freeing themselves from correct antiquarian detail and who go straight to nature' – Norman Shaw, John Bentley, John Belcher, G.F. Bodley, Leonard Stokes and J.D. Sedding – while in Scotland through the nineties and immediately after the turn of the century the work of J.M. Maclaren, J.A. Campbell, John Ednie, A.N. Paterson, Salmon and Gillespie, W.J. Anderson and W. Gibb Morton – were some of them in his audience? – provides a background in harmony with Mackintosh's revolutionary achievement. Of these Scottish names, only W.G. Morton was active as an occasional designer of furniture, notably for 'Lintknowe' at Darvel, and he seems also to have been a competent watercolourist, demonstrating a level of versatility not surprising in an architect whose family's business of Alexander Morton & Co. of Darvel commissioned fabric designs from Voysey. What sets Mackintosh apart from all his contemporaries, however, is his ability to

his small circle in Glasgow. A fully-fledged Art Nouveau of astonishing assurance and originality emerged in the work of Mackintosh, the sisters Margaret and Frances Macdonald and Herbert MacNair – 'The Four' as they were known from 1894 – at an early point in their respective careers. In the realm of the graphic arts, this flowering is nowhere seen to better advantage than in the four surviving scrapbooks, preserved by Agnes Raeburn and now appropriately in the possession of the Library of Glasgow School of Art, collected for circulation among the contributors and their fellow students at the School in the years 1893-96, and known as *The Magazine*. This compilation of autograph work must rank as one of the most extraordinary ever produced by students at any art college, and it underscores Glasgow's pre-eminence in the development of the new style.

view all the branches of the visual arts in a kind of synaesthesia which allowed his search for new forms in one branch constantly to be enriched by explorations in another. The experimental and 'Symbolist' watercolour paintings of the 1890s were one of the most rewarding avenues of exploration in terms of form and colour. The idea of form as symbol pervades Mackintosh's view of architecture and design. In the work of what other designer might we encounter a chair with a shaped backrail which frames the sitter's head like a halo, another with the hieratic solemnity of the throne of Minos; a games table formed (although gambling would certainly have been forbidden at Miss Cranston's) as a lucky four-leafed clover; a revolving bookcase of tree-derived form; a library (at Hill House) whose panelling resembles angels' wings; an organ case (Craigie Hall) decorated with carved songbirds; another (Queen's Cross Church) with minims on a kind of vertical staff; a school (Scotland Street) with a miniature entrance for its infants; a School of Art (with its east elevation's reference to Maybole Castle) whose 'fortifications' include railings shaped as crossbows with quivers full of – tulips? In these and in countless similar but more abstract examples, Mackintosh takes the idea of fitness or 'seemliness' (a favourite term) to a level of aesthetic expression undreamt of in the philosophies of his contemporaries. Mackintosh possessed a technical mastery which was the servant of a powerfully creative mind; he had a Mozart-like ability to endow decoration with significance. For him, form was like a veil shaped by and part-disclosing meaning while itself always remaining separate and visible, as the wall-veil (one of the few Ruskinian terms of which he approved) at once disguises and expresses the function of a building. Unlike the Macdonald sisters and MacNair, he always thought of himself as an architect first and foremost; his own writings indicate succinctly that the applied arts and painting were in his opinion subordinate to architecture.

His joblist for Honeyman and Keppie in the years prior to the commission in 1896 for the Glasgow School of Art was very considerable, and if one were to characterize his chief works of this phase – *inter alia* the Glasgow Herald building (1893) with its extraordinary, romantic tower and early Art Nouveau carved embellishments; Queen Margaret's Medical College (1894-95) visualized in the beautiful perspective drawing as a medieval nunnery surrounded by its own glebe; the medievalizing Queen's Cross Church (designed 1896) – one would qualify them as subjective, emotional rather than rational, and even romantic. As Billcliffe has pointed out, these are characteristics shared with his graphic work in the same period. After 1896 until the start in 1907 of the second stage of the School, which was to become his built masterpiece – others did not proceed beyond the drawing board, although the House for an Art Lover unpremiated

in 1902 was built in Glasgow during 1989-96 – his architectural output is truly phenomenal, but even so the list of projects alone gives only a partial indication of the scale of his creativity; in David Walker's words, 'One room would cost him more real effort than half a dozen buildings would another man'. The ten-year period from 1897-1907 coinciding with the gestation of the School of Art encompasses an early phase in which decoration is chiefly supplied by structural features or the simple provision of a stencilled mural, as at the Buchanan Street tearoom (1897); the middle phase adding ever more complex enrichments in furniture, glass, enamels, and metal works – compare the relative austerity of Windyhill (1900) with the complex bedroom and drawing-room schemes for Hill House (1902), and the transitional vernacular elevation treatment of both with the timeless modernity of the Haus eines Kuntsfreundes (1902); and a third, architectonic manner typified in the Willow tearoom of 1904, with its endless spatial interplay and elaborate plaster frieze abstractly symbolizing the willow theme. This third phase culminates of course in the 'overwhelmingly full polyphony of abstract form' (Pevsner) of the Art School Library interior, with its 'thrilling' (Howarth) exterior elevations, begun in 1907 and completed in 1909. Essentially, Mackintosh's main periods of activity as a painter occur before and after this decade of intensive architectural invention. In the difficult and frustrating years after the School of Art, when his architectural practice dwindled precisely when the completion of masterpieces of the stature of the Cranston tearooms, Hill House, Scotland Street School, and the School of Art itself (to say nothing of the brilliant unrealized designs for a Concert Hall, for Liverpool Cathedral, and for the Haus eines Kunstfreundes) had given proof to the world of his outstanding talents as a designer of limitless versatility, Mackintosh turned increasingly again to painting. Apart from Miss Kate Cranston, the one serious patron to employ Mackintosh after 1909 was W.J. Bassett-Lowke, for whom Derngate was built in Northampton in 1916 with interiors by Mackintosh. Here Mackintosh employed a newly minted language of geometrical decoration and a range of strong colours with which he had already begun to experiment as a painter.

Charles Rennie Mackintosh was apprenticed to the Glasgow architect John Hutchinson in 1884, and in 1889 entered the firm of Honeyman and Keppie as a qualified draughtsman. In 1891 he made a visit to Italy as the winner of the Alexander Thomson travelling scholarship, making architectural sketches of exceptional intelligence and accomplishment and recording his impressions in a diary later developed into a lecture given to the Glasgow Architectural Association at some time in late 1891 or early 1892. Mackintosh seems to have been in considerable demand as a speaker, understandably, as despite some indebtedness to W.R. Lethaby and the occasional

phrase borrowed from Sedding, his written ideas are penetrating, and expressed with clarity and an engaging mixture of passion and humour. Several further papers read to the same Association follow in swift succession: *Scotch Baronial Architecture* (1891), *Elizabethan Architecture* (1892) and *Architecture* (delivered to the Glasgow Institute of Architects in 1893); and finally after a gap of nine years the revealing *Seemliness* (1902) (all MSS. University of Glasgow, Mackintosh Collections). In the first-mentioned of these hobbyhorses, Scottish baronial architecture, 'a subject dear to my heart' which he considers to have the same claim on his love and loyalty as his own ancestors, he expatiates on its honesty of form and its fit use of materials. The paper on Elizabethan architecture, like its predecessor,

72 Charles Rennie Mackintosh
The Descent of Night
1893-94
Watercolour, 24 x 17 cm
From *The Magazine*, April 1894
The Glasgow School of Art
Archives and Collections

describes the forms of the style through perceptive analysis of a few examples, but prophetically (in view of Mackintosh's own future achievement) quotes James Fergusson on the interior decoration of the Elizabethans, to the effect that theirs was a style formed by artisans and not by artists, 'not of the true artistic character which calls for the cooperation of the sister arts of painting and sculpture'. In the *Architecture* paper of 1893 he goes still further: 'you ask what is the connection between architecture and painting. Everything . . . what is art but the fixing into substance the "invisible".' Addressing himself to the painters in his audience, Mackintosh writes of '. . . form, colour, proportions, all visible qualities – and the one great invisible quality in all art, soul. These are the essential qualities of all true architecture, and of the various subordinate arts – in the days when there was true art – for its further enrichment as a work of art. . .'

His colleagues at Honeyman and Keppie included Herbert MacNair (1868-1955) and the two became close friends. Mackintosh and MacNair attended the evening classes for architects which Fra Newbery had instituted at the Glasgow School of Art. Francis Newbery (1853-1946) had trained as an artist at South Kensington, where he taught before his appointment as Head Master of Glasgow School of Art in 1885. His enthusiasm for a form of art education which placed as much emphasis on the applied arts and crafts as on the traditional classes in his own discipline of painting was responsible for the considerable increase in new subjects offered – among them metalwork, enamels, embroidery and dressmaking – and would have attracted 'The Four' to the School. In 1893 – also the year of the first highly influential numbers of *The Studio* – Newbery organized a series of lectures on the crafts, the speakers including the great founding father of the English Arts and Crafts Movement, William Morris (1834-96), and probably Newbery himself. In the lecture on 'Seemliness' of 1902, Mackintosh conveys something of the flavour of just such an evening at the School: '. . . as I heard Mr Newbery say the other evening the education of all artists must be conducted on one grand principle – all must be educated alike – with one common aim'. Here they met their future wives, Margaret (1865-1933) and Frances (1874-1921) Macdonald, to whom they were introduced by Newbery, sensing the affinities between them, some time before November 1894 when they exhibited together at the Glasgow School of Art Club exhibition in the Institute Galleries. Fra Newbery's judgement was borne out by their formation into an artistic grouping, known as 'The Four', which lasted until the MacNairs' departure for Liverpool in 1899, the year of their marriage; Charles Rennie Mackintosh married Margaret Macdonald in the following year.

'The Four', with Newbery's encouragement, developed great versatility in the design of metal

work, enamels, book illustration, furniture and posters, and their work was exhibited, with that of several other Glasgow designers, at the London Arts and Crafts Society exhibition in 1896 in London, where it was received with vociferous hostility. Only Gleeson White, the editor of *The Studio*, admired the work of 'The Four', and he wrote an important series of articles on them, which received more attention abroad than at home.

> The appearance of this article led to an invitation to Charles Mackintosh and Margaret Macdonald . . . to hold a show in Vienna. The consequent exhibition there not only established his place as one of the first modern architects and decorators of the day, but gave new life to a group of brilliant young architects, decorators, sculptors and metal workers, who at once acknowledged him as their leader. The rooms in the Turin International Exhibition of 1902 . . . were very rich in the work of 'The Four' (Jessie Newbery, ibid.).

Margaret's collaboration with Mackintosh took the form chiefly of decorative panels for individual pieces of furniture or for specified interiors, where they were of central importance to the whole scheme, in terms both of colour and content. Writing to Hermann Muthesius in 1900, Mackintosh says, '. . . just now we are working at two large panels for the frieze [*The May Queen* and *The Wassail* for the Ingram Street Tearoom] . . . Miss Margaret Macdonald is doing one and I am doing the other. We are working them together and that makes the work very pleasant. We have set ourselves a very large task as we are slightly modelling and then colouring and setting the jewels of different colours'. Here Mackintosh is describing the extraordinary technique visible also in the most celebrated of these panels, that designed by Margaret for the 'Room de luxe' with its silver-painted furniture and 'inexplicable splendour' of enamelled and mirrored glass, on the first floor of the Willow Tearoom, based imaginatively on Rossetti's sonnet, 'O ye, all ye that walk in Willowwood', where string and coloured beads are worked into the modelled and painted gesso. Pamela Robertson informs us that Margaret provided five panels for furniture designed by her husband, and that her work was included in eleven of his projects. We know from the evidence of his letters how much he appreciated her and respected her work. Professionally as well, it was clearly a marriage made in Heaven. Although Mackintosh's espousal of the ethereal, Maeterlinckian, fairytale subject matter which we rightly associate with Margaret, and to a lesser extent Frances Macdonald, was of short duration and only a handful of his graphic works can be ascribed to it – *Part Seen, Imagined Part* (1896: GAG) and *In Fairyland* (1897: private collection) are examples – one wonders whether a masterpiece such as the astonishing bas-relief plaster frieze for the Willow Tearoom (1904) would have been within his grasp

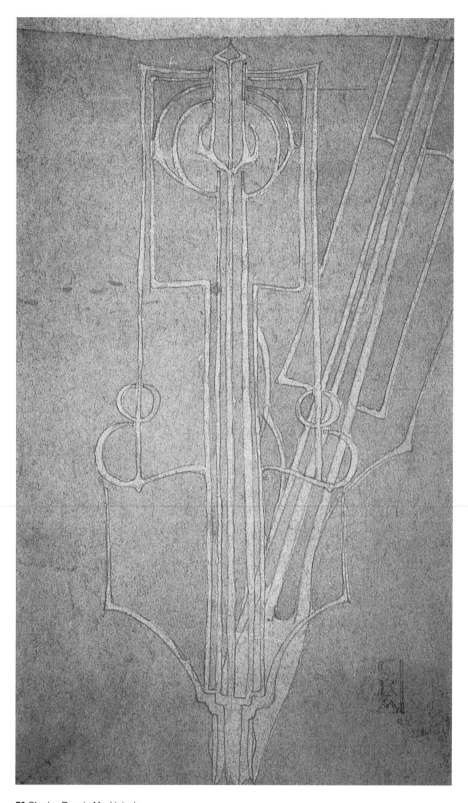

73 Charles Rennie Mackintosh
The Shadow
1895-96
Watercolour, 30 x 18 cm
From *The Magazine*, Spring 1896
The Glasgow School of Art
Archives and Collections

74 Charles Rennie Mackintosh
Cabbages in an Orchard
1894
Watercolour, 8.60 x 26 cm
From *The Magazine*, April 1894
The Glasgow School of Art
Archives and Collections

had it not been for the encouragement of Margaret's interest in modelled gesso reliefs.

Much ink has flowed on the difficult question of who among 'The Four' was the first to arrive at the new style. The available evidence may be inconclusive on this point, but it is extremely impressive as regards the originality of 'The Four' themselves. Well might the Macdonald sisters have teased the earnest Gleeson White who was questioning them on the sources of their style with the answer 'We have no basis'. Very early drawings such as Mackintosh's design for the Diploma of the Glasgow School of Art Club (1893: Howarth collection) – perhaps Mackintosh's immediate response to Jan Toorop's *The Three Brides* – or his *Conversazione* programme for the Glasgow Architectural Association (1894: ibid.), or Margaret's invitation card for a Glasgow School of Art Club 'At Home' (probably 1893: HAG), or the sisters' work for an illuminated manuscript within beaten metal covers, *The Christmas Story*, which includes very early work by Margaret and Frances (1895-96: ibid.), reveal such confident individuality that the truth is probably that these artists arrived independently at similar conclusions at the same time. Interestingly, the two invitation cards by Mackintosh and Margaret share an important and unusual compositional device, which seems to be based on a section cut through an apple or a pomegranate, formed in Mackintosh's case by a flight of birds, in Margaret's by the wings of an angel. This is an early hint of much that is to come in Mackintosh's vocabulary of ornament, just as his Diploma design is a distant forerunner of the Willow plaster frieze of circa 1904. However, David Walker has reminded us that in the interior of the Hall of Glasgow Art Club (and, he might have added, in the carved decorations to Craigie Hall in the same year) the details 'whose strange attenuated figures and elongated S-stems with balloon flowers and friezes of sinister whorls of thistles anticipate any mature work

of this type by the Macdonalds so far discovered'.

From the beginning Mackintosh's work as a watercolourist and draughtsman appears calmer, and less eccentric or eerie than that of his three colleagues. His wonderfully assured, poetic watercolour of 1892 *The Harvest Moon* (GSA) is a transitional work. It is his earliest masterpiece in this medium, which was favoured by 'The Four' and their contemporaries to the virtual exclusion of the more material, denser oil medium. Here, the subject itself is reminiscent of the crepuscular mysticism of the Kirkcudbright artists of the later Glasgow School, particularly Hornel and Henry, while the classically-draped recumbent female figure personifying a cloud distantly echoes the Aesthetic Movement. But the angel whose wings ring the moon, with her elongated limbs, tiny extremities and S-curve drapes clearly anticipates the new style, while the beautifully articulated thorn branches in the foreground, so strangely and vividly alive with their autumn berries and quinces, seem as vitally engaged in the mysterious drama of dusk as the personified moon and cloud. *The Harvest Moon*, related in its atmosphere of mystery to some of the work of the Glasgow School painters, like *The Descent of Night* (*The Magazine*, April 1894: ibid.), using the female figure as symbol, fascinates the viewer, irrespective of the subject, by the brilliant solution of the technical problem of a stencil-like separation of areas of paint from each other. This technique was also adopted in the extraordinary *The Shadow* (1895-96: *The Magazine*, Spring 1896: ibid.), an exquisite wash drawing in three colours of a plant form like a thistle but equally resembling one of his own wrought-metal finials, with its shadow drawn isometrically. On the other hand, Mackintosh was occasionally as ready as his three colleagues to be deliberately obscure, although with amusing disingenuousness he rebuts this charge in the justly celebrated text which accompanies his watercolour *Cabbages in an*

Orchard which appears in *The Magazine* of April 1894. The watercolour anticipates Klee; the text is equally original and since it offers a rare view of Mackintosh's imaginative processes at work is reproduced here in full:

Cabbages in an Orchard
The above title explains the picture on the opposite page, but to satisfy the ordinary ignorant reader I am forced to give the following explanation – The before mentioned kind of reader may imagine that the cabbages here shewn are the usual kind of every-day cabbage, or as some people call it 'Common or garden cabbage', but that is just because they never see cabbages unless when they are not growing. The cabbages in this orchard are different – they have stood through a severe winter of snow and hail and frost, and thunder: they have stood through a spring lasting three months, and raining all the time, and before they had time to dry in an ordinary way the sun came out with frizzling ferocity – yet still they stand. A glance at the sketch will convince anyone – (although it conveys but a poor idea of the rich variety of colour, the beautiful subtlety of proportion and infinity of exquisite form) – that the cabbages shown here are a particularly hardy and long-suffering kind. Neither is the orchard a common kind of orchard. I explain this because some people may not distinguish between cabbage and orchard, and will grumble accordingly. They might be right, the trees are old trees, very old trees, they are far away from any other trees, and I think they have forgotten what trees should be like. You see they have lived alone a long time with nothing to look at but cabbages and bricks, and I think they are trying to become like these things. That at least is what their present appearance would suggest (and the sketch suggests the same thing in a less perfect way). I know this much, I have watched them every day this winter and I have never once seen an apple, or an orange, or a pear on one of them, and I have seen clothes – and what is more I have seen mud – and a brickmaker once told me that bricks were made of mud. The mud I saw must have been the beginning of bricks. I would explain before concluding, that anything in the sketch you cannot call a tree or a cabbage – call a gooseberry bush. And also that this confusing and indefinite state of affairs is caused by the artist – (who is no common landscape painter, but is one who paints so much above the comprehension of the ordinary ignorant public, that his pictures need an accompanying descriptive explanation such as the above).

C.R. Mackintosh.

Mackintosh seems only once to have reverted to this mode of watercolour painting in the marvellous, mysterious later *At the Edge of the Wood* (circa

1905-06: private collection). The large watercolours, *The Tree of Influence, The Tree of Importance, The Sun of Cowardice* (1895: GSA) and *The Tree of Personal Effort, The Sun of Indifference* (1895 : ibid.) resemble the 'thinking machines' or mandalas which Patrick Geddes favoured to present the mechanics of thought as graphic symbols at about this time. The long titles with which they are inscribed *recto* by the artist are indispensable pointers to their meaning, the alleged impenetrability of which is in danger of becoming a hallowed tradition among Mackintosh commentators. In fact, their meaning is clearly revealed by a close study of what they actually represent and would immediately have been recognized by the close circle of students among whom *The Magazine* was circulated. *The Tree of Personal Effort*, whose healthy roots are visible, thrives in the

75 Charles Rennie Mackintosh
At the Edge of the Wood
No date
Watercolour, 50 x 37 cm
Private collection
Although this painting dates to c. 1905-06 by Roger Billcliffe, it appears on stylistic grounds to relate to earlier work.

76 Charles Rennie Mackintosh
The Tree of Influence, The Tree of Importance, The Sun of Cowardice
1895
Watercolour, 21.40 x 17.20 cm
From *The Magazine*, Spring 1896
The Glasgow School of Art
Archives and Collections

77 Charles Rennie Mackintosh
The Tree of Personal Effort, The Sun of Indifference
1895
Watercolour, 21.10 x 17.40 cm
From *The Magazine*, Spring 1896
The Glasgow School of Art
Archives and Collections

hostile climate of a freezing sky and arctic sun – *The Sun of Indifference* – wonderfully suggested by subtle washes of slate and emerald. Its leaves and blooms, though little, are healthy, well ordered and beautiful in colour. (In the famous lecture on 'Seemliness' in 1902 Mackintosh will write, 'Art is the flower – Life is the green leaf'.) But the 'personal effort' and 'indifference' of the title are anthropomorphic and can only refer to the artist and his public. The symbolism is clear: the artist will create and thrive, through his own efforts, in a climate of indifference. Whereas, in the companion watercolour, the baneful glare of *The Sun of Cowardice* produces in *The Tree of Influence, The Tree of Importance*, which is rootless, a crop of imposingly large fruit which however tend to break their own branches, together with sinister flowers as large as flags joined to a strange vegetable form shaped like a *cuirasse esthétique*, or classical breastplate, a familiar prop of the antique class of contemporary art education, and the 'influence' referred to in the title. Here we have a portrait of the very soul of the artist in travail, personified by the tiny, shrinking female figure of the tree itself, whose artistic growth is stunted by a 'cowardly' dependence on past influences and material reward.

The thought expressed by these two works is repeated in the paper on 'Seemliness' of 1902:

. . . you must be independent, independent, independent . . . Shake off all the props – the props tradition and authority offer you – and go alone – crawl – stumble – stagger – but go alone . . . The props of art are on the one hand – the slavish imitation of old work – no matter what date and from what country – and on the other hand the absurd and false idea – that there can be any living emotion expressed in work scientifically proportioned according to ancient principals [*sic*] – but clothed in the thin fantasy of the author's own fancy. The artist's motto should be, 'I care not the least for theories for this or that dogma so far as the practice of art is concerned – but take my stand on what I myself consider my personal ideal.'

If Mackintosh's work is the least florid and the least convoluted of all that was produced by the main exponents of Art Nouveau, that of the other three members of 'The Four' seems to deserve better the sobriquet of 'spook school' which came to be applied to their work in Glasgow. Frances Macdonald's *A Pond* (1894: GSA), included in *The Magazine* for November 1894, shows two emaciated and pallid figures beneath the waters of a pond gently lapped by weed-like growths with heads like tadpoles. Her *Ill Omen* (1893: HAG), also called *Girl in the East Wind*,

shows a girl standing with hair streaming in the wind with a flight of ravens – an ill omen – passing the moon behind her; a disturbing, forceful and haunting image of raw originality which must have been very striking in *The Yellow Book*, where it was published in 1896. (In the same July number, another work by Frances and two each by Herbert MacNair and by Margaret Macdonald were also published.) Margaret Macdonald's *Summer* (circa 1894: HAG), which appears to have been a design for stained glass, shows a man of ancient Egyptian appearance indentified with the sun kissing an immensely elongated, pale girl who perhaps symbolizes the organic life of the earth. The pair are nude; three years later, in the watercolour *Summer* (GAG), also by Margaret, we find a virtual replica of the earlier composition, but greatly prettified – and it is a very pretty work – by the replacement of the grotesque man by a group of cherubs who symbolize the fertility of the warm season, and above all by the fact that the Junoesque figure of summer herself, now no longer etiolated and sun- or sex-starved, is clothed in a floral gown. The contrast between the two versions illustrates clearly the sisters' tendency at this point to move towards subject matter of ever more feminine whimsicality. This is noticeable in the companion watercolours *Spring* (1897) and *Autumn* (1898) by Frances and *Winter* (1898: all GAG) by Margaret. In each case also the extreme attenuations of drawing have virtually disappeared; Frances's treatment of the female nude is frankly and surprisingly sensual. Her large delicate watercolour *Ophelia* in following year (private collection), with its ubiquitous butterflies, harebells and flowing draperies, resembles the work of Katherine Cameron (who contributed an amusing article on butterfly collecting to *The Magazine*) and Jessie M. King.

From 1896 the Macdonald sisters occupied a studio at 128 Hope Street, Glasgow, where painting was only a small part of their remarkable output in various applied media; in 1899 Frances married Herbert MacNair and left Glasgow for Liverpool, where he had been appointed instructor in design; and by 1899 Margaret had begun her long and immensely important collaboration with Mackintosh, whom she married in 1900, as contributor to several of his decorative schemes. After 1900 her work retains the perfumed melancholy of the nineties to a greater extent than that of Frances, although both sisters in different ways remain equally wedded to the formal vocabulary of that era. Margaret's *The Mysterious Garden* (1911: private collection), for which Billcliffe convincingly suggests a source in Maeterlinck's *The Seven Princesses,* relates to the Mackintoshes' scheme for the Waerndoerfer Music Salon in Vienna and employs a suitably Klimt-like decorative frieze of masks; while the almost monochromatic *The Pool of Silence* (1913: private collection) transforms the Ophelia-like subject in a near-abstract treatment which also has a sculptural

quality like one of her own gesso reliefs. It is a strange fact that after Frances's return to Glasgow with her husband in 1908 after nearly a decade of disappointed ambitions and dashed hopes, Frances and Margaret never resumed their former collaboration. After her return, Frances produced two moving watercolours which technically may suggest an unpractised hand but demonstrate that the Art Nouveau style of 'The Four' was still capable of poignant, painful expressiveness. The eternal triangle is the theme of *The Choice* and *'Tis a long Path which wanders to Desire* (both circa 1909-15: HAG); gone indeed, in the cold light of the new century, are the carefree fancies of the artist's young womanhood. The sequel is sadder still. Frances died in 1921; her husband lost all interest in art and destroyed the bulk of her work. As a response, surely, to the death of her sister, Margaret painted the beautiful *La Mort parfumée* (1921: HAG), where five mourning figures (possibly a single figure viewed episodically in a stooping forward movement) place roses on a bier, above which the soul of the departed rises serenely.

78 Frances Macdonald
'Tis a long Path which wanders to Desire
c. 1909-15
Watercolour, 35.20 x 30.10 cm
© Hunterian Museum and Art Gallery, University of Glasgow

In contrast with the sometimes outlandish conceits of the other members of 'The Four' in their youth, Mackintosh's graphic style seems almost classically serene. Throughout his life he made architectural notes and jottings, many of them beautiful in their own right, but strictly outside the scope of the present book. He also habitually drew flowers and plants, with such precision that several were used for teaching purposes in the Botany Department of the University of Glasgow by Professor John Walton (E.A. Walton's son), as he himself told me in 1968. It would not be too much to say of the botanical drawings that they provided Mackintosh with source material for the new vocabulary of form he was creating as architect and designer. Patently, they belong to a venerable tradition of botanical art which runs from Leonardo and Dürer to the Dutch flower painters of the seventeenth century and the later botanical illustrators like Redouté, for whom accurate description of the species in bud, flower, leaf and bulb or root is as important as a suggestion of its beauty. Mackintosh's father, Howarth records, was passionately interested in his garden; his family was surrounded by flowers from their earliest years.

Young Charles inherited his father's enthusiasm and habitually made studies from nature. The close examination of natural forms seems to have refreshed him; he loved flowers and found them inspiring, their natural structures helping to endow his own inventions with the energy and logic of their own organic life. There are on the one hand the botanical drawings, usually marked with the name of the species, and signed and inscribed not only with the date and place but also with the initials of those who were present on the day, rather like a scientific writing-up of a day in the field. These are essentially line drawings of the utmost lucidity, often with different 'elevations' superimposed on each other (Billcliffe makes a justifiable comparison between these and analytical Cubism), and with delicate wash indications of colour. We know from Desmond Chapman-Huston that it had been Mackintosh's intention to publish a collection of these in Germany, but the advent of war prevented it, and after the war the idea was considered but rejected as too expensive by John Lane at The Bodley Head. After 1914 he also painted flowers arranged in vases and here the technique was infinitely more elaborate, Mackintosh

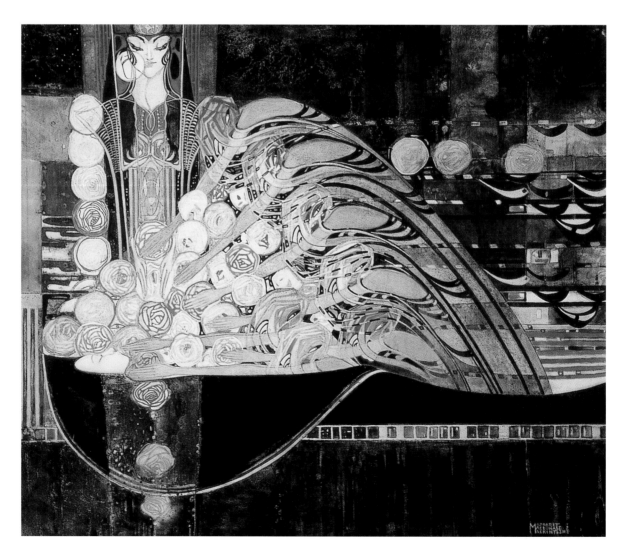

79 Margaret Macdonald
La Mort parfumée
1921
Watercolour, 63 x 71.20 cm
© Hunterian Museum and Art
Gallery, University of Glasgow

frequently delighting (as we have seen him do in earlier years) in solving fiendishly difficult self-imposed problems of technique in a successful effort to convey the beauty of the sumptuous blooms through an intoxicating display of virtuosity. This virtuosity is of no mean order. *Faded Roses* (1905: GAG) renders the very flesh quality of the drooping flower heads, their leaves on the turn, with a consummate sense of design and colour which gives tangible poignancy to the subject. *Anemones* (circa 1916: private collection) contrives to articulate two dozen examples of the species of all sizes and in whites, reds and blues of all shades with minimal drawing, the effect being achieved through brush-work of a delicacy and subtlety with which Arthur Melville himself would have struggled – and none of Mackintosh's contemporaries could have hoped – to compete, such is its combination of exciting immediacy with impressionistically descriptive accuracy. In the background, for we are now in a recognizable interior, an extraordinary abstract design (perhaps for a textile) based on a repeating sweetpea motif, hangs on the wall in a frame which is counter-balanced by the vertical blue stripes of the flower vase in the foreground. Abstract wave patterns of wallpaper add excitement to *White Roses* (1920: GSA) and *Peonies* (circa 1919-20: private collection) while in *The Grey Iris* (1900: GAG) all the colour comes from the wonderfully rendered still life – a Derby 'Imari' jug and a *famille rose* tea bowl. In *Pinks* (1922: GAG) Mackintosh paints nigh on fifty flower heads with the most attractive kind of virtuosity; the kind, namely, which communicates and proceeds from deep knowledge that is not merely technical. Their colour and form are brilliantly described, but their peculiar quality, character and beauty are also rendered with an amplitude which only just fails to convey their very perfume.

Discouraged by his failure to attract any commission commensurate with his architectural abilities – after the School of Art he was given no major architectural opportunity – Mackintosh resigned his partnership in Honeyman and Keppie in 1913, and in the following year he and Margaret left Glasgow for Walberswick in Suffolk. Here Mackintosh concentrated on painting flowers with the intention, mentioned above, of having them published by John Lane. The area was then and still is rich in certain varieties of wild flower, *Fritillaria* (1915: HAG) being a famous example in which nature appears to imitate geometry. The rather bizarre *The Little Hills* (HAG), painted in oils on two panels by Margaret but possibly designed by Charles, produced during the Walberswick period, revives the well-used 'Glasgow style' motif of subterranean figures – the cherubs who personify the 'little hills' – but its precise symmetry and mechanical design give it a Viennese look. A number of pensive landscape watercolours also date from this time of retreat. The end of the idyll, with Mackintosh's Glasgow accent,

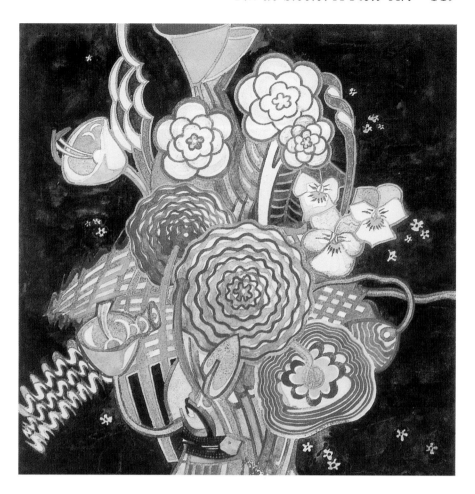

80 Charles Rennie Mackintosh
A Basket of Flowers
c. 1916
Watercolour, 31.70 x 30 cm
© Hunterian Museum and Art Gallery, University of Glasgow

ever-present sketchpad, and correspondence with German and Austrian colleagues leading to his being suspected of spying, could have come straight from the pages of 'Mozart on the Journey to Prague' when the composer's manuscripts aroused similar suspicions. The story of this and of his ultimately unsuccessful attempt, after moving to Chelsea in 1915, to set up an architectural practice in London in the difficult years during and immediately after the war, has been well told by others. Suffice to say that from this point until his death, and especially after his decision in 1923 to give up architecture, Mackintosh devoted himself increasingly again to painting.

A Basket of Flowers (circa 1916) is a characteristic *jeu d'esprit* in the Jazz Age idiom, but it is also something more than that. In this, one of a small group of geometricized studies of flowers painted against a black background of which seven examples are known, Mackintosh actually appears to anticipate one of the themes of Op Art, namely the eye-deceiving properties of a moiré design which can appear to move or to change pattern. Each species of flower – there are harebells, gypsophilia, pansies, pinks, peonies and chrysanthemums – is drawn in ground plan. The chrysanthemums alone, however, are presented *on the page* as lobed, concentric circles of alternating red and blue. But *to the eye*, these read as intersecting arcs, and not as the lobed circles they

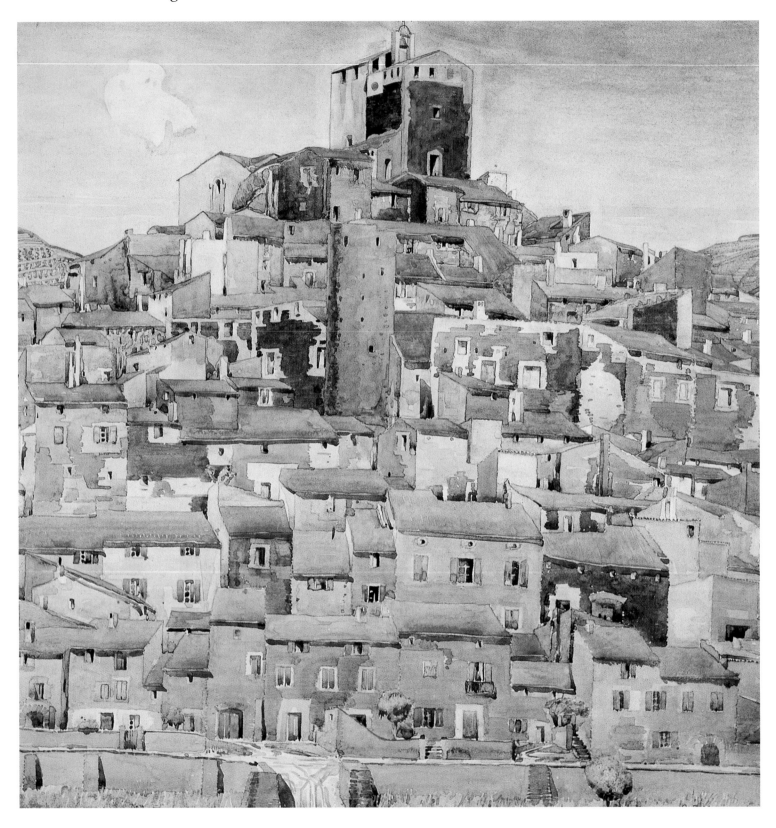

81 Charles Rennie Mackintosh
Boultenère
c. 1924
Watercolour, 44.70 x 44.70
Private collection

actually are – and in this respect describe the species admirably. These 'geometrical' flower paintings produced near the beginning of the Mackintoshes' London sojourn when they hoped to earn a living as textile designers, are related to textile designs of 1916. Lifted the merest jot from their modest origins as applied art, Mackintosh's astonishing textile designs, scaled up and presented as paintings like the framed sweetpea design seen in the background of *Anemones* would justly be regarded as precursors of Art Deco, of geometrical abstraction, of Op Art, Pop (in the American sense), as well as paralleling contemporary movements such as the *Section d'or*, or for that matter the colourism of Scottish painting; but they were never seen or exhibited, and remain objects of wonder without progeny or posterity.

The late landscape watercolours painted at Collioure and Port-Vendres, where the Mackintoshes settled on the advice of Margaret Morris and J.D. Fergusson in 1923, employ a chaste style of draughtsmanship and continue to the end to reveal the perfection of Mackintosh's technical gift in a series which allows no play of his remarkable imaginative powers. Their originality derives from the structural analysis of the motif and its translation into an extraordinarily pure combination of colour and line. We sense from these late works and also from his extensive correspondence of this period with Margaret, the artist's delight at his new-found freedom to experiment, without the worries of architecture or business, in a medium which tested to the limit his skill as painter and draughtsman. *Boultenère* (1924: private collection) typifies the architectural purity of his late landscape watercolours.

Among the associates of Mackintosh in Glasgow was George Walton (1867-1933), the younger brother of Glasgow School painter, E.A. Walton. George worked chiefly as an interior designer, in which capacity he became well-known for his designs for Kodak shops throughout Britain and the Continent. He shared with Mackintosh the responsibility for two of the brilliant schemes for Miss Kate Cranston's tearooms in Glasgow, at Buchanan Street and Ingram Street. His style is less radical than Mackintosh's and relates to Aestheticism; this is especially noticeable in his treatment of the figure and in his more crowded type of composition.

Outside Mackintosh's immediate circle in Glasgow, but owing much to it, and especially to the fairyland period of Margaret and Frances Macdonald, were the illustrators Jessie M. King (Mrs E.A. Taylor, 1875-1949) and Annie French (1873-1965), and the designers E.A. Taylor (d. 1952) and Talwin Morris (1865-1911). In the charming and accomplished decorative work of Jessie King and Annie French, the ethereal and other-worldly elements of Art Nouveau are sweetly intensified to a point where the world is reduced to a puff of thistledown, a web of gossamer, a diadem of forget-me-nots or a charm of finches, in which love-in-a-mist is personified as a pair of lovers, or where mermaids teach their babies to swim. These pretty conceits, delicate as butterflies' wings, will justly never lack admirers.

The hitherto unpublished *Journal* of Charles Mackie's wife Anne Mackie (MSS Collections, NLS), sold by her nephew, provides fascinating insights into the connections of this Edinburgh artist with leading French painters of the day. These turn out to be much closer than previously realized, and the diary is worth quoting *in extenso*. The first person is used throughout and refers to the writer Anne, and her husband the painter Charles Mackie. The young couple had been married in 1891. The undated diary begins:

> In high spirits we set off for France in the spring in 1892, spending a few days in London to see the National Gallery, then on to Cherbourg to make a pilgrimage to Millet's birthplace at Gréville [in fact, Millet was born at Gruchy. After spending a fortnight at Vauville nearby, the couple travelled on through Normandy and Brittany] always searching for a little town of the beauty of which we had read a description in a magazine but had forgotten the name. This turns out to be Huelgoat – a quiet little village in the heart of Normandy [it is actually in Brittany] and then only to be reached by a very long drive from Morlaix in a ramshackle *diligence* with two horses [where they found accommodation in a fine old hotel]. And here we made our first acquaintance with the most advanced French art and artists, calling themselves 'les Symbolistes' – Paul Sérusier and Clément, a Dane. Although to us their work seemed queer, yet it had a curious fascination in spite of misshapen peasants and pink ploughed fields. We were all very happy but our happiness had an abrupt and tragic end [when young Mme Sérusier suddenly died, probably of cholera] . . . There was a midnight service in the chapel where her coffin lay until it was taken to Paris. Never shall I forget the solemnity of that service – the bowed heads of the mourners, the dimly lit chapel, the chanting and the incense.

Accompanied by Clément whom they introduce to the works of Turner, they return to London where they stayed for a month studying the treasures of the National Gallery and of the British Museum.

> We returned to Paris the following May to be most hospitably received by M. Sérusier who introduced us to his friends at a delightful luncheon party in his beautiful apartment – 10 Place de la Madeleine, where he lived with his father and brother. He himself was on the point of leaving for Brittany but his friends welcomed us with open arms – Ranson, Vuillard, Redon and others whom I forget. [Sérusier recommends the great Manet exhibition which is about to close at

Durand-Ruel's] a great opportunity and lasting pleasure for still after many years his beautiful work remains in my memory. [Unfortunately the authoress does not say after how many years.] There we met Guthrie and Lavery. Lavery was a charming person to meet – Guthrie more self-conscious and aloof. [The diarist goes on to describe the Mackies' visit to Paul Gauguin in his Paris studio.] M. Sér[usier] had told us of another exhibition which was about to close – Renoir's, and also took us to a house which Renoir had just decorated . . . and last but not least gave us an introduction to Paul Gauguin who had just returned to Paris after his first visit to Tahiti. Mons. Gauguin asked us to visit him at his studio and there we spent one of the most interesting afternoons of our lives. The door was flung open by a tall young man with thick lips and very curly coal-black hair . . . who ushered us in to a beautiful studio where we were most courteously received by an enormously fat man, clad in a thin white silk undervest and a pair of trousers, for all the world like a great Chinese god with the same urbane, dignified smile. He was charming to us taking me under his wing, while the tall young man, who turned out to be a well known poet of the name (I think) of Leclerc, acted as guide to C.H.M. [Charles Mackie]. Strange, weird things we saw – wonderful pottery and wood carvings, paintings extraordinary to eyes which had been revelling in the beauties of the National Gallery and the Louvre but of beautiful colour and intensely interesting and sincere. The strong personality and charm of manner of our host, the amazing and varied collection of work, unlike anything we had ever seen and far removed from the affectations of his followers made a deep and lasting impression. [As one can readily imagine. Anne Mackie continues, with a now educated eye,] M. Sérusier's work disappointed me . . . I could not help feeling that his work although quite sincere, had little originality and seemed to have merit from his having associated with very clever people.

The diary continues with an intriguing account of the Mackies' obviously close acquaintance with the painter Paul Ranson and his wife, and ends with a visit to Vuillard's studio, where the leading Nabis makes the Mackies a present of one of his own paintings – the little *Deux ouvrières dans l'atelier de couture* which remained until he died in Charles Mackie's collection in Edinburgh, where it must have acted like the famous 'talisman' which Sérusier had brought back from Gauguin at Pont-Aven in 1888. The diary describes with such artlessness connections which are of great significance that no apology is needed for a final extensive quotation from it:

Our little studio in the rue Bara was open to our kind and hospitable friends . . . they loved my tea parties . . . tea and thin bread and butter and thin Paris cakes . . . Then on Saturday afternoons at M. Ranson's great, beautiful studio . . . an assemblage of friends presided over by his warm-hearted impulsive wife from the South of France with her black hair and large dark eyes and ample proportions and her beautiful sister, tall and slim of a dusky fairness with great violet eyes & golden hair curling all over her head in enchanting ringlets. It was delightful to see Mme. Ranson's pride in her beauty . . . The other studios we visited were more workaday and poverty stricken. I remember Mons. Vuillard's little garret stacked with pictures as if buyers came but rarely and his kind command to take the picture we liked best. And we were so afraid of being greedy that we took the smallest we could find but that picture is still a joy. And what quiet happy hours we spent looking over Japanese prints . . . the trusting shopkeepers letting us have great bundles home with us to choose what we wanted. We wanted all but although they were so cheap we never had money to spare . . .

In Edinburgh, *The Evergreen: a Northern Seasonal* published in four numbers by Geddes and Colleagues in Edinburgh in 1895-97, briefly had, through the French connections of its contributors Robert Burns and Charles Mackie, contacts as international as their Glasgow colleagues. Like 'The Four', Burns contributed to *Ver Sacrum*, and his own later work – e.g. the collection of Klimt-inspired illustrative drawings at the Hunterian Art Gallery – suggests that Burns was more influenced by the Vienna Secession artists than any of the other Scottish artists: unlike 'The Four', it could be said that the Edinburgh artists were more influenced than influential. However, this Vienna Secession journal seems to have borrowed at least one of the ideas of *The Evergreen*, the almanacs which preface some issues, although the idea may derive ultimately from the seasonal content and plan of *The Magazine* to which Mackintosh and his circle at Glasgow School of Art were contributing from 1894, and which it is entirely possible may have been seen by Geddes through his friendship with Newbery, rather than with the Mackintoshes whom he came to know later.

The Evergreen was a brave but short-lived venture producing results of mixed quality as far as the visual arts were concerned; its literary content is dominated by the 'Celtic twilight' sensibility of William Sharp, pseudonymously 'Fiona Macleod'. Perhaps the best things are the covers in embossed leather designed by Charles Mackie, and his charming, very Nabis black and white illustrations on such themes as 'Hide and Seek', 'When the Girls Come Out to Play' and 'Chucks'. Patrick Geddes, the publisher of the four seasonal numbers of *The Evergreen*, wrote to him to announce his delight that Mackie should have chosen for one cover the plant *aloe plicatilis* which d'Arcy Thomson and he were 'prepared to prove was the

original *arbor vitae* itself'. He adds, 'I take it as an omen that Science and Art are to be better friends than ever'. A note in the National Library of Scotland shows, too, that *The Evergreen* had at least two subscribers at Pont-Aven in 1895, one of them a Madame A. Henry at the Hôtel Gloanec. Charles Mackie, whose acquaintance with Gauguin and his circle brought him into closer contact than his Glasgow colleagues with the fountainhead of Symbolism, looks like a French Symbolist in the small study for *The Bonnie Banks O'Fordie* (1894: private collection). The convincing Nabis quality of this work was visible also in the wood engraving printed in *The Evergreen* but was lost in the scaled-up version exhibited at the RSA in 1897 as *There were Three Maidens Pu'd a Flower*. One wonders whether any others among Mackie's excellent compositions for *The Evergreen* were also painted in oils.

Robert Burns's *Natura Naturans* apparently produced during his stay in Paris in 1891, is the most original of all the illustrations; the contribution by Paul Sérusier – *Pastorale Bretonne,* in the Spring 1895 number – is disappointing, having perhaps suffered from bad block-making. The Celtic revivalism and biological mysticism which dominate the articles make heavy reading today, yet these are elements firmly interwoven also in John Duncan's work and which he passed on to his protégé, George Dutch Davidson, after the demise of *The Evergreen* in 1897. Duncan, Burns, Robert Brough and Mackie produced the most interesting work for the four issues, but this was their best period. Mackie's little sketch *By the Bonnie Banks O'Fordie* has an authentically Nabis appearance, but his work, and that of the others, later becomes humdrum, unless one has a special taste for the elaborate *kitsch of* Duncan's *Riders of the Sidhe* (DAG) and the many works of similarly Celtic inspiration which Duncan produced well into the late part of his career. Phoebe Traquair (1852-1936), the ceramicist who was Edinburgh's outstanding applied artist of the period, was inspired by similarly Celtic subject-matter. Mackie's Venetian studies painted in the early years of the century are beautiful but hardly break new ground.

In 1902, to commemorate their recently deceased colleague, members of the Dundee Graphic Arts Association published by subscription a memorial volume edited by John Duncan illustrating many of George Dutch Davidson's works in collotype and publishing his letters from Italy. The poet W.B. Yeats, returning a copy of this beautiful book which had been lent him by one of the members of the Association, wrote an accompanying letter full of a sense of *lacrimae rerum* appropriate not only to the death of a young artist, but perhaps also to the passing of a decade in which youthful originality had promised, and achieved, so much. Yeats writes:

> . . . the book is beautiful with a kind of ritual beauty – as of things that have by very energy of

feeling passed out of life, as though precious stones were made by the desire of flowers for a too great perfection – all such art delights one as if it were part of a religious service speaking to the whole soul, the passions not less than the moral nature uniting it to an unchanging order. Of course one can see influences, but that is an original nature using all, a nature more delicate and sensitive but less cold and logical than Beardsley's – whom I knew. How strange that these lyrical and decorative natures should so often be short-lived – Beardsley, Shelley and lesser men whom one has known, though the world has not.

George Dutch Davidson (1879-1901), the most talented of the east coast contemporaries of Mackintosh, achieved enough in a short life of twenty-one years – several haunting and startlingly prophetic watercolours and a group of supremely fine pen drawings – to make one wonder where his precocious visual intelligence might have led him granted only a few years more. He left school in 1895, intending to become an engineer. But in the spring of 1896 when he was sixteen, he fell victim to a severe attack of influenza, which left him with a serious heart condition that drastically shortened his life and left him a semi-invalid until his death at the age of twenty-one. A long convalescence was spent at Baldragon, near Dundee. He recovered slowly, and in the autumn of 1897, despite contrary advice from his physician and although he had shown no previous interest in drawing, he enrolled in the art classes of Dundee High School.

The return to Dundee enabled Davidson to extend his circle of companions to include a number of local artists, among them David Foggie (1878-1948), Frank Laing (1852-1907), John Duncan (1866-1945), Alec Grieve (1864-1933), and Stewart Carmichael (1867-1950). The young artist's style would probably not have developed as rapidly as it did without the benefit of his friendship with these talented and (in John Duncan's case) erudite artists. David Foggie, whom he met at this period, records:

> Together we studied energetically after the antique and after the life when we could persuade our friends to pose for us. We also worked much at applied ornament. The immediate outcome of this zeal, for him, was a phase during which he made some half dozen drawings in watercolour, applied in flat wash and with great strength, the form being curved lines merely . . . in them was first shown his unique decorative powers.

This very early period of experimentation bore fruit in the spring of 1898 with the *Abstract* of which only two versions have survived, one with a theosophical or cosmic setting of stars which the other lacks; and the powerfully symbolist *Envy* (all DAG). Davidson had probably met John Duncan by the time he painted this singular work, which shares certain

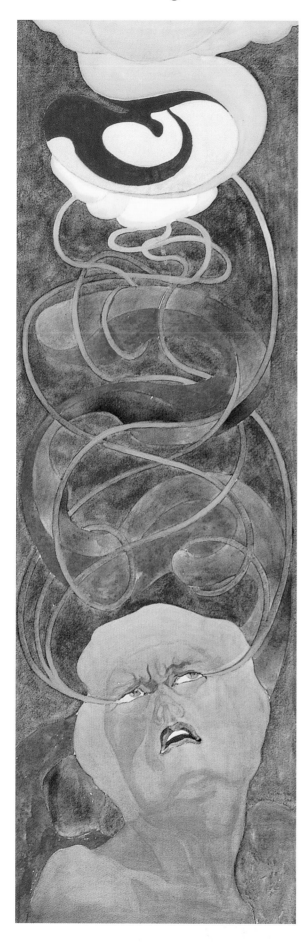

features with Duncan's line illustration *Anima Cel-tica* which had appeared in the Spring number of *The Evergreen* in 1895. In both designs, the head of the dreamer is shown in the lower half of the picture, but whereas Duncan's version of the reverie takes a concrete and illustrative form, Davidson's much more concentrated use of the decorative motif (a form of loose Celtic knot-work) is logically and dramatically superior. His colour is equally original. This extraordinary green-skinned creature, whose green eyes have bright red pupils, may be a distant cousin of the spooks engendered earlier in the decade by the Macdonald sisters in Glasgow, but even they, puzzling though their actions sometimes were, were never recorded with bad dreams sprouting from their eyes in the form of Art Nouveau tendrils exploding into gadroon-shaped blossoms of orange, lilac, and blue. Already in his first completed works Davidson had shown the personal quality of his imagination and subtle colour. The remarkable *Self-Portrait* belongs also to this period. Its fortuitous resemblance to a composition of Edvard Munch – *Im Menschenkopf,* (1897) – is all the more noteworthy when one realizes that of the two images it is the Davidson which is the more susceptible of Freudian interpretation. Rarely can there have been a more graphic illustration of the Freudian principle of id, ego and superego than here. Similarly, the abstract works seem extraordinarily prophetic and one can only speculate on how, and how far, their eighteen-year-old author would have developed this line of thought had he lived.

The symbolic style of *Envy* was discarded almost immediately, but the Celtic strain appeared again more conspicuously in a *Celtic Illumination* painted on vellum in 1899, in all probability under the influence of John Duncan, whose studio in Dundee at 31 Albert Square Davidson shared from the summer of 1898 until the autumn of 1899. The most purely decorative of George Davidson's works date from this period of his closest association with John Duncan. George produced several embroidery designs of great originality, some of them woven by Nellie Baxter who had (with Annie Mackie and Helen Hay) contributed interesting Celtic *culs de lampe* to *The Evergreen*, the artist's ultimate intention being to develop an embroidery school in collaboration with his cousin Elizabeth Burt. Of this period John Duncan wrote:

> He was the most ardent student, assimilated everything that came his way, Celtic ornament, Persian ornament, Gothic architecture, early Renaissance art, seventeenth century tapestries, and wove every new influence into the tissue of his style. For he already had a style, mere youth as he was . . . His ornament was made up of Celtic and Persian elements, sometimes one and sometimes the other prevailing, and at other times drawn direct from nature. He made a number of very beautiful drawings of flowers and of foliage,

82 George Dutch Davidson
Envy
1898
Watercolour, 76.20 x 24.10
The McManus: Dundee's Art
Gallery and Museum
Dundee Art Galleries and
Museums (Dundee City Council)

seeking the rhythmic laws of their being. His colour always tended to be sad, though he was ill satisfied that it should be so . . . But he strove forward into the light, and achieved a pensive sweetness of faded pinks, and gold, and misty blues, and clouded violets.

In September 1899 George and his mother left Tayport, where they were now living, for the ten-month period of residence in London, Antwerp, and Florence which was to be the great experience of George's life. Three weeks were spent in London, where he assiduously visited the National Gallery, the South Kensington Museum, and the British Museum, his highest enthusiasm being reserved for the early Italian painters, especially Fra Angelico, and for the Greek vases and Oriental textiles in the collections of the great museums.

Antwerp was reached at the beginning of October. Four productive months were spent there. The little *Flemish Landscape* which records an impression of the country seen while sailing up the Scheldt, shows the muted use of colour which henceforth characterized his work in this medium. It also shows how the artist saw nature in pattern – although by his own account the pattern in this case was pre-existing:

> We were sailing up the Scheldt. The country looks distinctly foreign and I found it very interesting no doubt because it is extremely decorative. There are no woods – the trees are placed in long straight lines at regular distances apart, and the foliage assumes some very nice forms . . . I could never have conceived houses so like toy ones – no! not even in a sampler design.

The pen drawing of a shrine opposite his window in the rue des Beggards, *A Street Corner in Antwerp* (1899: DAG) , is an equally remarkable example of his faculty for seizing the decorative essentials of a subject. A sensitive pencil portrait of his mother drawn in November 1899 completed this trio of works of a semi-objective nature.

The next group of Davidson's works – four in number, all executed in Antwerp – belongs to the category of imaginative illustration. He now moved still further from what he regarded as 'the deep pit of Realism', a hazard he had been advised by John Duncan to avoid by staying away from the classes of the Antwerp Academy. *The Hills of Dream* (1899: DAG) illustrates a quatrain from a book of the same name by the pseudonymous Fiona McLeod, the chief poet of the Celtic Revival:

> And a strange Song have I heard
> By a shadowy Stream
> And the Singing of a snow-white Bird
> By the Hills of Dream.

But the apparent influences on this picture are early Italian and Persian rather than Celtic, although the passage upper left showing the girl transported episodically and literally on the wings of the Song seems entirely original. Fiona McLeod's *On a Dark Wing* inspired another illustration, this time in watercolour grisaille, with the lettered text incorporated in the design – an idea which was taken further in a later project drawing for an illumination of the poem *A Dream of a Blessed Spirit* by W.B. Yeats. The last two works done in Antwerp, both

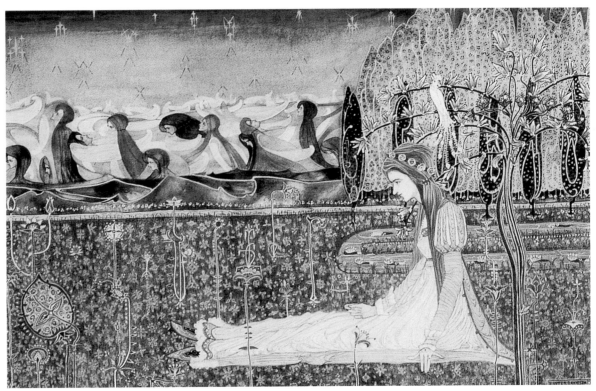

83 George Dutch Davidson
The Hills of Dream
1899
Watercolour, 43.20 x 68.60 cm
The McManus: Dundee's Art
Gallery and Museum
Dundee Art Galleries and
Museums (Dundee City Council)

84 George Dutch Davidson
The Tomb
1899
Pen and ink, 24.10 x 29.80 cm
The McManus: Dundee's Art
Gallery and Museum
Dundee Art Galleries and
Museums (Dundee City Council)

illustrations to passages from *The Rubáiyát of Omar Khayyám*, are extremely intricate pen drawings entitled *The Tavern Door* and *The Tomb* (both DAG). Both drawings, especially the latter, mark a technical advance on the awkwardness of *The Hills of Dream*. Indeed, *The Tomb* is something of a *tour de force* in its complex refinement.

On 1 February 1900, Davidson and his mother left Belgium for Italy. He left Florence at the end of June and arrived in Scotland in August, having spent the intervening time chiefly in Ravenna and Venice. The works produced after his return, in the last five months of his life, are still of a complexly decorative character; but the influence of *quattrocento* painting, and of the Tuscan landscape, is visible in *Ullalume* (1900: DAG) – an illustration to a poem of Edgar Allan Poe – and in *Apotheosis of the Child* (DAG), his unfinished last work. Both designs are more expressively poignant than any of their predecessors, in a more purely Italianate way. They also show an even greater degree of technical refinement. Of the other works from this final period, *The Silent Pool*

(private collection), for which a drawing had been done in Antwerp, is the most ornamentally decorative of all his watercolours; an embroidery design (DAG) which Davidson regarded as his best was executed posthumously; and three small pencil drawings exist (DAG) for projects which were never completed.

George Davidson had no artistic progeny. The little group of which he was briefly the centre in Dundee had already lost John Duncan to Chicago in 1901. Art Nouveau in Edwardian Dundee was restricted to architecture, notably the six schools designed for the Dundee School Board, and the fascinating Church of St. Mary's Forebank with its pagoda twin spires, by the Dundee firm of J.H. Langlands between 1905 and 1913. But in Davidson's work Dundee may be said to have made an original contribution to the iconology of that exotic movement. With its combination of intensity and refinement and its syncretic use of several decorative influences, it is one of the rarest blooms in the hothouse.

THE COLOURISTS

One possible view of the four painters who have been called the Scottish Colourists – S.J. Peploe (1871-1935), J.D. Fergusson (1874-1961), Leslie Hunter (1877-1931), and F.C.B. Cadell (1833-1937) – is that they continue a specifically Scottish tradition first established by William McTaggart and his younger contemporaries in Glasgow who formed the Glasgow School. McTaggart from before the 1870s and the Glasgow painters from the 1880s introduced vigorous handling and bold colour to Scottish painting at a period when accepted academic practice still rested on the twin pillars of high finish and imitative drawing. McTaggart's seashore pictures, and such a work as W.Y. Macgregor's *The Vegetable Stall* (1884), had restored to landscape and still life a certain monumentality and expressive breadth which resulted from powerful brushwork and the use of a lighter palette than was then common. That Fergusson and his friends were influenced by the example of these earlier painters is evident from some of their early paintings. Other evidence points to the same conclusion. A notebook of Leslie Hunter's, written about 1914, records the colours used on the palettes of Van Gogh, Gauguin, Cézanne, Whistler – and William McTaggart; and Cursiter states, 'Peploe had a high regard for McTaggart – one of his greatest regrets was that he never met this fine Scottish artist'. Peploe knew and admired W.Y. Macgregor, the 'father of the Glasgow School', one of whose paintings was the only work by another artist which Peploe hung in his own studio. F.C.B. Cadell also had a Glasgow School connection in the friendship of his parents with Arthur Melville, who was godfather to his young brother and persuaded his parents to send the young Cadell to study at Julian's in Paris. An early *Flower Piece* (1907: private collection) by Cadell is decidedly Melvillesque, and Cadell's *Jack and Tommy* drawings (1916: private collection) provide the clearest case of a Glasgow School influence; their humour is of the London Sketch Club variety, but their extreme economy of line emulates Joseph Crawhall. J.D. Fergusson claimed that Arthur Melville was the 'first influence' on his own painting, and that 'Although I never met him or saw him, his painting gave me my first start; his work opened up to me the road to freedom not merely in the use of paint, but freedom of outlook'.

Fergusson's remark serves to summarize the relation of the Colourists of his own generation to the Glasgow School as a body. There is little trace of Melville's highly individual style in Fergusson's own manner, with the notable exception of *On the Beach, Tangier* (1899: GAG), which is strongly reminiscent of Melville's *Mediterranean Port* (1892: GAG). The interest of Melville's style lay, more generally, in his painterly execution and exuberant use of colour; and it was under Melville's influence that Fergusson first went abroad to paint, visiting Paris in 1896 and North Africa in 1897. Foreign travel and the contact it provided with advanced painting on the Continent were of the greatest importance to each of the Colourists in their formative years. Fergusson's attitude in this respect is symptomatic. In his idiosyncratic and infuriating book *Modern Scottish Painting* (1943) he justifies his decision to exile himself from Scotland in terms which excoriate the philistine environment – equated variously within Victorianism, Calvinism, and academic art – which smothered the early vitality of the Glasgow School. We learn from Honeyman's account of Leslie Hunter that Hunter too was critical of the absence of colour in Scottish life, and in the Peploe correspondence we find the remark 'it is terrible to be an artist and live in Edinburgh' (1908), and in 1912, written from Edinburgh to his wife in Paris, 'I couldn't go back to this house and this life – it all seems so cramped and dull'. Whether or not one accepts these points of view, it is evident from them that in the eyes of Hunter, Fergusson, and Peploe, at least, colour had an important role to play in the salvation of a Scottish painter. Here is one explanation of the pilgrimages made by the Colourists to France: to the Paris galleries where they could see the works of the Post-Impressionists, and to the dazzling light of the Côte d'Azur.

The Glasgow School was at the zenith of its influence on Scottish art affairs in the Edwardian period when these artists were still at an early stage in their careers. Many of its members had by this time been made members of the RSA, and although most of the Glasgow painters had become formula-bound, at least three of them began in the earlier part of this century to use colour in a high-keyed manner which represented a genuine development from their earlier styles. These artists were E.A. Hornel, Stuart Park and W.Y. Macgregor. The two versions of *Oban Bay*

(neither dated: GAG) by Macgregor present a remarkable and by no means disappointing contrast with his earlier style: they indicate a convincing grasp of a new colour idiom. Hornel's paintings from 1900 until his second visit to the Far East in 1907, include some of his best work, not yet entirely spoiled by sentimentality or crude handling, and also in a higher key than previously. Stuart Park, too, had arrived by this time at a second, admittedly more superficial, phase in his work, but his use of strongly accented colour contrasts at this period is as striking as his fluid technique with a full brush. Certain parallels may be drawn between this artist's flower paintings and Peploe's 'white period' pictures painted between 1905 and 1910. But the comparison should not be pressed too far. It suffices to say that, while Peploe, Fergusson, Hunter, and Cadell were forming their characteristic styles, a few other Scottish painters were groping towards the consistent use of colour in a high key. With the exception of Robert Bevan, the Camden Town painters were less thorough-going than their Scottish contemporaries in this respect.

However, it would clearly be absurd to suggest that the sources of the Colourists were exclusively Scottish. In fact, the early lives of these artists were unusually cosmopolitan. This is especially true of Leslie Hunter, who left Scotland for the Mediterranean climate of California at the age of thirteen,

worked as an illustrator in San Francisco, and returned to Glasgow in 1906, after the earthquake of that year had destroyed all his pictures in his first one-man show on the eve of its opening. He had managed to visit Paris in 1904 and continued to do so at intervals during his career as an illustrator in Glasgow, which seems to have lasted until 1914. A compulsive draughtsman, Hunter was largely self-taught, like Fergusson, whose only formal instruction in painting seems to have been received at the Académie Colorossi briefly about 1898. Fergusson himself lived in France until the outbreak of war in 1914; after 1918 he made frequent return visits and was again permanently resident there from 1929 until 1939, when he returned to Glasgow. Peploe received a formal training in Edinburgh and Paris. However, he appears to have despised it and described Bouguereau, his teacher at Julian's, as a 'damned old fool' in a scribbled catalogue note to his exhibition at the Kraushaar Gallery in 1928. Before 1910 he had visited Paris on several occasions, and Amsterdam once. A mischievous early drawing, dated 1898 (J. Cadell) by F.C.B. Cadell, indicates an equal disrespect for the local establishment; it shows C.W. Hodder, head art master at the Edinburgh Academy, as a decrepit valetudinarian surrounded by plaster Venuses. Cadell studied in Paris from 1899-1903, and seems to have spent most of the decade from

85 John Duncan Fergusson
Afternoon Coffee
c. 1904
Oil on panel, 28 x 35.5 cm
Private collection
© The Fergusson Gallery (Perth and Kinross Council, Scotland)

1899 to 1909 on the Continent.

As their different ages and backgrounds would lead one to expect, the early achievement of these painters indicates unequal levels of maturity. As the oldest of the four, S.J. Peploe developed earlier than Hunter and Cadell, and two distinct phases are evident in his work before 1910, both showing his decided francophilism. J.D. Fergusson wrote: 'Before we met, Peploe and I had both been to Paris – he with Robert Brough and I alone. We were both very much impressed with the Impressionists whose work we saw in the Salle Caillebotte and in Durand-Ruel's gallery. Manet and Monet were the painters who fixed our direction, in Peploe's case Manet especially. He had read George Moore's *Modern Painting* and Zola's *L'Oeuvre*'. Peploe's Comrie landscapes of 1902 are indeed Impressionistic, while his early portraiture indicates an admiration for the *peinture claire* of Manet, although the influence of Frans Hals can be discerned in his *alla prima* method and the informal poses chosen for his sitters. The large portrait of *Old Tom Morris* (n.d.: FAS), clay pipe in hand and whisky glass upraised like a Hals toper, is a typically fluent example; the work of Peploe's close friend of this period, the Aberdeen artist Robert Brough (1872-1905), whom we have already encountered as a contributor to *The Evergreen,* reveals a similar fluidity of handling. With his move in 1905 to the studio which had once belonged to Raeburn at 32 York Place in Edinburgh, and which Peploe decorated 'in a pale grey with a hint of pink', the Manet strain became dominant in his work. Between 1905 and 1910 the mastery of Peploe's handling of his creamy, lustruous medium, and the boldness of his brushstroke are considerably more personal than anything achieved by Hunter or Cadell in the same period.

In 1906 Fergusson and Peploe spent the summer painting together at Paris-Plage, and in the following year Fergusson decided to settle in France and exhibited at the Salon D'Automne (of which he became a *Sociétaire* in 1909). In the first decade of the century Fergusson developed with great assurance and rapidity towards a fully Fauve style, which does not always seem entirely French. *The Pink Parasol* (1908: GAG) shows a remarkably early grasp of Fauvist colour practice, but sometimes his style has a bejewelled, ornamental quality (cf. *The Blue Hat,* 1909: ECAC) and at others an Expressionistic forthrightness (*Torse de Femme;* circa 1911: GAG) more reminiscent of Jawlensky or Erbslöh, but quite sufficiently individual to stamp Fergusson as one of the most powerful personalities among the contingent of foreign painters in Paris. Fergusson began as an admirer of the Glasgow School, particularly of Arthur Melville, and of Whistler. *Dieppe, 14th July 1905: Night* (David Long Co., New York) is joyfully indebted to Whistler's *Cremorne Gardens* fireworks pictures. There is something also of James Pryde's *John Jorrocks* in Fergusson's *Le Cocher:*

86 John Duncan Fergusson
The Blue Hat, Closerie des Lilas
1909
Oil, 76.20 x 76.20 cm
City Art Centre, Edinburgh
Image © City of Edinburgh
Council
Painting © The Fergusson
Gallery (Perth and Kinross
Council, Scotland)
The sitter was Yvonne Davidson,
wife of the American sculptor, Jo
Davidson.

Crépuscule (1907: J.R. Ross). By 1910 Fergusson had already demonstrated his command of a wider range of themes than his Scottish colleagues possessed, and in the remarkable groups of works produced in the years 1910-18, the female nude was added as a further major theme, and was followed, but not replaced, by the exceptionally original war paintings of naval dockyards.

Leslie Hunter at this time was still producing illustrations which show an admiration for Forain and Steinlen. About this period he became acquainted with the paintings by Kalf at Kelvingrove Art Gallery in Glasgow and with the three paintings by Chardin in the Hunterian Museum, which were influences on his early realism, of which *Kitchen Utensils* (circa 1914: TG) is an example. Hunter was the least intellectual of artists and never showed the formal sophistication of the other Colourists, preferring to develop gradually his use of high-key colour in a craftsmanlike way. Similarly, Cadell's work before 1910 does little more than hold some promise of future originality. The facility of his draughtsmanship and gift of colour are evident in the early *Flower Study* (1907) already referred to.

It was in the years 1910-14 that Peploe and Cadell began to paint in the distinctive way which J.D. Fergusson had to some extent pioneered for them, which was to be followed later by Hunter, and which

87 Samuel John Peploe
Boats at Royan
1910
Oil, 26.70 x 34.30 cm
Private collection

earned for these artists the title of 'Colourists' (which incidentally does not seem to have been used until 1948, when only Fergusson was still alive). Peploe, Hunter and Cadell had first exhibited together in 1923 at the Leicester Galleries, but they were joined by Fergusson as *Les Peintres de I'Écosse Moderne* at the Galerie Barbazanges in 1924, and brought to a total of six by the addition of Telfer Bear (1874-1973) and R.O. Dunlop (b. 1894) as *Les Peintres Écossais* at the Galeries Georges Petit in 1931. In 1910 Cadell visited Venice, sponsored by his friend Sir Patrick Ford, and also in 1910 Peploe moved with his family to France, where he painted at first in Paris and Normandy and then on the Côte d'Azur with Fergusson and Anne Estelle Rice. For both men their experiences provided the release which drew from them a number of novel works. Rapidly painted on panel, Cadell's little *St. Mark's Venice* (1910: J. Cadell) and Peploe's *Boats at Royan* (1910: private collection) boldly employ bright colour which achieves a striking lyrical intensity and simple immediacy.

Fergusson's *Royan Harbour* (1910: HAG) presents an obvious and close parallel to the Peploe, but already heavy outlines which expressionistically reinforce the composition are evident in Fergusson's work. These appear with greater aptness in the figure subjects of this period. In *Blue Beads* (1910: Fergusson Foundation), the simplifications of plane recall Matisse's portrait of Marguerite Matisse (*Girl with a Black Cat*) of the same date; *La Force* (1910: ibid.), fully justifying its title, calls to mind Fergusson's own later words in his chapter on *Art and Engineering*: 'We admire the woman that looks as if she was capable of procreation, in other words healthy and capable of functioning'. The sensuously hedonistic *Torse de Femme* at Kelvingrove is another example in which powerful handling is matched by a robust voluptuousness in the model. Thus, by 1910, the year of Roger Fry's celebrated exhibition of paintings by Manet and the Post-Impressionists in the Grafton Gallery, Fergusson, Peploe and Cadell were producing work which in terms of colour was as closely in sympathy with advanced French painting as anything in British painting. For his 1910 exhibition Fry had considered applying the title 'Expressionist' to the chromatic daring of Van Gogh and Gauguin, but in his Second Post-Impressionist Exhibition of 1912 he removed the emphasis which his earlier exhibition had laid on colour, and placed it instead on formal and constructional values in painting. The development of the Scottish Colourists at almost exactly the same period presents something of a parallel to the development of Roger Fry's views. Between 1912 and 1914 Peploe and Fergusson worked together and began to draw and paint in a more formalized

manner which reveals a knowledge of Cézanne and his Cubist followers. Furthermore, as described by E.A. Taylor in Paris in 1914, Leslie Hunter was 'Full of Cézanne – he had been to where Cézanne worked etc. and he . . . showed me a number of chalk drawings he had done, quite a departure from the things he had originally shown me'.

In December 1913 the Society of Scottish Artists, not to be outdone by London, included in its Annual exhibition a number of invited works by Cézanne, Gauguin, Herbin, Matisse, Russolo, Sérusier, Severini, Van Gogh and Vlaminck as well as works by Fergusson and Duncan Grant. In twelve letters written to me in 1973-74 (NLS) Stanley Cursiter (1887-1976) wrote that a chance introduction to Roger Fry and Clive Bell at the Grafton Gallery

exhibition of 1912-13 set in motion the loan of these European works to the SSA exhibition. Cursiter writes: 'I was actually responsible for the [SSA] Exhibition of Post-Impressionists in 1913 . . . Circumstances made it possible for me to borrow a group of pictures from the exhibition held in London in the Grafton Galleries . . . The Exhibition in Edinburgh nearly wrecked the Society!' Cursiter further explains that the SSA of which he was then a Council member 'had a very definite aim to secure on loan for each Exhibition, important works from France, etc.' Since Futurist artists were not in fact included in either of Fry's exhibitions, it is probably safe to assume that at the distance of some sixty years the artist had forgotten the Futurist exhibition of 1912 (Sackville Gallery) and the Severini exhibition

88 Stanley Cursiter
The Sensation of Crossing the Street, West End, Edinburgh
1913
Oil, 50 x 60 cm
Private collection
© Estate of Stanley Cursiter 2010. All Rights Reserved, DACS.
Four streetcars, a hackney carriage, twenty-three figures and a white dog at the corner of Princes Street and Lothian Road.

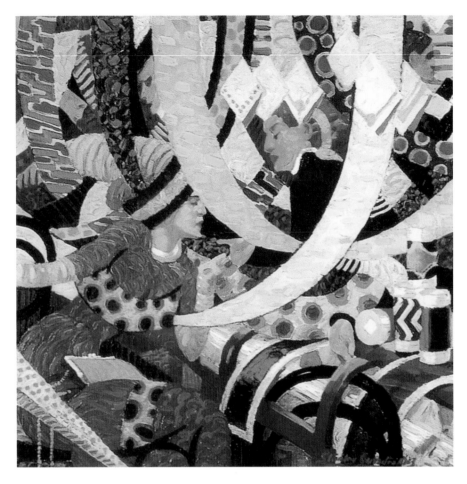

89 Stanley Cursiter
The Ribbon Counter
1913
Oil, 48 x 48 cm
Private collection
© Estate of Stanley Cursiter
2010. All Rights Reserved,
DACS.
Fashionable customer and
deferential assistant amid the
colours and patterns of Jenner's
haberdashery on Princes Street,
Edinburgh.

Tea Room and *Synthesis of the Supper Room at an Arts Club Reception* (ECAC), are small, deliciously painted, and tentative in the use of the Futurist style. *The Ribbon Counter* (private collection) is much more confidently composed and brilliant in colour and is based on a Severini composition, as is *The Sensation of Crossing the Street, West End, Edinburgh*. The most complexly geometrical of the series, the latter is a *tour de force* containing a crowd of figures, a hackney carriage, cable cars, a dog and a self-portrait of the artist against a detailed architectural portrait of Edinburgh's West End (including Binns's clock showing four in the afternoon). The viewpoint is from the south side of Princes Street and the whole busy, modern scene provides a 'sensation' pleasing to the pretty girl in the foreground. In the related, unfinished *Princes Street on Saturday Morning* (private collection), the artist is beginning to introduce a Futurist, Sant' Elia-like treatment of the architecture, this time looking towards the east. *Rain on Princes Street* (DAG), painted with a nearly monochromatic palette, contains a striking passage which shows the lamp standards outside the New Club modelled in the manner of sculpture by Umberto Boccioni. Almost certainly last in the series is the unfinished, Fergusson-like *The Regatta* (SNGMA). From the Commodore's yacht, flying the white ensign of the Royal Yacht Squadron at Cowes, an elegant party of spectators watch an afternoon's racing on one of those carefree summer days which the war was to bring to an end.

Cursiter, like so many artists, enlisted at the outbreak of the war and was sent to the trenches of the Somme, but not before completing several figure paintings of compelling quality, of which the most important is undoubtedly the beautiful *The Evening Hour* (1914: NGS), a conversation piece including portraits of the artist's sister, her husband and friends in the artist's studio in Queen Street, Edinburgh, and a passage of still life painting worthy of early Peploe and Fergusson. Incredibly a third style was added by Cursiter to the two we have already examined from this pre-war period, in a group of Maja-like reclining studies of an extremely pretty brunette model, at least one of them nude (except for a head band and a wrist watch). Brief mention only can be made of his vastly accomplished earlier work as an illustrator working for the Edinburgh firm of McLagan & Cumming (1904-1908); the early lithographs, often illustrating Northern legends, provide ample evidence of his versatility and technical prowess. Cursiter made a significant contribution to the development of aerial cartography during the war. His great talents were exercised in other fields after the war – in his own words he 'became a portrait painter more or less by accident', and also, he might have added, a distinguished painter of the landscape of his native Orkney. From 1930 to 1948 he was an innovative Director of the National Galleries of Scotland, laying plans for a Gallery of Modern Art and writing a

of 1913 (Marlborough Gallery) which he could well have seen in London. The pictures by Severini and Russolo were among several which were also shown at the Glasgow Institute a month before their appearance in Edinburgh at the SSA in December 1913. Stanley Cursiter's *The Sensation of Crossing the Street, West End, Edinburgh* (1913: private collection) was the artist's sole exhibited response in the SSA show of 1913, to his recent experience of Italian Futurism, and particularly the work of Severini, with whose *Le Boulevard* in the same exhibition it would immediately have invited comparison. This spectacular painting and J.Q. Pringle's *View of Bridgeton* interestingly, were shown at the Whitechapel Art Gallery's *Twentieth Century Art: A Review of Modern Movements* in the following year. In fact the painting was one of an astonishing series of seven Futurist compositions painted by Cursiter in 1913 and depicting that modern life – if not quite the machine age – so beloved of the Futuristi using the multi-faceted simultaneity of Severini and then the elastic rhythms of Boccioni. These paintings reveal such intensity of invention, such excitement at the discovery of a new formal vocabulary, and such painterly quality of colour and brushwork, that they merit listing individually in a chronological order suggested by stylistic progression and also by information provided by the artist himself in the 1974 correspondence already quoted.

useful study of Scottish painting and the standard biography of Peploe.

Press reaction to what must have been an unusually exciting SSA exhibition in 1913 was surprisingly open-minded. The *Scotsman* commented: 'Mr Stanley Cursiter, one of the younger Scottish artists, may be complimented on the step forward he has taken in his art. He has never before been so strikingly represented in an art exhibition as he is here. His "Studio Corner", in which a girl figures, is vigorous and realistic, but he will surprise his friends more by his life-size study of the nude, with a mirror reflection, in which the figure is satisfactorily drawn, and the colour has power and vitality. Mr Cursiter has also tried his hand at a cubist composition of the maze at the West end of Princes Street . . . It is a pretty bit of patchwork, but was there ever such colour seen on the humble double-deckers and open roofed cars . . . ? The pretty face in the foreground is quite like Edinburgh.' The *Glasgow Herald* on the same day (13 December 1913) was equally receptive: 'One of the members of the Society, Mr Stanley Cursiter, has apparently come under the spell of the new movement. In cubist style he has painted the scene of a 'West End

Crossing', . . . coloured cubes representing humanity and cable cars . . . Mr Cursiter's adventure is not to be lightly dismissed; it seems to suggest that Cubism may really have a future.'

The Studio commented on the SSA Exhibition of 1913 as follows: 'That some of the younger men are not unaffected by these modern developments was seen in Mr Peploe's fruit and flower studies, which are a limited and tentative essay in Cubist practice', and the same writer singled out a painting by Cadell, *Fancy Dress*, as a 'bold impressionist picture distinguished by the dexterity and surety of its colour design'. The comments quoted above indicate something of the respective responses of Peploe and Cadell to their experience of recent French painting. We would not now apply the term 'impressionist' to Cadell's work. Nevertheless, such a brilliant example of his early maturity as *The White Room* (1915: private collection) and *Still Life* (1914: DAG) put colour and fluent handling above volumetric considerations, whereas the paintings produced by the other Colourists at the same time show more evidence of the lessons of Cézanne. Writing to T.J. Honeyman in 1939, E.A. Taylor throws an unexpected sidelight on the development of Hunter

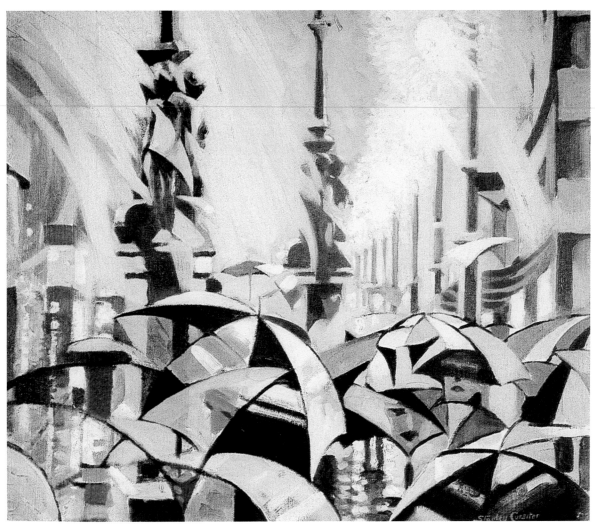

90 Stanley Cursiter
Rain on Princes Street
1913
Oil, 50 x 60 cm
The McManus: Dundee's Art Gallery and Museum
Dundee Art Galleries and Museums (Dundee City Council)
© Estate of Stanley Cursiter 2010. All Rights Reserved, DACS.

and Peploe before their return from France at the beginning of the First World War: 'while in Paris Peploe was tremendously taken up with an artist's work, an artist named Chaubad *(sic), very strong stuff, thick thick lines* and flat colours, and Hunter was very much taken up in a way with it too'. Auguste Chabaud (1882-1955), a follower of the Fauves, had his first one-man show at Bernheim-Jeune's in 1912, and, like Peploe and Fergusson, exhibited at the Salon d'Automne as well as contributing to the English journal *Rhythm*, of which Fergusson was art editor, in 1911. Taylor's report is of particular interest, because it suggests that in the midst of the brilliant extremes of pre-war artistic life in Paris, Hunter and Peploe (and presumably Fergusson too) were still attracted by a painter of relatively conservative disposition. Chabaud's connection with Provence and with the aged poet Mistral invited analogy with the decision of Cadell, Peploe, and Hunter to base themselves in Scotland at a time when authors such as Pittendrigh Macgillivray were conducting a minor revival in Scots dialect poetry. Yet the illustrators whom Fergusson was able to persuade to contribute to *Rhythm* in 1911 constitute a veritable Who's Who of the contemporary Parisian *avant-garde:* Derain, Friesz, Gaudier-Brzeska, Goncharova, Larionov, Marquet, Picasso, and Segonzac, as well as Peploe, Anne Estelle Rice and Fergusson himself.

The contemporary use of the word 'Cubist' in connection with Peploe's work in 1913 is somewhat startling, but there is no doubt that, broadly speaking, he and Fergusson were more immediately affected by Cubism than Cadell or Hunter. Between 1911 and 1913, when J.D. Fergusson was art editor of *Rhythm*, both he and Peploe contributed drawings to that journal which have a schematic, geometrical quality absent from the work of the other Colourists. Fergusson went further in this direction than Peploe, however, and his style subsequent to this period shows an interest in the abstract qualities of linear rhythm which aligns him with the post-Cubist School of Paris. This and the long periods during which he was domiciled in France effectively separate him from his three Scottish colleagues, whose later development in Scotland follows tamer paths. In fact the Colourists pursued independent careers except on the infrequent occasion of a group exhibition, although Cadell and Peploe did go painting together in the Hebrides in the 1920s. In 1936 Cadell, writing to Ion Harrison, remarks that he had not seen Fergusson since 1909. Malcolm Easton has convincingly suggested that the origin of the visual style of *Rhythm* lay in the first performances of the Russian Ballet. In his *Memories of Peploe* Fergusson himself wrote of the evenings they spent together at the Ballets Russes: 'No wonder S.J. [Peploe] said these were some of the greatest nights of his life. They were the greatest nights in anyone's life – *Shéhérazade, Petrouchka, Sacre du Printemps*, Nijinsky, Karsavina, Foukine'. Larionov and Goncharova both contributed to *Rhythm*. Fergusson's most ambitious work of the *Rhythm* period, the monumental *Les Eus* (1910-11), a neologistic title meaning 'the possessed', or, as Margaret Morris suggests, 'the healthy ones', with its frieze of athletic men and maenads, carries at least an echo of the ballet. More than Derain's *La Danse* (circa 1906: Josefowitz collection, Geneva), *Les Eus* is full of a powerful tonic vitality which derives principally from the rhythmical repetition of arcs which give the dancing figures the outline of a bow drawn taut. A remarkable drawing for the flying female figure on the extreme right shows real mastery of the nude in movement (private collection).

Together with certain other works of the same period such as *At My Studio Window* (1910: Fergusson Gallery) and *Rhythm* (1911: University of Stirling) *Les Eus* announces a recurrent preoccupation in Fergusson's later work, that of the female nude treated monumentally, with conical breasts and cylindrical limbs. An example of this is the punningly titled *Megalithic* (1931: private collection), a portrait of the artist's wife, the dancer and painter Margaret Morris. Two of Fergusson's regrettably rare excursions into figure sculpture, the *Dryad* (1924: HAG) and the brass *Eastra, Hymn to the Sun* (1924: SNGMA) – representing 'the triumph of the sun after the gloom of winter' – are likewise dithyrambs to youthful female vigour expressed in

91 John Duncan Fergusson
Damaged Destroyer
1918
Oil, 73.60 x 76.20
Kelvingrove Art Gallery and Museum
Image © Culture and Sport Glasgow (Museums)
Painting © The Fergusson Gallery (Perth and Kinross Council, Scotland)

92 Samuel John Peploe
Spring, Comrie
1902
Oil, 40.50 x 51 cm
Kirkcaldy Museum and Art
Gallery (Fife Council Libraries
and Museums)

generalized, almost totemic forms. The painting *Eastra with Fruit* (1929: Fergusson Gallery) incorporates the Eastra piece with the pile of ripe fruit which often accompanies these subjects. The inanimate remoteness so conveyed is not far different from the effect gained with a living model, as in the later *Full of the Warm South* (1953: DAG). The title of this latter work is taken from Keats's *Ode to a Nightingale*, a poem presumably particularly sympathetic to Fergusson's meridional taste. The very late *Wisteria, Villa Florentine, Golfe-Juan* (1957: Fergusson Gallery) is quite as hedonistic as the other painting despite the absence of the model. It is a lyrical work showing a table set *al fresco* with a *compotier* and overlooking the blue sea on which appears the white triangle of a sail. It incidentally shows that Fergusson's artistic output remained undiminished in quality, although it lost some of its original edge, until the end of his long life.

During the years of the First World War, which Fergusson spent in London and Edinburgh, his work continued to develop. The first pictures of this period suggest an attempt to consolidate and to codify the discoveries of the *Rhythm* years of 1911-13. The portraits *Complexity: Mrs Julian Lousada* (1915: Fergusson Gallery), *Simplicity: Kathleen Dillon* (1916: Angus Morrison), and *Rose Rhythm: Kathleen Dillon* (1916: Kathleen Dillon) are conspicuous

for a formal organization which is still very dependent on line but already less two-dimensional and more planar than the *Rhythm* work. Fergusson's own comments on *Rose Rhythm* illuminate the remarkable unity of portraiture and fashionable *chic* in the painting. It arose from his initial observation of the sitter's hat which she had just made: it 'was just like a rose, going from the centre convolution and continuing the *Rhythm* idea developed in Paris and still with me. Looking at K. I soon saw that the hat was not merely a hat but a continuation of the girl's character . . . I painted *Rose Rhythm* – going from the very centre convolutions to her nostril, lips, eyebrows, brooch, buttons, background cushions, right through. At last, this was my statement of a thing thoroughly Celtic'.

Landscape, which was to be important to Fergusson in the post-war years, was also fruitfully developed by him during the war, with a new delight in Scottish scene. *A Lowland Church* (1916: DAG) shows a convincingly Cézannesque simplification of volumes into geometrical colour areas, and looks forward to the later Scottish landscapes painted as a result of Fergusson's tour of the Highlands with the Glasgow writer John Ressich in 1922, of which *A Puff of Smoke near Milngavie* (1922: Macfarlane Collection) is an outstanding example. In 1918 Fergusson produced a small group of pictures which

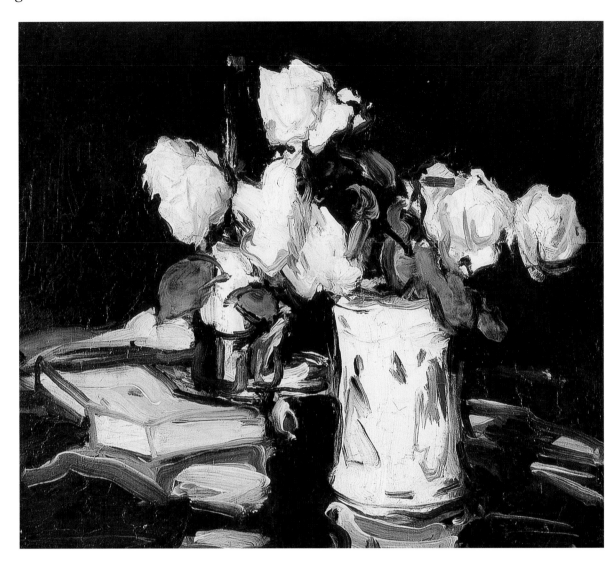

93 Samuel John Peploe
Roses in a Blue Vase
c. 1904-05
Oil, 40.60 x 45.70 cm
Private collection

are among the most freshly original of all his works. The Léger-like dynamism of *Damaged Destroyer* (1918: GAG) produces a remarkable sense of space and volume, and of the scale and strength of the dockyard installations.

Peploe took the two numbers of *Blast* published by Wyndham Lewis in 1914 and 1915, and it is reasonable to assume that Fergusson would also be aware of the work of the Vorticists, although both artists remained entirely outside Wyndham Lewis's circle and show very little of its influence. We know from a letter of 1916 that Peploe met McKnight Kauffer in Edinburgh and thought his work 'interesting', but he does not appear to have had more than an academic interest in Cubism and its offshoots in Britain. Peploe's experimental paintings produced from about 1913 until about 1918, with their rhythmical abstract backgrounds, make only a cursory bow towards Cubism – but a bow nevertheless. A painting such as *Still Life* (circa 1916: SNGMA) is plainly influenced by Cubism, and makes a serious attempt to digest the new style. Yet its seriousness does not entirely redeem the awkwardness of the relation of the abstract linear pattern of the background to the figuratively drawn objects in the foreground. Like Fergusson, Peploe possessed painterly instincts and a concern for colour which forbade experimentation with analytical Cubism. Writing on Peploe in 1923, Sickert noticed two areas in which he had matured:

He has transferred his unit of attention from attenuated and exquisite gradations of tone to no less skilfully related colour. And by relating all his lines with frankness to the 180 degrees of two right angles he is able to capture and digest a wider field of vision than before . . . His *volte-face* has been an intellectual progress. And it is probably for this reason that, obviously beautiful as was Mr Peploe's earlier quality, his present one will establish itself as the more beautiful of the two.

Sickert has here put his finger on Peploe's two most admirable qualities: the intellectual probity of his line, and the subtle power of his colour. These were the qualities which, untrammelled by a too-conscious imposition of another style, re-asserted themselves

quickly in Peploe's work. In about 1920 he began to paint on an absorbent ground and eschewed the heavy black outlines characteristic of his earlier paintings, and the use of varnish. The effect is an increased emphasis on the two-dimensional aspect of his design. Each colour-area now explodes laterally into the neighbouring patch of colour, and colour is given a dynamic rather than a monumental function. *Roses and Fruit* (circa 1923: private collection) is an example of this. These paintings on gesso are perhaps the most exciting of all Peploe's pictures. Throughout the rest of his career he continued to paint variations on the themes of landscape, still life, and flowers, with the exception of *Old Duff* (1921-22: GAG) which is a rare but entirely successful excursion into the field of portraiture.

Unlike Peploe and Fergusson, Hunter and Cadell were totally unaffected by the Cubist revolution. In Hunter's series of still life and flower paintings with dark backgrounds (generally assumed to be early: Hunter like Peploe and Cadell rarely dated pictures) the influences of Kalf and Chardin are still visible, and among modern masters one does not have to go beyond Monticelli (who, thanks to the advocacy of Daniel Cottier and then Alexander Reid, was extremely well known to Scottish collectors, and of whose work Hunter himself possessed several examples), for a precedent in the use of sombrely glowing colour. The early still life paintings show Hunter still concerned with a realistically suggestive treatment of surface and texture. In landscape, however, his style showed the influence of Cézanne from an early stage, and from about 1916-20 both landscape and still life are treated with ever-growing freedom in the use of colour and expressionistic impasto. The second *Loch Lomond* series, painted at the very end of Hunter's life, includes some of his finest paintings, one of which elicited from Peploe the compliment 'that is Hunter at his best and it is as fine as any Matisse'. *Reflections, Balloch* (1929-30: SNGMA) and *House-boat, Loch Lomond* (1929-30: private collection) are subtle enough to make such praise seem not too exaggerated. Hunter's control of colour in his best pictures shows the greatest sensitivity and his palette takes on a limpid quality which sometimes recalls the great Fauve master. It was Hunter who persuaded William McInnes to buy the Matisse still life *La Nappe Rose*, which is now in the Glasgow Art Gallery.

By contrast with Hunter, whose development was slow and steady, during the course of his career Cadell employed four quite distinct styles. The early interiors and still life pictures are painted with great verve and brilliant use of whites, with dashes of orange, mint green and lemon. The best-known example is *The White Room* (before 1915: private collection). Equally fine is his *Still Life* (1914: DAG). A similar range of colour appears in the earlier landscapes. The white sand and bright green stretches of water characteristic of the east shore of

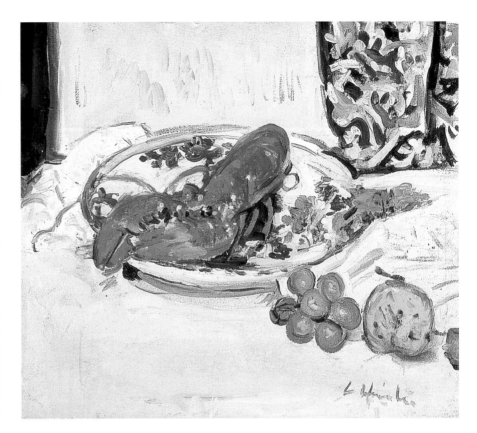

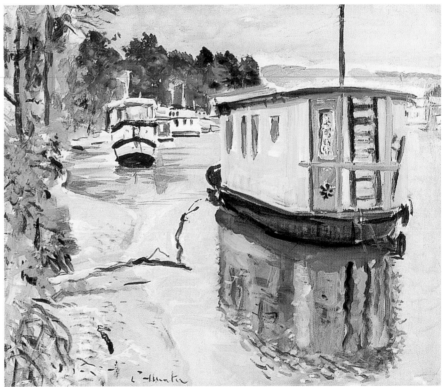

94 George Leslie Hunter
Still Life – Lobster on a Blue and White Plate
1927
Oil, 35.50 x 40.50 cm
Private collection

95 George Leslie Hunter
House Boats, Loch Lomond
c. 1929-30
Oil, 51 x 61 cm
Private collection

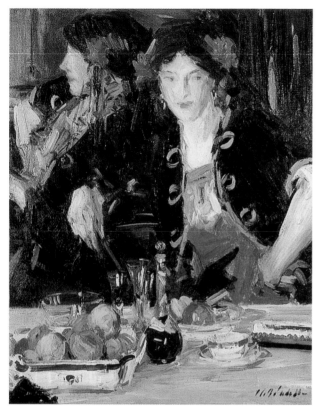

96 Francis Campbell Boileau Cadell
Crème de Menthe
1915
Oil, 107 x 84 cm
McLean Museum and Art Gallery
(Inverclyde Council)

97 Francis Campbell Boileau Cadell
The White Room
1915
Oil 63.50 x 76 cm
Private collection

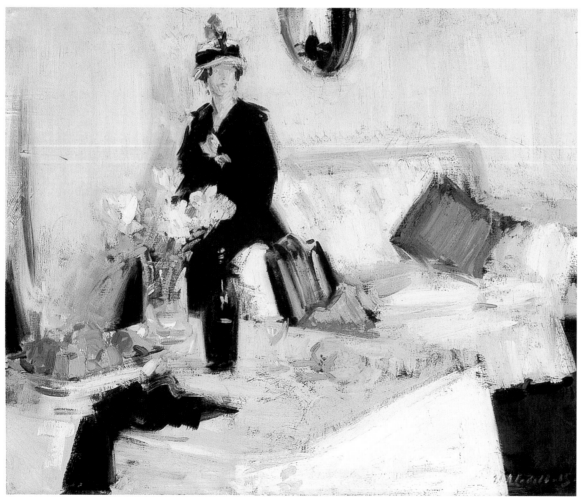

Iona in certain weather conditions provided a pretext for the bold colour schemes of the earlier Iona pictures, as the vermilions of Collioure had for Matisse. Cadell's later Iona pictures of the twenties, when he sometimes worked in company with Peploe, are more quietly coloured and more precisely drawn. A third style, in which elegant interiors are painted with a flat, unmodelled use of scarlets, oranges and bright greens, appears in the early twenties, and is strikingly evident in *The Opera Hat* (circa 1922: private collection) and in the audaciously coloured *Still Life with Lacquer Screen* (n.d.), which implausibly but successfully juxtaposes black, pink, bright green and orange. A fourth mode is used to evoke the airy interiors of Croft House in the early thirties, in a series of pictures commissioned by Ion Harrison. It was to Harrison that Cadell wrote in a letter of thanks for a copy of *The Whistler Journal* in 1933 that Whistler was

> the most exquisite of the 'moderns' and he had what some great painters have, a certain 'amateurishness' which I rather like and feel always in Gainsborough. I can best describe what I mean in the words 'a gentleman painting for his amusement' . . . Raeburn, on the other hand, was a pro. if ever there was one.

There is something of the gentleman amateur in Cadell himself, who was related to the Dukes of Argyll, and had a considerable reputation in Edinburgh as a wit. This quality was apparent in his works, and it is none too common in Scottish painting. Cadell was also a founder-member of the Society of Eight, which started in Edinburgh in 1912 and included Lavery and, later, William Gillies (1898-1973). Two other Scottish painters of this gen-eration, Telfer Bear and Joseph Simpson (1879-1939), were considerably influenced by Cadell's work.

In the two decades from about 1910 until 1931 the Colourists produced a number of minor masterpieces. Stanley Cursiter's espousal of Futurism in 1913 was brief but intense. The four Colourists, however, showed a much greater ability than the Glasgow School to stay the course, so that their later work generally stands up well to a comparison with their vigorous early productions, and does not leave behind the taste of disappointment and embarrassment characteristic of the later productions of the Glasgow School. If the Colourists derive more from Cézanne and Matisse than from the radical group of French painters associated with Picasso who were their closer contemporaries, this does not diminish the originality of Peploe, Fergusson, Hunter, and Cadell. Nor, paradoxically, does it diminish their Scottish character or compromise their natural evolution. An absence of theory need not imply an absence of logic. The best paintings by these four Scottish artists are eminently logical, but their logic is primarily determined by the material, the paint itself. This painterliness, this insistence on the quality of paint and the beauties proper to it, is their greatest strength. It is also the source of their considerable influence on subsequent Scottish painting.

BETWEEN THE WARS

The 1920s and 1930s were years of retrenchment for painting in Britain generally. The First World War had a less immediate effect on Scottish than on English painting because Scotland had at that point no radical equivalent of the Vorticist movement in England, which was first dispersed by conscription and then decimated through fatalities in action. Several Scottish painters became official war artists, and although J.D. Fergusson received a commission for only one picture for the Ministry of Information in 1918, he painted a series of naval dockyard subjects at Portsmouth including the powerful *Damaged Destroyer* (dated to 1918: GAG). But Scotland produced no artist of the calibre of Nash or Nevinson as chroniclers of war. Cursiter, Peploe, Fergusson and Mackintosh (the latter two remaining in London after the war before taking up prolonged residence in France), who in their various ways had kept abreast of *avant-garde* developments on the Continent and had mastered the language of Modernism in one form or another, found that no-one at home was interested in what they had to say. Mackintosh alone, despite all difficulties and discouragement, sustained the momentum of his earlier innovatory work in a new discipline, that of textile design. Stanley Cursiter pioneered advances in aerial cartography during the war, but, as with so many of his contemporaries including Peploe, his post-war career was emphatically a case of 'goodbye to all that' in terms of stylistic innovation. Two members of the former Glasgow School, Sir D.Y. Cameron and Sir John Lavery, and also Sir Muirhead Bone and James McBey, who with Cameron and the portraitist William Strang had a large share of responsibility for the revival of etching in Britain in the early twentieth century, also received commissions for work documenting aspects of the war. Lavery's *The First Wounded in London Hospital, August 1914* (DAG), Cameron's *Bailleul* (1919: DAG) and *The Battlefield of Ypres* (1919: Imperial War Museum), and McBey's portrait of *Lt-Col. T.E. Lawrence*, 'Lawrence of Arabia' (1918: Imperial War Museum), are all conspicuously successful documentary records. Cameron remarked that the Ypres picture was 'not a portrait of any one spot (photographers can do all that) but is founded on my notes on the road from Ypres to Menin', yet the utterly still desolation which he depicts appears closer to the bare facts than the eye-witness accounts of Paul Nash in canvases like *We are making*

a New World (1918: Imperial War Museum) – the very title full of a bitter irony. In this Nash conveys with great dramatic intensity the scene which he described as 'the most frightful nightmare of a country more conceived by Dante or Poe than by nature', with the intention that his work would 'bring back word from the men who are fighting to those who want the war to go on for ever'.

Retrenchment can lead to consolidation. Much of the best painting in Scotland in the two decades after the war was the work of already established artists. The four Colourists all produced work whose masterly colour and handling are worthy of their best earlier efforts – indeed Hunter only really comes into his own as a Colourist after circa 1922 – and Charles Rennie Mackintosh's French landscape watercolours of 1925-27 are an important aspect of his career as a painter. But of the younger artists who remained in Scotland, only very few showed any willingness to experiment with new forms of expression. In 1918, Peploe's brother William painted two little Vorticist-inspired near-abstract watercolours, one of them titled *Souvenir of the Red Triangle*, the other untitled, both now SNGMA. They mark a startling advance from his earlier Beardsleyesque drawings for a privately printed book *Memories and Illusions* (1906), but appear to have had no sequel in his work.

The only Scottish artists to come to prominence in the 1920s who showed a serious interest in a radically contemporary style were William McCance (1894-1970) and William Johnstone (1897-1981). McCance was influenced by Vorticism and Analytical Cubism (in that historically inverted order) and took part with his first wife Agnes Miller Parker in the revival of wood engraving in the 1930s. Johnstone developed a form of surrealistic abstraction and became an eminent and influential teacher and writer on art. Both McCance and Johnstone spent the main part of their creative lives in London and the south, finding Scotland still the 'narrow place' Robert Adam had deprecated.

Plainly, there was a lack of confidence in the 1920s which can be attributed to the aftermath of a war which had exhausted both sides (the victor having less motive, however, for the angry iconoclasm of Dada or Expressionism). In Scotland this was accompanied by worsening economic conditions, due to over-reliance on heavy industry, which made the

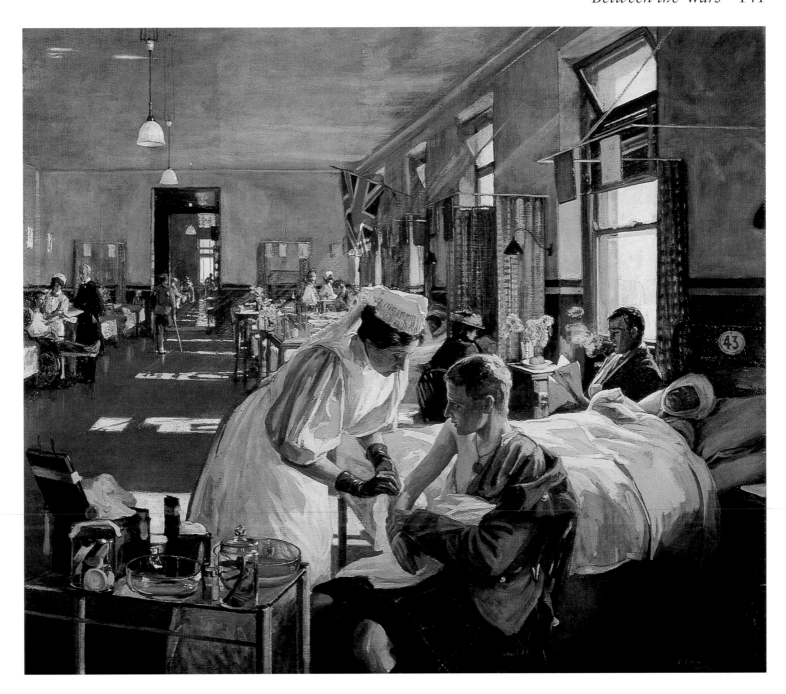

98 Sir John Lavery
*The First Wounded in London
Hospital, August 1914*
1915
Oil, 175.60 x 200.70 cm
The McManus: Dundee's Art
Gallery and Museum
Dundee Art Galleries and
Museums (Dundee City Council)
By courtesy of Felix Rosenstiel's
Widow and Son Ltd, London on
behalf of the Estate of Sir John
Lavery

Depression of the 1930s particularly severe in the industrial central belt of the country. In 1931 we find F.C.B. Cadell writing to his friend and faithful supporter, the shipowner Ion Harrison,

Shipping certainly sounds depressing! But everything appears to be in a hopeless state and I have never known such depression in my trade as exists at present. I sell my things now at a quarter of what I got for them some years ago and I furthermore sell *very* much fewer.

Cadell, at least, was more fortunate than many painters in having a group of wealthy patrons who could be relied on to buy his work regularly.

In a climate generally so unfavourable to patronage, it is understandable that most artists should, first, turn to forms of expression which are accessible, exerting a frank appeal to the eye and untroubled by undue intellectualism. The great majority of the more interesting Scottish artists of this period appear as traditionalists who show a cultivated awareness of the more decorative styles of the recent European past. Second, in such a period the security of salaried employment was particularly valuable, and it is noticeable that almost all the more prominent figures taught at one of the four art colleges (Edinburgh, Glasgow, Dundee, and Aberdeen). S.J. Peploe himself taught at the Edinburgh College at the end of his career, where David Foggie,

99 Sir David Young Cameron
Bailleul
c. 1918-20
Oil, 99.10 x 114.30 cm
The McManus: Dundee's Art
Gallery and Museum
Dundee Art Galleries and
Museums (Dundee City Council)

D.M. Sutherland, William Gillies, Sir William MacTaggart, Henry Lintott, and John Maxwell – the founders, with Anne Redpath, of the Edinburgh School – were all at one time or another on the teaching staff. James Cowie (1886-1956) was a schoolmaster for twenty years until his appointment as Warden of Hospitalfield House in 1935 enabled him to exert a wider influence on younger painters. Of the other outstanding figures who emerged in the 1930s, J. McIntosh Patrick, Edward Baird and Robert Sivell became teachers at the colleges of art in Dundee and Aberdeen. The period is *par excellence* that of the teacher-artist, not only in Scotland; local style is generated largely at the local art school.

A characteristic development in the earlier part of the twentieth century is the proliferation of small exhibition societies which sprang up in Glasgow and Edinburgh, following to some extent the lead given in 1891 when, through the efforts of Robert Noble and others, the Society of Scottish Artists was founded to provide an exhibiting body in Edinburgh which would be independent of the RSA. Many of the Glasgow School painters like Arthur Melville who were already academicians had also joined the SSA as

did the veteran William McTaggart, whose relations with the RSA by this time had apparently become somewhat strained. The SSA thus was never a secessionist body; many painters retained membership of both societies. In 1912 the Society of Eight was formed in Edinburgh, comprising a mixture of Glasgow School and slightly later names: P.W. Adam, David Alison, F.C.B. Cadell, James Cadenhead, James Paterson, Harrington Mann, Sir John Lavery and A.G. Sinclair. Since, with the exception of Cadell, most if not all these artists were already well established, the Society of Eight was not in any sense the expression of a new wave of Scottish painting, but instead united artists who all tended to adopt a painterly approach and to use light-keyed colour. In the same year, 1912, however, a group of younger artists including Eric Robertson, W.O. Hutchison, A.R. Sturrock and D.M. Sutherland exhibited as a group at Doig, Wilson and Wheatley's Gallery, and in the following year at the New Gallery in Shandwick Place in Edinburgh. This group became known as the Edinburgh Group when it was reconstituted in 1919 with Dorothy Johnstone, Mary Newbery, and Cecile Walton (E.A. Walton's daughter

and by now Eric Robertson's wife) joining it. Their 1920 exhibition was particularly successful and it was said by the critic of *The National Outlook* that 'people look to the Edinburgh group for something unique rather than universal; for something of pagan brazenness rather than parlour propriety'. *Dreamer* (1911: the artist's daughter) by Eric Robertson (1887-1941) exemplifies that variety of post-1900 Symbolism in which figures levitate ubiquitously through the firmament; forerunners perhaps of the 'floaters' of Henry Lintott, perhaps even distant ancestors of the fantasy figures of John Maxwell. It plainly demonstrates the connection between Robertson and John Duncan, which was to be terminated in 1915 by Duncan, who disapproved of what he considered to be the immorality of Robertson's art and private life. Robertson's *Dreamers* (1911: private collection) is a rather innocently sensual work obviously by a highly talented draughtsman, which nevertheless must have caused a few raised eyebrows when it was shown at the RSA in 1913. The same artist's *The Two Companions* (1913: the artist's daughter) derives from the *Rose + Croix* manner of Duncan and shows a young man (a self-portrait) accompanied by two familiars, a young man and a girl both nude, who seem to compete for his mental and physical allegiance. In *Love's Invading* (1919: ECAC) which resembles a Poussinesque bacchanale choreographed by Margaret Morris, Robertson essays a kind of Edinburgh version of Fergusson's *Les Eus* of circa 1911 – an unlikely-sounding combination which is strangely effective. Robertson's post-war works show the influence of Vorticism – *Cartwheels* (1921: the artist's daughter) is an obvious instance of this – although the use of something very like the 'rays' of the strip-cartoonist to indicate movement suggests a superficial assimilation of a style which the Edinburgh public clearly found as hard to take as they did Robertson's unorthodox behaviour. *Despair* (1921: GAG) shows a rather conventional nude despairer posed theatrically against a Nevinsonian background; but it does no doubt reflect the difficulties of Robertson's life at this time, which resulted in his departure from Edinburgh in 1923 to years of unrewarding exile in Liverpool. He was the most experimental of the 'Idylls' as this group of friends were wont to style themselves, but three of the women in the group had painting in their blood: Dorothy Johnstone, Mary Newbery and Cecile Walton being the daughters of three distinguished figures in Scottish painting, George Whitton Johnstone, Fra Newbery and E.A. Walton. Breeding tells: each artist – each daughter that is – demonstrates formidable professional skill, Mary Newbery concentrating on embroidery and flower painting, Dorothy Johnstone and Cecile Walton introducing refreshingly modern, intimate subject-matter into their portraits and interiors. Cecile Walton's *Romance* (1920: private collection) is a self-portrait semi-nude lying on a bed holding aloft her newly born second son, whose older brother and a nurse are also present: a tender, and for those days, an unconventional theme. The characterful 1918 portrait of Cecile Walton by Dorothy Johnstone or the earlier *Marguerites* (1912: RSA), a portrait of the artist's young sister, exemplify her fine quality. Between 1914 and 1924 Dorothy Johnstone was a popular teacher in Edinburgh College of Art, a post she relinquished in 1933 when her husband, the landscape artist D.M. Sutherland, was appointed Head of Gray's School of Art in Aberdeen. At the same time, another of this talented circle, W.O. Hutchison, became Head of Glasgow School of Art; and so the Edinburgh Group was finally dispersed.

In Glasgow James Kay (1858-1952), and in Dundee and latterly on the Isle of Arran, John Maclauchlan Milne (1885-1957), stand a little apart from their contemporaries. Essentially self-taught artists (Kay briefly attended evening classes at Glasgow School of Art, and Milne's father was the excellent Tayside painter Joseph Milne), these two independently pursued a precarious living as landscape artists, producing some of the most interesting work of the period. As the older man, Kay's style reflects the dominance of the Glasgow Boys and of The Hague School whom they admired, in the early part of his career, while Maclauchlan Milne's early work is rural, tonal and descriptive like his father's. Their characteristic later styles, which in different ways give a new impetus to the painterly Colourist tradition in Scottish painting, develop only slowly, but in each case it is a maturity worth waiting for. Kay's father had been a naval officer taking part in operations in the Black Sea in the Crimean War, and young James was brought up on Arran – a coincidental point of contact with Milne, whose last years were spent on the island – to a life of fascination with the sea and the river. The seagoing traffic of the great days of the Clyde became a favourite theme, but Kay rarely romanticizes, preferring the 'dirty British coaster with a salt-caked smoke stack', the bustling commercial traffic with cargo vessels and tugs by the wharves or the steam ferries at the Broomielaw in the centre of the Clyde. He did paint the *Lusitania* (1912: GAG), but at the moment of her launching, not during her brief reign afloat as queen of the liners. The earthy realism of the Glasgow Boys had prepared Kay's patrons for these views of their river, and their ready acceptance was no doubt due to recognition, pride, and pleasure in fine painting in which a vigorous technique and an individual, often austere palette were matched to workaday river subjects.

Kay's younger contemporary Maclauchlan Milne is another artist whose personal handwriting develops without the rigid training of the art school. Sinclair Gauldie remembers that 'he did indeed display in his own person much of the *bravura* which characterized his own painting'. Milne's attractive, ebullient and urbane temperament is described in affectionate

100 John Maclauchlan Milne
The Harbour, St. Tropez
c. 1928
Oil, 49.50 x 59.70 cm
Image courtesy of The Fleming–Wyfold Art Foundation and the Bridgeman Art Library
Painting © The Estate of John Maclauchlan Milne, care of the Portland Gallery, London

detail in the centenary catalogue (DAG), from which we also learn that his francophilism dated from the war years spent in France, during which he fought on the Western Front. From 1919 until 1932 he spent a substantial part of every year in France. Milne's first stay was in the rue des Quatre-Vents in Paris, but the habit of going to the Mediterranean coast was soon established and in 1924 the Milnes were in the company of Peploe, Cadell and Duncan Grant at Cassis (a favourite painting location for Cursiter and Fergusson also); later they spent much time at Saint-Tropez. Through the 1920s almost all his exhibits at the RSA were landscapes of the Midi. His obituarist at the RSA wrote of this period: 'Like Peploe, he saw Cézanne and was immediately conquered . . . Here in the Midi, Milne found himself and the impact of this new experience stamped all his subsequent work'. We may today feel the reference to Cézanne to be a little wide of the mark: Milne modelled form with colour, but without aiming for the monumentality of Cézanne. Rather, his modelling tends to a decorative flatness which emphasizes the picture plane and simplicity of outline and form; the results have a beguiling, lyrical innocence suggestive of the serenity of life in these quiet places. In the paintings dating

from 1940 onwards, when he had moved to High Corrie on Arran, his palette too is simplified to include a tinted white for the whitewashed cottages like his own which formed the tiny village. Sometimes he would paint the little jetty below the village, sometimes the interior of the island with the peak of Goat Fell, and he was always a notable painter of flowers. Many of Milne's supporters such as Matthew Justice and the collector of Impressionists William Boyd, lived in Dundee or in neighbouring Broughty Ferry, and it was to Angus that he returned in 1956, the year before his death, to become Warden of Hospitalfield House at Arbroath.

It is clear that for Milne, as for Rennie Mackintosh and so many other Scottish artists at this period, the attraction of France lay in the country itself and in the life one could live there (helped by a favourable exchange rate) as an artist. To be domiciled in France was in itself a form of hedonism, celebrated in the paintings of its landscape, its flowers, its warmth and colour, by Milne and numerous Scottish artists of the same generation. These Scottish francophiles include the Aberdeen artist and potter Majel Davidson, who, with Edward Overton Jones, studied in Paris (and also painted with J.E.H. Macdonald and other

members of the Group of Seven in Ontario); the Edinburgh-based New Zealander Francis McCracken whose ECA travelling award took him to France to study under André Lhôte; the Selkirk artist John McNairn who like so many of his compatriots also gravitated to Lhôte in his scholarship year in Paris; and of course the Colourists like William MacTaggart the younger who were connected with the Edinburgh College of Art. William Macdonald's annual painting tours of Spain, like those of John Lavery, James McBey and Alexander Graham Munro in Morocco were part of the same pattern, the attraction of the warm Mediterranean to northern eyes in a depressed period of European history. The artists mentioned share with the Colourists not only their avowed francophilism but also an interest in broad effects of colour which go beyond the merely descriptive, together with an emphasis on surface rather than perspectival pattern. These are characteristics of French landscape painting, especially of Derain, Marquet and Dufy and the influence of these artists, and of Marquet above all, is clear in Graham Munro's *The Admiral's House* (circa 1930: William Hardie Gallery), painted in Tangier, and John McNairn's *The Harbour Saint-Mâlo* (circa 1936: ibid.). McNairn's splendidly confident *Champagne and Oysters* of about the same date, very much in the austere, spare style of Derain whose work he

had admired in Paris, may be compared with McCracken's no less assured *Champagne Breakfast* (circa 1930-35: private collection), which shows a stronger influence of the Franco-Scottish *belle peinture* practised by Cadell and Peploe in Edinburgh. Francis McCracken, claimed like his compatriot Frances Hodgkins for the New Zealand School despite long exile from that country, came to Europe at the tender age of sixteen with the New Zealand Expeditionary Force in 1914, lost a leg in the fighting, and attended classes at the Edinburgh College of Art. His lifelong friendship with Graham and Ruth Munro in Edinburgh began at this point, and around 1924 we find him painting in Paris and Concarneau, probably in Graham Munro's company although we do not know whether he attended the life class, as several oil studies from this period prove Munro to have done. Of the two artists, McCracken alone went on to paint figure subjects of an earthy realism in the tiny studio in Forth Street to which his lameness increasingly confined him. He also went, as Munro did, to Tangier in the late 1920s, but probably because of his disability did not follow him to Rabat, Fez and Marrakesh and into the remoter foothills of the Atlas Mountains, where Munro in 1926-27 produced a remarkable series of pastels. These drawings by Munro, sent home as scholarship material from Morocco at regular intervals to

101 Alexander Graham Munro
The Admiral's House, Tangier
c. 1930
Oil, 92 x 122 cm
Private collection
© The Artist's Estate

102 John McNairn
The Harbour, Saint Mâlo
1936
Oil, 75.50 x 99 cm
Private collection
© John McNairn

demonstrate his assiduity to the assessors, which he had kept for nearly sixty years in a drawer as never-used compositional notes until I persuaded him to ventilate them at the Edinburgh Festival in 1984, compare interestingly and by no means unfavourably with Mackintosh's watercolours of the same period. Munro in his early years was a beautiful draughtsman, in a style Mackintosh would have appreciated: crisp, elegant, spare, precise – and had a keen eye for the architectural or structural essentials of his subject. Pastel suited his style better than any other medium; Munro thought naturally in terms of its rich colours and pearly surface. The smooth gradations of plane in these drawings remind one of Georgia O'Keefe's early landscapes.

Of course, all these artists also painted the Scottish landscape. For other painters, however, the Scottish landscape, especially their own place in it, was subject enough for a lifetime's work. Sir D.Y. Cameron (1865-1945), George Houston and James McIntosh Patrick (born 1907), despite great differences of temperament and style, share a common preoccupation with Scotland's topography. Although Cameron was included in the studies of the Glasgow School by Martin (1897) and Baldwin Brown (1908), he was not associated with that group in its formative years and his most characteristic works were painted after the turn of the century. The main early

influences on his style in the 1890s were Whistler, the Barbizon painters and Matthew Maris, but from an early date Cameron was laying the foundations of his reputation as one of the most outstanding of a brilliant generation of British landscape etchers. He was also a prolific watercolourist and many of his informal landscape sketches in this medium are especially fine. The main ingredients in his landscape style, which changed imperceptibly from Realism to Romanticism, are his dainty draughtsmanship and sense of form, together with a Glasgow School breadth of handling and use of a richly sombre palette which lightens over the years. The Trossachs and the countryside around Kippen, where he lived from 1908, were his favourite themes, with an occasional tour to Perthshire or the western Highlands. Cameron was a deeply religious man, it seems; the emphatic colour contrasts in the large landscapes of the twenties and thirties express a quasi-mystical view of the majesty of the natural scene, rather than a descriptive or decorative intention. The equally prolific George Houston interpreted the quieter and less dramatic landscape of Ayrshire and the intimate and magical landscape of the Mull of Kintyre by the shores of Loch Fyne or Loch Awe, using a painterly technique and tonal palette influenced by the Glasgow School.

The landscapist James McIntosh Patrick – whose

popularity as an artist and wide circle of congenial friends stemmed from an indefatigable and kindly intelligence which continues to illuminate his views of his native Angus, as it did his views on a host of other topics from modern painting to the walled garden at his home of which he was justly proud – returned to Dundee from his studies at Glasgow School of Art in 1928. In the same year his friend Edward Baird returned to Montrose. Obvious parallels exist between the work of these two remarkable draughtsmen, who between them carried off all the prizes worth having at the School, a fact which indicates, at the least, that their precise style of drawing was compatible, with what was being taught there. Under the aegis of Maurice Greiffenhagen as Principal, printmaking was being taught by Josephine Haswell Miller, among whose other pupils was Ian Fleming (1906-1994), another brilliant etcher, who became Head of Gray's School of Art in Aberdeen. Patrick's father was an architect and young James had begun to experiment with etching at the age of fourteen. In the summer months of 1926 he made a series of etchings in Provence, including the hill towns Les Baux and Carcassonne. These are *tours de force* of technique, influenced by the high horizon, architectural detail, and meticulous line of Méryon. A large painting of 1927, *The Egotist* (collection of the artist's family) is an architectural fantasy which shows a mountainous landscape based partly on that of Mantegna's *The Agony in the Garden,* littered with the Classical monuments of Provence – the Maison Carrée, the Pont du Gard, the amphitheatre at Nîmes, and the Arch at Saint Rémy – and populated with figures in modern dress who debate with the egotistical architect/builder the modern-looking building concealed under wraps in the foreground with which he hopes to rival the monuments of old. With the benefit of hindsight it is fascinating to see in this bravura performance all the skill which Patrick was to deploy in rearranging landscape and buildings to suit his compositional requirements in the paintings of his earlier period before 1940. After that date, his landscapes are all painted *en plein air* and with correspondingly greater immediacy.

Patrick was achieving a considerable reputation in his preferred discipline of etching, with the support of the etcher F.L. Griggs whose strong contrasts of light and dark and ability to create depth in landscape Patrick admired, but by 1930 it was becoming apparent that the demand for etchings was falling off. When he turned to painting, the lessons learnt as a printmaker stood him in good stead, and it is to that testing early discipline that the clarity and conciseness, the confident massing and tonality of the studio landscapes of the thirties is owed. *Winter in Angus* (1935: TG) shows the fortified manor house of Powrie Castle, which stands a little to the north of Dundee, against a background which the artist tells us was painted separately, but of course, *sur le motif*

– actually from a window at Glenalmond many miles away. Further, Patrick has turned the building round by one hundred and eighty degrees, as he shows us the south instead of the north elevation of the building facing uphill; for the excellent reason, no doubt, that the north elevation is blank, windowless and therefore less welcoming to the eye. The composition employs a serpentine series of curves to lead the eye in through the various stages of the composition to the background in the far distance. Patrick pursued Bruegel's theme of the seasons through *Midsummer in East Fife* (1936: AAG), *Autumn, Kinnordy* (1936: DAG), and *Springtime in Eskdale* (1938: WAG). In each one the high horizon and elevated viewpoint provide an immense vista, through which the eye meanders as the composition subtly directs. The immediate experience provided by these beautiful and pondered works and their fellows is one of close identification with the landscape; but as time increases the distance between the viewer and these scenes, their significance as fixed portrayals of the very character of the land, and through it the people who have shaped it, becomes clearer as the years pass.

Immediately after the First World War, a shortlived Glasgow Society of Painters and Sculptors was founded in 1919, including the three Glasgow-trained artists Robert Sivell, James Cowie and

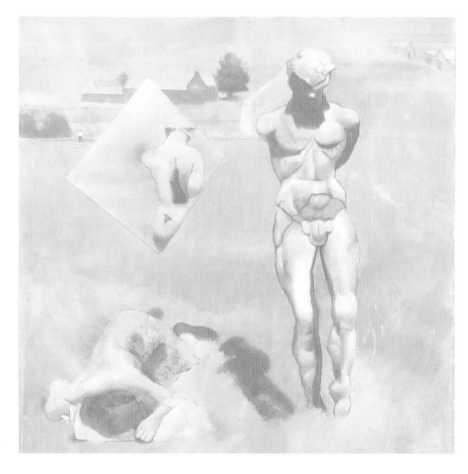

103 James Cowie
Noon
1946
Oil, 55 x 55 cm
Aberdeen Art Gallery and Museums Collections
© Ruth Christie
Painted at Hospitalfield House, the residential art school where Cowie taught until 1948. The figure of the girl was composed in 1938. 'A picture ... must be built of much that ... it would never be possible to see and to copy.' James Cowie, 1935.

Archibald McGlashan. They are usually thought of together as figure specialists who employ a noticeable restraint in their use of colour, as drawing is the quintessence of their styles, partly as a result, perhaps, of the presence at the Glasgow School of Art of Frederick Cayley Robinson from 1914 to 1924 as professor of Figure Composition and Decoration. The sculptor Benno Schotz was also an exhibitor with this Glasgow group, as were two younger artists, William McCance and his wife Agnes Miller Parker, who in 1920 moved to London.

The older painters of this group, Cowie, Sivell and McGlashan, were traditionalists who emphasized careful drawing. McGlashan (1888-1980) was more spontaneous and more painterly than the others, and his *Mother and Child* (before 1931: GAG) is as free from mannerism (in a period when draughtsmanship was frequently forced and affected) as Augustus John at his best. But James Cowie (1886-1956) was the most original artist of the three, and the most adventurous, making excursions into a personal kind of Surrealism which suggest a possible knowledge of

the metaphysical painting of de Chirico – whose work was included in an exhibition of Surrealism by the SSA in 1937, and then in a major one-man exhibition at Reid & Lefevre in London in 1938 – in drawings and paintings produced at Hospitalfield near Arbroath after he had moved in 1935 to become Warden of the residential art school founded there by Patrick Allan Fraser. His earlier works all date from his time as art master at Bellshill Academy in Glasgow, as his frequent choice of children in their school uniforms as subjects indicates. Its linear precision and conciseness gives Cowie's work a palpable, spartan air of integrity. His schoolgirl subjects attend to their lessons only slightly distracted by the *Falling Leaves* (1934: illustrated Memorial Catalogue 1957, untraced) passing the classroom window. In *Two Schoolgirls* (AAG) two of them sit as models with expressions of innocence and sagacity, in calm and dignified indifference to the plaster art class 'prop' of a nude *discobolus* placed behind them on a pedestal. *Noon* (1946: AAG), which shares something of the nostalgic view of early

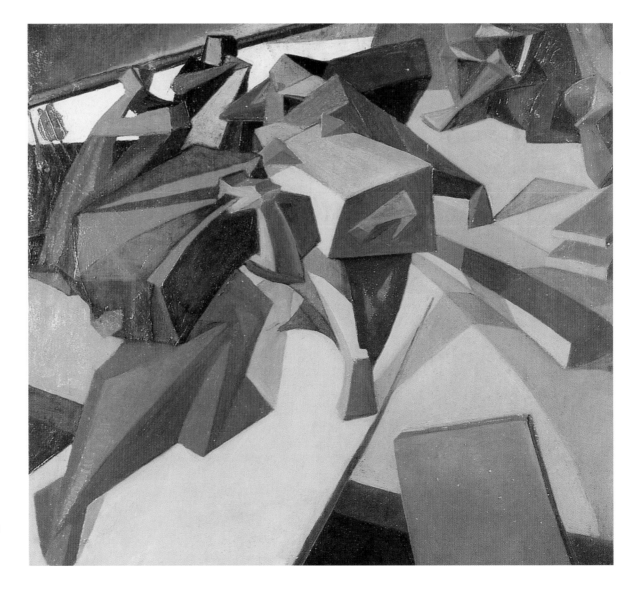

104 William McCance
Boatyard
c. 1922
Oil, 63 x 67.50 cm
Private collection
© Dr. Margaret McCance
A Vorticist design, based on Nevinson, with figures loading a yacht from the quayside. There is an abstract painting on the reverse.

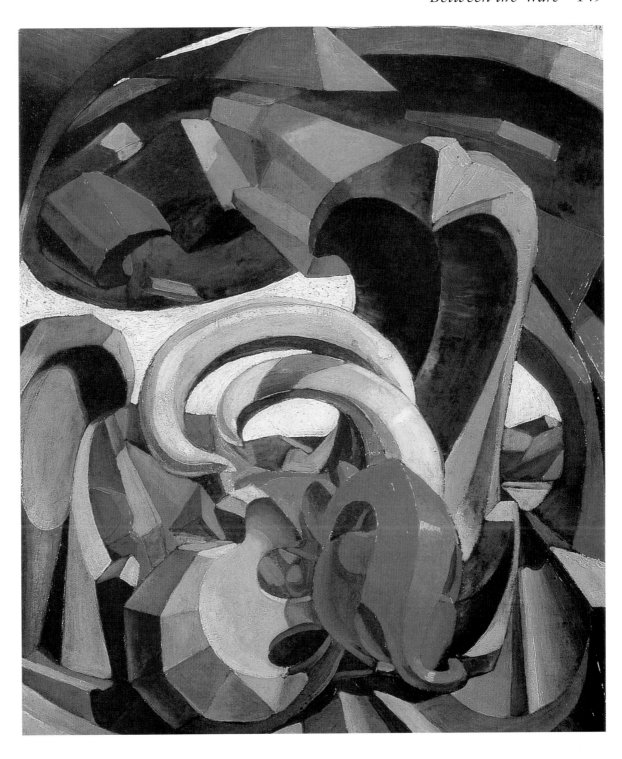

105 William McCance
Conflict
c. 1922
Oil, 76.20 x 63.50 cm
Image © Culture and Sport
Glasgow (Museums)
Painting © Dr. Margaret McCance
The most sculptural of this
sculptor-artist's works, its severity
is modified by its unusually
powerful colour and painterly
surface.

adolescence of Andrew Wyeth's *Christina's World* (1948: Museum of Modern Art, New York), combines Realism and Surrealism in a highly individual way; the plaster male figure is now life-size and is placed in the open air beside the sleeping girl, and it is reflected in a lozenge-shaped mirror which typically suggests the world outside the canvas rectangle as well as defining aerial space within it. Cowie's later drawings, which develop this type of complex reference with great ingenuity, are perhaps the most characteristic of all his works.

In an article 'Idea in Art' published in *The Modern Scot* in summer 1930, another Glasgow-trained artist, William McCance (1894-1970) wrote a brief critique of *fin-de-siècle* aesthetics and of the theories and practice of the Bloomsbury painters who were his own contemporaries. By implication his piece also attacks the drawing-room sophistication of the current Edinburgh School. He comments that the Aesthetic Movement (art for art's sake) was succeeded by an 'art-for-craft's sake' attitude which invited us not to talk about art but instead 'to admire

the magnificent brush-WORK . . . Then there arrived on the scene a new foreman called Roger Fry whose ancestors had been marking oblong pieces of chocolate into four oblong sections and he saw that art was not only brush work and vibration of colour, but also Design, while Mr Clive Bell evolved an idea that it was not the milk in the coconut that counted, but the "Significant form". When you painted a chair, according to Mr Bell you had to get "the chairness of the chair". Since the Great War Bloomsbury has been sitting on comfortable divans surrounded by cushions, trying to discover the "chairness" of chairs.' McCance then differentiates between pattern which is two-dimensional and design which involves spatial relationships, and stresses the value of Cubism and of the

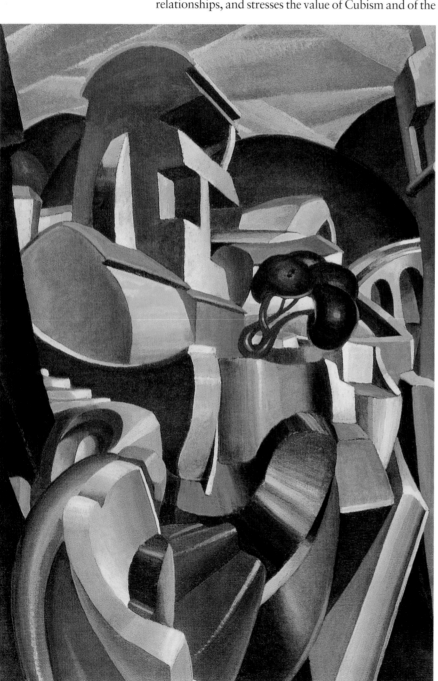

106 William McCance
Mediterranean Hill Town
1923
Oil, 92.10 x 61 cm
The McManus: Dundee's Art Gallery and Museum
Dundee Art Galleries and Museums (Dundee City Council)
© Dr. Margaret McCance

Expressionist reaction against 'the cold intellectualism of the Cubist'. McCance concluded that the future of painting could lie in a synthesis of the two, and that this might be done in Scotland, provided that the Scot could break through his 'narrow provincial barriers and gain a knowledge of what is actually taking place in the world around him'. When this was written, three expatriate Scottish painters, J.D. Fergusson, William Johnstone and McCance himself had achieved something like McCance's desiderated synthesis, although of the three painters only Johnstone continued to develop. McCance had been living in London for ten years, illustrating for *Lloyd's Magazine,* holding a variety of teaching appointments, and writing a column of art criticism for *The Spectator* from 1923-26. As an art critic he displays the incisiveness of his best work as an artist, which belongs approximately to the period from 1919 until 1930, when he became controller of the Gregynog Press at Newtown in Wales and began a distinguished separate career as a typographer and book designer.

McCance never seems to have supported himself by his painting. His works have a private, experimental quality, and he was the opposite of prolific. An early *Self-Portrait* (1916: Dr Margaret McCance) is a competent exercise done shortly after he had left Glasgow School of Art, where Fra Newbery was still Principal. It shows the influence of Pryde and Nicholson in its fluid handling and monochromatic tonality. It is a startling jump from this sober performance in an earlier style to *Conflict* (circa 1922: GAG), with its bold colour and even bolder, sculptural approach to form. There can be little doubt that *Conflict* is McCance's most important surviving work. It shows a well-assimilated Vorticist influence combined with an almost Surrealist content – a landscape contains a recognizable cat and human figure (both modelled on small clayslip figurines which McCance had made), as well as unidentifiable writhing vegetable forms and a tree whose branches turn into girder-like shapes. In it the inanimate hovers on the point of being animate and vice versa. The simplification of form and powerful use of colour produce a work of forceful individuality. There are only a few other works on a similar scale in this style dating from the early 1920s, including an untitled oil – which bears more than a passing resemblance to C.R.W. Nevinson's lithograph *Loading the Ship* of 1917 – showing figures working in a *Boatyard* (circa 1922: private collection) again schematized to a point approaching abstraction; and the powerful *Mediterranean Hill Town* (1923: DAG), a very striking example of his faculty of simplification through drawing of almost mechanical precision and a smooth, geometrical rendering of form. This latter work also possesses a certain surreal atmosphere contributed by the Corbusier-like architecture including a menacing villa which is almost anthropoid, like Epstein's *The Rock Drill*. This motif was

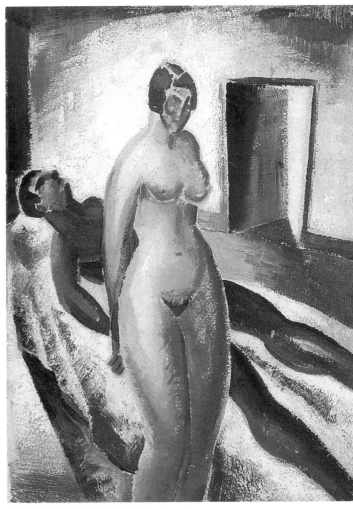

107 William McCance
Charleston
1925
Oil on card, 35 x 26.40 cm
Private collection
© Dr. Margaret McCance

108 William McCance
The Bedroom
1925
Oil on card, 35 x 26.40 cm
Private collection
© Dr. Margaret McCance

possibly taken from a sculpture by McCance which has not been preserved.

A few paintings from the middle 1920s give evidence of continuing development. *Charleston* (1925: private collection) and *The Bedroom* (ibid.) are evidently a pair, showing with abrasive humour a couple firstly dancing the Charleston and later nude in a room which contains only a bed. Although small, both pictures are painted with a powerfully Expressionistic use of colour which suggests that McCance had seen the works of the German Expressionists whom he mentioned later in the 1930 article already quoted. But some evidence of failing impetus is visible in the painting of the later twenties, and the best works from then are mostly small, beautifully executed prints and drawings in a Synthetic Cubist style, as *The Engineer, his Wife and Family* (1925), and *Moloch of the Machine* (1928, both linocut), *Early Telephone* (1927: Dr Margaret McCance), and *From a Window in Thrums* (1926: private collection), an anti-Romantic reading of J.M. Barrie's fey tale of life in Kirriemuir of which McCance also produced a scaled-up version in oils. One painting from this period, *The Fall* (1928: private collection) resembles the work of Picasso's Neo-Classical

period. It contains a typical joke in the Xs with which Adam and Eve have signed their marriage contract. Thereafter, McCance worked at the Gregynog Press where he was responsible for the beautiful editions of (among others) *The Fables of Aesop* with wood engravings by Agnes Miller Parker and initial letters by McCance), *The Singing Caravan* by Sir Robert Vansittart and *The Relevation of St. John the Divine* (with wood engravings by Blair Hughes-Stanton). That and his subsequent job as a lecturer in typo-graphy at Reading University effectively brought McCance's development as a painter to an end, although he continued to paint occasional pieces with his usual intelligence, producing an acidly pacifist *Hiroshima* in 1947 (Dr Margaret McCance).

William Johnstone (1897-1981) is a very different figure. As consciously a Scot as McCance and their mutual friend the poet Hugh McDiarmid, and equally concerned that Scottish art should be aware of developments outside, he was consistently concerned with art as expression, and in his work we confront the man and never a mere material fact. His sometimes inchoate, formally dense work at times has a gestural element, as if in impatience or frustration at the puniness of man's efforts to suggest

or capture immensity. His art is technically sophisticated but naive in effect – to the point almost, of suggesting the incapacity of paint to grasp the riddles of life and man's subconscious. His technique is always individual, from the sombre and subtle earth tones of the early palette to the 'bright' later use of black with colours in a high key applied with great variations of brushstroke, and a tendency to combine a background of saturated colour with a surface tracery of lines which indicate perspective in a manner reminiscent of Giacometti as a painter. As with naïve art, we discern in Johnstone's work less a perception of the thing itself, than an account of the artist's excited inner reaction to it.

Johnstone first received encouragement to paint from the Borders artist Tom Scott, whom he met in 1912, and several of whose grisaille wash drawings of landscape Johnstone acquired at an unknown date. He studied at Edinburgh College of Art from 1919 to 1923 and then in Paris in 1925 and 1926, in André Lhôte's studio. The Proto-Abstract painting in two gessoed panels of 1926 (William Hardie Gallery) began as a single composition which was divided and continued in separate halves. It has an elemental vigour and an interest in patternless forms suggestive of mass and density, with landscape references, to which one looks in vain for any influence of Lhôte.

Rather, the automatic drawing of André Masson seems more relevant – how one regrets the lost opportunity of asking the artist himself about Masson's work, and the amused, quizzical, and probably highly unexpected response which would follow – especially in the light of the psycho-sexual content of the painting indicated by the figurative overdrawing. The little *Composition* of 1926 in black watercolour (published in Douglas Hall's short monograph) is fully an automatic drawing in the surrealist sense of allowing the hand and eye to follow subconscious stimuli; it also anticipates action painting and much of Johnstone's own later output. In the following year Johnstone painted the large *Folies Bergères* (private collection) which codifies the academic synthetic cubism of Lhôte with something very close to brute strength in a composition of genuine power.

In a letter I received in 1972 Johnstone gave me a succinct account of his own early work. When he went to Paris in 1925, he says, Abstraction and Cubism were being criticized and the influence of the Symbolists – of the viewpoint that, as Gustave Moreau said, 'I believe only in what I do not see, and solely in what I feel' – led to the cult of the unconscious which is the essence of Surrealism. Johnstone writes:

109 William Johnstone
Abstract
1926
Oil on gessoed plyboard,
61 x 76.50 cm
Private collection
© Sarah Johnstone
Painted in Paris.

110 William Johnstone
A Point in Time
1929-37
Oil on canvas, 137.20 x 243.80 cm
Scottish National Gallery of
Modern Art
© Sarah Johnstone
'Through painting I began to
understand a concept of eternity
in which always and forever
there is illimitable change, a
continuous metamorphosis and new
identification ... These paintings
grew out of the disease of war, of
the anticipation of future tragedy.'
William Johnstone in *Points in Time*
– an autobiography.

All the influences of the school of Paris were most valuable but one thing had to be remembered and that was that the finding of oneself was the main purpose of the exercise. What did I have that was mine? . . . On my return to Scotland [in 1925] I was thrown back on my own resources. There was no immediate tradition in Scottish art worth talking about. So I turned to the Queen Street Museum [The National Museum of Antiquities] in Edinburgh to study the early Pictish carved and incised stones . . . The study of Celtic or Scandinavian primitive art made a powerful impression on me. This seemed to be an earlier form of symbolism or surrealism. I worked on several large paintings . . . These pictures began to be motivated from an inner being, the subconscious, and had no relation to the visible world as seen by the photographic eye. In these paintings too I was trying to bring back form into painting as I felt that form had disappeared from painting. These paintings, too, represented a feeling of disillusion after the war.

The most important painting from this post-Paris phase is probably *Painting, Selkirk Summer 1927* (SNGMA) which is a reworked version of a virtually identical composition (published by Hall) which naïvely combined biomorphic, curvilinear abstractions with suggestions of a bird and a human eye. In the second version the artist seems to have realized that Nature – the presence of life in a landscape with a human observer – could be more effectively evoked by substituting for these obtrusive symbols a ballet of abstract forms painted in earth colours of ochre, sienna and black, with a tracery of lines to suggest scale, perspective and contour. If disillusion is too strong a word – the 'paranoia' of the Surrealists certainly is – to describe the mood of this mysteriously compelling work, its feeling is close, rather, to that lack of illusion with which the farmer regards the landscape upon which man depends, as a great mechanism obeying its own slow rhythms heedless of those who would control it.

Johnstone was in America (where a large number of his pictures have been lost) in 1928-29, and after an unrewarding sojourn teaching in the Borders left Scotland for London in 1931. Here again he took a succession of teaching posts but found time to paint and exhibit (his first one-man show was at the Wertheim Gallery in 1935), met the circle associated with Alfred Orage's *New English Weekly* including Eliot, Pound, Dylan Thomas and Wyndham Lewis, and frequented E.L.T. Mesens's London Gallery which promoted the work of the Surrealists. The paintings dating from the years immediately after his return from the States suggest a knowledge of the American painters Georgia O'Keefe and Arthur Dove, as Hall has suggested; but the resemblances are restricted to a smoother and more coherently formal approach in Johnstone's work which at this stage has become virtually *sui generis*. Of *Ode to the North Wind* (1929: DAG), Hugh McDiarmid wrote

111 Edward Baird
The Birth of Venus
1934
Oil, 51 x 68.60 cm
Scottish National Gallery of
Modern Art
© Graham Stephen

in 1933 (in a series of poems based on Johnstone's paintings written in 1933 but only published in 1963):

> Our task is not to reproduce Nature
> But to create and enrich it
> By method like musical notes,
> mathematical tables, geometry.
> Of which Nature knows nothing.
> Artificially constructed by man
> For the manifestation of his knowledge
> And his creative will.

The last two lines summarize Johnstone's approach. The paintings produced in the late twenties and early thirties, of which *A Point in Time* is the most ambitious, are unique in the history of modern painting; they hint at the biomorphic world of Tanguy or the palaeological sources and planar ambivalence of Henry Moore, but with a technique that suggests Abstract Expressionism, while often exploiting the contrived situations dear to Surrealism. It may be questioned whether Johnstone was not too ambitious and whether his magniloquence found its proper vehicle, despite the manifest originality of his periods, which are now quicksilver, now lead, with the former predominant. His pedagogical work can still be gauged by his extensive and far-seeing writings, with their advocacy of child art and the art of primitive

societies; by all accounts he was an inspired teacher, as anyone who knew him in his old age can readily believe. In 1938 he became Principal of Camberwell School of Art and Crafts, a post he held throughout the war until his appointment in 1946 as Principal of the Central School of Arts and Crafts in London. His retirement from this position in 1960 to resume the life of a farmer in the Borders, his emergence ten years later from that seclusion to growing public awareness of him through an initiative at the Scottish National Gallery of Modern Art, and the immensely productive new career as a painter (and autobiographer) which unfolded in the last dozen years of his long life – all this is a story which belongs to a later chapter.

Surrealism took many forms, but perhaps none more fantastic than the whimsical art of Scottie Wilson (1889-1972), born in Glasgow but resident in Toronto when at some time in the late twenties or early thirties, in the back room of his second-hand junk shop, he picked up a pen and began to doodle. 'The pen,' as George Melly has said in his biography of the artist, 'like the red shoes in Andersen's story, refused to stop' but Scottie's mode of automatic drawing appears precisely guided by a logic of the absurd. In silhouette (his drawings make a very sparing use of outline as such) the endlessly varied forms (one almost wrote, creatures) are crisply Rococo: s-scrolls, f-scrolls, c-scrolls, indeed virtually every scroll known to calligraphy. The fields bounded

by the silhouette are subdivided by gadroon-shaped areas of gently curvilinear hatching which gives the whole a soft, invertebrate appearance like a swarm of plankton magnified. The forms themselves include plants, birds, fishes, hippocamps and bulbous-nosed 'greedies' or 'evils', half-materialized incubi and succubi bodied forth from the artist's subconscious and expressing moods of serenity or, more often, feelings of persecution or unexplained dread. Scottie returned permanently to London in 1945 with his style essentially fully formed and was quickly claimed by the Surrealists.

His later work pays more regard to pictorial values and shows an expressive use of an individual range of colour – velvet blacks, midnight blues, burnt orange – and he was an obvious choice for commissions for tapestry at Aubusson and for porcelain decorations

for the Royal Worcester Porcelain Company.

Three Glasgow-trained artists, Edward Baird (1904-49), William Baillie of Hamilton (b. 1904), and William Crosbie (1915-99) showed a brief interest in different aspects of Surrealism in the 1930s. Baird, who came from Montrose and was a friend of the Dundee artist McIntosh Patrick, who had also come to Glasgow School of Art, won a travelling scholarship which enabled him to study in Italy. Here, like Patrick, he was especially impressed by the work of the early Renaissance masters, especially Mantegna. *The Birth of Venus* (1934: private collection) exemplifies Baird's tightly controlled draughtsmanship and high finish. It is contemporary with and resembles the work of Tristram Hillier in its minute rendering of the flotsam of the shore, but the lenses (of a collector or a film director,

112 William Baillie of Hamilton
Painting
1939
Oil, 61 x 77 cm
Reproduced by kind permission of Perth Museum and Art Gallery (Perth and Kinross Council, Scotland)
© William Baillie

113 William Crosbie
Heart Knife
1934
Oil, 60.30 x 43 cm
Scottish National Gallery of
Modern Art
© Pauline and Anne Crosbie

William Baillie of Hamilton is a rare excursion into Surrealism with echoes of Paul Nash and Edward Burra. The artist has explained to me that the painting was born out of feelings of premonition prior to the outbreak of war. The dream-like atmosphere in which time is accelerated, bringing sudden death and somewhat ominous vegetable growth, is enhanced by a delicate effect which works like a gauze in the theatre to suggest interstellar dust in an impending cosmic drama. Alone of these three artists, William Crosbie was able to make a study of Surrealism at first hand in Paris where he studied under Léger and Maillol in 1935-36. One of the most brilliant students to have graduated from Glasgow School of Art, Crosbie demonstrated enormous versatility in a career that included mural commissions and decorative schemes for several of the Clyde-built liners as well as easel paintings, including decorative nudes and still lifes which show the influences of Maillol and Picasso. *Heart Knife* (1934: SNGMA), however, suggests Ozenfant and Jeanneret and Purism; although as it predates his Paris year it may reflect a knowledge of the work of the English Constructivists of Unit One and particularly Ben Nicholson, whose predilection for pure geometry and a distressed, painterly surface it shares. The painting is a brilliant construction of geometrical abstract forms inscribed with set square and dividers on the plane surface and yet occupying three-dimensional space, demonstrated by the presence of areas of light and shadow and by the spring-like line with a ball at its top which is in arrested motion. In *Design for Living* (1944: private collection), a self-portrait in Navy clothes, the artist literally toys with Abstraction: is this the way forward?

The designer and painter Alastair Morton (1910-63), was on terms of close friendship with Ben Nicholson and his first wife Winifred from the early thirties when the Nicholsons and Morton himself were living near Carlisle. Morton was a member of the Morton family of Darvel, already encountered in the architect W. Gibb Morton and in the link of Voysey with the firm of Morton Sundour of Carlisle, a successor of the Darvel, Ayrshire family lace-making and textile firm of Alexander Morton and Company. Through his directorship from 1932 of the Scottish firm Edinburgh Weavers, founded by his father in 1928 to develop textiles compatible with the most recent developments in architecture and design, Morton was able to support one of the most fruitful and original developments in twentieth-century design in Britain, and at the same time to pursue his own experiments as an abstract painter to a remarkable and successful conclusion. After only two years in Edinburgh, the slump of 1930 forced the firm to merge its Edinburgh workshops with the main factory in Carlisle, but Edinburgh Weavers continued in business from its new base, with showrooms in London in Hanover Square and, after 1935, in New Bond Street. It not only continued in business, but

who knows?) and the enigmatically smiling antique head suggest an ironical view of what, suitably for a picture given to the Patricks as a wedding present, was a Hollywood-glamorous subject. Baird's output was small but of consistently beautiful draughtsmanship. *Unidentified Aircraft* (1942: GAG) began as a view of the town of Montrose rendered with Mantegna-like precision to resemble a northern Italian town, its suspension bridge, no longer extant in 1942, included to impart a strangely medieval antiquity to the town, now threatened by the unseen enemy aircraft towards which the heads in the foreground look skywards, added later when the bombing raids had begun.

Painting (1939: William Hardie Gallery) by

under Morton's increasingly well-informed and enthusiastic artistic directorship – he visited Hoffmann in Vienna in 1936, and would certainly have seen the exhibition of Constructivist art organized by Edinburgh University in May 1937, which included Piper, Moore, Hepworth and Nicholson – entered a highly creative phase in which superb modern designs, particularly by Hepworth and Nicholson, were sympathetically realized in textiles using mixtures of different yarns as well as prints. These designs were launched in 1937 as the 'Edinburgh Weavers Constructivist Fabrics'. In the previous year Morton had commissioned a house from Leslie Martin and Sadie Speight, and had added a canvas by Piet Mondrian – *Composition* (1932-36) – to the paintings and sculptures he had bought from his friends.

Morton began to paint abstract compositions in 1936. In a letter to Ashley Havinden of 12 May he writes, 'I have had great fun since I got back trying abstract painting. I have nearly finished my second and have a third in mind . . . It takes much longer than I thought but it is exceedingly interesting work'. C.H. Waddington's account of Mondrian in *Behind Appearance* succinctly analyses the arcane differences between Mondrian and pesudo-Mondrian; this can be simply summed up in Ben Nicholson's words to Morton in a letter of 18 February 1940 regarding Morton's own work: 'I expect the new oil abstracts are very good. It is the *sustained* tension in these more serious works which is really satisfying'. Morton's paintings, often in gouache and on a small scale after 1940, possess the delicate poise of weight and counter-weight of Mondrian as well as Mondrian's impassive surface and an almost identical, sparing use of red and yellow, but he resembles Nicholson in his occasional introduction of circles, lines which suggest shadows and hence the presence of light, and straight lines which depart from the rectilinear grid of Mondrian. In at least two examples, as Calvocoressi has pointed out, a four- or six-frame quasi-animation of the component shapes of the composition results in a sense of movement, as if these forms were turning in space, like a Calder mobile. The plywood constructions and related paintings of the Edinburgh-trained artist Margaret Mellis (1914-2009) likewise show the humanizing influence of St. Ives, where Nicholson and Naum Gabo were neighbours after her move there in 1939 with her first husband Adrian Stokes.

The playfulness of the Jazz Age and the geometrical emphasis of Art Deco, brilliantly anticipated by Mackintosh in the work for his Northampton clients Mr and Mrs Basset-Lowke and in his textile designs, belong essentially to the big city, to Glasgow rather than Edinburgh. Weddell and Thomson's Beresford Hotel, the Cosmo Cinema, the great gates to the Shawfield dog stadium, and Thomas Tait's Art Deco tower at the Glasgow Exhibition of 1938 were among the more conspicuous monuments of the style in Glasgow. There were also the interiors designed by Charles Cameron Baillie for luxury liners and, famously, for Rogano's Restaurant in Royal Exchange Place. Charles Cameron Baillie was also an extremely incisive portraitist, often painting on small

114 Alastair Morton
Untitled
1940
Gouache, watercolour and pencil,
35.60 x 51 cm
Scottish National Gallery of
Modern Art
© Alison Morton

115 John Laurie
The Cocktail
1936
Oil, 138 x 91 cm
Reproduced by kind permission
of Perth Museum and Art Gallery
(Perth and Kinross Council,
Scotland)
© The Artist's Estate

glass panels; sadly, his work is very rare and he has remained an obscure figure about whom virtually nothing is known. But perhaps the Art Deco interlude is most convincingly represented in Scottish painting by a single large painting, *The Cocktail* (1936: Perth Art Gallery) by John Laurie (d. 1972), who taught drawing at Glasgow School of Art from 1946-1972, having himself been taught by James Cowie at Hospitalfield. One wonders what Cowie would have made of the suddenly emergent decorative panache of his pupil, which unfortunately did not resurface after the war when delicious decadence had given way to austerity and rationing.

The last aspect of the work of Scottish artists of the twenties and thirties briefly noticed here is perhaps also the best-known today. The 1922 Group, consisting of students who had qualified at the Edinburgh College of Art in that year, included William Gillies (1898-1973) and William MacTaggart (1903-81), respectively a future Head of Edinburgh College of Art and future President of the Royal Scottish Academy, with whose names the twentieth-century Edinburgh School is practically synonymous. Francophile, colourful, serious and civilized, these prolific artists have stamped contemporary Scottish painting with an image which refuses to fade even today. In MacTaggart we find a powerful impasto and glowing colour reminiscent of Rouault, applied chiefly to landscape and still life. Gillies employed a decorative idiom resembling the later Braque – who was made an honorary member of the RSA in 1957 – to some extent a legacy of his Paris experience, in treating very similar subject matter. Equally painterly and partly inspired by their example, Anne Redpath (1895-1965) employed an increasingly rich palette when she returned to painting after living for many years in France, and her travels to France, Spain, Corsica, Britanny and the Canary Isles provided themes. A more wistful, haunted art which owed a good deal to Chagall and Redon was developed in Edinburgh by John Maxwell (1905-62). As these Edinburgh painters and their colleagues and successors at Edinburgh College of Art continued and renewed the Franco-Scottish painterly tradition of the Colourists well into the post-war period, their work will be described in the chapter which follows.

POST-WAR PAINTING IN EDINBURGH AND GLASGOW

The star of Edinburgh was again in the ascendant between the wars and after World War II. This was due firstly to a negative factor, the decline in influence of the Glasgow Boys, the dispersal of many of them to Edinburgh or London, and the lack of any convincing succession to them in the west. But there were real, underlying strengths to Edinburgh's position. Its Art College, founded in 1908, drew upon traditions established by the Trustees' Academy and the RSA Schools in earlier decades and thus enshrined the major part of the history of Scottish painting and especially the painterly Colourist tradition. Two of the Colourists, Cadell and Peploe, had studied there, and Peploe had recently been a member of the teaching staff. An enlightened regime prevailed in the College – Sir William MacTaggart singled out Adam Bruce Thomson, D.M. Sutherland and Henry Lintott as inspiring teachers – and the Andrew Grant Bequest, which from 1930 enabled nearly all the most gifted or promising students to spend a post-Diploma year abroad, was of crucial importance. In addition, the SSA in Edinburgh played a major role, which is only beginning to be recognized, in introducing the Scottish public to the work of unfamiliar masters such as the Post-Impressionists, the Futurists and Picasso in 1913, Paul Nash in 1919, Munch in 1931, Klee in 1934, Braque and Soutine in 1935, and Max Ernst and other Surrealists in 1937. As Council member and then President of the SSA (1933-36), of which he had been a member since 1922, MacTaggart played an important role in securing these shows, the first of which was in fact also shown in Glasgow before travelling to Edinburgh. None of this would have counted of course without the five singular artistic personalities who were the originators of the new Edinburgh style: Anne Redpath (1895-1965), William Gillies (1898-1973), William Crozier (1897-1930), William MacTaggart and John Maxwell (1905-62). Precisely at the time when the rising stars of painting in Glasgow – Patrick, Baird and Fleming and the older James Cowie – were concentrating on linear precision and the hard edge to the virtual exclusion of all else including colour, these Edinburgh artists, inspired by frequent visits to France,

opposed painterliness to line, richness to austerity, and decoration to descriptiveness whether of colour, modelling or perspective. Of the Glasgow names, only Fleming was a native of that city, and by 1948 he had moved to the north-east of Scotland on his appointment as Warden from 1948 to 1954 of Hospitalfield House. Cowie preceded him as Warden from 1937 to 1948 after serving two years as Head of Painting at Gray's School of Art in his native Aberdeen and as we have seen, Patrick and Baird returned to their native Dundee and Montrose immediately on completion of their training in 1938. Their dispersal prevented the Glasgow-trained artists ever being regarded as a group, despite the obvious homogeneity of their work; not so the Edinburgh artists who remained attached to the capital city.

The teaching of André Lhôte in Paris, under whom Crozier and Gillies studied, might have been expected to provide a resolution of the Edinburgh–Glasgow polarization of styles by introducing the Edinburgh artists to the formal approach of Synthetic Cubism. Instead, the unexpected happened, and Gillies and Crozier, in temporarily espousing the more structural method of Lhôte, also adopted his earthy palette: perhaps Derain's later style too was an influence in this respect. Gillies's *The White Lodge* exhibited in the 1926 exhibition of the 1922 Group and the *Two Pots, Saucer and Fruit* of 1933 both look decidedly French, but in terms of colour it is as if Fauvism had never existed, nor for that matter its Scottish aftermath in the Colourists. Crozier's palette is similarly subdued. Before his early death his French enthusiasms had influenced his friend William MacTaggart. The delicate health of both men disturbed, or perhaps stimulated, their early training; they made frequent winter visits to France and in Crozier's case to Italy, and attended classes at the ECA when they could. MacTaggart, who had intended to study under Lhôte with his two friends, but was prevented by ill health, later remembered in those days hearing a lot of Lhôte's philosophy from Crozier. The Old Town of Edinburgh as it rises towards the Castle was a frequent subject for Crozier, both in etching and in painting. Repeated study of the city enabled him to reconstruct it in

simplified planes and volumes illustrated typically by a soft sunlight, with pliant outlines blunted by a light haze to produce a soft edge, as in *Edinburgh (from Salisbury Crags)* (1927: SNGMA). If this is Cubism, it is soft Cubism, but the influence of Lhôte is clear.

In 1926, his training and a year's teaching in Inverness behind him, William Gillies returned to Edinburgh to take up a part-time appointment at the ECA and so began the association which was to last forty years. He became Head of the School of Painting in 1946, and Principal in 1960; he was knighted in 1970. In the same year his lifelong friendships with the painters D.M. Sutherland, Donald Moodie, and John Maxwell began. After Crozier's death in 1930, Gillies shared the studio at 45 Frederick Street with MacTaggart. These friends shared many painting holidays throughout the thirties and when Henderson Blyth joined the ECA staff in 1946 he too became involved in these trips, which were to prove a cementing influence on the style of this group of individualists. Throughout the thirties Gillies and John Maxwell went every Sunday evening to visit Dr Frederick Porter and his wife Margery (Peploe's sister), in Morningside Road, Edinburgh, where the issues of modern art would be eagerly discussed in a nursery of ideas to which Gillies later acknowledged his indebtedness. After the Gillies family's move to Temple in Midlothian in 1939, the village and its surroundings became the mainstay of his landscape work, and his still lifes were painted in the studio there.

Gillies is *par excellence* the kind of painter whose naturalness defies verbal explanation. There are no iconographical mysteries to unravel and little in his uneventful life which appears to be reflected in his work, and in the very large *oeuvre* in watercolour as well as oils produced over half a century there are few, very few, deviations from a steady and stately course. A work of his early years will not have so very different an appearance from a late one. There is a slow development towards a higher key and greater transparency, and an increasing tendency towards the disembodiment or dematerialization of the object and its detachment from its surroundings, in the process of which the ground plane will tend towards the vertical and function also as background. But this is itself only a late stage in a preoccupation which is constant in his work, and to which the experience of relevant masters such as Munch and Braque brings only a mild and temporary distraction. Gillies's gift is such that, painting every day – 'What else is there to do?' he would ask – he found in the daily exercise of the craft of painting all that he required to solve the problems of painting as an art. The preoccupation was, essentially, the composition currently before him on the easel and how to marshal its constituent elements so that the 'mood' (a favourite word) of landscape or the 'almost pure abstraction' of still life (by this he must have meant the purity of inanimate form) could be preserved in their conveyance from three dimensions onto two. The skill was in the touch which ensured that in the process none of these delicate things was bruised. Although equally at home in oils and watercolour, the transparency and fluidity of watercolour he clearly found particularly congenial.

Gillies himself mentioned Matisse, Pissarro, and Braque as the three artists whose work had meant most to him since his year in Paris but was dismissive about the importance of that year to his own development. Perhaps it was the serenity of mood of Pissarro and the flat, decorative style of Matisse that seemed in sympathy with his own practice, although Gillies's palette is a long way short of Matisse's chromaticism and employs secondary and tertiary colours in preference to anything more assertive. When he does use primary colours, he does so judiciously, aiming always at subtlety and understatement. In landscape, and also in still life, where the example of Braque is more relevant, Gillies remains wedded to the motif and to the sense of place, of man's domestic or landscape environment, with its associations preserved intact. His fluent, economical drawing is perhaps the key to his style. Where Braque will combine two or more elevations of an object simultaneously in a single fluid line, Gillies will select one viewpoint and draw it with sure elegance. Braque's objective imagery thus transcends the particular; Gillies, conversely, renders the particular transcendent. One is always conscious in his work of the individual landscape in just *that* set of weather conditions at just *that* time of the year, of those particular flowers or that still life as being a true record, as well as possessing great decorative beauty of colour and form in their new juxtapositions on the canvas. By all accounts his felicitous touch was the accurate reflection of the inner felicity of the man. His sane and positive influence on his contemporaries was immense as painter and teacher.

Gillies's lifelong friend William MacTaggart attended the ECA at the same time (when he was not painting in France) and with Gillies founded the 1922 Group of artists who had gained diplomas in that year. The 1922 Group held annual exhibitions for about ten years and as well as William Crozier included A.V. Couling, William Geissler, David Gunn, George Wright Hall, Alexander Graham Munro and George C. Watson in its membership. From a very early point in his career – he began attending classes at ECA at the age of fifteen – MacTaggart shows a greater feeling for the handling of paint than any of his contemporaries. MacTaggart's father was an inventor and marine engineer, co-founder of the firm of MacTaggart and Scott, and an amateur watercolourist who encouraged his son's desire to be an artist. As the son of the great Scottish landscapist William McTaggart, Hugh MacTaggart had none of the usual parental qualms about the artist's life for his own son. William MacTaggart the younger (as he habitually signed his paintings,

abbreviating the last word to 'ynr') possessed several major examples of his grandfather's work – more of his work than that of any other artist – including three large and very painterly landscapes from the elder McTaggart's impressionistic late phase. It is not known when these came into his possession, perhaps in 1930 on his father's death; but they were always there in the background, an ever-present reminder of the family tradition of artistic independence and the painterly treatment of landscape.

At the risk of oversimplification, it is possible to divide MacTaggart's career into four phases, which spring in turn from his encounters with four European Modernists. André Lhôte's formalist influence, mediated by Crozier, is visible in his work of the early twenties: but in the mid-1920s a gradual return to fidelity to the forms of nature rather than of geometry is accelerated by the example of Dunoyer de Segonzac – 'I remember being very, very thrilled by Segonzac' were his words to Douglas Hall. Segonzac, a friend and admirer of Fergusson in Paris (Fergusson had enlisted him as a contributor to *Rhythm)*, was opposed to Cubism; his own paintings of landscape have a meandering, free-flowing line. This came to MacTaggart as a welcome release from the aridities of the earlier style. Like Gillies, he was a compulsive sketcher from nature, as his many notebooks testify, preferring charcoal and its broader effects to the nervous pen and ink technique of Gillies. But MacTaggart's encounter with French painting seemed to mute his use of colour for a period – it affected Gillies and Crozier in the same way – and the powerful colourism with which his name is associated was hardly apparent until MacTaggart had seen the Munch exhibition in Edinburgh in 1931. (This exhibition, initially suggested to him and the SSA by the etcher Harold Morton, was arranged on the Norwegian side by MacTaggart's future wife Fanny Aavatsmark.) In the later works shown by the Norwegian master MacTaggart found a model for a style which expressed the moods of landscape with a strength of colour and handling which were congenial to his own temperament. After the war the MacTaggarts were able to resume their visits to France, and in 1952 MacTaggart saw the large Rouault exhibition at the Musée de l'Art Moderne in Paris. This exhibition changed the course of MacTaggart's work and prepared the way for the very rich final phase which only ended with his death in 1981. The glowing colours, sumptuous impasto, and emotional charge of MacTaggart's late work are frankly indebted to the French artist, with the significant difference that while for Rouault the human figure always remained the central concern, MacTaggart confines himself exclusively to landscape and still life which he infuses with human feeling. This humanism remains the chief point of contact between the art of MacTaggart the younger and that of his grandfather, but the revelation of Rouault was required to set it free.

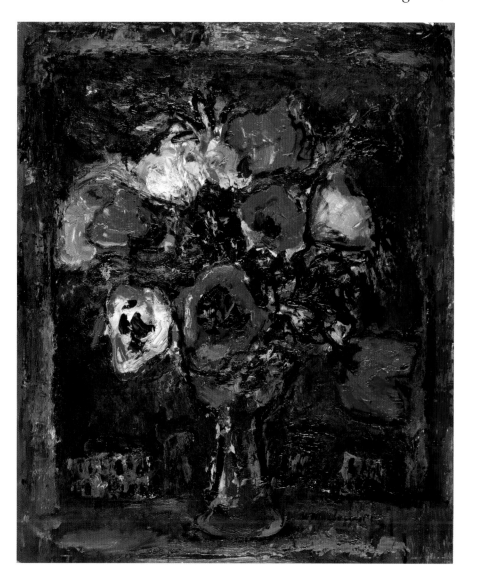

The confident, fluid handling of the little painting of *The Croisette at Cannes* (1923: Sir Arnold Clark), painted on the first of his winter visits to the south of France, suggests an influence of Fergusson's and Peploe's Royan period, and in the more formally composed slightly larger paintings of the twenties such as *Cassis* or *Bormes-les-Mimosas* (MacTaggart Studio nos. 238 and 270) awareness of Lhôte is evident. But it is also noticeable from the beginning that MacTaggart's style is his own, with a concern for *matière* and for beauties of surface which determines the way the paint is applied as much as any descriptive requirement. The artist remained true to this view of painting throughout his long career, and it is a noteworthy feature of his gradual development that form and content advance at the same pace. The formidable technique grows to accommodate the increasingly profound and dramatic subjects, the mysterious, brooding landscapes, and the view from his studio window over the garden in Drummond Place one day filled with a meek procession of nuns (MacTaggart Studio no. 100) painted with great

116 Sir William MacTaggart
Poppies against the Night Sky
1962
Oil, 76.20 x 63.50 cm
Scottish National Gallery of Modern Art
© William F. MacTaggart (as representative of the copyright holders)

simplicity, and on another dominated by a magical night sky with stars and a red moon *(Starry Night, the New Town*, 1955) above a still life of fruit, painted with a palette of lapis, amethyst, sapphire and cornelian. The assumptions underlying a career devoted to painting landscape and still life must include a view of the value of such subject-matter itself. MacTaggart shares from the beginning the hedonism of the traveller-painters who take pleasure in nature, in unspoiled places, in the sun, and for whom landscape, like the flowers, the food and wine and the man-made things in still life, conduces to man's well-being and is indeed necessary to it. He begins by describing these things objectively but ends with a more subjective suggestion that their beauty and necessity depend on man and that these qualities have no independent existence outside man's perception of them. In the richly painted, visionary later work a tremulous sense of flux parallels the fragility of our grasp on them as well as their own transience. Their beauty is a function of our perception, but their being remains ultimately as mysterious as our own existence. The worked surface, the sulphurous yellows and reds, the petrol blues and greens of a palette in harmony with its own geological origins, present a paradigm of human creativity, man working with the materials of nature. In *Poppies against the Night Sky* (SNGMA), the flowers possess something of the poignancy with which Rouault invested the human figure, because MacTaggart's true subject, perhaps, is not the beauty of this world so much as man's struggle to hold it fast.

> We are the music makers,
> And we are the dreamers of dreams,
> Wandering by lone sea-breakers,
> And sitting by desolate streams; –
> World-losers and world-forsakers,
> On whom the pale moon gleams:
> We are the movers and shakers
> Of the old world for ever, it seems.
> Arthur William Edgar O'Shaughnessy, *Ode*

John Maxwell's art of fantasy and dream is unparalleled in Scottish painting of the twentieth century, unless one harks back to Jessie Marion King and the other Art Nouveau illustrators who employ a very different vocabulary and technique. Yet we know Maxwell to have enjoyed the company of fellow artists like his close friend William Gillies and to have appreciated his student years at ECA as well as his years there as a teacher, where, as David McClure stresses in his excellent and sensitive monograph, he in turn was greatly valued by the students for his encouragement of individuality. His pupils at ECA included Alan Davie and William Gear. His own teachers were Henry Lintott, David Alison, D.M. Sutherland, Adam Bruce Thomson and Donald Moodie all of whom, with the exception of Lintott, were essentially realists and admirers of Impressionism. Lintott alone

followed a very different tradition, that of Symbolism informed by the painterliness of Impressionism. His 'floaters', as he liked to call his allegorical figures would be noted by Maxwell as presenting an alternative to the more literal style of his other teachers. Maxwell did not spring Minerva-like, fully-armed from the head of Chagall, but he did develop his unique style at an early point in his career and did not alter its essentials thereafter. He would of course have received encouragement from Chagall's work as that of a kindred spirit; but until we know more of the precise circumstances of his acquaintance with that artist's *oeuvre,* it is premature to talk of influence.

Regarding Maxwell's relationship to the other master of the French School whose work has the most obvious affinity with his, Odilon Redon, it will be remembered that Charles Mackie had actually met Redon in Paris in 1892-93. Although Mackie died in 1920, it is clear from his widow's diary, which records this meeting, that Redon was regarded at that early date (and at the later date of the diary) as a figure of considerable importance. Charles Mackie, as a prominent member of the Royal Scottish Academy living in Edinburgh, can be assumed to have regaled his brother artists there with the tale of his early encounters with Vuillard, Ranson, Gauguin, Sérusier and Redon, and would certainly through his extensive circle of friends have increased awareness in the artistic community in Edinburgh of these *avant-garde* names. It is probable that Maxwell would have been alerted in such a way to the work of Redon, and also to that of Gauguin, whose drawing of the figure Maxwell's resembles in the 'Floral Queen' and 'Trellis' series. But this is conjecture. What is important is that Maxwell's art amply demonstrates that inner necessity which is the basis of genuine style. It is mysteriously, magnetically self-sufficient. In 1927, after a brilliant final year at ECA Maxwell received a travelling scholarship which took him to Spain and Italy where, as Anne Redpath had done before him, he discovered the painters of the Sienese *trecento,* and finally to Paris, where he enrolled in the classes conducted by Ozenfant and Léger at the Académie Moderne. We may assume that it was at this point that he encountered the work of Chagall and Redon. In 1929 he was given an appointment at ECA from which he retired in 1943 on receiving a small legacy to concentrate on painting full-time. His friend Gillies persuaded him to return to teaching in 1955, however, and he held the post of Senior Lecturer in Composition at the college until his early death in 1962.

Maxwell, unlike his friends, did not work naturally from the motif; the figures, plants, animals and birds that populate his pictures are imagined, and even the landscapes or little street scenes are transformed by his imagination. The panel *View from a Tent* (1933:SNGMA) is revealingly different from

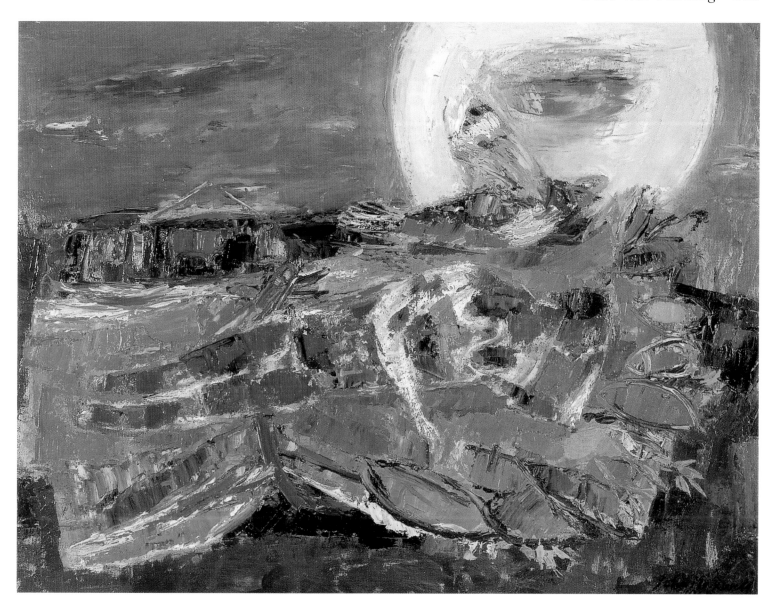

117 John Maxwell
Harvest Moon
1960
Oil, 76.20 x 101.60 cm
Private collection
© Brian Maxwell

Gillies's open-air studies: Maxwell uses the open door of the tent like a theatre curtain to frame the enchanting scene of the little house and boats beside a jetty with the hills beyond so that these assume the expectant air of an empty stage, lit and ready for the play to begin. Immediately, we are in a very different world from the naturalism of Gillies. A similar atmosphere of *Marionettentheater* (but without marionettes) is visible in *Harbour with Three Ships* (SNGMA) painted in 1934, the year of the Klee exhibition at the SSA, a homage to the master which eschews Klee's diminutive scale and delicate handling. A watercolour of a similar subject, *Harbour with a Warning Light* (1937: AAG), achieves the authentic Maxwell resonance using his favourite method of painting on paper supported by a sheet of wet glass so that the pigment stains spread over the surface in a way which is partly random, adding to the effect of mystery. What danger threatens the Milk Wood-like village which seems to huddle in

concern? With the tender *Two Figures in a Landscape* (1934: private collection) we sense an unmistakable debt to early Picasso, just as *Flowers in a Square* (1938) or *Flowers on a Beach* (1937-39: private collection) dwarf village houses and churches in a manner strictly the property of Chagall. But the flower pictures are wonderfully, magically, rendered in colours which run the gamut from low to high register and justify his empirical view (quoted by McClure): 'if the colour's right, the tone will be right'. Maxwell (whose student life drawings in a conventional style are among the most beautiful ever done at ECA) arrives at a perfection of a simplified, hieratic style of figure drawing at about the same time as his power of colour comes to maturity, around 1938. The large *Three Figures in a Garden* (1938: private collection) has the archaic look of a Minoan fresco, partly through the use of deliberately primitive drawing and a palette of earth colours dominated by terracotta, and partly by the

device of placing the figures in an irregular panel like a wall-painting at Knossos. They are in a garden with flowers against a flat background which can be read as a wall or as a horizon and sky. The antique air of the painting lends timelessness to its theme of love and innocence which has special poignancy in the uncertain period before the cataclysm of war.

We forget too readily perhaps the degree to which the state of Europe immediately prior to 1939 contributes to the *Angst* discernible behind the apparent sybaritism of the art of the period. *The Falling Vase* (1941: private collection), painted in the year after Dunkirk, could almost illustrate a passage from *The Snow Goose* which was inspired by Dunkirk and published in the same year; it shares the same tragic view of the transience of the individual life which gives rise to the eternal ideals of love or of beauty. It also shares its unbearable poignancy, its ellipses, and its sense of the beauty of the 'Lost Princess', of the girl Fritha, and of the nobility of soul of the artist Rhayader:

> Wild spirit called to wild spirit, and she seemed to be flying with the great bird, soaring with it in the evening sky and hearkening to Rhayader's message. Sky and earth were trembling with it and filled her beyond the bearing of it. 'Frith, Fritha, Frith, my love. Goodbye my love.' The white pinions, black-tipped were beating it out upon her heart, and her heart was answering, 'Phillip, I love 'ee'.

Man with Flowers (1942; private collection) inhabits the same emotional atmosphere of passionate and unrequited longing. The ugly man offering flowers to the unseen object of his hopeless suit could almost be an imaginary portrait of Rhayader. The female figures of this period, known as the *Floral Queens*, have a very different demeanour; proudly bearing flowers like attributes of themselves, they are at once sensuous and impassive, distant yet vulnerable: *Floral Queen I* (1939-1940: private collection), *Woman with Flowers (Phyllida)* (1941: private collection). The hieratic mode is retained in the *Trellis series* which follows, in which Maxwell explicitly adopts a mural style with flat panels against which the figures stand with frozen gestures like players in a masque. In *The Trellis* (1951: private collection), measuring nearly four feet by five, fantasy reigns: a crown is placed by a bird on the head of the Queen of the four garlanded nude figures and a cat who dance to the beat of a drum and at the same time seem to be reserved in the biscuit of a painted antique terracotta bas-relief. Ambivalently, all these figures appear simultaneously to be absorbed by their own rites and to provide a decoration for ours, all, that is, except for the Queen, who looks out of the picture as if the spectator were also part of the dance.

Maxwell's paintings from the fifties until his death in 1962 demonstrate further decorative enrichment, with incrustations of colour and impasto in which meaning and allusion are enmeshed. The watercolour *Moon Changes* (1958: private collection) hauntingly evokes the mystery of the lunar phases with childlike images of a sickle moon, flowers and stars, and a pair of birds on the wing watched by a dark flower queen like a Tahitian girl painted by Gauguin. Unexpected juxtapositions of scale give a child's perspective and suggest the intimate relationship of animate and inanimate nature in a way at once credible and mysterious. A beautiful example of Maxwell's painting of these twin sides of nature is *Flowers and Frost Flowers* (1958: ECAC) where the frost flowers crystallized on a window pane (among which a characteristic hunting scene with an archer and a cockerel is visible) surpass in scale and rival in profusion of form the living flowers in the white jug beside them. In the same year, Maxwell produced the most complex design of his career for a commission from the Scottish Committee of the Arts Council for a tapestry woven by the Edinburgh Tapestry Company. This is *Phases of the Moon* (SAS) which is a large and very much more elaborate version of the *Moon Changes* composition. Maxwell went to considerable lengths to master the technical aspects of designing for the loom; the triumphant result has a Lurcat-like richness and sense of ornament, brilliantly combining the staccato of the central panel with a legato effect in the medievalizing border which is subdivided into twenty-two emblematic panels of birds, animals and insects. The endless creative profusion of natural history and the cosmic laws of natural philosophy are happily married in his work, which hints at the grandeur of Creation itself.

Textiles were in Anne Redpath's blood as the daughter of a Borders textile designer. 'I do with a spot of red or yellow in a harmony of grey, what my father did in his tweed', she once said. Born in Hawick in 1895, her productive life as an artist divides with unusual sharpness into four phases: her student years at ECA (1913-17) and a post-Diploma year spent in Brussels, Bruges, Paris, Florence and Sienna in 1919; her career as a wife and mother after her marriage in 1920 until the family's return from France in 1934, when she settled in Hawick while her husband, the architect James Michie, worked in London; then a period of gradually increasing activity as a painter culminating in her first solo exhibition at Gordon Small's gallery in Edinburgh in 1947. Finally, after her move to Edinburgh in 1948, and earlier visits to Skye and Paris, extensive travels to Spain (1951), Brittany (1953), Corsica (1954), the Canary Isles (1959), Portugal (1961), Holland (1962), and Venice (1963), which provided landscape or interior themes for her rapidly burgeoning career as a painter.

Redpath's work is seldom dated, and although one would like to understand better her transition to the vibrant colour and delicate sense of form of her maturity, it is clear that this coincides with, or

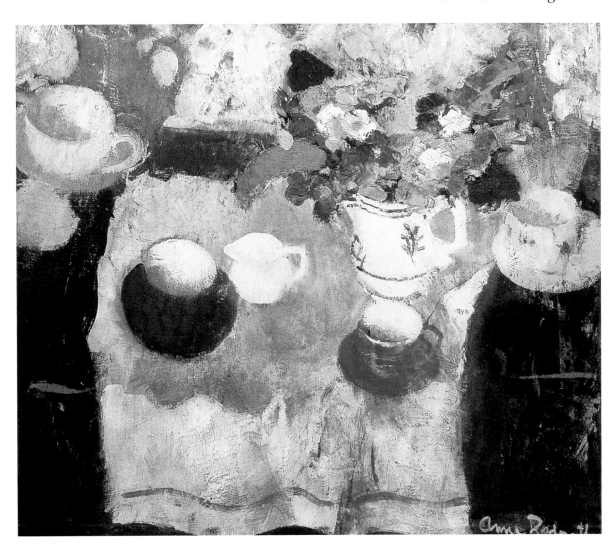

118 Anne Redpath
Still Life with a Jug of Flowers
c. 1948
Oil on panel, 61 x 50.80 cm
Private collection
Courtesy of the Artist's Family
and The Bridgeman Art Library

precedes by a short period only, her return to Edinburgh in 1948. *The Indian Rug* (SNGMA) has been dated to 1942 on the strength of a catalogue entry for a picture with the same title exhibited in that year. On the reverse, rather puzzlingly, is a *Landscape near Hawick* which lacks the confidence and indeed the sophistication of the interior subject. If the two compositions really were painted at the same time, this is only possible if even at this early stage in her career the artist employed two modes for the two genres. Her compositional method, which involved balanced massing of shapes and the use of strong colour applied locally within the outlines of the drawing, seems to have predisposed her to greater experimentation in the more easily manipulated area of still life. For she was as wedded to the motif as Gillies, and, perhaps more than he, cherished surface pattern and texture. Certainly, *The Indian Rug* is a *tour de force* which displays to the full her natural feeling for paint and colour. The drawing is delicate and the decorative pattern and colours of the rug itself are closely followed – the rug departing from the horizontal considerably more than is demanded by perspective, in order to bring it closer to the

picture plane – while the modelling achieves great plasticity with the most sparing of means, producing a characteristically painterly surface. The whole composition is in fact calculated as a vehicle for a remarkable exhibition of colour at once strong and subtle, a bold combination of the pastel shades of the rug and the crimson slippers and scarlet chair.

A surface pattern of strong colour in clearly defined forms originating in still life sounds like a recipe from Matisse and, as her biographer has pointed out, Adam Bruce Thomson, who was one of Redpath's teachers at ECA, had returned from a scholarship year in Paris in 1910 with the news that the name of Matisse was on everyone's lips. But in fact there is no need to look further than local examples – Cadell's 'geometrical' still life style of the twenties, and Gillies's tip-up tabletop still lifes – for precedents with which Anne Redpath would be thoroughly familiar, and with which her work indeed has more affinity. Having mastered the principles of flat pattern defined in areas of self-colour with minimal modelling, solid and void being indicated through crisp outlines, it was natural that an artist with her feeling for paint should proceed to the freer,

less deliberate manner of her later work. This is the tendency which marks her later still life, landscape and interior pictures (the latter including a group of church altarpieces and icons or Madonnas painted in Mediterranean countries), which are painted with Expressionistic breadth of handling and wonderful vivacity of colour.

By temperament a great lover of life with a wide circle of devoted friends, Redpath was perfectly equipped to play a major role in the development of the Scottish Colourist tradition. One may speculate that had she come from a more intellectual school – with her exquisite sense of form, colour and surface, she would have made a brilliant addition to the Nicholson-Hepworth circle at St. Ives – the result would have been no less a thing to conjure with. But she was well aware of the alternatives and chose her own path as a painter more concerned with colour and form as the means of heightened visual enjoyment than as aesthetic ideals. She thought naturally in terms of colour, shape and texture. Her art is that of a traditionalist for whom the still life in a painting could never be dissociated from its role in the artist's life. The humblest teacup bespeaks a way of life as eloquently as a Baroque altarpiece suggests religious yearning. The landscapes reflect back personal meaning, like pages from a diary. An aesthete she unquestionably was, but always accessible.

Sir William Russell Flint (1880-1969) was perhaps the most popular in terms of public appeal and also probably the most commercially successful of the Edinburgh-trained artists of this generation. His success should not be grudged him. He was a genuine artist who possessed a wonderful feeling for *matière*, especially for watercolour of which he was one of the outstanding exponents in the modern era. In this medium he was a purist, allowing the white of the page to provide all the luminosity, transparency and depth of which watercolour is capable without ever resorting to the meretriciousness of Chinese white. No artist records as well as he the topaz, amethyst, and sapphire depths of the sea, the waterlogged fluidity of sand after the tide has run out, the flounces of a Spanish flamenco dancer as well as her fiery carriage, or the firm breasts of a beautiful young model. In an approximately ascending order of interest to collectors, such subject matter could hardly fail to please. His concentration, increasingly, on groupings of bare-bosomed girls in hot and sunny picturesque locations are escapist, but they undeniably convey and impart a hedonistic pleasure. Escapism, deny it as one might, is inescapably a natural human reaction; his paintings should not be reproached with any failure to record the grimmer aspects of a difficult period in history, not only because they make no attempt to do so, but also because they

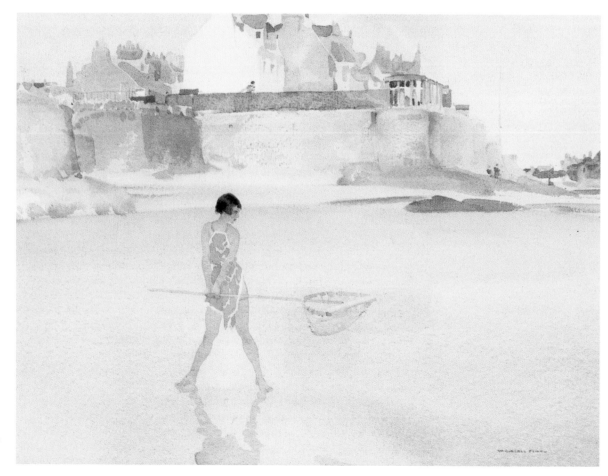

119 Sir William Russell Flint
Disobedient Jane at Elie
c. 1935
Watercolour, 24.50 x 33 cm
Private collection
© The Artist's Estate
Although he usually preferred more exotic places, Russell Flint also sketched in Scotland.

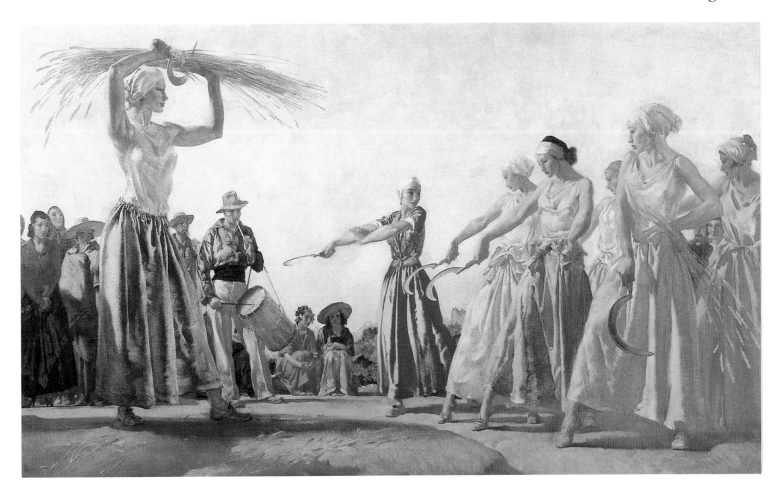

120 Sir William Russell Flint
Homage to Demeter, Provence
c. 1932
Tempera, 91.40 x 152.40 cm
Private collection
© The Artist's Estate

embody the very real daydreams of a generation. It is not the least of their aesthetically satisfying characteristics that these daydreams are recorded in watercolours of such stuff as dreams are made on – transparent, exquisite, delicate and evanescent. Russell Flint's sanguine drawings and his easel paintings, often in tempera rather than in the less fluid oils, show equally great technical command and a never-failing sense of chic. His *Homage to Demeter* is a large and classically choreographed composition which has something of the period elegance of Art Deco together with one of most commonly recurring themes of its iconography, the beautiful Amazon, in this case wielding little scythes which ought to make any mere male think twice before assuming that these pretty harvesters are intent on cutting off anything as mundane as sheaves of corn.

Wartime Glasgow witnessed a surprisingly vital and determinedly Modernist revival of creative activity in the theatre, letters and visual arts. There were productions of James Barke and other writers of the literary left at the Unity Theatre; modern dance by Margaret Morris's Celtic Ballet; and the Citizens' Theatre, founded in 1942 by James Bridie, T.J. Honeyman and others. A remarkably enterprising list of Scottish poets and writers was published by William MacLellan in finely produced *feuilletons* often illustrated or decorated by the members of the

'New Art Club', several of whom – notably Donald Bain, William Crosbie, and Tom Macdonald - were also active as designers for theatre productions in Glasgow. Although the riverside areas of the city like Clydebank suffered badly in the Blitz, the city centre was relatively lightly affected, and life went on as near normally as possible.

The return of J.D. Fergusson and his wife Margaret Morris from France to live in Glasgow shortly before the outbreak of war in 1939 was the single factor which, more than any other, galvanized the Glasgow scene. We have seen that a small but highly talented group of painter-draughtsmen (McIntosh Patrick, Edward Baird, Ian Fleming) had recently carried off all the prizes at Glasgow School of Art, where Hugh Adam Crawford, a greatly respected and influential teacher, had taught for ten years before becoming Head of the Painting and Drawing School in 1938. The great English artist Stanley Spencer was also in the city at this period, working in isolation at Port Glasgow. But the new movement owed allegiance to no institution and its mentors were its own senior members: the Polish *émigré* Josef Herman, who arrived in Glasgow at the end of 1940; and Jankel Adler, who was demobilized from the Polish Army and came to Glasgow in 1941, where he shared a studio with Benno Schotz and then with William Crosbie and, of course, Fergusson himself.

There were two centres of activity. On the initiative of the Fergussons, informal discussions were held in November 1940 at Glasgow School of Art on the possibility of founding a New Art Club. The 'old' Art Club, its bastions stormed by the Glasgow Boys of fifty years earlier, was once again regarded as a citadel of the Establishment, with a subscription which seemed rather expensive to young and impecunious artists. The New Art Club duly came into being in December 1940, with a one-pound subscription 'which may be paid in quarterly instalments', and a no-jury system like that of the Salon des Indépendants of which Fergusson had been a *sociétaire*. In the following year, 1941, The Centre – Gallery, Bookshop, Coffee Room – was founded by the bibliophile David Archer who published Dylan Thomas, David Gascoyne, W.S. Graham and many others for the first time at his Parton Press in Glasgow. The painter Benjamin Creme, a member of The Centre, became friendly with these and other writers from Archer's stable; they tended to stay in his flat when they came to Glasgow. Many members of the New Art Club also joined The Centre, which as Dennis Farr has written seems to have been an attempt at an Institute of Contemporary Arts. Four one-man exhibitions were held there and it is unfortunate that no catalogue seems to have survived, as the artists were of real stature: Adler, Herman, Crosbie and Taylor Elder. Farr (the writer's authority for most of the foregoing) tells us that Robert Frame and Benjamin Creme took over management of The Centre before it finally collapsed after some eighteen months of precarious existence. The closure of The Centre and the occupation of its former premises by

the Unity Theatre left a vacuum and led directly to the foundation of the New Scottish Group in November 1942 with Fergusson as its President.

The informal, at times anarchic nature of the NSG, and the greatly varying aspirations, styles and talents of its members, would not lead us to expect much stylistic common ground among them. Individualism was greatly prized and encouraged, particularly by Fergusson. But three main strands of influence, running from Fergusson, Herman and Adler are

clearly visible. Fergusson's Cézannesque treatment of landscape has clearly inspired Margaret Morris's *Les Toits rouges, Dieppe* (1924: SNGMA), and Donald Bain's landscapes, e.g. *Environs de Saint-Paul-de-Provence* (1947: DAG); his Fauvism, Bain's early cityscapes such as *Place de la Concorde* (1946: author's collection). Josef Herman's admiration for the proletarian subject matter and painterly social realism of Permeke is relevant to Bain's early figure style, e.g. *The Blind Musician* (1943: HAG), and

122 Margaret Morris
Les Toits rouges, Dieppe
1924
Oil on board, 35.50 x 27.30 cm
Scottish National Gallery of
Modern Art
© Margaret Morris Movement

also to the work of Millie Frood and Tom Macdonald who took over Adler's studio on the latter's departure for London in 1943. Adler's influence, in which the example of Picasso combines with that of Adler's friend Paul Klee, informs the work of Ben Creme, who moved to London in 1946, where he retained his close link with Adler. Adler from 1943 shared a studio in Bedford Gardens with John Minton, having left Glasgow in 1942, and here his work was to have a decisive bearing on two Glasgow-trained artists who were already installed in the same studio, Robert Colquhoun and Robert MacBryde.

The New Scottish Group produced a body of work which provides an alternative to the incipiently anodyne Edinburgh style. Fergusson's *Spring in Glasgow* (1941-42: HAG), where the model is posed against the view of the University and Kelvingrove seen from the window of Fergusson's studio apartment at No. 4 Clouston Street, must have seemed like a veritable breath of Paris spring air to his friends in Glasgow. The picture is typical of the generalized monumental style of this late period of his long career, when Fergusson also showed an increasing interest in his own Highland ancestry and in Celtic mythology (he had long been interested in Celtic art). Donald Bain added his own highly original contribution

to the Celtic movement in two extraordinary works which have Celtic subject-matter. These are the rebarbative, fiercely vehement *Ossian* (1944: Perth Art Gallery) and the placid *The Children of Llyr* (1945: SNGMA). Despite titles which might suggest the recent Celtic Revivalism of John Duncan in Edinburgh, *Ossian* looks as much like a work by one of the COBRA painters (1948-51) in Paris as anything produced in Britain at this date, while the pantheistic *The Children of Llyr* has affinities, albeit tenuous, with English Neo-Romanticism. Of *Ossian*, the artist wrote to me of a 'sudden realization that I was able to say something of my own in paint and I didn't care whether anyone liked it or not. But Fergusson realised what I was doing and didn't discourage me.'

Significantly, much of Bain's work is on a small scale. For one thing, his studio was the kitchen in a tiny flat in Springburn in north Glasgow where he and Eunice Bain raised three sons; for another, as his work stood small chance of selling, there was little point in saying at length what could be said equally well with brevity. Fortunately he was sustained by a courageous self-belief with which posterity is increasingly in agreement. Throughout the 1940s and 1950s – not always successfully – he essayed a wide range of subject-matter and styles, leaving his sources behind. The little watercolour *Jazz* (1943: SNGMA),

123 Donald Bain
Ossian
1944
Oil, 86.36 x 61 cm
Reproduced by kind permission of Perth Museum and Art Gallery (Perth and Kinross Council, Scotland)
© The Artist's Estate
The visionary Celtic bard of myth is Bain's subject in this work, which parallels contemporary COBRA painting or that of Ernst Wilhelm Nay. Bain frequently visited France in the later 1940s; these visits were to inspire a rejection of raw experimentation in favour of a return to the Franco-Scottish Colourist tradition.

124 Donald Bain
The Children of Llyr
1945
Oil on canvas, 107 x 94 cm
Scottish National Gallery of Modern Art
© The Artist's Estate

125 Donald Bain
Pleasure Craft
1968
Oil, 49.50 x 61 cm
Museum of Modern Art, the
Calouste Gulbenkian Foundation,
Lisbon
© The Artist's Estate

for example, is much more abstract than anything ever attempted by Fergusson, and shows Bain's very individual sense of design. He spent several months in 1946-47 in Paris and the Midi and met Matisse at Vence and Picasso at the Colombe d'Or at Saint-Paul, where he drew the latter's portrait (private collection) and where he was welcomed as a compatriot of Leslie Hunter who was well remembered as an *habitué*. *Autumn* (1943: private collection) and *Fisherman* (1944: author's collection), with *Ossian* represent three aspects of his earliest, pantheistic style which already shows great originality. Several little abstract panels were painted with titles like *Spring*; these seem to date from his time in Paris, but it is not known whether he was aware of the work of the COBRA artists and his compatriot William Gear in Paris at this time, which Bain's resembles. *Encroachment* (1948) was the most ambitious and largest of these; strictly, it is semi-abstract, with a recognizable animal's head surrounded by 'encroaching' urbanization. An abstractly structured *Calvary* (1958) further demonstrated his intelligent command of a fully contemporary idiom. Despite his isolation in Glasgow, Bain never stood still for long, consistently showing a painterly ability to adapt technique to

style. Never aiming at virtuosity, his technique involved a firm control of strong colour harmonies, and an awareness of the weight and scale of the brushstroke as unifying factors in the design. The turbulent brushwork and murky colour of *The Blind Musician* are essential to its powerful impact, while in the later work, such as the beautiful *Deux citrons* (1966: private collection) or *Pleasure Craft* (1968: Calouste Gulbenkian Foundation) the paint is applied very flat in broad areas of bright colour to give an effect of great simplicity and clarity.

Louise Annand, Marie de Banzie, Isabel Babianska, Anne Cornock-Taylor, William Crosbie, Andrew Taylor Elder, Robert Frame, Millie Frood, George Hannah and Tony St. Clair were among the other artists whose work benefited from the stimulus provided by the NSG. Their pictures from the war years show a varied and individual striving for modern forms of expression, from the biomorphic fantasies of St. Clair and Cornock-Taylor to the atmospheric Glasgow street scenes of Hannah. Louise Annand, in particular, painted one of the most striking images in her *New Art Club Meeting* (1944: William Hardie Gallery), which presents abstract symbols of the various factions in the New Art Club. She followed this successful and original parody with

The artist uses abstract symbols to personify individual members of the New Art Club and their styles of argument: nebulous or brilliant, convoluted or political; the last symbolized by a red star.

two brilliant Rayonnist paintings of crossed beams of colour – *Magic* (1944: lost), and *Heraldry* (1945: Murray Johnstone Ltd.) without, as she has informed me, ever having seen a work by Larionov or Goncharova. The NSG included several particularly interesting sculptors, notably the wood carver T.S. Halliday, and George Innes, whose work looks so interesting in the literature but most of which seems to have vanished into private hands. The New Scottish Group seems to have held only four annual exhibitions with well-produced catalogues with essays by Naomi Mitchison, Professor Alan M. Boase (whose portrait was painted by Herman), Maurice Lindsay and William Montgomerie. The last was also the author of the only monograph published by MacLellan on any Group member, Donald Bain. The last such exhibition was held in 1946, although in 1947 several NSG artists sent works to an opening exhibition of Modern Scottish Painting organized for the first Edinburgh Festival by the Society of Independent Scottish Artists. To this exhibition the 'two Roberts', Colquhoun and MacBryde, were also invited to send. Sadly the NSG seems not to have survived as a group much after 1951, when a retrospective show was held. They, and especially Donald Bain, today seem to us to have been 'primitives of the new sensibility'; they appeared at a

difficult time, but perhaps it was something of a miracle that they appeared at all. Although no equivalent grouping rose to succeed them, they initiated in Glasgow a certain receptiveness to new ideas from outside Scotland and – equally importantly – the idea of that independent art which J.D. Fergusson wished to foster in Scotland in a period when Scottish art was either linked to the local art establishment or was losing its identity in a welter of efforts to catch up with earlier twentieth-century styles.

The most striking work produced by this conscious cosmopolitanism is that of Robert Colquhoun (1914-62) and Robert MacBryde (1913-66), who both trained under Hugh Adam Crawford and Ian Fleming at GSA and under James Cowie at Hospital-field House in company with John Laurie (1916-72) and Henderson Blyth (1919-70). A fellow student at GSA, John Houston, recollected that Colquhoun's painting was markedly different from that of his contemporaries even in his student days, and suggests the influence of Picasso (particularly an unidentified drawing seen at the MacLellan Galleries in Glasgow in the mid-1930s), and also the impact of Herbert Read's *Art Now,* published in 1933. The two artists met in 1932, when they were both beginning their first year of study at GSA. For the rest of their lives

they were inseparable. Both showed remarkable talent as draughtsmen and were consequently well equipped to carry on the Glasgow linear tradition recently established at GSA. An early stylistic direction was given above all to Colquhoun by the work of Jankel Adler which they encountered, meeting the artist himself, during Adler's brief sojourn, in Glasgow. Adler acted as a vivid channel of the Synthetic Cubism of Picasso, and his drawing of the figure is given a certain indefinably central-European *Weltschmerz* by emotive distortions which surface again in Colquhoun's work at its most stark. We should also remember that, as John Houston convincingly reminded us, the desperate conditions of the hungry poor in the artist's native Kilmarnock and the atmosphere of the Hunger Marches of the thirties deeply affected Colquhoun's view of the human condition. After Colquhoun was invalided out of the army in 1941, Colquhoun and MacBryde moved to London to join John Minton in the studio at 77 Bedford Gardens, which became an important focal point for some of the most *avant-garde* names of literary and artistic London in the war years: the poets W.S. Graham, George Barker and Dylan Thomas were *habitués* as were the painters Michael Ayrton, John Craxton, Prunella Clough and Keith Vaughan, with less frequent visits by Francis Bacon, Lucian Freud and the young Hamilton Finlay. In these early years they must have made a striking pair, with mutual obsessiveness leading to fierce jealousy followed by reconciliation and the inevitably unequal interdependence of a latter-day Verlaine and Rimbaud, whom they admired, their artistic and social isolation a matter of pride, their noisy and often drink-inflamed Scottish nationalism expressed in strong Glasgow accents. Lefevre's keen-eyed Duncan Macdonald, the 'discoverer' of L.S. Lowry, gave the Roberts an exhibition in 1943; several more followed, but Macdonald, their most enthusiastic advocate, died in 1949 and Colquhoun's last show with Lefevre was in 1951.

Another success, minor but significant, came in 1945, when after an interview with Kenneth Clark, Colquhoun was commissioned to record *Women Weaving Army Cloth* (War Artists' Advisory Commission) in the Hebrides. Both artists also made prints in the late 1940s including monotypes and lithographs, the latter printed at the Miller's Press in Lewes run by the sisters Frances Byng Stamper and Caroline Lucas. Kenneth Clark was again supportive in 1948, suggesting the Roberts to Léonide Massine as designers for his projected Scottish ballet *Donald of the Burthens* which was performed in 1951 at Covent Garden with sets and costumes by MacBryde and Colquhoun and choreography by Massine. Colquhoun also designed décor and costumes for *King Lear* at Stratford in 1953. In 1951 both artists were invited to contribute to the Festival of Britain Exhibition *Sixty Paintings for '51*, and MacBryde received a commission for a mural for the Orient

liner SS *Oronsay*. But by the time of the Colquhoun Retrospective exhibition organized by the Whitechapel Art Gallery in 1958, for which the artist painted eight new canvases, the reckless lifestyle and years of penury were beginning to take their toll of Colquhoun, who died in 1962, while working on a drawing of a man dying. MacBryde was inconsolable and died in obscurity, run over by a car in Dublin, four years after his friend in 1966.

The fact that their lives were lived and their careers as painters developed permanently in each other's company, added to their common training and background, inevitably meant that their work would be extremely closely related. But there are major differences between the two artists, and something of the difference appears in two interviews they gave to *Picture Post Magazine* in 1949, to which Malcolm Yorke drew attention. The essential difference is that Colquhoun's art is ordered by a subjective view of the world; MacBryde's is dispassionate and aims to reveal hidden relationships which underlie appearance. Colquhoun begins with a defence of Cubism in the guise of an explanation of his own method: 'Each painting is a kind of discovery, a discovery of new forms, colour relation, or balance in composition. With every painting completed, the artist may change his viewpoint to suit the discoveries made, making his vision many-sided.' Crucially he adds, 'The special forms, evolved from the relation of colour masses, line and composition to express the painter's reaction to objects, will be the reason for the painting's existence.' In stressing the reaction of the artist, Colquhoun admits the possibility of that emotional, humane response that characterizes his formal distortions as a figure painter. By contast, MacBryde's formalism as a painter predominantly of still life is revealed in his own words as that of a classicist who seeks universal truth behind accidental appearance:

I set out . . . to make clear the order which exists between objects which sometimes seem opposed. I do this because it is the painter's function, generally speaking, to explore and demonstrate in his work the interdependency of forms. This leads me beneath the surface appearance of things, so that I paint the permanent reality behind the passing incident.

When MacBryde paints the figure, as in *Two Women Sewing* (SNGMA), it is reduced to a mere cipher which contributes to the formal relationships of the composition, having no intrinsic significance greater than that of the sewing machine, the table, and the material, each one of them an object suggested in a brilliant shorthand which emphasizes formal essentials: the woodgrain of the table end, the planks of its surface, like the simplified masks of the two women, undergoing a kind of distillation by which each becomes an equal component in the unified composition of two-dimensional shapes. In

certain pictures, presumably the later ones (a chronology has never been established) MacBryde adds these distilled forms as a background which is more frankly abstract and often suggests alternating light and shadow; but even at his most abstract, that reference to the world of natural shapes so characteristic of Neo-Romanticism – and so unlike the machine-like forms of Vorticism, for example – is never far away. The sinewy uninhabited landscapes of Benjamin Creme, who had left Glasgow and the NSG for London in 1946, similarly add a certain Glasgow muscularity to English Neo-Romantic content.

Colquhoun's spare and economical approach to composition can ultimately be traced back to Cowie's training. An early Cowie-esque drawing such as the powerful *Allegorical Study* (Dick Institute, Kilmarnock), couches a very un-Cowie-like theme of religion and sexual repression (a caged man, nude, is ignored by a despairing plaster Madonna whose classical drapes also seem to form the steps of a church) in the pseudo-academic language of

127 Robert Colquhoun
Boy with a Basket
1949
Oil, 61 x 51 cm
University of Dundee Museum
Services
© Estate of Robert Colquhoun
and The Bridgeman Art Library

metaphysical painting. If anything, it was Colquhoun of the two Roberts who initially owed the greater debt to contemporary English painting. His *Portrait of David Haughton* (circa 1941: Mayor Gallery) is obviously derived from Wyndham Lewis (who, like the Roberts, was represented by the Lefevre Gallery) just as the early *Tomato Plants* (1942) and *The Barren Land* (1942: both ibid.) have the look of Craxton or Minton. But after Adler's arrival at Bedford Gardens in 1943, and especially after the Picasso exhibition held at the Victoria and Albert Museum in 1945, Colquhoun forsakes local influences, and with the example of Adler and Picasso develops his own Expressionistic style. *The Woman Weeping* (circa 1945: Dick Institute) shows itself less concerned than the well-known Picasso archetype with a Cubistic interplay of planes; the emphasis is on continuity rather than fragmentation, the continuous line of the drawing expresses on the one hand the artist's 'reaction' to the subject and at the same time functions as a means of articulating the flat surface of the picture plane. An increasingly heroic manner is evident in the paintings of the late forties, which invariably contain figures such as the *Woman with a Birdcage* (Bradford Art Gallery) or *The Fortune Teller* (TG) set against a wall in a shallow space as oppressive and constricting as their own destinies. At this period Colquhoun's palette is individual — acidulous, acrid, and as astringent as a *Weltanschauung* which views humanity and animals as equals in appetite and in suffering, although the vitality and independence of the cat in *The Whistle Seller* (1946: private collection) contrast with the hopelessness of the human figure. Mannerism ousts feeling generally, in Colquhoun's later work, except in the late prints, where unfamiliar techniques and a more private sense of scale draw forth the artist's tragic vision in a series of compelling images, again often on the theme of men and animals. Always more painterly than MacBryde, Colquhoun in the late monotypes achieves a richness of texture too often absent from the declamatory late oils. His powerful style of draughtsmanship never deserted him. The obscene grin of the huge pig in *Figures in a Farmyard* (1953: SNGMA) has an uncomfortable familiarity and graphically suggests callous human greed, suggesting that the stoicism and resignation displayed by the human figures in the painting originate in bitter experience of this form of inhumanity. Alienation, futility, desolation, isolation were all states of mind expressed by Colquhoun's best paintings of the period; it need not be doubted that they were as familiar to many of his audience in the austere climate of the Cold War as they were to the artist in the difficulties of his own personal life.

Joan Eardley (1921-63) in her short life brings together several Glasgow traditions – an emphasis on the importance of line and drawing, a certain earthy realism and preference for realist subjects, and a belief that an artist's life must be one of independ-

ence and commitment. She was a remarkable draughtswoman, with a vital sense of line and *mise-en-page*; with brushes or palette knife she held in painterly balance the opposing demands of surface and depth, of objective 'decoration' and subjective 'theme'. She possessed not only humanity, but spirit; compassion and passion too. Thus in a fascinating correspondence with her mother and with Margot Sandeman, published by Cordelia Oliver in her excellent biography of Joan Eardley, we find the artist on a study-tour of Italy in 1948 lamenting her inability to talk to potential subjects in their native tongue:

> You can't converse and get to know the peasants who speak to you. There is always this stumbling block – to me a very great one. To become friends and, in this way, to partly understand these people, is the only way I feel I can paint them with truth . . . otherwise, as I am now, I only know what I see from outside. I suppose painting is only a visual reaction to things, in a way – but to me it must be more. The story part of it does matter.

At the same time, her painter's eye leads her to analyse the secret behind the beauty of Giotto's frescoes at Assisi:

> It's the thing that makes the beauty in everything outside, here – that is the way a dark figure – a peasant, say, dressed in a suit of dark colours, appears in the sun and the shade *all in one*, black. And a peasant dressed in clothes washed and bleached by the sun appears, against the white stone, *all in one*, almost as white as the stone. They are single unbroken shades of dark and shades of light, unbroken by shadows or chiaroscuro.

In each case, what mattered to her was the authenticity of her own experience whether of the heart or of the eye; this for her was a prerequisite to the act of recording it in paint.

Joan Eardley returned to Bearsden with her mother in 1939, and in January 1940 began her studies under an outstanding teacher, Hugh Adam Crawford, at Glasgow School of Art, obtaining her Diploma in 1943. Among her contemporaries was Margot Sandeman, who became a close friend and painting companion, especially at Corrie, where her family had a small house. At this early stage in her career there is an obvious dichotomy between her considerable facility as a draughtswoman and her awkward technique – or lack of it – as a painter. The hard-won achievement of a level of painterly skill commensurate with her fluency of line and her expressive vision is not the least engrossing aspect of her early development. Having seen the ladder to Heaven, like Jacob she wrestled with her angel. A Lowry-like, almost childlike painting, *The Rush Hour* is followed by the noticeably more confident, monumental but still inchoate *The Mixer Men* of 1944, which dates from the period when for the

remainder of the war she worked at the reserved occupation of joiner's labourer in a small boatyard where part of her time was spent painting camouflage on boat hulls, and it was occasionally possible to find time to paint. She painted *A Pot of Potatoes* in the same year. The subject matter of both these early efforts reminds us that the NSG were currently prominent in Glasgow: Herman, and Bain's oil *The Porridge Pot* (1944: lost) are at no distant remove from Eardley at this point. After a spell on her own in London after the war she successfully applied for a place as a student at Hospitalfield House in 1946. Here she began a lifelong mutually supportive friendship with the mentally unstable but gifted painter Angus Neil – and encountered for the first time the redoutable James Cowie. Oliver quotes a revealing letter written by Eardley from her first week at Hospitalfield: 'I think I will have to be very strong to stand against Mr Cowie, and I don't feel very strong just now – he asked me if I had changed my way of painting since I left the art school, and when I said, yes, that I was trying to tighten it up a bit, he said "I'm very glad to hear it – this self-expression business is no good at all."' Strange comment, one might think, from a present master to a future mistress of line: but Cowie was certainly expressing criticism of her painterly approach, so different from his own, on canvas. In 1947-48 she spent a year of post-diploma study at GSA at the end of which she travelled to Italy and France, returning in April 1949. From this tour resulted several fine ink drawings of landscape and towns in the manner of Van Gogh's drawings at Saint-Rémy, and also a number of studies of individual peasant figures of great expressiveness, including an oil of *Beggars in Venice* (private collection) which is prophetic of her later work, although in the Glasgow or Port Glasgow street scenes which came later her subject was not abject poverty and destitution so much as stubborn human vitality in the midst of urban deprivation.

Her student years past, Eardley turned with impressive assurance to the aspect of the urban scene which was to remain a major preoccupation throughout her career, the depiction of the underprivileged and undernourished children who flourished, despite everything, in the decaying industrial slums of Glasgow and Port Glasgow. Before her departure for Italy she had secured tenancy of a studio at Cochrane Street in the then unreconstructed Merchant City area of Glasgow; and a new friendship with Dorothy Steel, begun as a result of her part-time lecturing commitment at GSA, brought her to Port Glasgow in 1949. Her first truly characteristic work dates from these encounters. Apart from the expected facility of her beautifully taut, nervous drawings of the seaward skyline of Port Glasgow filled with the shipbuilders' cranes, the waifs and urchins of the streets now appear, at first tentatively as in the Vuillard-like *Shipbuilders' Street* (dated by Oliver to circa 1952 but surely earlier), then with increasing

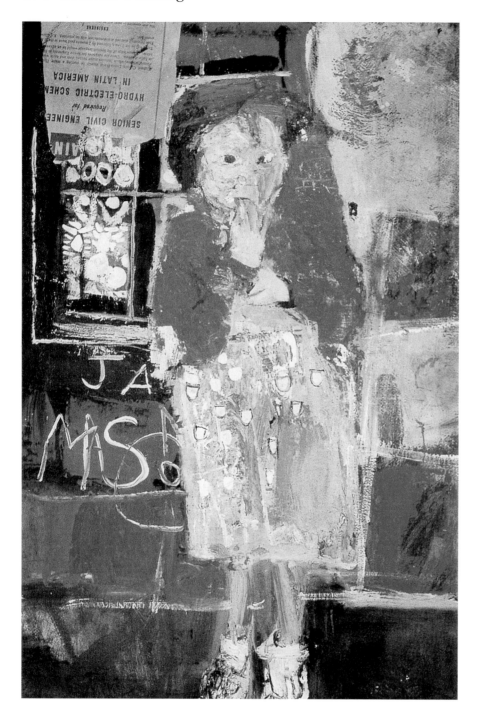

128 Joan Eardley
Little Girl with a Squint
c. 1961
Oil, 76 x 51 cm
Dumfriesshire Educational Trust
© The Eardley Estate

The problems of integrating the figure aspect into the composition, and of reconciling linear expressiveness with painterly colour, were now close to resolution. Several oil studies of Angus Neil in his lodging at Montrose Street – *Angus Reading* (1953), *A Glasgow Lodging* (1953), *The Table* (1953-54) – achieve an aesthetic balance between expressive accuracy and pictorial self-sufficiency. The most striking of the series is A *Sleeping Nude* (1955: SNGMA), in which the gaunt recumbent figure is modelled in simplified planes against a similarly simplified background. The result is powerfully realistic and achieves grandeur alike of form and of feeling.

The scene was now set for the accumulation of riches which is Eardley's last phase and for the series of paintings of street children and of the Catterline sea and landscape by which she established her pre-eminence in post-war Scottish painting. Catterline was discovered in 1950; she acquired No. 1 Catterline in 1954 and it remained her studio until the end of her life, although she also acquired No. 18 in 1959 as it had greater living space. This ancient, tiny fishing village on the exposed north-east coast of Kincardineshire retains its unspoiled character even today, perhaps because there is so little to spoil, just two rows of little single-storey houses, perched on a rocky outcrop looking down to a wide expanse of sea and the little harbour, with their backs turned to the cornfields which still hide them from the visitor until the last moment. Here at last Joan had a home which she could call her own, which she loved and which rewarded her love by providing endless subjects for painting: the sea in all moods, and the cornfields and the village in all seasons, painted in the open air. But she always retained her Glasgow base, moving from Cochrane Street to St. James's Road in Townhead, which became her studio from 1951. In a letter to her mother in that year, before she had secured her new Townhead studio, she wrote:

> It is desperate to lose the [Cochrane Street] studio . . . because I have become attached to it and it has been so useful in my work in that it is so near the slum parts of the town that I draw. And so easy to get the slum children to come up. And I have become known in the district . . . I wouldn't like . . . anything that was not in town, because my work is among the towny things, particularly places like the tenements around my studio. I know that now, much as I love the country and country things, my work does lie in the slummy parts – unfortunately.

Eardley's mature Glasgow work fuses European Expressionism and intensely local subject-matter: her children belong to Glasgow as surely as the gauche gamines portrayed by Duncan MacRae or Stanley Baxter in Bridie's *The Tintock Cup* of 1949 and its fifties successors which are today still part of Glasgow pantomime tradition. It is interesting that

authority: *Street Kids* (circa 1949-51: SNGMA) shows three boys in typically nonchalant poses, one reading a comic, another eating an apple, all sitting on the pavement (what would their mothers say?) in a tightly-knit group but wearing highly individualized expressions. *The Kitchen Stove* (circa 1950: SNGMA), which contains no figure, is perhaps one of her most satisfying designs, since the distortions of drawing aid the composition and are not expression-linked as in her figure painting. Here the quality of paint and the powerful but subdued palette with the spare drawing, invest the humble stove with surprising monumentality.

three major shows of German Expressionism had been seen in Scotland in 1939, the year of her arrival in Glasgow, and in 1950 (SSA) and 1953 (ACGB), as her figure painting immediately brings German practitioners such as Nolde or Käthe Kollwitz to mind. In *Children, Port Glasgow* (1955) a group of five small boys pass two girls of the same age who are pushing a rickety baby chair, with a huge but not unfriendly tenement and a tracery of shipbuilders' cranes in the background. Joan Eardley did not, as a rule, paint adults, but she had no need to: male self-superiority versus female as the persecuted guardian of the race, the battle of the sexes is joined at an early age. These hard-bitten, street-wise kids have a universality in which we recognize something of ourselves, and their good humour stems from a sense of survival despite their unpromising surroundings. A favourite model from her favourite Townhead family the Samsons, *Andrew* (1955) stands temporarily still, hands in pockets, wearing his hand-me-down clothes with as much masterful nonchalance as the selfsame Lord Snooty whose adventures he is perhaps studying while eating a jeely piece (prepared by the artist

perhaps?) in *Andrew with Comic* (circa 1955). These paintings reveal a new technical assurance and the figure is painted with the same rapid shorthand as the still life. The comic in the latter picture is denoted with an inventive painterliness which also provides the main visual *raison d'etre* for the poetic *The Music Stand* (1955), a private memento of her friendship with Audrey Walker and of their mutual love of music.

The work of Joan Eardley's last years both in Glasgow and at Catterline, because it employs increasingly powerful colour and handling, can be called decorative rather than realist, but that would be to describe its surface characteristics only. During her Italian tour, Joan had worried that the language barrier was preventing her from painting the people there 'with truth' and 'only from the outside'. Her ambition implicitly was to paint them from the inside, from personal knowledge and understanding, not (in her words) only as a 'visual reaction to things'. Increasingly we find her identifying with the motif, whether the Samson children and their friends who haunted her studio, or the sea and fields at

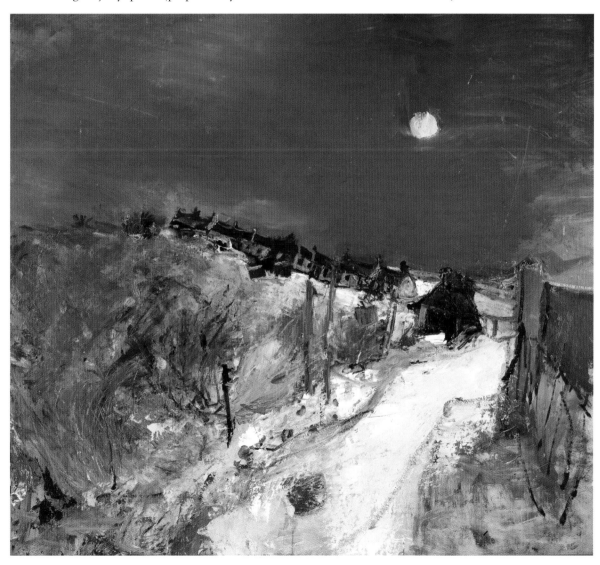

129 Joan Eardley
Catterline in Winter
1963
Oil on hardboard,
120.70 x 130.80 cm
Scottish National Gallery
of Modern Art
© The Eardley Estate

Catterline, in the act of painting them in a manner which imitates their living energy. Perhaps the most obvious form of this new *mimesis* are the wall graffiti so prominent in *Three Children at a Tenement Window* (1956); the artist is literally recreating (with the aid of photography: it would be impossible to achieve this degree of authenticity without it) the original calligraphy, and thus reliving – and conveying to the viewer – the mysterious impulses which prompted these scrawlings. Purposeful though they are, they are obviously the work of young hands, and thus provide an inspired setting for the three little girls at the window, suggesting something of their interior life or that of their near contemporaries. Several beautiful variations on this theme were painted, with increasingly bold use of colour and schematic drawing, and with a further layer of meaning provided by the stencilled words 'metal', 'licenced broker', 'rags' from the adult milieu. In the unfinished masterpiece *Two Children*, her last work, Eardley achieves a kind of near-abstraction which is indeed decorative but which at the same time penetrated to the core of the life of her subjects.

At Catterline the artist's identification with her subject led her to paint out of doors, in all weathers. Having characteristically taken a good deal of time getting to know the village, its people and its history, she began by painting the fields to the landward side of the cottages, and the makin' green below it. *Cornfield at Nightfall* (1952) is a view over the red field with corn stooks towards her house, and a moon in the dusk sky above. The composition is of exquisite simplicity and the palette has an almost Nabis tonality. *Sheep and Neeps* views the same field from the house, but this time in winter. The original harmony of grey and red, suggested by the red earth of the place, is accompanied by painterly brushwork which, not without a touch of humour, explores the similarity of the round bodies of the sheep and of the turnips. For Eardley, landscape was far from the 'passive creature which lends itself to the author's mood' which T.S. Eliot saw in Thomas Hardy's literary use of landscape; on the contrary, for Eardley what mattered was not her own mood, but the landscape's; the role of the artist was to be alert to the nuances of mood of the living scene before her. If a frozen winter's day with the white rime still on the hard earth, then the paint would be applied with the palette knife or with restricted movements of the brush (*Catterline in Winter*, 1963: SNGMA) to accord with the motionless, frozen rigidity of the scene; in the warmth of *A Field by the Sea, Summer* (1962), freer brushstrokes suggest the movement of warm air and life through the landscape. Occasionally, as in *Seeded Grasses* (1960: SNGMA), actual flower heads, grasses and earth were incorporated in the composition and painted over, not with the emotive symbolism of Kiefer with whom this technique has become identified, but simply in order to add an element of the real to the *tessitura* of the

work, and by this means to aid the feeling of identification.

In comparison with the sea and sky, of course, landscape is static. The vast elemental forces which every day altered the panorama of the North Sea seen from her studio window offered a theme well suited to her independence and largeness of vision. Audrey Walker's famous photograph of the artist standing dressed in waterproofs as close to the waterline as possible, a four by six-foot plyboard on the easel, before a boiling sea covered with white foam (SNGMA Archive) reminds us of that other great photograph of the elder McTaggart painting the Atlantic combers at Machrihanish shore. There were obvious similarities of approach, but in a fascinating interview with Sydney Goodsir Smith, Eardley disclaimed McTaggart's influence on her method with the remark: 'As a matter of fact my greatest influence is just looking at Nature. I never look at other painting at all.' In the same interview, she revealed that while the art of Jackson Pollock, de Kooning and the Tachistes interested her, the emphasis in her own painting lay in the direction of concrete subject matter. Two large paintings on ply (supplied by a local joiner) illustrate the essence of her powerful late manner. *The Wave* (1961) is as painterly as the well-known Realist works on the same theme by Courbet, but Eardley's painterliness has a different object: her brushwork imitates the movement, not the appearance, of the wall of water. *Foam and Blue Sky* (1962) is less formal than *The Wave*, more 'abstract', but this is determined by the subject, no longer a wall of advancing water, but a confused mass of flying spray and foam which has the colour of the sand below. Through Joan's love of Catterline we have in her paintings an extraordinarily full representation of Nature in microcosm; of the sea which provided the little fishing village with its *raison d'être*, the cornfields and the wild flowers – *Flowers* (1963) is a too rare example of her work as a painter of flowers – which nourished the inhabitants of the cottages and the beehives too. Joan Eardley's vision of the vitality and beauty of the world was celebrated with rare lyricism in the work of her last short years.

In the exceptionally fine summer of 1957 four young Glasgow artists who were all in their final year at GSA, together with two older Glasgow painters, Tom Macdonald and Bet Low, hung an exhibition of their work on the railings of the Botanical Gardens at the corner of Queen Margaret Drive and Great Western Road. The artists were Douglas Abercrombie, Alan Fletcher (1930-58), Carole Gibbons (b. 1935), and Alasdair Gray. The four friends together formed a little bohemia of which Gibbons and Fletcher were the centre; they stood somewhat apart from the Young Glasgow Group founded at about this time by several of their contemporaries. Alasdair Gray was the literary member of the quartet, as well as being a talented line illustrator and muralist. Douglas Abercrombie at this point was painting in a semi-abstract

style, and Carole Gibbons was painting a series of cat-figures which retained a witty feline character, although painted in a style of simplified colour and volume which was part-abstract. Her drawing came a little later to resemble Hockney, with a metaphysical content in a strange personal poetry further developed in an increasingly painterly abstract style which, however, never quite loses its references to mythical landscape. In many ways her work prefigures the work of the women artists associated with the 369 Gallery today.

Fletcher's premature death in an accident in Milan at the age of twenty-eight robbed Scottish painting of one of the most exciting young artists of his generation. He had decided to specialize in sculpture on enrolment at GSA in 1951, partly out of a desire to keep his painting free from influences. Twelve pieces were shown at his Memorial Exhibition in 1958, but most of them are now lost. His terracotta *Self-Portrait with Tuba* (HAG) and *Underwater Hunter* (William Hardie Gallery) show his confidence and originality as a modeller in a modern European tradition absorbed from his teacher at GSA, Benno Schotz. Fletcher's style of draughtsmanship, like that of his friend the cartoonist John McGlashan, was developed during his Glasgow student years through contributions to the student magazines *GUM* and *Ygorra*. He evolved a personal iconography of a man carrying a ladder, or perched precariously on a wheel, tense and full of fear. As Benno Schotz has written: 'Alan Fletcher had an inherent fear of accidents and he made no secret of it, as if he had a premonition that one day fate would play a trick on him.'

The de Staël exhibition organized by the SSA in 1956 was a revelation to Fletcher and immediately suggested possibilities of an existentialist treatment of still life which resulted in a remarkable series of about seventy paintings, many of them studies of single paraffin oil lamps, sometimes accompanied by other still life, e.g. *Lamp and Pear* (DAG). This has a soft-edge, friendly quality; in other examples a more linear, hard-edge treatment is suggestive of the Readian 'geometry of fear', and something of the same atmosphere is obvious in *Screaming Man, Shattered Clown*, and *Man on Wheel*. Fletcher uses unusual and sombre colours made from a recipe including printer's ink, and invariably restricts his palette to three, four or five colours which are never mixed or modulated. His treatment of the edge is one of the fascinations of his work, as he achieves a sense of spatial ambiguity by reserving foreground objects in the underpainting of the picture; objects closest to the viewer are often bordered by a 'background' which is applied last and overlies them as it defines

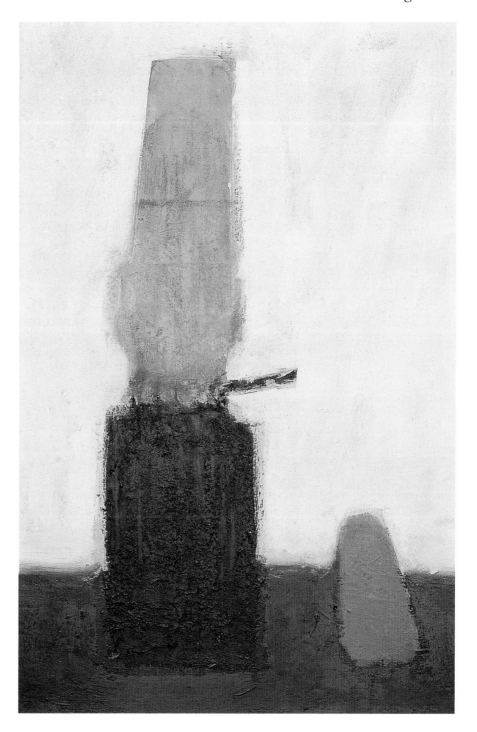

their outlines. This device lays bare the mechanics of spatial illusion, while the spare elegance of his draughtsmanship and very personal palette contribute to an *oeuvre* which is among the most haunting of its period. Alan Fletcher's fears for the future were only too justified in his own case, but he expressed them in a manner which sums up much of the mood of his time.

130 Alan Fletcher
Lamp and Pear
1957
Oil on board, 83.80 x 57.10 cm
The McManus: Dundee's Art
Gallery and Museum
Dundee Art Galleries and
Museums (Dundee City Council)
© Carole Gibbons

11 CONTEMPORARIES: ABSTRACTION AND NEW FIGURATION

Although several of the most interesting British abstract painters have been Scottish or are Scottish, like the expatriates Colin Cina (b. 1943), Alan Gouk (b. 1939) and John McLean (b. 1939) in the present day, it is noticeable that abstract art has never found a receptive climate in Scotland itself, as William Johnstone discovered in his one and only exhibition at Dott's in Edinburgh in 1935, when not one picture was sold. (In fairness, one should add that even Cadell had difficulty selling pictures in the depressed 1930s.) Johnstone's first essays in abstraction date from the later 1920s. In previous chapters we have also noted the various early abstract conclusions reached in two little *jeux d'esprit* by William Peploe in 1918, by Charles Rennie Mackintosh in London at about the same time, and over twenty years later by Alastair Morton who, by 1939, was working in the studio of his new house designed by Leslie Martin in Brampton, Cumbria. It is no accident that the abstract work of Mackintosh and Morton coincides with their activity in the applied art of textile design, although Morton's Mondrian-inspired abstracts were in fact conceived independently of his design work, and Mackintosh, as we have seen, thought at least one of his own highly schematic flower-based designs suitable to be hung as a picture in its own right *(Anemones)*. There remain two extraordinary and prophetic mural decorations by Mackintosh, the coloured stencilled panels which seem based on a clock movement for the hall at Hill House in 1903, and the white plaster frieze panels for the Willow Tearoom circa 1904. Aspects of Mackintosh's work were well known in Munich and Moscow through articles in *Mir Iskusstva* and *Deutsche Kunst und Dekoration* from as early as 1903 as well as from exhibitions and we can assume that his work in general, if not these works in particular, formed part of the background against which the pioneers of abstraction – the Constructivists and Suprematists in Moscow and Kandinsky in Munich – were working before the First World War.

During the later 1940s and 1950s several Scottish artists demonstrated an intelligent interest in the European abstraction of Constructivism, then in Klee

(but not in Kandinsky, whose work long remained unknown in Britain) and later still in the New York school. Margaret Mellis and Wilhelmina Barns-Graham in the 1940s and in the following decade Gear, Paolozzi, Davie and Pulsford – all of them trained at ECA – with William Turnbull, made significant contributions to the abstract canon. But like William Johnstone they had to leave Scotland for this to be possible. Margaret Mellis (1912-2009), who had been taught by S.J. Peploe at ECA, became an early adherent of the Constructivist tendency of which Alastair Morton was the chief apologist in the north, after her move to St. Ives in 1939 where she was influenced by Ben Nicholson and Naum Gabo. Here she began to create abstract wooden reliefs of pure geometrical forms which exploited effects of grain, figuring and colour in the woods used in a very English version of Constructivism. A little after Mellis, her ECA contemporary Wilhelmina Barns-Graham (1912-2004), on a suggestion of Hubert Wellington who was Principal at ECA, chose to work in St. Ives during her Andrew Grant scholarship year in 1940. Here she met Nicholson, Hepworth and Gabo. But it was not until a visit to Switzerland in 1948 that the glaciers suggested a subject which would offer the vehicle she had been seeking. The glacier theme was to haunt her for many years. *Glacier (Vortex)* (1950: private collection) shows the distressed or weathered textures, the vestiges of naturalistic colour, and the naturally occurring forms which are characteristic of the St. Ives school of Constructivism, particularly of Gabo whose transparent structures she admired. Her later work is often playfully decorative and uses bright colours and textured geometrical patterns. The only Scottish-based artist of that generation who had consistently remained faithful to the abstract ideal as expounded by R.H. Wilenski and as practised by Nicholson and the Unit One and Circle artists of the 1930s, is William Baillie of Hamilton (b. 1905). A similar use of pure geometrical shapes and of textures of limestone, alabaster or schist informs his work, except for a brief Surrealist interlude noted in the previous chapter. Baillie's pupil William Bunting (b. 1951)

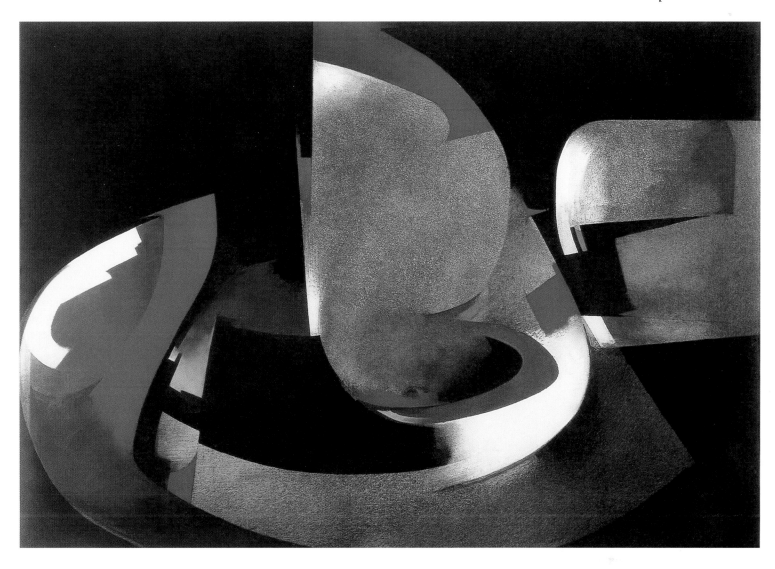

131 William Bunting
Rondo
1987
Oil on paper, 30.50 x 43.20 cm
Private collection
© William Bunting

OVERLEAF
132 David Donaldson
Bright Morning
c. 1975
Oil, 121.90 x 96.50 cm
Private collection
Image courtesy of St James's
Art Group
© The Artist's Estate

employs a closely related vocabulary with a personal accent of interlocking forms defined by taut lines and modelled by subtle gradations of light, rather than texture. Baillie has said, 'We find ourselves two painters who believe implicily in two aphorisms – that art begins where imitation representation ends, and that all art is abstract. We also believe with Schopenhauer that art should aspire to the condition of music.'

In Scottish painting of the 1950s the outstanding reputations were still those of the forward-looking traditionalists: Gillies, MacTaggart and Maxwell who, with the more recently established Anne Redpath, were exponents of the Colourist tradition of still life and landscape; Joan Eardley, an innovator in the Realist mainstream; and, working in London, Robert Colquhoun, whose paintings of the human figure fuse a personal vision with a manner ultimately derived from Picasso. Each of these artists can be seen to continue specifically local traditions absorbed during their student years, with colour and *belle peinture* a continuing preoccupation in Edinburgh, and GSA's concentration on line and tonal painting

equally determinant for Eardley and Colquhoun. These local traditions have shown surprising durability.

David Donaldson (1916-96), Painter and Limner to Her Majesty The Queen in Scotland from 1977 till he died, who was until his retirement in 1981 the enormously influential Head of Painting and Drawing at GSA, where he had been a student from 1932-37, and where he began teaching in 1938, has a deserved reputation as a brilliantly incisive portraitist. But over the years he also painted imaginative, mysterious and witty fantasies as much for his own pleasure as with any audience in mind. These may have their roots in an earthy realism which never disappears altogether from his work – *Susanna and the Elders* (1978-82: GAG), although ostensibly very different from *Annette and the Elders* (1980-81: private collection) in theme is actually very close to it in treatment. One is a well-worn vehicle for painting the life model via the Biblical story, the other frankly contemporary as its 'elders' are Donaldson's colleagues at GSA James Robertson, John Cunningham and a favourite model, Annette.

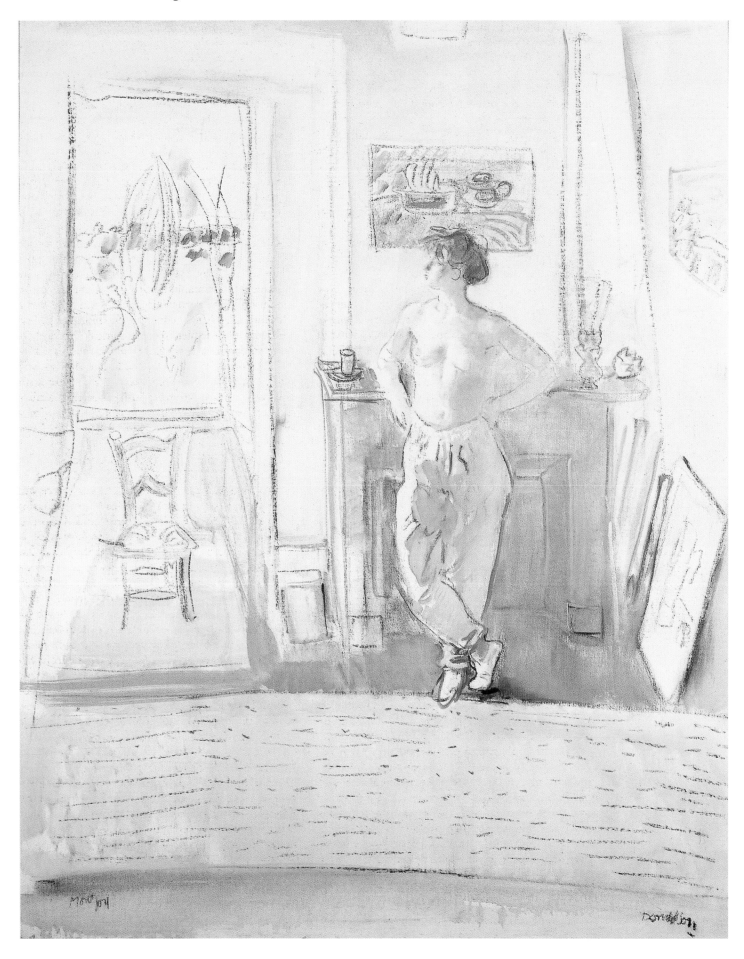

Another Biblical theme is represented by *The Marriage at Cana* (1972: private collection), but here the artist deals with a recurring concern, the transience of life, beauty and happiness. This modern bride seems weighed down by her finery and oppressed by the revellers around her, who include her starchy in-laws and a madly dancing couple. She clutches a pathetic nosegay as she contemplates a hand on which a pretty butterfly has alighted. The inventive and cerebral approach revealed by this side of his work – a cult of the unexpected – nourishes his portraiture, e.g. *The Skater* (circa 1975, a portrait of the artist's daughter on roller skates). Even in his still life a certain wittily acerbic detachment holds good: the delicious *Dessert* (private collection) departs from the usual tasteful arrangement with a newly opened tin can of juicy pears which have just been emptied into a vulgarly twee glass dish. Low marks to the cook for presentation, perhaps, but the still life is more visually appealing than any *nouvelle cuisine*. Similarly, in landscape Donaldson's sense of irony often adds point to his subject: *Rage* (1972-73) shows a naked man wrestling with an angry swan, the two of them seemingly bent on each other's destruction, oblivious to the fragile stem of lilies dominating the foreground; in pure landscape he seizes often on an unexpected visual impression rather than resting content with a mere record of the scene: *Olive Trees, Pierrelongue* (1975: Vallar Fine Art). Donaldson's formidable technique belongs recognizably to a Glasgow tradition with subtle drawing with-the-brush matched by a rather sombre palette which has only lightened in recent years. Another Glasgow virtuoso is Alexander Goudie (1933-2004) who remained a devotee of the *peinture claire* of Manet in portraiture, landscape and especially in still life. But whereas a glint of irony or a frisson of psychological unease is never far from the surface in Donaldson, Goudie's work shares the untroubled hedonism of the later Edinburgh School: of David McClure (1926-98), Elizabeth Blackadder (b. 1931), John Houston (1930-2008), David Michie (b. 1928), Denis Peploe (1914-93) and Lord Haig (1918-2009).

These ECA-trained artists share a love of colour and painterly handling; they are at once conscious traditionalists and independent individualists. Elizabeth Blackadder's painting of still life and flowers is derived from Gillies and Redpath, but also possesses an almost oriental mood of quiet contemplation and a delicate, minimalist sense of composition which have translated easily into the medium of tapestry. She tends often to adopt a cool colour harmony which allows the individual colours of the flowers to sing like a solo voice before a chorus. Her husband John Houston was known chiefly as a landscapist whose work shares with that of Sir William MacTaggart an admiration for Munch and Nolde – for their effects of strong colour and an atmospheric treatment of landscape – although he briefly showed an interest in landscape-abstraction of which *Village under the Cliffs* (1962: private collection) is an example, and in later years adopted a style in which landscape increasingly serves as a pretext for colouristic abstraction. David Michie retains only the colourist bias of his mother Anne Redpath's style. Principally a landscape painter, and very often of beach scenes with figures, he has invented a painterly shorthand which is akin to that of Craigie Aitchison (1926-2009), a Scottish artist long resident in London where he was trained at the Slade School. Denis Peploe, son of the great colourist and brother of Willy Peploe (q.v.), of all his contemporaries was the leading exponent of 'truth to materials': in his landscapes and still lifes each brushsroke is left visible as a carefully considered unit in a construction which never ceases to declare itself as paint on a plane surface. His palette is subdued and this, with his quietly craftsmanlike approach, reminds one of Bloomsbury and particularly of Vanessa Bell. David McClure interestingly combined the fantasy of Maxwell with the earthier, more empirical approach of Anne Redpath in a range of subject matter which parallels theirs: mysterious Redon-like flowers, still life seen against flat fields of colour with ornaments and toys invested with magical properties, Sicilian church interiors or studio interiors, often with a female nude, which reflect the Matisse of *Luxe, calme et volupté* or the *Red Studio*.

David McClure lived in Dundee from his appointment in 1957 to the staff of Duncan of Jordanstone College of Art, where he succeeded Alberto Morrocco (1917-98) as Head of the Painting School, and where his colleagues included Gordon Cameron, a subtle follower of Vuillard. The presence in Dundee of these three highly professional and accomplished artists instigated a conspicuous upturn in Dundee's position among the four Scottish art colleges, presided over by the genial and protean Alberto Morrocco. Picasso was as much an influence on Morrocco as on Robert Colquhoun, not the Picasso of *Femme pleurante*, but rather of *Pêche de nuit, Antibes* or of *Jeune fille devant le miroir*. His first teachers at Aberdeen were James Cowie and Robert Sivell whose exacting instruction Morrocco enjoyed. As he explained in an interview with Alice Bain, the well-ordered city of Aberdeen and its Neo-Classical art school, in which he and a few other students took instruction 'in the way a Renaissance apprentice might learn from a master', was not uncongenial to his Italian temperament (he was the son of Italian immigrants parents). Although his paintings were executed in his Dundee studio, they often began life as sketches made during long periods spent in Italy or Tunisia. With rare exceptions his work is 'full of the warm south', although there were also a few excursions in the romantic vein associated with Chagall. Morrocco's pictures convey the enjoyment of holiday or carnival; some unframed pictures-within-the-picture made an appearance, but this evidence of a *working* holiday need not elicit sympathy; the pictures seem to be

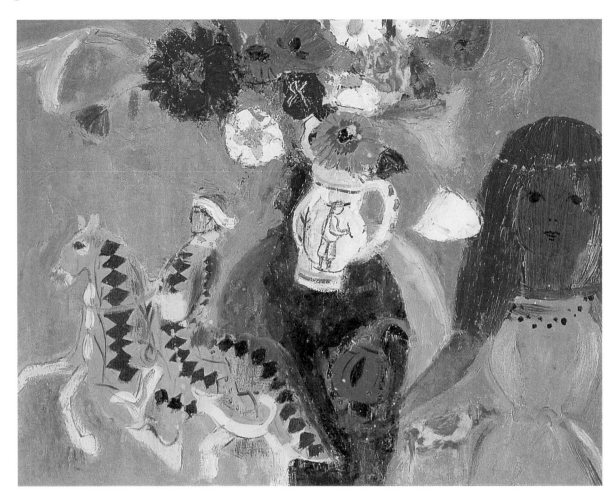

133 David McClure
Children's Tale
c. 1978
Oil, 46 x 56 cm
Private collection
© The Artist's Estate

coming along well, and the artist clearly enjoys his work. Few paintings by a contemporary hand are as sheerly pleasurable as those by Morrocco. Their firm structure and sophisticated drawing underlie a surface rich in colour if not in material. A witty show of his Picasso-inspired sculpture of painted *objets trouvés* at Compass Gallery circa 1968 made one regret the rarity of his excursions into three dimensions.

Donaldson's and Morrocco's Edinburgh counterpart was Robin Philipson (1916-1992), who was Head of the School of Drawing and Painting from 1960 to 1982 at ECA (where he had been a student from 1936-40 and a member of staff since 1947), and was President of the RSA from 1973 to 1983, receiving a knighthood in 1976.

High office confers distinction on its recipients; Philipson is a case of the converse also being true. As teacher, as Head of Department, and as President, he performed with an effective urbanity which perhaps obscured his perpetual willingness as a painter to experiment. In a School where painterliness is second nature he extended the painter's vocabulary in a constant effort to forge a language capable of clarity and eloquence side-by-side with a veritable fireworks display of form and colour. His Edinburgh Festival retrospective exhibition (ECA 1989) reminded us that in range of subject-matter, painterly bravura, and in his largeness of

conception and of execution as well, he was the outstanding subject-painter (in the Victorian sense) of his generation in Scotland. Like almost all his generation, Philipson saw service with the Army – as a Cumbria man, with the King's Own Scottish Borderers – during which he fortuitously discovered and devoured a book on Oskar Kokoschka, the sole example in Edinburgh of whose painting, *High Summer* (NGS), was to provide inspiration at a crucial and formative stage after the War. While on station in Burma he made several sketches of village life including studies of the cockfights that were to become a recurrent theme. Philipson has explained the link between the influence of Kokoschka on his work and the choice of the cockfight subjects in these terms:

I particularly recall my careful scanning of the National Gallery's painting *High Summer* . . . hoping that [Kokoschka's] creative strategy might be revealed to me . . . My satisfaction was in identifying the achievement of a rich plasticity of form within a limpid and impressionistic structure. I began to learn to construct through the grouping of small lightly placed brushstrokes of rapidly changing hue. With this method firmly established, I moved to the painting of the cockfights and I realised that I did indeed owe a great debt to Kokoschka. But it was not his style that I sought

after . . . It was his ability to create resonances of colour and animation of the surfaces of the picture plane. It was the dynamism that was created in the forms themselves that appealed to me.

Several cityscapes of Edinburgh, reminiscent of Kokoschka's wartime views of London, are as near the Austrian master's style as Philipson was ever to come. The cockfight theme, suggested to the artist by his colleague at ECA, Henderson Blyth, from a drawing of a cockfight in one of Philipson's Burmese sketchbooks, began to dominate Philipson's work in the 1950s. In his own words, 'With these pictures I moved away from Kokoschka's 'phrasing' completely with the impulse to make the fighting cocks into something other than just bird descriptions with strands of very thick paint and their strange unpredictable behaviour'. The Scottish Arts Council's *Fighting Cocks* of 1952, one of the earliest examples, remains close enough to its subject to be instantly identifiable; in later versions, e.g. *Fighting Cocks, grey* (1960: SNGMA) the paint itself, with its 'strange unpredictable behaviour', all but completely usurps the place of the motif, providing an analogue for the aggression, violence, movement and energy of a cockfight while retaining an often exotic richness of descriptive colour. It was a logical step to the near-abstraction of certain works by Philipson at this period – e.g. *Burning at the Sea's Edge* (1961: SNGMA) – which suggest a knowledge of COBRA practice and of the abandoned gesturalism of Willem de Kooning.

Philipson was never the kind of artist to give himself over completely to abstraction, and his 'abstract phase' – which was never wholly abstract– was of short duration. His natural gifts included a remarkable graphic power of suggestion and description which seems often to have required the spur, the injection of adrenalin, of emotions aroused by the visual evidence of the stupid cruelties perpetrated by martial man or of the literally fatal feminity exerted indolently, innocently, and irresponsibly (witness a predella of a falling soldier beneath a scantily-clad chorus of *demi-mondaines*) on the distaff side. Philipson's treatment of such themes suggests that the roles of man as aggressor and woman as victim are at the root of the war of the sexes and perhaps also at the root of war *tout court*. There is no doubt however on which side the glamour lies, and in case we miss the point, a large wardrobe of exotic lingerie provides a powerful *aide-mémoire*. Hand-in-hand with the introduction of a variety of technical and compositional innovations calculated to add richness and clarity to his style after he had established his basic technique by about 1950 – the use of a vinyl toluene medium and paper collage, and of colour ladders and a two- or three-panel presentation – Philipson added further themes: cathedral interiors with their jewel-like stained glass, the 1914-18 War, 'humankind', the French Revolution, 'women observed', and –

after an English-Speaking Union scholarship tour to South Africa and Kenya in 1976 – white boys and black girls with zebras doing nothing in particular, perhaps practising English? Latterly he painted a spectacular group of paintings of poppies executed in very rich, resonant colour glazes or stains over a white ground. From 1960 he occasionally presented a subject episodically in a triptych or with predella divisions, or with meaningful juxtapositions of unlike subjects, as in the large *Women Observed* of 1979, where the coquettish nude girls on a purple divan occupying the left panel are observed by a pack of eager dogs beside a dead bird painted in sepia monochrome on the right. When not over-emphatic or melodramatic, the expressive power of this procedure is considerable and is perhaps best exemplified by the large triptych *The Trap* (1984-87). But Philipson's preoccupation with the alchemy of *matière*, his sense of colour and his ability to create images simultaneously exotic and intensely real also enabled him to work on a small, intimate scale with no loss of strength of colour or sense of sexual excitement or physical danger.

Emergent in the same decade of the 1950s were several young artists whose links with any Scottish tradition were much more tenuous, and who continued their training in Paris and their careers ultimately in London or elsewhere in England: William Gear (1915-1997), Alan Davie (b. 1920), Eduardo Paolozzi (1924-2005) and Charles Pulsford (1913-89). These artists had all studied at ECA, Pulsford alone returning to teach there from 1947 to 1960. Together with William Turnbull (b. 1922) who studied at Dundee Art College and then at the Slade School, they introduce a profoundly new set of concerns and approaches to problems of style. Their attitudes were aggressively Modernist when Modernism was virtually synonymous with abstraction, whether geometrical or painterly. Turnbull and Paolozzi are sculptors who move easily between sculpture and painting (Turnbull) and sculpture and graphics (Paolozzi). Gear, who was actually an exhibiting member of the COBRA group in Paris, had the most international career of them all in the sense that he lived and worked abroad until returning to England in 1950; but all of them share a profoundly non-parochial, internationalist outlook. This takes various forms. One of them is Abstract Expressionism, to which Alan Davie was introduced during his ECA travelling scholarship tour to Venice in 1947 by Peggy Guggenheim, who as well as buying one of Davie's paintings showed him work by Jackson Pollock and Mark Rothko in her own collection. The same transatlantic painterly abstract style was also an influence on Charles Pulsford whose richly textured web-structured surfaces have particular affinities with Pollock, and also with the flickering, flame-like colour field painting of Clyfford Stills. The minimalist painting of Turnbull, with its Zen overtones – a rare point in common between this master

of understatement and the dionysiac Alan Davie – is in striking contrast with the interest of Turnbull's friend Eduardo Paolozzi in Dada and Surrealism. The relevance of these European movements to Paolozzi's many-sided style is primarily semiotic; they offer the means by which the artist comments on today's hi-tech and pop culture and its relationship to the concept of Art. His discovery of an unexpected humanity in the animal, monster, robot – and human – characters of the pulp media, and of the pathetic mortality or laughable *hubris* of man-made machinery, provides a theme at once highly contemporary and yet universal: the soul of modern man reflected in his artefacts.

William Gear has been the subject of renewed interest as his contribution to European abstract painting becomes clearer. After ECA he spent a year in Europe including several months in Paris in 1937-38 studying at Léger's studio. During the second war he travelled widely with the Royal Signals Corps and then served from 1946-47 with the Monuments, Fine Art and Archives Section of the Central Commission. At this point he met the artist Karl-Otto Goetz, another future member of the COBRA group, who was later to devote an entire number of his review *Meta* to 'Young Painting in England' (March 1951), which concentrated on the abstract movement: Peter Lanyon, Charles Howard, Alan Davie, Stephen Gilbert and Gear himself. Davie never joined the COBRA group, as Gear did with his Scottish compatriot Stephen Gilbert in 1948 when he moved to Paris, where he remained until 1950. COBRA was an informal grouping round Alechinsky, Appel and Jorn of artists from the northern countries – the first letters of Copenhagen, Brussels, and Amsterdam giving the acronymic title – who adopted an expressionist or lyrical mode of abstraction. This was opposed to the Tachiste style of Atlan, Hartung, Poliakoff and Soulages (all of whom Gear knew well), then causing a considerable stir in Paris. Gear exhibited widely in Paris at the Salons and also with the COBRA group and until his return to England in 1950 was in every sense a member of the *Ecole de Paris* of this period.

It was perhaps still too early to give Gear a precise place in the ferment of influence and counter-influence in the heady early years of the new gospel of abstraction. There was clearly a considerable measure of cross-fertilization between COBRA and the Tachistes, and indeed between the COBRA painters themselves; realization was dawning too of the far-reaching innovations of Klee and Kandinsky, and of the potent work of Jackson Pollock and Arshile Gorky in New York. What is undeniable is that Gear's COBRAbstractions (as they have been called) of the years 1946-49 form an impressive body of work and certainly possess as much confidence and authority as anything emanating from Paris in the later forties. Figurative elements, as in the gouache *La Danse de l'or* (Galerie 1900-2000) of 1946, which is reminiscent of Matisse's *papiers collés*, are quickly discarded, although tree and leaf forms

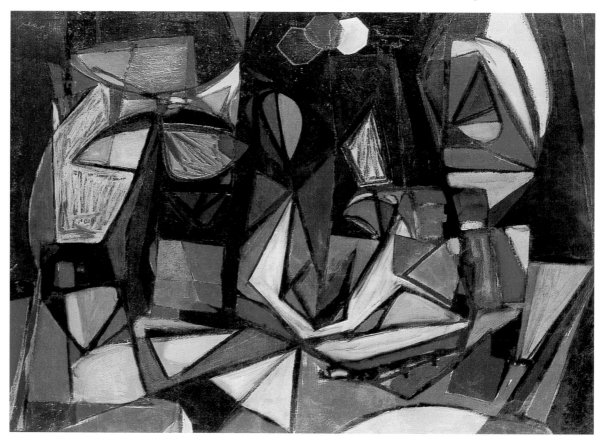

134 William Gear
Intérieur
1947
Oil, 46 x 65 cm
Private collection
Image courtesy of England & Co.,
London
© The Artist's Estate

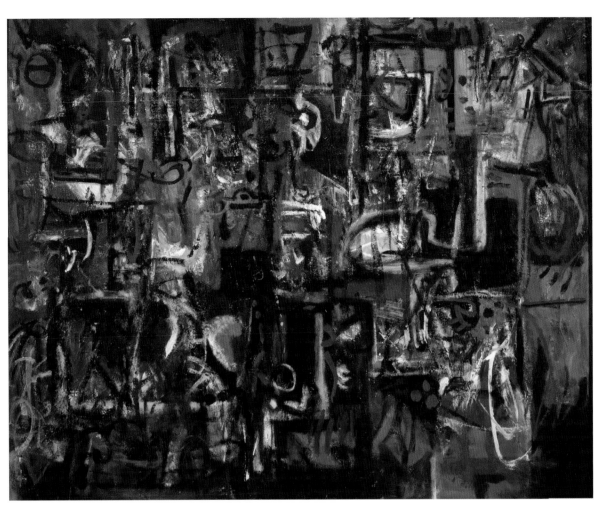

and other vestiges of reality are retained in the landscape subjects for a short while. But by December 1947 these props too have all but vanished. The *Intérieur* (ibid.) of that year is resolutely non-figurative and sets a pattern of often sombrely coloured compositions articulated by means of a semi-geometrical armature of dark lines which suggest form and space. The *Paysage* (ibid.) which follows it in January 1948 is equally powerful, if less austere, and there follows a series of adventurous variations on the newly discovered theme, with occasional excursions into pure geometry. By 1950 these have led in turn to a new manner which incorporates light, with a slight suggestion of the Rayonnism of Larionov, the patches of colour now divided from each other, not by black outlines, but by intersecting straight lines which result from the edge-to-edge confrontation of colour with colour. This latter manner provided Gear with his main theme. Klee's belief that art should penetrate the inner mysteries of the natural world and not confine itself to surface description certainly finds an echo in Gear's approach, although with very different results. Unlike Klee, Gear improvises on the canvas, allowing instinct to guide his hand. He has said 'My paintings are ways of relating to the visible world of nature. They are made with

both eyes on the canvas, but with a visual repertoire of things seen, selected and stored in my mind's eye. It is essentially a physiological process.'

Alan Davie met Gear in Paris in 1948 during his scholarship year. It seems most likely that Gear's view of painting as a physiological process involving hand, eye and intuition in a kind of *perpetuum mobile* – an instinctive gesture with the brush suggesting another to the eye which would evoke another instinctive response, and so on – would have struck an immediate chord with the younger artist. Or rather, that the paintings demonstrating Gear's approach would have done so more eloquently than any theory. Davie's subsequent encounter with the abstract works of Motherwell, Rothko and Jackson Pollock in Peggy Guggenheim's collection in Venice provided further evidence of the power in performance of the theory of intuitive abstraction. And as an accomplished jazz musician Davie had long been familiar with the practice of improvisation.

The very title of an early work, *Jingling Space* (1950: SNGMA), indicates the direction in which Davie was moving soon after absorbing his experiences of Paris and Venice. Whereas the landscape-abstractionists like Gear or the less abstract Joan Eardley provide a painterly analogue for aspects of the visual world, Davie appropriates the non-visual

world as a sphere of legitimate interest to the painter also. The musical, improvisational overtone of *Jingling Space* invites the viewer to 'listen' to the painting as he would a jazz solo; there is no specific 'meaning' beyond the creative will which produced the melodic line and tone-harmonies; but the flight of fancy can be spellbinding, liberating. If Alan Davie's paintings may be said to 'aspire to the condition of music', it is to the spontaneity of the solo break or the extempore cadenza rather than the preordained formality of written music. In this work and in much of Davie's output of the early fifties there is a conspicuous sense of germinal organic growth which seems to arrogate to itself the entire surface of the canvas: the painting seems to be creating its own form with minimal interference by the artist beyond the provision of a grid of vertical and horizontal divisions. Space, light and form are ambivalent, miasmic. By the middle and later 1950s there has been a significant change. Individual forms are now given greater prominence and scale, and they are set against a flat background of a single colour. The empty spaces isolate the forms which now begin to assume concrete and recognizable archetypal shapes: the wheel, the cross, the egg, the crescent, the triangle, the cube. Davie presumably realized that automatic drawing yielded its own repertory of strangely compelling forms, and beyond that, that some of them suggested a more or less legible symbolism as religious or sexual emblems: *Fetish with a Yellow Background* (1954), *Witches' Sabbath (1955), Martyrdom of St. Catherine* (1956). At about the same time Davie was also practising a quite different mode which develops the very dense early style but without the controlling grid or framework: *Sorcerer's Apprentice* (1957) and the triptych *Creation of Man or Marriage Feast* (1957) seem to echo the *automatiste* mode of the *École de Paris*, and are somewhere between Masson and Dubuffet. It is fascinating to note that these works which are intensely dramatic in the true sense of creating, resolving, and releasing tensions *in the paint* can also serve to illuminate – one almost said, illustrate – the human dramas suggested by the titles obviously chosen *post facto*. There is somehow a sense of human panic before chaos in the *Sorcerer's Apprentice*, as there is something celebratory or momentous in the triptych.

Occasionally however Davie inserts a disconcerting element of realism. *The Blue Bubble* (1957) shows, against a background resembling corners of stretched canvases, a large bubble shape actually modelled with a highlight which seems to make fun of all the other, abstract, shapes in the 'scene'. (Fun and games of all kinds seem to happen in this nursery of shapes when their father's back is turned or when he is not feeling like being serious; which fortunately is quite often.) Realistic elements of *Farmer's Wife No. 1 or Annunciation* (1957) are an interior with a window and a rather Gordon Russell chair

and lamp. But the two figure shapes are transparent and dematerialized to a greater extent than in Giacometti or Bacon; they become presences which have more in common with the non-material ether than do the material things which surround them; they belong more to the spiritual than the material world. These untypical works provide clues to the artist's interest in the spontaneous world of child art and in a religious and, despite the Christian alternative title of *Annunciation*, specifically Zen Buddhist view of life, with its emphasis on intuition as a way to enlightenment. As he has said, 'Sometimes I think I paint simply to find enlightenment and revelation. I do not practise painting as an Art; and the Zen Buddhist likewise does not practise archery as an exercise of skill but as a means to enlightenment.' *Portrait of a Buddhist* (1960) might suggest a figure bowed in prayer beneath the sun; its reduction to very simple, bold forms and strong colours looks forward to Davie's style of the sixties and beyond to the present day. *Magic Serpent* No. 2 (1971: private collection) shows an interior with religious emblems and a sign of the trefoil on the walls; on the floor stands a little figure which resembles an East African idol, but which may also be Christian, while through the air the 'serpent' – a low form of life in the Buddhist hierarchy – coils itself into a figure-of-eight in an unmistakable writhing movement. This conjuring trick-without-a-conjuror brilliantly evokes an atmosphere of primitive magic with mysteriously religious overtones relating to Fate, Chance and Enlightenment. These works are decorative in their joyful celebration of myriad form and high-keyed colour and their idiom has translated with brilliant success into the medium of tapestry.

Mythic, totemic, Jungian, fetishistic, childlike: these and similar adjectives are frequently applied to describe Davie's form of abstraction, quite justly, for they are all applicable. In the lines written above we have seized gratefully on fragments of recognizable reality and on picture titles which seem to offer clues to the content of these works. Yet the titles are often highly ambiguous and are carefully chosen to discourage a too-restricting interpretation, while there is no discernible system to which the few visible symbols relate, so that they are not so much symbols as totems which possess their own life and significance. We may conclude that Davie goes to considerable lengths to dissociate form from specific content in the paintings because in a real sense their form is also their content. Their inherent drama (comedy rather than tragedy) or playfulness, solemnity or gaiety are analogous to the same manifestations of the human psyche.

Totemic imagery and a suggestion of primitive (specially, Cycladic) art are integral features of the earlier sculpture of William Turnbull which might suggest a kinship with the work of Davie. The common ground lies not in the forms these artists employ however (as a moment's comparison of their

work will confirm), but in the region of a shared Zen mysticism. Where Davie would stress the importance of instinct to action, however, Turnbull would emphasize the role of contemplation. Where Davie's work is spontaneous, rhythmical, riotous, Turnbull's is calculated, still, silent. Yet to the accustomed eye his art is no less rich than that of Davie: the concentrated intensity of his extreme reductions of form and colour simply provide a diametrically different experience.

Before leaving his native Dundee and Scotland for good in 1941 on enlisting with the RAF, William Turnbull had been working as an illustrator employed by D.C. Thomson's in Dundee while attending evening classes at Duncan of Jordanstone College of Art. To the aspiring young artist Dundee must then have seemed very remote from the centres of art. But as Britain's centre through the huge Thomson concern of the pulp magazine and comics industry, Dundee offered first-hand experience of the unselfconscious, vital graphic style of the commercial artists. Supplemented by American comics sent by relations, this diet of an eloquently contemporary style owing nothing to academe made art-school teaching at Dundee, and later in London, seem effete and nostalgic. Turnbull became a pilot in the Royal Air Force and flew on war service in Canada, India and Ceylon. In 1946 he enrolled as a student at the Slade School of Art which he found parochial and inward-looking; he stayed for only a few terms. Here, however, he met Nigel Henderson and Eduardo Paolozzi, who like Gear and Davie went to Paris in 1947. After an initial visit in 1947, Turnbull also went to live in Paris for two years from 1948 to 1950. Here he met Hélion, Léger, Giacometti, Tristan Tzara, Brancusi, and of course his compatriots Gear and Paolozzi. At this stage Paolozzi and Turnbull as sculptors show some influence of the table sculptures of Giacometti. Paolozzi's *Growth* of 1949 is a true table with four supports. Turnbull's *Aquarium* and *Game* are stylistically close to it, with stick-like figures and forms sprouting from flat bases. Throughout Turnbull's career sculpture and painting have evolved in parallel, and in 1949 he had produced at least two paintings on the Aquarium theme which have a Klee-like playfulness and sense of movement, the fish in one of them denoted as arrows, as they are in the sculpted version and also in a mobile made the same year.

On his return to London in 1950 he shared a studio for a while with Paolozzi, whom he had seen frequently in Paris. Until about 1957 the main motif of Turnbull in both painting and sculpture is the Head or Mask, which is also one of Paolozzi's preoccupations at this time. But the divergent treatment by the two artists of this theme is striking. Paolozzi's fascination with the discarded artefacts of the consumer society which is largely synonymous with modern culture led him to a collage method owing something to Picasso and Dubuffet, but

producing remarkably original results. Paolozzi's silkscreen *Engine-Head* (1954) has a head-shaped contour filled with drawings and diagrams of machinery; his bronze *Head* (1957), similarly, is a head-shaped accretion of real mechanical parts, toys, etc. collaged by the *cire-perdu* method. Paolozzi himself listed some of the things that went into his compositions at the time: 'Dismembered lock, toy frog, rubber dragon, toy camera, assorted wheels and electrical parts, clock parts, broken comb, bent fork, various unidentified found objects. Parts of a radio. Old RAF bomb sight. Gramophone parts. Model automobiles. Reject diecastings from factory tip sites.' The remarkable anthropoid bronze sculptures – icons of our age – *Krokodeel, St. Sebastian, AG5, His Majesty the Wheel,* and *9XSR* date from 1956 to 1959, and were assembled and patinated to suggest the ravages of time: they are like relics of a lost society. It was appropriate to their imagery that these works should be realized in the form of metal sculpture. They also conveyed something of the immediacy of Action Painting, but as Paolozzi himself pointed out, 'A sculptor's task is much more slow and laborious than that of a painter . . . The use of *objets trouvés* as the raw materials of sculpture makes it possible to suggest a kind of spontaneity that is of the same nature as that of modern painting, even if, as in my case, this spontaneity turns out to be . . . an illusion.'

How different are Turnbull's concerns. Gradually all accretions of association, movement, and gesture that distract from the quintessential experiences offered by each medium are discarded: in sculpture, form; in painting, colour on a rectangle of canvas; and in each case, their precise relationship to the artist and to the spectator. The 'Head' series represent a transitional, reductive stage in this process as the motif is used to suggest things that are non-head, or in the artist's words:

> how little will suggest a head
> how much load will the shape take and
> still read head
> head as a colony
> head as landscape
> head as ideogram
> head as mask, etc.

Mask (1955-56) might suggest several of these possibilities, but it is essentially a vehicle for pure colour used chromatically rather than tonally, most conspicuously blue and its complementary orange, but also red and yellow and their complementaries green and purple. Unencumbered from associations, it is a liberating work and surely one of the most beautiful paintings of our age. Morphet has observed that 'in these paintings Turnbull attempted to make marks having the general character of drawing, but entirely free from denotative significance. This was another means of focusing, for artist and spectator, the autonomous reality of the action and of the work produced.' The next stage in the development of

Turnbull's style was the eschewal of the painterliness which indicates the action of the painter's hand, and a movement towards one-colour painting. He had already produced several nearly monochromatic works before visiting New York for the first time in 1957. Here he saw at first hand the work of all the Abstract Expressionists (except Barnett Newman), being more drawn to the work of Rothko and Still than to gesturalists like de Kooning and Kline, although as Richard Morphet once again points out, 'aspects of the work of Rothko and Kline to which he did not respond were its evocation of the sublime, and its tendency to illusion'. The beautiful and still-experimental paintings of the late 1950s are increasingly thinly painted, emphasizing rather than dissolving the surface. Their soft-edge flashes are a little reminiscent of Rothko; since red gives more saturation and luminosity than the other colours, new ideas would be tried out in a red painting, e.g. *15-1959*; alternatively, other canvases such as

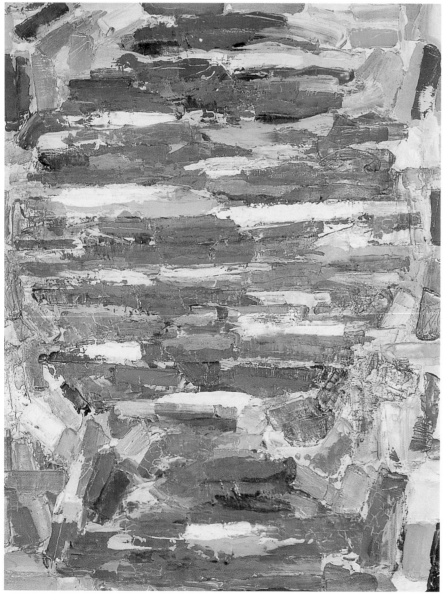

7-1959 are closer to the colour-field painting of Still. This was also a particularly productive phase in Turnbull's sculpture, in which he adopts a Brancusi-like, gnomic language of very simple, self-contained forms in various materials which together make up the often columnar, totemic structures: *Hero, Aphrodite, Magellan, Eve, Sungazer, Oedipus, Lotus* (all between 1958 and 1963).

From about 1958 the paintings are titled by number and year only, and the last vestiges of figuration and *matière* vanish one by one; at about the same time, from about 1963, Turnbull's sculpture follows suit and is based on pure geometry with the subtlest entases or surface embellishments such as burnish-marks or monochromy, and the titles are purely descriptive, not associative: *Duct, Steps, Transparent Tubes, Angle,* and so forth. In a sense the purity of Turnbull's style – not to be confused with rigidity or aridity – makes him an heir of the Constructivists of the 1930s. Like them he saw the artificiality of the traditional divisions of fine art. The large single-colour canvases of 1960 and later seem by their very size and stillness to aspire to the condition of the interior wall, but emphasizing the wall as *Gestalt* and not as the no-thing which it has become in modern architecture. This is implied in the following far-reaching statement of 1963:

> What is the nearest we have come to the equivalent of a temple or shrine in this century (and of this century)? The closest I have got to this experience has been the large exhibitions of Pollock or Rothko; the Monets in the Tuileries (the Nymphéas); and especially the late Matisses exhibited in the Museum of Modern Art, New York. These were for me an experience close to the exaltation of the sacred, a ritual of celebration which avoided the guilt of the Crucifixion or the blood of sacrifice which I often associate with such sensations. Is it a desire to create environmental experiences of this sort that makes some artists prefer personal exhibitions, and find group showing unsatisfactory? It is with some such idea in mind that I work.
>
> As confused ideas about purity were causing architects to banish sculpture and painting from their world, and when the apotheosis of the glass box had almost banished architecture also, sculpture and painting in an outburst of magnificent vitality have been creating heroic personal environments that lack only the necessary walls to be complete.

Turnbull is thus no iconoclast whose object is to make a *tabula rasa* of everything that had previously made a painting interesting (or deplorably bourgeois or dully materialist, depending on one's point of view): association or illusion, theme or subject-matter, shape, movement, seductive colour, or painterly gesture. These blandishments of the old art are indeed jettisoned one by one in his work, but with the

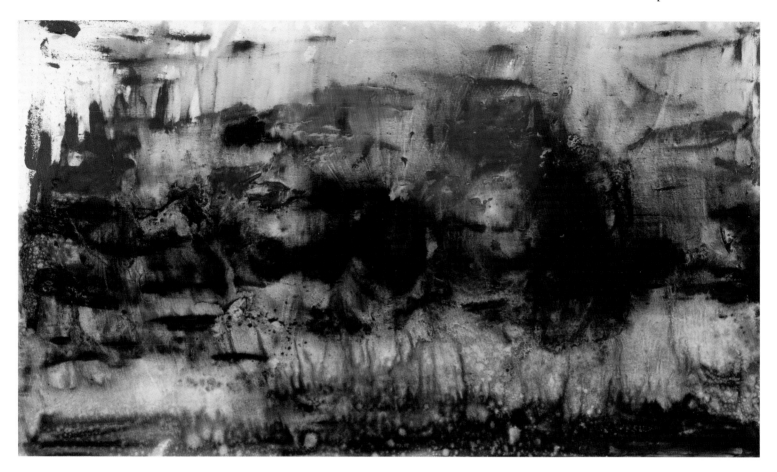

137 William Johnstone
Celebration of Earth, Air, Fire and Water
1974
Oil on canvas, 137.20 x 242 cm
Scottish National Gallery of Modern Art
© Sarah Johnstone

sole aim of enriching and strengthening the oneness of the painting or sculpture, so that we apprehend it, its colour and its form, the more vividly as the thing that it is – a flat, rectangular woven canvas primed and painted with an unmodulated single colour. On the subject of colour Turnbull wrote in 1960: 'I'd like to be able to make one saturated field of colour, so that you wouldn't feel you were short of all the others.' The aim is plenty, not dearth.

Throughout the exciting period of the 1950s when these Scottish artists were prominent members of the *avant-garde*, the abstract painter William Johnstone was Principal from 1947 to 1960 of the Central School of Arts and Crafts in London. Here his imaginative appointments included Paolozzi (from 1949 to 1955) to teach textile design, Davie (from 1953) to the Jewellery Department and Turnbull (from 1952 to 1961) to teach experimental design. Johnstone's administrative and pedagogical activities in London limited his own work as a painter, exactly as those of William Dyce had done over a century earlier. Nevertheless Johnstone continued to experiment in London with an increasingly automatic, tachiste form of abstraction which drew strength (like so much English abstract painting of the same period) from landscape references. *Earth Movement* (1948-49) is built of solidly constructed dense forms which are modelled by light, and whose colours bespeak the green land and the black earth. *Landscape*

(Fields) circa 1954-57 similarly offers a horizon with a delicate line of dripped-on trees (as if in comment on the gravity-defying nature of biological growth) which seem infinitesimally small in the vast scale of the landscape itself. After his retirement in 1960 from the Central School, Johnstone returned to live close to his ancestral roots as a farmer in his native Borders country. In this isolated situation he adumbrated the painterly, gestural, tachiste, auto-matiste style which characterizes his extraordinarily prolific last phase. The *Northern Gothic* series whose title was suggested by Picasso's dealer Daniel Kahn-weiler, begun in 1959 and continued through the middle sixties, are large works in oil which retain a sense of landscape and aerial space, but now light interpenetrates form rather than illuminates its surface. The result is a complex metaphor for the visual world which may suggest many things – the oxygenation of the earth, meteorological forces at play on a vast scale – but which also possesses its own decorative power. These are painted in one colour (usually black) on a white ground. A beautiful later example, however, *Celebration of Earth, Air, Fire and Water* (1974: SNGMA) employs explicit colour-symbolism, with red (fire), blue (water), and green (earth) painted transparently on the visible ground, which is white (air) and is as necessary a component of the colours as oxygen is of the elements of fire, earth and water.

These works clearly anticipate the elliptical, calligraphic watercolours of the 1970s (usually grisaille, sometimes with tiny touches of colour) of which Johnstone latterly painted a large number and of which he would discard many. These seem, like a visual equivalent of five-finger exercises, to have satisfied a daily technical and emotional need to keep in practice. The watercolours show enormous variations of application, from tiny, delicate fossil-like striations, splashes and drips to broad washes which often suggest atmosphere and distance. They form a small-scale counterpart to the mural-sized abstract oils painted at the very end of his life, in which the artist demonstrates his continued willingness to take calculated risks, like a practised actor in performance. In 1973 Johnstone had been working with plaster as a means of mounting his collection of found objects and by accident realized the expressive potential that the unfamiliar material had for him. The result was a series of about twenty large white plaster reliefs which he called *Genesis* and of which he gave the following account: 'I knew that in myself I must produce a condition, relaxed and free from thought or deliberation; that which would be produced through my hands would then be from my inner self and completely unconscious. I throw the lump of crude, wet plaster on the smooth, polished surface; a gesture of creation, a brief experience of the variation of a simple earth movement, and the plaster sets.' Such a view of the artist as the dedicated but self-obliterating medium of his own subconscious was the lasting legacy of Surrealism to Johnstone's quixotically individual practice of abstraction as a painter.

In Johnstone's *Genesis* the exigencies of the search for new ways of expression cracked the old mould of easel painting as the main receptacle of the painter's ideas. Several of the most innovative Scottish artists habitually cross interdisciplinary boundaries, and traditional easel painting does not enjoy its former monopoly. This is related to the fact that never before has graphic design pervaded our culture to the extent true today, and as a corollary, never has technical drawing – in engineering, electronics and the media for example – reached such levels of discipline, inventiveness and skill as in our own day. For these usually anonymous draughtsmen drawing is a serious business and they are very, very good at it. Paolozzi has half-seriously said that he would have liked to be a commercial artist, but it is too difficult. But *hic labor, hoc opus est* – the graphic work involved in industrial or commercial design is only a stage in the long process leading from conception to realization in a vast variety of media, from semi-conductors to jet engines, from chemical compounds to – everything on the production line. It is not an end in itself, and its quality and inventiveness are directly related to that fact, and are not due to aesthetic criteria in the fine art sense. No artist did more to draw this to our attention than Eduardo Paolozzi. His brilliantly inventive sculptural collages from real objects derive their theory ultimately from the ready-mades of Marcel Duchamp and their interest in mechanical drawing from Duchamp's friend and fellow Dadaist Picabia. As we have seen, Paolozzi had actually met Tzara, one of the original Dada circle in Paris. But there is a most significant difference. Paolozzi 'interferes with' his pre-existing material, either by editing it as in the *Bunk!* collection which provided the material for his famous lecture to the Independent Group at the ICA in 1952, or by transmuting it through printmaking or casting processes. And Paolozzi's sources are very different from those of his French predecessors.

'Abstraction' in Paolozzi frequently derives from concrete sources: electronic games or circuit boards, wave patterns, mechanical diagrams or sections of components (cams, valves, the gear wheel). In their use of this polyglot vocabulary his remarkable screenprints show as clear an admiration for the industrial draughtsman as his later sculpture does for the processes and forms of mechanical engineering. As Paolozzi himself famously expressed the matter in a television interview with Jakob Bronowski,

a wheel, a jet engine, a bit of a machine is beautiful, if one chooses to see it that way. It's even more beautiful if you can prove it, by incorporating it in your iconography. For instance, something like the jet engine is an exciting image if you're a sculptor. I think it can quite fairly sit in the mind as much an art image as an Assyrian wine jar.

The *Bunk!* images with which Paolozzi had bombarded his audience in 1952 were culled from a vast collection of toys, robots, games, comics and pulp magazines and also car manufacturer's manuals including reports on terminal collision in automobiles and books on prosthetics and physiology such as *The human Machine and how it works* which were the source of Surrealist images in the matter-of-fact vein of Max Ernst's collages. Ernst's influence is perhaps strongest in the *As is when* screenprints (1965) inspired by Paolozzi's reading of the biography of Ludwig Wittgenstein, in which the artist exploits the experience he had acquired at the Central School of silkscreen printing, a technique then used mostly in the commerical art sphere (a recommendation as far as Paolozzi was concerned). Paolozzi's collection has provided him with a mine of images which are either presented straight or more often collaged, retouched and then photolithographed or photo-etched as in the set of twenty-four prints comprising *The conditional Probability Machine* (1970) and *Cloud atomic Laboratory* (eight tandem images; 1971). Paolozzi's large colour silk-screen prints, which are of breathtaking technical quality, also use collage, but in an infinitely more complex way. *Standard Pacific Time* (1969) for example, includes a section of an internal

combustion engine, a telephone switchboard, a skeleton watch, photographs of model girls and children among its recognizable images, within a framework which apes Op Art – or perhaps the flashing lights of the pin table. The overall result is witty, richly suggestive – and very decorative. *Who's afraid of Sugar Pink and Lime Green?* (1971) is a brilliant example of which the reader may at least imagine the colour scheme. Such images, which date back to Paolozzi's ICA lecture of 1952 and before, are Paolozzi's main contribution to British Pop Art.

The imagery of the earlier collagist sculpture of Paolozzi has been briefly discussed on page 189. Here also, Paolozzi's role as collector of the industrial detritus and junk of the throwaway technological society fed the imagery of his art. But after a two-year tour as visiting professor at the Art School in Hamburg (1960-62), a more positive attitude appears to what the artist calls the machine aesthetic. An unmistakably original, transitional group of sculptures appeared, which combine the anthropoid element visible in the earlier works with an emphasis on a new machine-made look (many of their parts began life as real machine components), but which characteristically retain a sense of fun. They are at once totems of the age of hi-tech, and at the same time strangely friendly, like juke boxes or the machines in a penny arcade. *Konsul* (1962), *Wittgenstein at Casino* (1963), *City of the Circle and the Square* (1963) are three impressive examples. These worshipful entities, with their impressive elevations of straight lines and right angles, are quickly succeeded by an incorrigibly playful tribe of tubular, contorted specimens, much less prone to stand on their dignity or to take life too seriously. *Parrot* and *Crash* (both 1964) – their anatomies are as absurd as the latest scrape they have got themselves into – cast in aluminium and frozen in gesticulating animation, acquire heroic status through the ironic view of the artist. They are a form of homage to Mickey Mouse. A related drawing is titled 'variations on a theme of Micki'. Like so many strip cartoon characters Mickey Mouse is not only anthropomorphic; his experience of life as refreshingly inconsequential and fun, or irritatingly hectic and absurd is actually more lifelike than that of the humankind often portrayed in academic art. *Hamlet in a Japanese Manner* (1966), which like the others is a freestanding sculpture without a base but unlike them is gaily painted, in its complexity and animation, with anthropoid forms that are also part-machine, again suggests the ironic modern hero rather than the tragic or comic hero of the schools. These sculptures adopt a language very different from, but share a perspective on the human condition akin to, that of Marcel Duchamp in *The Bride stripped bare by her Bachelors, even* – human life as seen by a visitor from another planet who can't make head or tail of it all – reminding us again of Paolozzi's roots in Dadaism. It was a logical next step for Paolozzi now to exploit

the new repertory of forms provided by his machine aesthetic. This he does in increasingly abstract pieces, which may be chromium-plated to suggest the smooth perfection of mechanical engineering and also in the case of *Ettso* (1967) to provide a distorting mirror, like a fairground mirror, giving the earnest viewer a comical appearance like Paolozzi's cartoon heroes. In a further equally logical separation of iconography from form, his later ready-mades at once embody his admiration for them as given forms and underline his ironic view of the modern hero. As *Three American Heroes* (1971) Snow White, Batman, and Bugs Bunny appear in their own characters, moulded in rubber; *The Hulk* (1970) in moulded plastic-sprayed chrome; and the engaging *Florida Snail* in black wax.

The anti-modernism of Pop Art was in a sense short-lived because having begun with a wholesale plundering of images from the popular media, it itself soon became an esoteric form. But this did not happen in two cases where the artists concerned had a connection with the most truly popular art form of the sixties and seventies, pop music. Mark Boyle spent part of his early career devising light shows for Jimi Hendrix and The Soft Machine; and John Byrne, whose multifarious talents have enabled him to turn with equal success to writing for the stage and television, and to theatre design as well as painting

138 John Byrne
Self Portrait: The Yellow Cigarette
1986-87
Oil, 76.20 x 76.20 cm
Manchester City Galleries
© Estate of John Byrne and
The Bridgeman Art Library

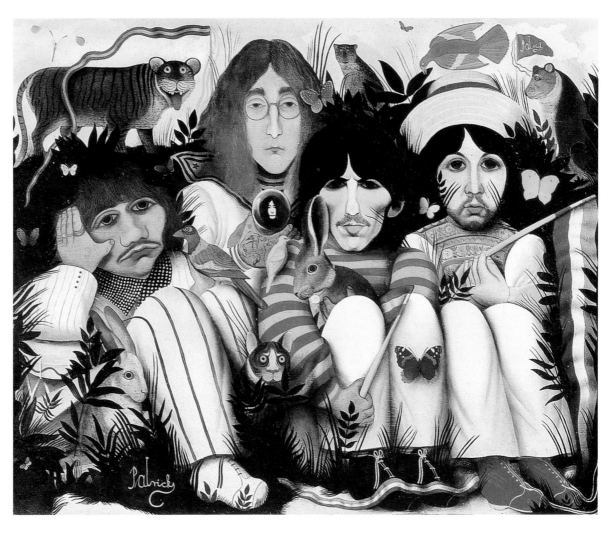

139 John Byrne
The Beatles
c. 1969
Oil on board, 91.40 x 121.90 cm
Private collection
© Estate of John Byrne and
The Bridgeman Art Library

and illustration in a bewildering variety of styles, has the distinction of having painted one of the most evocative as well as one of the most famous of all pop icons, his study of the Beatles for the *Illustrated Beatles Lyrics*. This work, with its obvious debt to the Douanier Rousseau, is signed 'Patrick', the signature Byrne used for the series of dreamlike, *faux-naif* works painted in the sixties and seventies which, despite an initial desire to conceal his authorship of them, have become alternative landmarks of the period. Perhaps no other Scottish painter of our day possesses Byrne's technical mastery; these works carry off the most difficult feats with consummate ease and inventiveness – the folding patterns of a silk scarf, the inner glow of negro skin or of a flower, the surface tension of a drop of water – in images which often include a kind of Simple Simon figure reminiscent of Paul McCartney's *Fool on the Hill* or *Country Boy*. Byrne is still regarded at GSA, where he gained his Diploma in 1950, as one of the most gifted students ever to have studied there. His 'Patrick' style, which was used in a portrait of his friend Billy Connolly (People's Palace, Glasgow) and for record sleeves for the group Stealer's Wheel and for Gerry Rafferty, was only one of several options employed by this chameleon-like artist. Another

manner is a kind of Chardin-like sobriety in still life, yet another a brilliant series of story-board illustrations to his own innovative television drama in six parts, *Tutti Frutti*. Recent self-portraits further demonstrate his quixotic brilliance.

A powerful and fascinating secondary current, of which Paolozzi is a precursor, has run counter to abstract painting and Modernism and offers an alternative to both. To this stream one might give the name of Concrete Art (by analogy with the concrete poetry of one of its main practitioners, Ian Hamilton Finlay) because it is the antithesis of abstraction. We are dealing here with a handful of original individualists whose work has nothing in common except a new objectivity in the literal sense of actually incorporating or reproducing real objects in a way which goes far beyond collage or *bricolage*. Some of the main names which come to mind in this context are the Boyle Family, Hamilton Finlay, Bruce McLean, Rory McEwen, Will Maclean, Robert Callender and Glen Onwin. In their very diverse ways these artists refresh us with visual experiences which are communicated directly and not couched in the elaborate mandarin of one of the contemporary modernisms.

The brilliantly gifted Rory McEwen (1932-82) was the very paradigm of the contemporary artist

who was aware of the challenge of abstraction, and who after long preparation met this challenge in a series of glass sculptures, shown by Richard Demarco in 1969, which were built as box constructions and sometimes incorporated polarized light. The artist explained that his use of glass was dictated by its combination of density and transparency. These qualities allow the constructions to act as a medium for the play of light, so that they become sculptures with light and at the same time display the beauty of the material. Rory McEwen as a painter concentrated to the exclusion of virtually all else on botanical studies, and achieved an unassailable primacy in this field. His *Autobiographical Fragment* relates how Wilfrid Blunt at Eton, who was then working on *The Art of Botanical Illustration,* and Sacheverell Sitwell at Cambridge, were the chief influences that drew him to the study and painting of flowers. He adds:

> I came to modern art largely, it seems, through twentieth-century music; but that is not a matter of regret for me. Today Nature is everywhere abused and insulted, art is everywhere made to serve commerce; too many shallow half-truths pass muster for what they are not, too much of the past is forgotten or misunderstood . . . So I paint flowers as a way of getting as close as possible to what I perceive as the truth, my truth of the time in which I live.

McEwen's art is minimalist in that nothing is added for the sake of interpretation, effect, or expression. But his choice of subject-matter is subjective and is connected to one of the most ancient branches of the art of painting.

Boyle Family (Mark Boyle, b. 1934, his partner Joan Hills, b. 1936, and their children, Sebastian and Georgina Boyle) equally strive for absolute objectivity of treatment. But their objectivity extends also to the subject. In the continuing project *Journey to the Surface of the Earth,* the *1000 World Sites* which they set themselves to record were chosen by a scientifically random method; between 1967 and 1969 darts were thrown by blindfolded friends and family at a map of the world. At each site a metal right-angle is thrown into the air to determine precisely which area of the earth's surface is to become the subject of the work. This area, often measuring six feet square, is then subjected to scrupulous documentation and translated with absolute fidelity from a plastic mould of the surface including all the loose material lying on it, into a fibreglass-based relief which replicates the patina of the original surface with quite startling verisimilitude. These works are indistinguishable to the eye from the real thing; they look like actual slices of road, or field, of whatever surface happens to have been studied. As Boyle Family have increasingly refined their technical means, less and less of the actual is retained, although as Lynne Green explains, 'In the latest pieces real elements – a pebble, a tile, a fragment of carpet – set the standard to which the painted surface aspires.' For these are in a sense paintings: a resin-based paint is used to amplify the fidelity to concrete facts of these works which appear so heavy and are in fact only of about the same weight as a canvas of the same size: they are translucent when seen against the light. By 1990 about sixty of the sites had been recorded.

Mark Boyle in 1966 succinctly put the case for an artistic credo which refused to alter, edit, or interfere with the objective facts of the concrete world:

> The most complete change an individual can effect in his environment, short of destroying it, is to change his attitude to it. This is my objective . . . From the beginning we are taught to choose, to select, to separate good from bad, best from better . . . I believe it is important to accept everything and beyond that to 'dig' everything with the same concentrated attention that we devote to what we consider to be a good painting or a good film . . . I am certain that, as a result, we will go about so alert that we will discover the excitement of . . . our environment as an object/experience/drama from which we can extract an aesthetic impulse so brilliant and strong that the environment itself is transformed.

Although Boyle Family's aim has been to produce as objective a work as possible, as Boyle has said, 'to cut out . . . any hint of originality, style, superimposed design, wit, elegance or significance' in their work, their underlying aesthetic is undeniably original, elegant and significant and the resulting work possesses an inescapable authority directly due to its lack of pretension.

Lack of pretension and a keen eye for pretension in others: are these perhaps traits of the Glasgow character? Like Mark Boyle, Bruce McLean (b. 1944) comes from Glasgow where he studied at GSA before accepting a place on the post-graduate sculpture course at St. Martin's School of Art in London. McLean directs a parodist's caustic barbs at aspects of modern art and above all of modern sculpture, which must be among the most esoteric of contemporary pretensions. The installations and performances through which he pricks the pomposities of the *derniers cris* in the art world are correspondingly esoteric and often ribaldly funny. As a critique of the styles of Henry Moore, Anthony Caro (with whom McLean came into contact at St. Martin's), and of the land artists like Richard Long, McLean's *Pose Work for Plinths* (1971) and *People who make Art in Glass Houses, work* (1969) – photographed performances with himself as sole performer – and *Landscape Painting '68* – a photographed installation – are hilarious and devastating. In fact, McLean has made his own interesting contribution to land art, not by making his own marks on it like Long in England (or Kate Whiteford

(b. 1952) who was trained in Glasgow), but by intervening in, or just simply recording, nature's processes, for example of evaporation *(Evaporated Puddle Work January '68)* or the freezing and melting of water and the action of the wind *(Scatterpiece Woodshavings on Ice '68)*, and photographing the result. With their self-mocking titles and alert respect for nature these 'works' approach the ego-effacing attitude of Boyle Family.

Two slightly younger artists who were contemporaries at ECA, Eileen Lawrence (b. 1946) and Glen Onwin (b. 1947) continue a related vein. Lawrence has concentrated on painting an austerely limited repertoire of such natural forms as feathers, shells and twigs until quite recently in monochrome, and often on scrolls of handmade paper as if in allusion to a fetishistic primitive religion, in other words, suggesting that these simple natural forms possess a power or significance of importance to man, as well as depicting them in and for themselves. Onwin has been equally self-restricting in his interest in the role in nature of one of the simplest compounds, salt, beginning with a series of beautiful photographs of a salt marsh near Dunbar in 1974. The photographs were accompanied by a simple text:

Today I came across a spit of land, a joining of the river to the sea, brackish water, flooding salt resistant grassland, a near grid of circular pools not yet covered by the constant rise, regular with undercut edges, some reflecting back the sky, solid underfoot, one easy leap from land to land, flooding, patterned oily water, mud, undrained, stagnant near the edge, alive, replenished twice daily, high pitched sounds, sea bird wader water, velvet blocks beneath the green of trees.

The fascination for the artist was in the constant change wrought on the appearance of the marsh by the tides, and in the ability of salt, now brine and now crystalline, to change its form in a manner at once inimical to and supportive of life. In a subsequent exhibition, *The Recovery of dissolved Substances,* the eternal metamorphoses of salt itself became the subject of his work in a mixture of media. Onwin's interest in the ecology, in the perfection of the natural world and its vulnerability to the trivial self-absorption of mankind, has provided a logical continuation of his earlier concerns.

But mankind is not wholly unregenerate, or more correctly *was* not so, as we are reminded in the work of Will Maclean, who studied at Gray's School of Art in Aberdeen (1961-67). Here the Principal, Ian Fleming, was at this point painting local landscape and harbour subjects, as was also the exciting Glasgow-trained William Burns (1921-72), whose work combined an Eardley-like vigour and sense of the *genius loci* with a tendency towards abstraction. An ethnic sensibility was in the air. Maclean, a scion of a family of Inverness fishermen, was commissioned in 1973 to undertake a study of ring-net fishing (as opposed to modern trawling) in Scotland. Will Maclean had himself worked as a ring-net fisherman and his fascination with, and deep understanding of, this pre-industrial way of life led to a voluminous portfolio of drawings and diagrams documenting a vanishing aspect of Scottish society. The drawings of the fishing vessels in particular are executed with the precision and attention to technical detail of a marine architect's blueprint; nevertheless, they are redolent of a bygone age, of the shipwright's craft and of the fishermen's skill, and of a nostalgia for a life lived in harmony with nature, when the boats and the tackle had a simple functional beauty often summed up by the evocative names of the vessels themselves. Within the terms defined above, Maclean after this moved into a more concrete phase which began in 1974 and was certainly nourished by his 1973 researches. Using a mixture of found objects, flotsam and jetsam, and carved pieces, he created a series of box constructions, which like the mariner's ship in a bottle, seem to transmit the look, the feeling, the very sounds of a seafaring way of life which now belongs to the past. The sculptor Fred Stiven adopted similar imagery in his carved constructions at about the same time; another artist, Robert Callender (b. 1932), created in painted cardboard similar objects of uncanny realism, like so many specimens towards an archaeology of the pre-industrial world.

140 Boyle Family
Red Sandstone Cliff Study with Blue-Green Veining
1981
Mixed media, resin, fibreglass,
183 x 183 cm
Private collection

Ian Hamilton Finlay's early collection of poetry, *Rapel* (1963), dwelt on the antithesis of the Fauves and the Suprematists: a script which might almost have been written to William Turnbull's swing from the pure colour of the *Head* series to the Minimalist purity of his work of the early 1960s. Like Paolozzi, Hamilton Finlay (1925-2006) too was interested in the linguistics of style, and he appropriated the Classical mode in much the same way as Paolozzi adopted the language of Dada and Surrealism. But whereas Paolozzi employed Dadaist collage and Surrealist juxtapositions to comment powerfully on the machine age and man's place in it, Hamilton Finlay's approach was more strictly philological, that is, more concerned with specific individual words or images as concrete entities and with their relationship to actuality. Hamilton Finlay's art, which comes in unexpected and original forms, most frequently executed by other hands under his direction – carved stone tablets, postcards with printed line drawings, screen-prints whose imagery seems in its simplicity the opposite of *avant-garde*, all invariably accompanied by an inscription or title – attempts to bring us as close to absolute truth as language can, whether visual or verbal. Again like William Turnbull he operates reductively by dispensing with or eliminating everything extraneous to 'the thing itself' which he wishes to describe. Since unlike Turnbull, however, he is also dealing with words, he must take account of the objects embodied by nouns, or the action by verbs. Or, put the other way round, the object will suggest a word, a title, which will then be suddenly and clearly illuminated by juxtaposing it with another word or object. For example, in his garden 'Little Sparta' at Stonypath, planned, as he would say, not as a 'retreat' but as an 'attack' of Classicism against Modernism, a tree bears the simple label

A PINNATE EVERGREEN
sea

The presence of the single word 'sea' suddenly reveals sea and tree with brilliant clarity, thus. The botanical word pinnate describes how the branches of the tree grow laterally from the trunk and also the way the needles grow out from the branches; the word 'sea' reminds us that this is also how waves are constructed in appearance, with lines running up and down their slopes joined by their crests in a single long line. We now visualize 'sea' as ramified by as many 'pinnate' waves as there are branches in the tree, and we have a colour, 'evergreen' for each, which describes sea by tree and vice versa. The image is extraordinarily complete. It even operates out of context, on the page; in front of the actual tree it must seem richer still. It does not suffer from the pathetic fallacy and there is no overlay of emotion or sentiment, nothing in fact which distorts the expression of a pure and significant visual perception. Similarly

THE CLOUD'S
ANCHOR
swallow

describes to our mind's eye the swallow, with its swept wings resembling the arms of an anchor, suspended on an invisible cable far below the cloud, but it also makes us visualize a (unmentioned) ship riding at anchor.

Perhaps these two small examples (they are in fact physically tiny: Hamilton Finlay characteristically works on a miniature scale) indicate something of his visual quality as a conceptual poet. In the screen-prints and carved tablets and inscriptions, words whether titles or inscriptions are an indispensable pointer to the meaning of the work. *The Little Seamstress* (1970: screenprint with Richard Demarco) may on one level be the name of the little gaff-rigged yawl whose wake makes a line of ripples like little stitches on the surface of the calm water behind her, but the name also draws attention to the action of her hull going through water like a needle drawing the thread through the cloth in a line of little stitches. In *Homage to modern Art* (1976: screen-print with Jim Nicholson) an equally pretty gaff-rigged two-master with tan sails (perhaps a sturdy Thames barge; certainly a venerable design) sports a Robert Indiana-like two-colour triangle on its topsail. Modern art, it is suggested, has no momentum of its own and is merely carried along by the seaworthy barque of the classic art of the past; it is the gaudy and unnecessary gilding on the lily (to mix metaphors) whose sole purpose is self-advertisement.

Hamilton's Finlay's thematic material is restricted to a narrow compass – the sea and sailing boats, the reflection of natural cycles in his garden; as a minor diversion, the distorted Classicism of Nazism or the French Revolution; and, as a major distraction, his polemical warfare waged against a philistine Establishment: 'Whenever I heard the words Scottish Arts Council I reach for my water pistol.' He is fascinated by the forms and inscriptions of classical civilization and as an extension of this, by the more recent manifestations of 'classic' design in a single area, boat design. Thus we find *Mozart* personified as that ultimate in sailing ships, the four-masted ocean-going clipper under full sail; *Kandinsky,* as a modern destroyer, superstructure bristling with the bizarre shapes of its instruments of aggression. The inscriptions on stone set in his garden may consist of words only, as

ONE.ORANGE.ARM
OF.THE.WORLD'S
OLDEST.WINDMILL
autumn

which prompts the visitor to the garden to meditate on the cycle of the seasons. Or, as in *ET IN ARCADIA EGO after Nicolas Poussin* (1976), there may also be a carved image, in this case a tank which

replaces the monument in Poussin's two famous paintings on this theme; hence, 'I, death (and warfare), am also in Arcady.' The latter was actually executed by John Andrew in a style reminiscent of Eric Gill; Finlay always remained at one remove from the imagery he conceived, speaking through the personality of the executant as a further means to Classical detachment.

Ian Hamilton Finlay's styleless approach ran counter to the conscious modernism of many artists in the post-war years. The realization that Britain was not the supreme law-giver in the arts that the Victorians liked to believe her to be had led since the beginning of the century to a more sympathetic and admiring view by Scottish artists of what was happening abroad, especially in Paris. From being the preserve of a few individualists in the days of the Colourists it was logical that modernism – emulation of what was perceived to be best in world contemporary art – should become enshrined in the academies and colleges. Colin Thoms, who taught from 1951 to 1977 at Gray's School of Art in Aberdeen, had a Damascus road conversion to the work of Miro at the latter's Tate gallery exhibition in 1963: an experience which Thoms quite correctly has likened to Peploe's earlier discovery of the significance of Cézanne; he might equally have instanced MacTaggart's discovery of Munch, Philipson's of Kokoschka, Alan Fletcher's of de Staël, Paolozzi's of Giacometti, and others too numerous to mention. Yet individualism has always remained strong in Scotland and such movements as Op or Pop Art, *art brut*, *arte povvera* and others have met a limited response. Instead there has been an admirable determination among certain artists to depart from the more stifling aspects of local tradition and to experiment with new modes of expression. Not surprisingly, this was most evident at the newest of the four Scottish art schools, Dundee. In Edinburgh, however, John Bellany and Alexander Moffat boldly set their faces against the *belle peinture* and landscape-and-still-life syndrome by concentrating on a new form of realist figure painting. Bellany's search for a fully contemporary mode of expression is as Anti-modernist as that of Ian Hamilton Finlay, but has led to very different conclusions.

Bellany and Moffat were already well on the way to the foundation of a new school of Scottish Realism in the late 1960s when an interesting group of painters emerged who had recently been appointed to the staff of Duncan of Jordanstone College of Art in Dundee. Introducing an exhibition of their work in 1970, I disclaimed any identifiable 'Dundee style' of painting and pointed out that the seven Dundee artists did not constitute a movement, nor did they seem to adhere to any of the currently fashionable international 'isms'. But certain important links did exist which to some extent set them apart from their contemporaries in Scotland and especially from the new realists in Edinburgh. The Dundee artists

appeared as individualists who all, however, tended at this point in their careers towards great restraint in the use of colour and a high degree of refinement of handling and finish. Such a development ran counter to the recent traditions of Scottish painting, and while there were other young painters in Scotland whose work showed similar tendencies, Dundee seemed to contain a cadre of exponents of this type of painting. Further there was a general unwillingness among the Dundee seven to abandon a figurative mode of expression: Jack Knox (b.1936), Peter Collins (b.1935) and Ian Fearn (b.1934) had recently returned from abstraction to a semi-figurative style, and Neil Dallas Brown (1938-2003), James Howie (b.1931), James Morrison (b.1932) and Dennis Buchan (b.1937) all retained figuration to a greater or lesser degree in their work, although Buchan's diffuse, atmospheric treatment of aerial space comes close to painterly abstraction. My conclusion was that 'what the French have called *la nouvelle figuration* provides the only term which describes the work of the Seven with any degree of general accuracy'.

A figurative element was always conspicuous in the work of Neil Dallas Brown, and he had always been an overtly naturalistic painter. But often the naturalism is more apparent than real. The intertwined limbs and torsos – analogous in form and texture to the pieces of bleached wood occasionally incorporated into his compositions around 1970 – are frequently seen on closer inspection to be imaginary anatomical assemblages which are nonetheless explicitly erotic. The almost monochromatic tonality of these paintings, the strong contrasts of lighting and the smooth modelling of surfaces, achieved by a refined use of thin glazes, produce a soft lyrical quality or alternatively a sombreness sometimes amplified by the presence of a sinister animal figure. Whether the subject be Vietnam, Belfast or a girl in a hayfield, Dallas Brown's paintings possess a dramatic ambivalence at once voluptuous and menacing.

If Dallas Brown was primarily a tonal painter, Ian Fearn is more of a colourist, although his colour tends to be in a low key and he often restricts himself to combinations of not more than two colours. Fearn often uses photography directly in his paintings, transferring a carefully composed image with an air gun through an organdie screen onto the canvas, making delicate alterations to the image in the process. Colour combinations are arrived at by long experimentation, and are sometimes calculated to produce an Op vibration where they meet. *Garden City* (1967: private collection) which is based on a photograph, much interfered-with, of a television valve, appears to represent a mantis-like figure seated at a piano under a crescent moon. There is a distinct feeling too of the strange city paintings of Tàpies (an important influence on Fearn's early work and also greatly admired by Robert Cargill, a Dundee-trained

141 James Howie
Wait
1970
Oil, 162.60 x 177.80 cm
The McManus: Dundee's Art
Gallery and Museum
Dundee Art Galleries and
Museums (Dundee City Council)
© James Howie
Minimalism by Howie, a
landscape specialist associated
with the Dundee Seven.

artist slightly younger than the Dundee Seven). Tàpies was also an influence on James Howie, whose *City Painting* (1964: SNGMA) has a firm structure which evokes an imaginary urban landscape in the atmospheric style of the Spanish artist. But in later paintings by Howie structure became secondary to the effects of light, of increasing lyricism and classical serenity. *Wait* (1970: DAG) is an exquisite example with its minimalist composition, resembling a horizontal fluted column of palest blue suffused with light, suggested by waves at the shore at Broughty Ferry, where Howie was living at the time.

Like James Howie, James Morrison is essentially a landscapist, although he first made his mark with a series of paintings of Glasgow which capture the intimate grandeur of its Victorian terraces as they appeared in the late 1950s before restoration. These remarkable studies, painted in a virtually monochromatic style, are affectionate portraits of the artist's native city and demonstrate the expressive dexterity of his handling of paint.

Morrison began painting Glasgow terraces and

tenements in their sooty but very real grandeur in 1955. In his own words 'The paintings were done for a number of reasons. While I was a student I became friendly with Tom Gardner, an art teacher in the city, and his wife Audrey Gardner. Gardner, along with Bill McLucas and an older teacher George Mcgavin, saw painting in a socially relevant way. They produced works of considerable power and commitment, which in the light of the subsequent development of painting in Glasgow, were well ahead of their time. I learned of their ideas through Gardner particularly and he recommended two books to read – *Goya in the Democratic Tradition* by Klingender, and *The Social History of Art* by Hauser. The Glasgow painters and these two books made me think that simply by looking and recording I could make some valid comment on the city and its people.' Morrison adds: 'As a student rich colour and thick paint were beyond me. I never really responded to the Post-Impressionist paths travelled by many of my colleagues, and in any case could not work adequately in such a language. My hero was Daumier, a

purely tonal painter in whose works colour does not have a prominent role. In the city tenements I had a subject which matched both my social and aesthetic aims and fitted my limited technical ability.'

Morrison moved to Catterline in 1958 and the associations of the village with Joan Eardley encouraged for a time a landscape style less tonal and less descriptive, and painterly in the Eardley manner. Before leaving Catterline in 1965, Morrison had already began to paint landscape with the refined, calligraphic approach familiar today, with the vast horizon of the countryside around Montrose under immense banks of cloud and the details of the landscape indicated with economy and elegance.

Peter Collins too had abandoned an earlier, more painterly manner, reminiscent of the work of John Maxwell with whose style he was familiar from his day as a student at ECA. In his case the transition was abrupt, the first example of a new interest in Magritte after a brief flirtation with geometrical abstraction being the *Winter Rose* exhibited at the RSA in 1969, which indicated a new commitment to very precise drawing and fastidious treatment of detail and finish allied to surreal content and atmosphere. Latterly his work has been more super-real than surreal, and his immense craftsmanship has been devoted to minutely detailed landscapes which call to mind the Scottish Pre-Raphaelite William Dyce (q.v.) who like Collins hailed from the far north of the country and with whom as an artist Collins has more than a little in common. John Gardiner Crawford (b.1941) of nearby Arbroath has developed a similarly concentrated landscape style, although he has no link with the Dundee Seven.

Jack Knox's acrobatic stylistic leaps have included a development in the late 1960s in the direction of a tighter and more controlled style which is the antithesis of the immediacy and exuberance of his own earlier work – and of his later work as well. After study with André Lhôte in 1958, Knox visited Brussels the following year to see the great exhibition of Abstract Expressionism which made a lasting impression on him. Through the early sixties when he was living on the Isle of Bute, he painted a number of essays in various forms of abstraction including a few collages which incorporated objects found on the beach. A little later he developed a de Kooning-like, gestural near-abstraction *(Studio 11.1.64:* MAG) in parallel with a wholly non-figurative manner which made no reference to the rhythms or textures of landscape. The works of this period show something of the influence of Rauschenberg's or Kline's Abstract Expressionism; they are powerful rhythmical and have clue-titles like *Aftermath* (1961: SNGMA), which refers to atomic holocaust; or are riotously coloured and make play with perspective and colour planes in a modern version of Cubism like *Pedestal for Georges* (1965: Cyril Gerber), which is a homage to Georges Braque. In the later 1960s in the *Studio* and *Battle of San Romano* series, formalism takes over completely and we find this painterly artist producing extremely spare, austere compositions, hardly more than coloured drawings, which continue his spatial concerns with a strange repertoire of delicate forms executing a weird ballet in the picture space.

The obvious kinetic bent of his work at this stage – even at its most abstract his work had always suggested movement – was only on one occasion taken to the logical conclusion of a kinetic construction, a sparklingly witty piece which justified the flimsiness of these *jeux d'esprit* of which the artist had begin to tire by about 1972. A visit to the Stedlijk Museum in 1972 provided a clue to the way out of the impasse of minimalism. Negatively, a large exhibition of colour field painting at the Museum depressed him and confirmed his doubts about the path he was currently pursuing in his own painting. Positively, his admiration for the unpretentious directness of the little seventeenth-century Dutch masters of still life had an almost immediate impact on his subject-matter – cheeses, loaves, fishes, lobsters, and on a more modern note, cakes and ale, the beer glass replacing the *rohmer* of the old masters. The title of Knox's *Dutch Still Life: Pronkstilleven* (1977: SAC) pays tribute to the origin of what for him was a new-found freedom to paint with simplicity subjects which offered a welcome relief from the minimalism which he increasingly felt as a constraint. With only an occasional foray at this stage into a rather Hockney-like treatment of interiors, Knox has continued until the present to paint still life and, less frequently, landscape. Returning to his old school, GSA, as Head of Painting and Drawing in 1981, he has in recent years painted some of his most characteristically exuberant works – *Lamp and Oysters* (1980) and *Café* (1981) are among his most successful – which proclaim a revived kinship not only with the values of Braque, but also nearer home with earlier Glasgow contemporaries such as Alan Fletcher and Joan Eardley.

Abstraction, particularly Abstract Expressionism, presented an inescapable challenge to the forward-looking artists of Knox's generation. Two of his contemporaries at GSA, Ian McCulloch (Lecturer in the Architecture Department of Strathclyde University) and William Crozier (Head of Painting at Winchester College of Art), were among those to respond; and in Aberdeen Knox's friend Ian McKenzie Smith (Director of Aberdeen Art Gallery) and William Littlejohn (Head of the Painting School at Gray's School of Art) came close, approaching abstraction from different aspects of external reality. McKenzie Smith's painted low-relief construction *Yellow Celebrator* (1968), with its minimalist geometry and cheerful colour, was something of a landmark of modernism in Scotland; following his return to Aberdeen in 1968 he concentrated exclusively on those minimal but delicately painterly atmospheric paintings described by

142 John Bellany
Kinlochbervie
1966
Oil on hardboard, 243.50 x 320 cm
Scottish National Gallery of
Modern Art
Courtesy of the Artist and
The Bridgeman Art Library

Edward Gage as 'a distillation of some quiet state of weather as it hangs perhaps softly poised over sea-towns, streets or breakwaters'. Philip Reeves (b. 1931), long a lecturer at GSA, employs painted collage in subtle evocations of similar themes.

Less abstract, but abstractionist in tendency, are the landscapists Alexander Fraser (b.1940) in Aberdeen and James Robertson (1931-2010) and Barbara Rae (b.1943) in Glasgow, each of whom occupied teaching posts at the colleges of art in the respective centres. Robertson and Rae frequently used collage in their paintings, Robertson to increase the richness of the picture's surface and to give objecti-vity (he often placed the composition within a painted rectangle which is anti-illusionist), Rae unusually employing collage to inject a momentary sense of illusion into her abstracted landscapes. Another Glasgow-trained artist, Duncan Shanks (b. 1937), brilliantly employs a painterly technique involving an almost de Kooning-like use of strong colour applied

gesturally with a loaded brush in large-scale landscapes – a recent group entitled *Falling Water* concentrated in the theme of the Falls of Clyde near the artist's home – which are among the most exciting landscape paintings produced in Scotland in recent years. Archie Forrest (b.1950) is another painterly landscape specialist whose work, with its powerful and subdued colour harmonies, contains that earthy vibrancy which the Glasgow painters of the post-Donaldson era have made peculiarly their own.

To celebrate the twenty-fifth anniversary of the Edinburgh Festival, and as a counterblast to the Düsseldorf exhibition staged at the College of Art in the previous year by Richard Demarco, which had featured the work of Joseph Beuys, ECA in 1971 assembled an exhibition which surveyed twenty-five years of work by artists who had been students at the College. This show was inevitably somewhat heterogeneous as it represented more than 140 artists,

nearly a dozen of them on the College staff. Nevertheless it was instructive to see on the one hand the ubiquitous evidence of the continuity of the Edinburgh manner – the first Edinburgh School were represented, then Robin Philipson, Penelope Beaton, Margaret Hislop, John Houston, Elizabeth Blackadder, David Michie, Denis Peploe, and William Baillie – and on the other, young Modernists such as Gordon Bryce, Derek Roberts, Kenneth Dingwall, James Cumming and others who appeared beside Alan Davie. In this company the work of John Bellany and his friend Alexander Moffat, who exhibited a portrait of the chief literary ally of the new Realism, the poet Alan Bold with his wife, stood out in stark contrast alike with the decorativeness of the Edinburgh School and with the internationalism of the Modernists.

The luxury of hindsight permits us to view John Bellany (b. 1942) as an eloquent link between earlier exponents of the human figure such as James Cowie, Joan Eardley, and Robin Philipson, and the interest in figure painting of the younger painters who have emerged in the past few years. Not that his predecessors in Scotland influenced his development, except negatively. Bellany's humanism springs from a passionate belief that art should be about life and that it should communicate universally recognizable truths. His real mentors have been those northern European masters, past and modern, who have worked within the great humanist tradition. His theme is fallen, suffering humanity, racked by religious doubt, guilt of conscience, the seven deadly sins, mortal dread, weaknesses of the flesh and spirit; but also redeeemed by fortitude, integrity, love. Joan Eardley's figures show a resilient instinct for survival but lack a moral dimension. Bellany provides that extra dimension. He achieves this through an autobiographical perspective and the use of an arcane but legible system of symbols. Alexander Moffat has vividly recorded Bellany's and his own early development, their admiration of the exiled Alan Davie and his rebel status 'as one who had abandoned the Scottish art scene because it was out of touch with the modern movement'. Moffat describes the determination of the young friends to be artists of their own time, their questioning in late 1962 of the premise that modernity was synonymous with abstraction, and their search for a figurative mode capable of dealing with the realities of life in the twentieth century. Certain figurative masters suggested themselves as exemplars: initially Kokoschka, Picasso, Matisse and Léger and then 'Breughel, Bosch, Cranach, Gruenewald, Rembrandt. Munch and Beckmann came later. Oddly enough in this context Goya seemed more a 'northern artist'. In the following year, 1963, Moffat and Bellany were stunned by the power of the French Neo-Classical and Romantic masterpieces in the Louvre by David, Ingres, Géricault, Delacroix and by the master of Realism himself, Gustave Courbet. Courbet's exam-ple, Moffat tells us, led directly to their exhibiting canvases in the open air during the Edinburgh Festival in the three years 1963-65, when Bellany was producing the powerful works of his earliest maturity. The work of these French masters also suggested the possibility of epic scale for modern figure painting, soon to be realized by Bellany in four important works.

Alexander Moffat has written that 'Without an understanding of this essential Scottishness, this absolute identity with the people, the landscape, the sea-coast between Musselburgh and Eyemouth, it is impossible to grasp the real meaning of John's activities as an artist.' (Bellany originates from fishing stock on this part of the Scottish coast.) The fishing community features in Bellany's extraordinary early masterpiece *Allegory* (1964: SNGMA). This is a triptych which shows three gutted fish hung out to dry on three crosses. The fish is the early Christian symbol for Christ and the scene is like a Calvary as each panel is dominated by the crucified fishes; the nineteen bystanders – fishermen, porters, gutters in their working clothes – form a frieze in arrested motion, facing the viewer like an early photograph of tradesmen at work which required the suspension of activity and movement. Like the shepherds in a Piero *Nativity*, they have a still, sober demeanour which suggests both fatigue and awareness, participation. The allegory is of the necessity to life of sacrificial death. The boldly original placing of the three fishes centre stage is as important as it is successful: the arresting image impresses the sacramental dimension of the scene on our minds like a solemn ritual.

In 1965 Bellany moved to London, where he has remained ever since, for three years of study at the Royal College but, as Alan Bold has told us, his house in Battersea and then in Clapham Common has remained an enclave of Scottishness where Bellany continues to paint scenes inspired by his memories of his background among the fishfolk of Port Seton. *Kinlochbervie* (1966) is a large-scale composition which shows figures gutting fish on a long table parallel with the picture plane, and behind them a fishing boat with additional figures one of whom is carrying a piece of tackle which looks like a cross. The allusion is to the Last Supper and, again, to the Crucifixion. *The Obsession (Whence do we come? What are we? Whither do we go?)* painted in 1968, further concentrates the expressive elements of *Kinlochbervie*: this is still a scene of fish guttting, but the facial expressions suggest suffering, even madness, while the figures are either armless like butchered trunks – as if they themselves had suffered the tender mercies of the flensing knife as well as the fish – or, in one case, crossed to form the cross of St. Andrew, or in another, with hands clasped in an attitude of prayer. Bellany's work passes through a dark phase at this period as a result of his visit to Buchenwald concentration camp in 1967, but

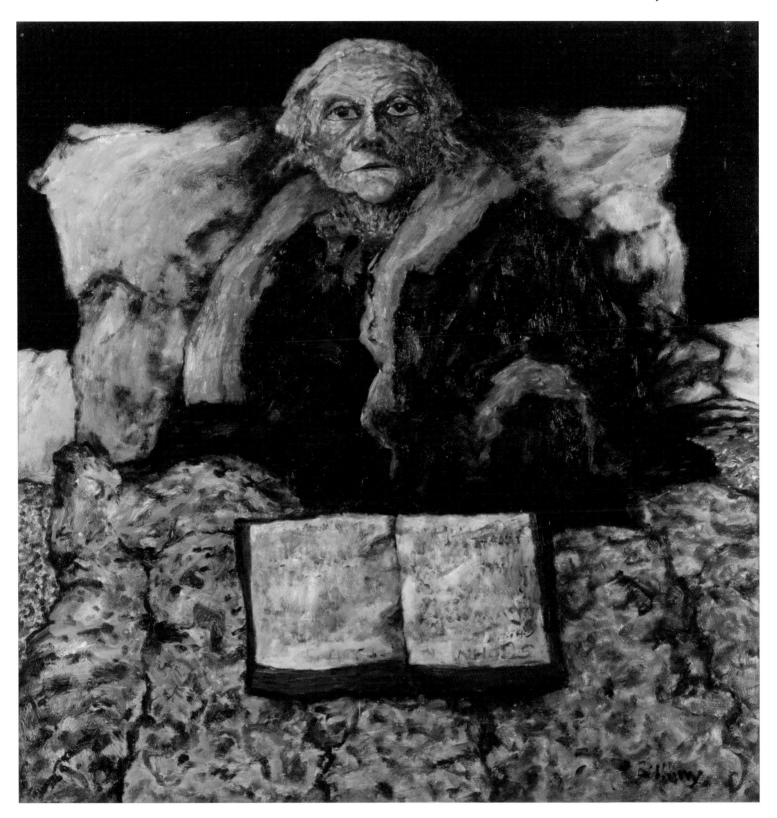

143 John Bellany
The Bereaved One
1968
Oil on hardboard, 91.50 x 91.40 cm
Scottish National Gallery of
Modern Art
Courtesy of the Artist and The
Bridgeman Art Library

astonishingly, man's inhumanity to man is hardly ever taken as a theme; what Bellany conveys is the humanity in suffering man, rather than the agencies through which man suffers. But *Homage to John Knox* may be regarded as an exception; here the strict Calvinist ethos with which the artist was familiar from his own experience of life in a small Scottish fishing village, is portrayed with all the appurtenances of a sinister cult: furtive, minatory priests, baleful religious symbols including a Goya-esque bat, a religion which, it is implied, actively adds to the dolours of matrimony, of work and of conscience. Whether self-imposed or not, humanity's miseries are real enough: the left panel of the triptych has a couple literally chained together in bed, he wearing a prisoner's striped pyjamas, she naked, her face a mask of terror, watched over by priests who clutch symbols of lust, procreation, and holy matrimony; the centre, two fishermen with raddled faces in anguished prayer, and a third holding up a skate so that its disturbingly human face *in extremis* replaces his; the right panel, a Day of Judgement, with a naked woman smiling dementedly like a *dulle Griet* from Bruegel, and a man who raises a broken bottle to his mouth in a gesture which also reminds us of the Last Trump. Several moving portraits were also painted at this point, most notably *The Bereaved One* (1968), a portrait of his grandmother reading the Bible in bed. The dignity of self-knowledge through suffering and recent bereavement is manifest in her gaze as she looks at us and beyond to her own mortality.

The Max Beckmann exhibition at the Tate Gallery in 1965 was perhaps the most crucial single influence on Bellany's work. Here was a modern master working in a figurative expressionist idiom whose concerns were with humanity, with human sympathy and understanding as well as man's inhumanity to man, and who had forged a contemporary vehicle of form and colour to match these humanistic themes. Although the triptych form of *Homage to John Knox,* and its use of the theme of a voyage in the central panel, are reminiscent of Beckmann's *Departure,* just as Bellany's very fine portrait of his sister Margaret (1968) gives her an expression very like that of Beckmann's wife in *Quappi with White Fur,* Bellany's full assimilation of Beckmann was not immediate. It is noticeable that he employed the darker palette and more detailed, old-masterish approach typical of his earlier style as appropriate to the portrait of his grandmother, while the portrait of the younger woman is aptly couched in the more modern idiom of Beckmann. Beckmann's monumentally simple treatment of the figure and his use of strong, expressionist colour increasingly informed Bellany's work throughout the 1970s.

So often regarded as a Realist, Bellany is an artist whose work is permeated by a spiritual dimension. The sign of this is, on the one hand, the invariably moral implications of Bellany's themes: and on the other, the language developed to serve those themes, the bestiary developed in the paintings of the early 1970s – dog/fidelity, monkey/lust, lobster and ram/male desire, fish/Christ, sheep/abnegation – which with the later, more familiar symbolic images of the Cross, the heart, the clock, and the puffin-or fish-mask disguises of the human protagonists (often the artist himself), form a coherent and personal symbolism. The function of these symbols, instantly recognizable though they are in themselves, is the opposite of realistic verisimilitude; they provided a literal glossary on the moral and spiritual themes developed in the paintings. In a later treatment of *My Grandmother* (1971), for example, the subject is now the grandmother as venerable ancestor seated on the bed which at once symbolizes her progenitive role and death, as the lobster she holds also signifies procreation and the means by which a fishing family have gained their livelihood; indeed, their life stems from its death. The theme may be a very Scottish one, but it is also universal.

The Calvinist ethos is never far from the surface. *Madonna* (1971) luridly represents the guilty ecstasy of forbidden female desire. *The Fishers* (1972) shows a further development of the central panel of the *John Knox* picture, but now one of the fishermen on the boat of life holds a skate, which seems to take the part of the man who holds it like a ventriloquist, while another fish provides solace to its capturer like a doll. Is the latter to be seen as taking comfort in religion, or sex? The defeated men seem as much victims of life as the abused fish creatures. A similarly cowed male (a self-portrait) appears in *Lap-Dog* (circa 1973) entering through a doorway with his familiar monkey (desire) a claustrophobic room where a naked woman sits on couch which is also a raw steak, the lap-dog (fidelity) on her bare thigh, and the meekness of her sheep's mask belied by her predatory, carnivorous smile. A ladder symbolizes the gates of Heaven – an ambiguous concept given the presence not only of the object of desire but also of the Christian symbol of the sacrificial fish whose eye witnesses the scene. *Obsession* and *Celtic Feast II* (both 1973) further explore the tensions of holy matrimony, but with a gradual erosion of the distinction between protagonists and symbols; the human figures seem to metamorphose into fishes or animals and vice versa. The triptych *The Sea People* (1974: ACGB) represents a culmination of Bellany's exploration of the theme of the relationship of the sexes through the language of animal-symbolism. Much simplified in colour and form (Hartley has identified a parallel in Munch, whose exhibition the artist would have seen in London in the same year), and indeed, showing a masterly sense of decorative unity, the bridal couple – he wearing a top hat, she represented as a fish – are flanked and witnessed *sub specie aeternitatis* by two familiar, perhaps ancestral, spirits as they journey through their life together. In *Celtic Fish People* and *The Voyagers* (both 1977) the metamorphosis is complete; the figures no longer

carry masks but are literally half-fish, half-human, acquiring a new autonomous reality rather than the borrowed reality of masquerade.

Bellany's paintings of the early 1980s are at once more overtly autobiographical than before, and at the same time are couched increasingly in terms of gestural abstraction. These are revealing and moving documents in which the artist candidly shares with the viewer the vicissitudes of his inner life. *Mizpah* 1978) is an epithalamium which celebrates his marriage, as does *The Voyagers* painted in the same year. Their compositions are respectively dominated by the form of a cross (a sea-harvest suspended from a mast) and the form of a ring (a radar aerial on a fishing boat). But the fish and bird symbols representing the artist and his new wife Juliet are more deeply incorporated into the texture of the painting; the surface forming one painterly continuum in which recognizable forms appear and disappear. The premonitory *Self-Portrait with Juliet* (1980) and *Time and the Raven* (1982) chronicle her illness and the tensions and transience of a marriage which ended with her death in 1985; less overt, but equally passionate, are the more abstract paintings

Time will tell and *Shipwreck* (both 1982) which come closer to de Kooning than any other works by Bellany. Hartley has pointed out that in these works, 'The ancestral voices prophesying doom, formerly restricted to side panels, have come centre stage', and has also drawn attention to their kinship with the new *wilde Malerei* in Germany, as well as to American Abstraction when Bellany was exhibiting for the first time in New York.

Further changes in Bellany's style have mirrored as usual the circumstances of the artist's life. His odyssey has brought him through the perils of serious illness and has brought the hero back to his first wife Helen, their reunion inspiring the profoundly optimistic *Celtic Lovebirds* (1985). Nothing daunted by a major surgical operation in 1988, Bellany produced with the aid of a mirror a remarkable series of watercolour studies of himself starting almost from the moment of his emergence from the anaesthetic. This was entirely consistent with a lifelong practice of art in which the artist always used his own emotions and experiences as the basis of an impressive commitment to their expression and communication in a style of powerful eloquence.

12 CODA

The New Image Glasgow exhibition at the Third Eye Centre in Glasgow in 1985 was the first to present a coherent view of the new figure painting emanating from Glasgow. Organized by Alexander Moffat, who had been an early associate of John Bellany in Edinburgh and had since 1979 been a Lecturer at GSA, it consisted of works by six young artists – Stephen Barclay, Steven Campbell, Ken Currie, Peter Howson, Mario Rossi and Adrian Wiszniewski – for whom the human figure was a central preoccupation, whether as a vehicle of communist propaganda (Ken Currie) or of conundrums in natural philosophy (Steven Campbell), or imaginative fantasy (Wiszniewski) or social realism (Peter Howson). Stephen Barclay and Mario Rossi stood somewhat apart from the others, since Barclay's interest lay in haunted landscapes or interiors where the human presence may only be suggested, while Rossi is a painter-sculptor concerned with a modern re-interpretation of the classical tradition. The New Image paintings demonstrated extraordinary self-certainty: often on a very large scale, they were painted with a raw vigour which did not exclude formidable technical qualities.

Even more importantly, their commitment to the difficult art of the human figure clearly derived from a refreshing desire to communicate rather than from the more usual desire simply to be different. But different they also were. These artists not only had something original to say, but had also found original ways of saying it. *Pace* the Edinburgh writer Alan Bold, the acknowledged influence of Beckmann and the artists of Weimar Germany has had the same importance to Currie and Howson as to John Bellany; like Géricault, Fernand Léger and the Mexican muralists Orozco, Siqueiros and Rivera, the German artists are part of the general education of any artist attempting figure painting on a large scale, but they add an element of contemporary *Weltschmerz* which had commended them to Howson, Currie, Hugh Byars and other young Glasgow painters like Scott Kilgour and Keith Ross who frequented Moffat's studio in the early 1980s. As Ken Currie has said 'At that time, in 1980-81, we were the only students in the art school producing new figurative painting.'

While these students of Alexander Moffat were working towards a figurative style with social relevance or containing social comment, Adrian Wisz-niewski and Steven Campbell were working under the guidance of Roger Hoare in the experimental Mixed Media course at GSA which included performances, some of them staged by the students. This was a radically different route to a new style in figure painting. A memory of Polish folk art, too, informs the work of Adrian Wiszniewski. Campbell adopts the intensely individualistic methods of *faux-naïveté* in pursuit of aims which are far from naïve. It is as possible to refer to Titian's interpretations of Ovid's *Metamorphoses* as to John Byrne's whimsical improbabilities in the 'Patrick' pictures as precedents for Campbell. Each would be equally wide of the mark – and equally true – but it is worth emphasizing that Byrne, in a lighthearted vein, had shown that an alternative treatment was possible for the figure. His Simple Simon figures appear as distant relations to the ingenuous young men who inhabit Campbell's paintings.

The New Image painters have a notably graphic emphasis in comparison with the painterly modern genre of Joan Eardley or the subject-pictures of Sir Robin Philipson. John Bellany's sparer technique and anti-modernist stance, which was also anti-bourgeois, provided an important Scottish precedent for Currie and Howson. Where Sir Robin Philipson's figures inhabit a certain social milieu (even his courtesans look expensive), and his unashamedly decorative colour is very much in the Edinburgh tradition, Bellany's are unequivocally working people and his use of colour is more dramatic than decorative. Bellany's neo-expressionism, like that of two Glasgow contemporaries Anda Paterson and Patricia Douthwaite, involves a return to the figure and human, indeed humanitarian, subjects. Perhaps Peter Howson comes nearest to Eardley's compassionate view of those who live at the margin of society in the inner city. But Howson's denizens of flea markets, the sleazy joints, the betting shops and drinking dens, his winos, prostitutes, thugs and derelicts are on the way down. The artist does not share their rare moments of optimism: *On a Wing and a Prayer* (1980: Summer Collection).

Howson uses the methods of realism based on his memories and observations of life in the Army (he was in the Infantry and boxed for his Division), and in the Gallowgate area of Glasgow near his studio. He infuses into that realism an imaginative vision at

once apocalyptic and monumental. *Regimental Bath* (1985) and *The Great Log Race* (1986: private collection) are large-scale compositions which are obviously based on Army experiences. The powerful concentration of Howson's sense of composition based on the human figure is immediately evident in these large confident works, where any indebtedness to Beckmann, Rivera, or Léger (who are frequently quoted as influences) is submerged in the momentum of the artist's verve as a draughtsman and his monumental treatment of form. Howson, like Bellany, has found inspiration in the work of Géricault, most obviously in the impressive large *The Last Parade* (1986: GAG) modelled on *The Raft of the Medusa*. This frightening vision shows a group of mindless thugs roaming the deserted, hostile city; like so many blind leading the blind, they are in peril of falling to disaster impelled by the one-track energy of the group spirit. Several of Howson's paintings continued the theme of group mindlessness with bodies clambering on each other's shoulders or moving together closely in a kind of unrehearsed drill-parade where everyone's uncoordinated movements impede those of everyone else. On the lighter side of Howson's exclusively masculine world, the football crowd of *Just another bloody Saturday* (1987) comes into this category; on the darker side, *The Fools of God, The Psycho Squad* and *The Stool Pigeon,* and most apocalyptically of all, *Death of the Innocent* (all 1989).

The large pastel study for the complex and monumental composition of *The Last Parade* has a steely tension like a Vorticist drawing and reminds us that for Howson drawing is a nursery of ideas for the larger paintings, whereas Campbell and Wiszniewski develop their ideas in front of the canvas itself. Howson's use of pastel and his extremely impressive graphic works both in etching and woodcut confirm the expressiveness of his line. His powers of observation and ability to create striking compositions were well displayed in his three contributions to the sheaf of lithograph illustrations commissioned for George Mackay Brown's *A Scottish Bestiary* in 1986. *The Mouse* was inspired by the idea of Burns gazing at a 'red, red rose' while a 'wee, sleekit, cowerin', timorous beastie' is seen in the foreground helping itself to the poet's supper; *The Stag* is a stuffed deer's head on the wall of a drinking den with the taxidermist's stitching visible on its snout but with enough intelligence still in its glass eye to remind us that this was once a monarch of the glen, and a good deal more intelligent than its new human companions. *The Moth* brilliantly shows in two views of a single episode a death's-head moth striking the upstairs window of a house where a party is going on and startling the inhabitants. Howson's smaller scale works in the graphic media include a large number of studies of single figures, like *The Seer* (Howson is good at titles) which shows a half-demented blind man sitting on a pavement declaiming like a shaman;

Saint Jim and *Journey's End,* the former beatifically resisting the demonic blandishments of a half-suggested devil with horns at a window – is the devil a pawnbroker, barman, or bookie, or merely friend? – the latter down-and-out on the street by a fire hydrant on which the firemark glows red like a half-imagined scene from hell. This is one of the group of studies which includes *The Heroic Dosser,* one of Howson's most telling compositions in which the craggy figure of the down-and-out stands holding a rail like a heroic oarsman in a storm.

Howson's range of expression is wide. At the darker end of the spectrum his scenes of violence and brutality suggest man's folly and stupidity rather than his capacity for evil. Or rather, that it is these

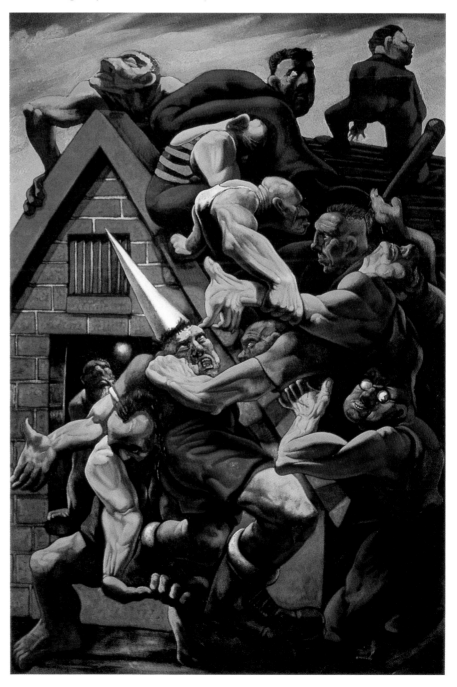

144 Peter Howson
The Stool Pigeon
1989
Oil, 274.50 x 183 cm
Private collection
© Peter Howson, Courtesy
Flowers

qualities in man that create evil. The aggressors are as much victims as the victims themselves; there is little to choose between *The Psycho Squad* and *The Fools of God*. The victims – the dossers, inebriates, prostitutes and the victims of the mob or the gang – may be innocent, but they are also benighted, work-shy, shiftless. The giant man, who is too blind to see that the *Sisters of Mercy* whom he has exploited are sending him over the cliff edge, becomes a victim of the victims because he cannot see what is happening to him. There are no winners, there is only the struggle, with only temporary refuge provided by The Game, whether it be the oldest game or the masculine sports of boxing (*The Stare, Marvin*) or football, body-building or arm-wrestling.

Ken Currie has given us his own account of the steps which led to his figure style which is founded on a belief that art can change society. His study visits to Calderpark Zoo where he was fascinated by 'the idea of incarceration for public display and the related themes of brutality and persecution' took him through the blighted east end of Glasgow. Currie remarks:

> I had never seen such scenes of dereliction . . . The mysterious buildings, machinery and railway sidings of the sprawling Ministry of Defence bomb-making plant at Bishopton fascinated me . . . I saw people moving amidst all this, going about their lives, surrounded by unremitting bleakness and began to identify completely with their plight . . . That whole revolutionary culture which flourished in Europe between the wars remains the richest and most inspiring reservoir of historical precedent and, naïvely, we thought it possible to reproduce that culture in Scotland in the nineteen eighties. In perceiving what we recognised as a period of reaction in Britain, with the ascendancy of the New Right, we saw parallels in Weimar Germany and realised that there could not be a better time in which to produce this new kind of painting.

In his final year at GSA in the Session 1981-82 Currie took many photographs of people and locations all over Glasgow:

> the monolithic Red Road flats, the shipyard gates all along South Street, the huge dusty Meadowside Granary and, across the Clyde, the stark outlines of Govan Shipbuilders; the deserted Queen's Dock with its mysterious rotundas and the powerful shape of the Finnieston Crane; Parkhead Forge, slowly fading away and that whole area around Barrowland, London Road, Celtic Park, Duke Street and the Gallowgate. These locations became vital resources for ideas and images.

Currie then became involved in two further projects which were to persuade him of the validity of the medium of painting as opposed to his early preference for film, and which at the same time clarified in his own mind what his subject matter was to be. As

organizer of a large Third Eye Centre exhibition on unemployment in 1982, Currie again, in his own words

> was confronted with the reality of people's lives in our city and was particularly moved by the spirit of resistance and construction which motivated people in seemingly hopeless situations. I became convinced that artists had to abandon purely aesthetic concerns and directly assist people in communicating that spirit.

The second project, *The Clyde Film*, of which Currie was director, came in 1985 (after Currie had made visits to Europe which brought disillusion at the spectacle of the drab and grim cities of the Eastern bloc, and had experienced the intensest contrasts of despair and optimism in visits to Dachau, and then to the Léger Museum at Biot). Currie tells us that it was during the editing 'surrounded by thousands of feet of film depicting images of Glasgow today and in the past that I decided to take on the theme of Scottish labour history'.

The large, mural-sized paintings and charcoal drawings on this theme have thus had a long gestation. Currie began by reverting to charcoal which he had favoured in his earlier work, and in which he soon showed remarkable mastery, in terms of both handling and composition. His line is incisive and a tendency to mannerism in the treatment of the profile is soon abandoned for a more genuinely observative realism, although he does tend to favour a very limited repertoire of facial types and self-portraiture is ubiquitous. Compositionally many of these large works containing many figures are *tours de force*, combining the utmost clarity with an enormous amount of politically significant detail (inscriptions abound, whether slogans or union banners or book titles, or negatively, the dread words 'bar', 'tattoos', 'amusements' in lurid neon) quite brilliantly fused into a rhythmical, lucid, at times almost decorative whole. Currie's studies of single figures – *Young Mother, Study for The Wandering Man, Shipyard Poet* (all pastel, 1987-8) are close to those of Peter Howson, although polemics are never far from the surface.

The *Glasgow Triptych* (1986: SNGMA) was the first large work completed by Currie since leaving GSA three years earlier, but its confident execution and inventiveness give no hint of his absence from his easel. Three panels, each measuring seven by nine feet, comprising *Template of the Future*, *The Apprentice*, and *Young Glasgow Communists* treat the single theme of a lesson in communist theory conducted round the workers' warming brazier, as the hope of revolution kindles their spirits, in the cold, hard environment where they sell their labour. This work led directly to a commission to paint a mural cycle for The People's Palace Museum in Glasgow to commemorate the bicentenary of the massacre of the Calton Weavers in 1787. Currie tells

us that 'in completing the People's Palace mural I realised that I no longer wanted to deal with history . . . I felt that my new commitments lay in the realities of today and my own urban experiences . . . I wanted to explore the tension, broadly speaking, between self-education and self-destruction in our communities'. This phase, with its contemporary subject matter still set in the same milieu of industrial wasteland, is typified by *A Scottish Triptych* (1987-88: private collection) – *Night Shift, Departure,* and *Saturdays* – where single figures in settings of apocalyptic dereliction express the isolation of the part-time worker, the unemployed, and the young mother who reads a political work as she passes the packed, men-only Riveter's Arms pushing a boy in a pram whose toys, ominously, are a warplane and a war missile. Several of these works do include many figures, but these are now treated with less of the formalism of the mural style. They employ bold effects of light and receding space as well as a palette which is less tonal than in his earlier work. *On the Edge of the City, Boy's Night Out,* and *The Scottish Mercenaries* are among the most powerful images to emerge from the new painting in Glasgow, and they are adequate to the ambitious ideals of the artist who declares that his aim is 'to paint about the realities of the human condition as well as to depict the existing possibilities for world reconstruction'.

Performance Art – pioneered by the Futurists before the First World War and more recently developed by Joseph Beuys whose performances were seen at ECA in 1971 – has a notable Scottish exponent in Bruce McLean, whose work had a considerable bearing on the early productions of Steven Campbell and Adrian Wiszniewski, and has had the effect of helping to concentrate minds again on the human figure and on art as performance, as drama. Campbell and Wiszniewski work improvisationally as figure painters. To the degree that their paintings are composed in execution rather than to a pre-ordained plan, they are records of the artist's performance, as well as presenting a tableau performed by their dramatis personae. As Campbell succinctly put it: 'The painting starts off as one thing and if that doesn't work I try something else until a memory of all these things is in it but none of them is particularly true except the one I've picked to title the work. The picture is a summing-up of all the mistakes; it's what's left.'

Painting is a static art which 'freezes' movement or represents it episodically, or as a kind of optical illusion, a blur, which can then be represented in stasis. Our perception of movement can be recorded cinematically, episodically (as in Futurism) or Impressionistically (as a blur). Steven Campbell (1953-2007) presents us with a jigsaw of interlocking forms in arrested movement, described not merely for their own sake, but for their meaning. His *Footballing Scientist* (1984) is not only not on the ball; he is

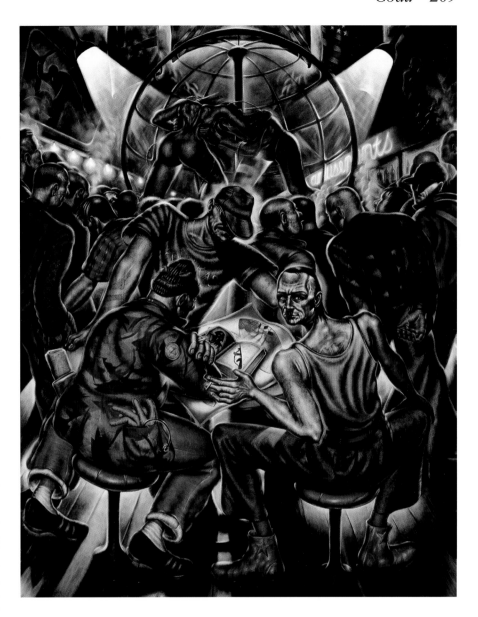

deluded, as there is in fact no ball visible; and inept, since he has fallen into the ridiculous pose of kicking at a ball and missing it. The outlines of each piece of the jigsaw, with the human figure the main element in its composition, is (unlike a jigsaw) no more arbitrarily determined than form and colour are arbitrary elements in composition. Campbell's chief *formal* principle is gesture, which is another way of saying significant movement: his main *thematic* principle is that of metamorphosis. His work was concerned with the constant changes in nature which confound man's desire to control or to keep pace with them. In *After the Hunt* (1983) the two sportsmen have become dimly aware of the bleakness of man's relentless war against Nature; in *English Landscape with a disruptive Gene* (1987) Nature seems in insurrection against the two heavily armed and by now seriously worried sportsmen who are surrounded by rebellious lobsters and a half-human ape. Metamorphosis in Campbell has a Kafka-like literalness – as in the opening

145 Ken Currie
The Scottish Mercenaries
1987
Oil, 274 x 213 cm
Image © Tate, London, 2010
Painting © Ken Currie, Courtesy Flowers

146 Steven Campbell
To the North with Good Luck
1983
Oil on paper laid down,
182.90 x 121.90 cm
Private collection
Courtesy of Marlborough Fine Art
© The Estate of Steven Campbell

often on a large scale, which demonstrates an intensity of creative imagination that placed him on a lonely pinnacle among his contemporaries. The formal density of his work, with its closely-worked surfaces and impenetrable tangle of forms, challenges the visual faculty much as the meaning of his work resists the logical interpretation offered by the engaging titles. In a fascinating radio interview with Professor Martin Kemp, the artist described how the deliberate chaos of his studio provides a kind of mine of ideas which may be gleaned randomly from a book, an illustration, or some similar chance encounter which may provide the means to go forward in the composition on which he is currently engaged. He innocently declares that he never reads any book to its end, which (taken with a pinch of salt) ought to warn us against the temptation of seeing him as an expositor of his favourite authors. He is in fact a true artist who rarely loses sight of the purely visual imperatives of art, which in his case, as we have already noted, relate to a visual language of gesture – significant movement – applied to the metamorphoses of Nature.

The authors who spurred his imagination have included Wodehouse (Campbell's heroes show a Wooster-like propensity for ingenious schemes which have a wildly improbable denouement, as well as sharing Bertie's fondness for 1920s tweeds and turn-ups), Michel Foucault, whose casebook man made of glass who finally becomes invisible provides a recurring theme, and Hume and Darwin, whose writings provide the inspiration for a painting of two of the former's disciples 'preaching causality' to an unheeding Nature, or the (Wellsian more than Darwinian) *English Landscape with a disruptive Gene* or the (very Darwinian) *Portrait of an Island Splitting*, referring specifically to the cataclysm which divided Bali and Lombok and caused their flora and fauna to evolve along different paths. Yet sight should not be lost of the poetic qualities of these works, which interpret the complexity and energy of Nature with a lyrical humanism reminiscent of the late landscapes of Titian or Poussin.

Four main phases are discernible in Campbell's development. In the primitive early works, such as *Man with Spiral Tree* and *To the North with Good Luck* (1983: private collection) the hero is a solitary protagonist against an antagonistic Nature whose elemental presence is suggested by tempes-tuously painted skies. The man with the spiral tree seems a kind of rain god who is able to conjure the elements; the hiker who clutches like a drowning man the kiln unaccountably placed at the summit of a hill – the others who have been there before him were made of sterner stuff – needs luck to reach his goal, but the wishbone has fallen from his grip. In the following year, 1984, at the end of which Campbell held his first major exhibition in Britain which Stuart Morgan titled 'Between Oxford and Salisbury' Campbell begins to paint figures like walking table

sentences of *Die Verwandlung,* when the hero wakes to discover that he has turned into a giant beetle. There is a similarity between his literal description of events which defy logic and that of the New York writer Barry Yourgrau, whose 1984 collection of short stories *A Man Jumps out of an Airplane* appeared in a jacket designed by Campbell. Campbell however, unlike Yourgrau, does not suspend in dreamlike fashion the dramatic unities of time, place and action: Newtonian physics and Darwinian biology are still intact, but they operate in vast indifference to man whose pretensions, endeavours and ambitions are comically unsynchronized with the rest of Nature.

In the space of less than ten years from the Fulbright Award which took him to New York in 1982, Steven Campbell produced a body of work,

sculptures by Giacometti, who are entrammelled by layers of impedimenta – *Through the Ceiling through the Floor* – or who, as lost hikers on an imaginary journey from Oxford to Salisbury, encounter an increasingly mystifying or downright hostile Nature – *Hiker's Ballet with yawning Child, Owl butting Hiker on the Knee, Fall of the House of Nook with Tree Blight* (all 1984) – or teeter on the brink of disaster like the architect hero who stands in hen-toed embarrassment high up on a gargoyle in *Building accusing the Architect of bad Design.*

The pictures assembled for Campbell's exhibition in London in 1987 were introduced by the artist in a 'Pre-Ramble' in the form of a narrative linking several paintings into a cycle:

A man moves to a small town which is traversed by a railway. The town has been designed so that it can grow in only one direction, east, so in consequence the centre of the town is in the west.

The railway is a later development and cuts the town directly in half. He decides after careful consideration to live near the railway, the location offering greater mobility and accessibility to other regions, particularly a small town which at a distance seems to be made from gorgonzola cheese. He is amused by this and remembers Wodehouse talking at length about cheese mites and their impish ways . . .

As time goes by the man becomes disenchanted with life by the tracks and begins to imagine what life is like in the direction west. After various encounters, he decides to head east, in other words home, but not before 28 other small adventures befell him.

The town at first appeared beautiful, until he saw it move. He ran to his home by the tracks, only to see the last chair leg being carried off. He reached to stop this theft but was too weak after his journey. Lying down tired, all his possessions gone,

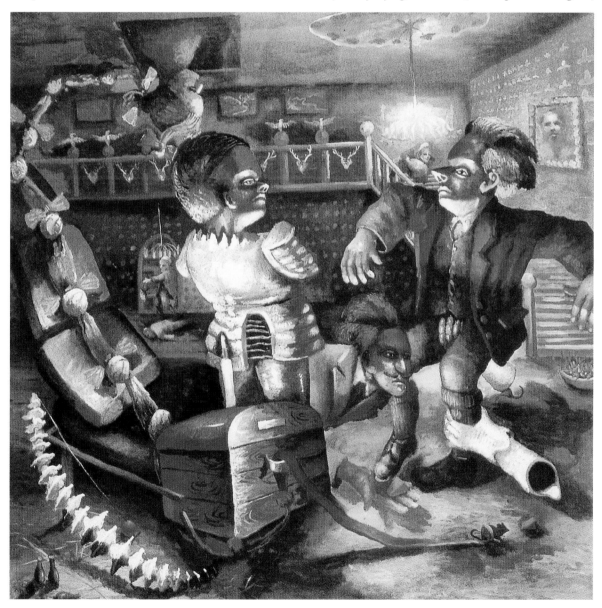

147 Steven Campbell
The Mousetrap: a Play based on the Inability of Animals to breed in Zoos
1986
Oil, 218.50 x 246.50 cm
Private collection
Courtesy of Marlborough Fine Art
© The Estate of Steven Campbell
A 'gothick' scenario strewn, Agatha Christie-like, with clues to meaning.

he saw the last piece of the town disappear, it was a sign which read, west bound to termite town.

The emphasis in these paintings moves from Nature to the natural sciences and there is a concentration too on questions of psychology or psychosis: *Portrait of Rorschach testing himself and finding himself guilty* and *Travelling Silhouette Collector* focusing on problems of identity, while the painting which concludes the cycle in narrative terms, although it was completed in 1986 before some of the others, *Down Near a Railway a Man's Possessions are carried away by Termites,* suggests that the unexplained cataclysm which annihilates the town may have been a man-made catastrophe. Perhaps the most successful of these is the gothic *The Mousetrap: a Play based on the Inability of Animals to breed in Zoos.* Here the ancestral hall, decorated with views of Etna erupting and with antler trophies, is the zoo whose inmates are the elder brother favoured by primogeniture and aloof but armless in his suit of armour: the disembodied arms catch the other by the leg and by his progenitive equipment. Above them the woman whose head appears upside down has a plait of hair which reaches to the floor but is in the process of ossification to resemble the spinal vertebrae lying on the floor nearby. The men have enlarged snouts like overbred animals which have difficulty in breathing. Campbell's fourth phase, seen in his 1988 exhibition, entailed a development of the play/parable form in paintings which deal with questions of aesthetics, such as the brilliant parody *Collagist in the Drama,* where Picasso's Harlequin lies dead on the ground against a Pointilliste landscape upon which an eighteenth century tapestry imposes an earlier sensibility. In *Down there between a Rock and a Hard Place* Campbell contrasts the megalomania of an architect with the venerable stones which he is intent on dismantling. One should add that Campbell did not invariably paint on a large scale, and that his small paintings equally reveal the vigour of his imagination and his feeling for paint: *Role Reversal* amusingly shows a man delivering a baby to a stork on its roof-

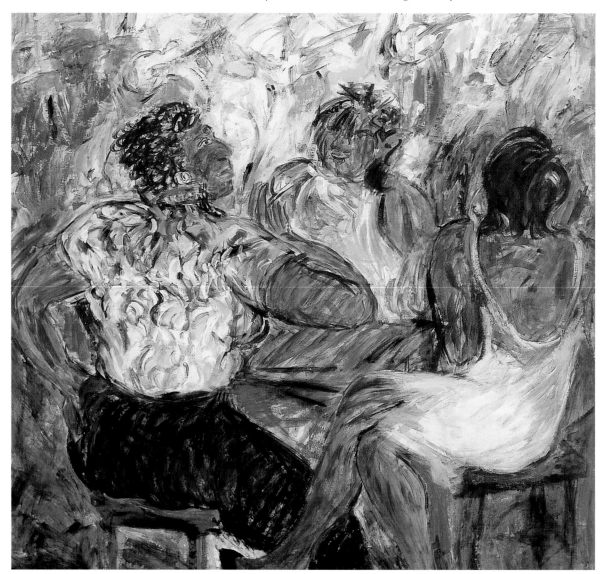

148 Fionna Carlisle
Theresa's Place
1984
Acrylic on paper, 182 x 197 cm
Private collection
© Fionna Carlisle

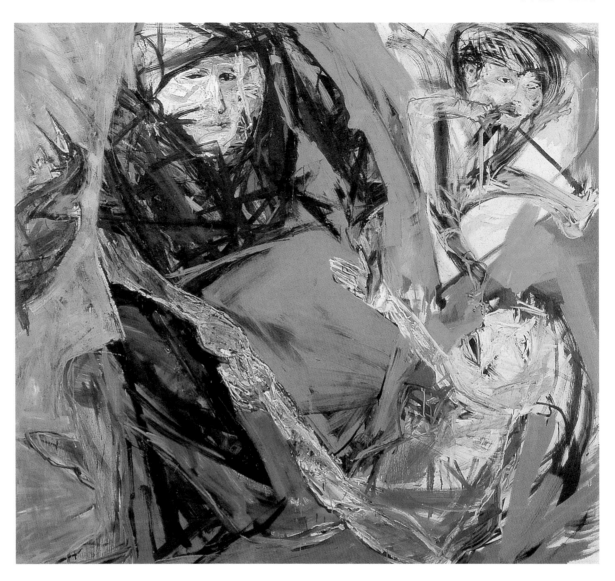

top nest; *Whispering to a Wall evokes* all the secrecy of 'o wall, show me thy chink'; and a little painting of a *Man in a Fire* can be read as a study of panic – or of a man playing bongo drums.

Adrian Wiszniewski (b. 1958), who is of Polish extraction, attended the Mackintosh School of Architecture for four years before studying at GSA, where Steven Campbell was a contemporary, from 1979-83. He attracted a considerable amount of attention, with pictures being bought by the Museum of Modern Art in New York and by the Tate Gallery, in the few years between graduation and his move to Alnmouth in Northumberland in 1986 – 'They don't appreciate art in Scotland unless they're told it's good by someone outside', he commented to Alex Kidson in an interview conducted for his Walker Art Gallery residency exhibition in 1987. His early work was characteristically done in charcoal on paper, with a recurring theme of the dreams of adolescence. These drawings possess an interlacing, meandering, improvised line which at once provides decorative background and a lively, vitalized surface; their spontaneity allows happy trouvailles in the way of symbols,

juxtapositions and staffage of trees, flowers, birds and animals which are cognate with the artist's subconscious intention. Wiszniewski's line provides a kind of *perpetuum mobile* which unifies his compositions as well as defining their subject matter. The dense texture of his earlier work has given way to a more objective placing of the figure or figures – always the same facial type, an alter ego of the artist and a companion – 'the kind of troupe that tours about using the minimum of props, but always does a good job because the actors know each other so well,' as Wiszniewski told Kidson – usually against a plain background of a single colour. *Toying with Religion* (1986-87) is a well-known example of this style and typifies Wiszniewski's use of symbolism. Two young 'non-believers bored with being atheists' literally toy with religion, symbolized in a paraphrase of Marx as a giant opium plant one of them holds as they turn their backs on the distant church building, which stands for conventional or institutionalized religion. However, a literal knowledge of his sometimes arcane use of symbols is not essential to an apprehension of the overall mood – a

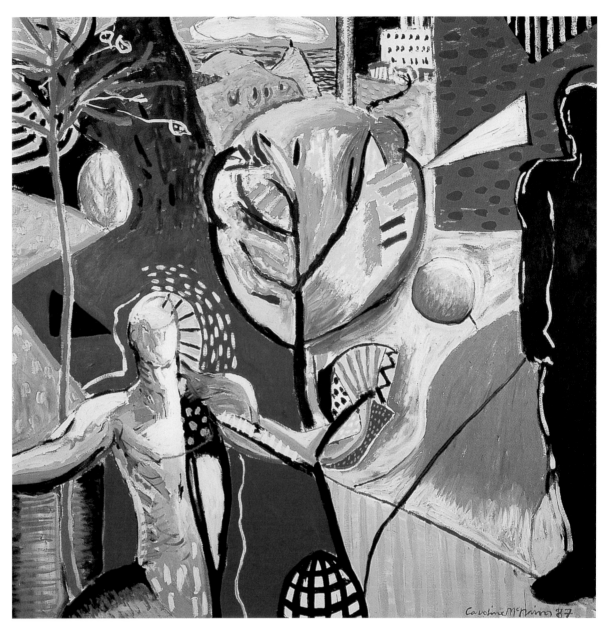

150 Caroline McNairn
In the Making
1987
Oil, 182.90 x 182.90 cm
City Art Centre, Edinburgh
Image © City of Edinburgh
Council
Painting © Caroline McNairn

mood of quiet elegy for the fleeting Arcadia of adolescence – which pervades Wiszniewski's richly decorative paintings and his brilliantly accomplished, complex etchings and woodcuts.

In earlier chapters we have identified something Scottish in an art which is more painterly than linear, more visual than intellectual, more concerned with colour for itself than in any descriptive role. Although these traditional qualities persisted in the work of the Edinburgh School, they were much less evident in the advanced painting of the fifties, sixties and seventies – or for that matter in the New Image Glasgow painting which attracted international attention on a scale not enjoyed by Scottish art since the 'Glasgow Boys' of last century. They reassert themselves in the other of the two main strands to have dominated new Scottish painting in the eighties: the lively 'wild painting' *(wilde Malerei)* emphasizing colour and painterliness and centred to some extent

on the 369 Gallery in Edinburgh. Fionna Carlisle, June Redfern, and in Glasgow Anne Elliot and Alison Harper – the predominance of female talent here is striking, and several other artists could be mentioned, like Sheila Mullen and Caroline McNairn. The latter is the sister of another talented artist, Julia McNairn. As befits the daughter of John McNairn (q.v.), Caroline McNairn's work is strongly francophile and demonstrates a sensitive grasp of a decorative language originating in Matisse's *papiers collés*.

The work of these artists provides a refreshing feminine contrast with the dinosaur masculinity of the communist realism or macho headbangers which the new Glasgow School holds up to our view. Redfern and Carlisle have tended to concentrate on the constructive solidarity of women in modern society or on the theme of woman caught in the web of time or in the turmoil of her own emotions.

Specifically feminist, however, are Gwen Hardie, who has undertaken under Georg Baselitz's direction in Berlin a campaign to turn the female body inside out in order to remind us that it possesses concavities as well as convexities – this must relate to Baselitz's fascinating discovery that a painting representing a human figure when turned upside down will still be a painting; and Sam Ainsley, whose 'warrior women' are paradoxically battling for 'such traditional female virtues as caring and gentleness'. The formal vocabulary employed – Hardie's knotwork of line and Ainsley's adaptations of traditional Japanese costume – in each case seems outweighed by the polemical task it is called on to perform.

Stephen Conroy's degree show at GSA in 1986 announced the arrival of a brilliant new star among the young figure painters of Glasgow. Conroy (b. 1964) immediately became the talk of Glasgow and in a short space of time (via a much publicized lawsuit with his first agent) followed Campbell to the Marlborough stable, Howson, Currie and Wisz-niewski having also signed with London dealers. Conroy was the most outstanding of a 'second wave' of young painters which included a group of 'Glasgow girls' – Rosemary Beaton, Helen Flockhart, Mary McLean, Alison Harper, Margaret Hunter, Karen Strang, Kirsty McGhee and Annie Cattrell – as well as several Dundee-trained artists – Phil Braham (b. 1959), Ian Hughes (b. 1958), Keith McIntyre (b. 1959) and Joseph Urie (b. 1947) who exhibit an absorbing concern with the human figure which enabled the organizers of the SNGMA's compelling survey exhibition *The Vigorous Imagination* to show them with the New Image Glasgow people at the Edinburgh Festival in 1987.

Two things are always noticed about the phenomenally gifted Conroy: the eclecticism of frequent quotation from artists he admires – Degas, Spencer, Sickert, Titian, Rembrandt – and the old-masterish technique, based partly on his assiduous attendance at the Life Class and on an extraordinary natural flair for the craft of painting, with an emphasis on tone and chiaroscuro rather than chromatics, and an ability to employ half-forgotten recipes for coloured varnishes, for traditional scumbles and glazes, which make him seem a repository of the old lore of the artist's pharmacopoeia. (It was wholly appropriate that he was the winner in 1985 of the Harry McLean Bequest for picture restoration at GSA.) The masculine self-sufficiency of the world he portrays, with its profoundly unattractive unsmiling gallery of strangely typecast characters – clubmen, actors or singers, boffins, or businessmen who shelter behind formal dress or impenetrable glasses or tinker with scientific apparatus which all emphasize the feeling of distance from normal life – seems hermetically sealed against the world outside. Or perhaps, rather, it is the artist who feels excluded from this establishment network of experts,

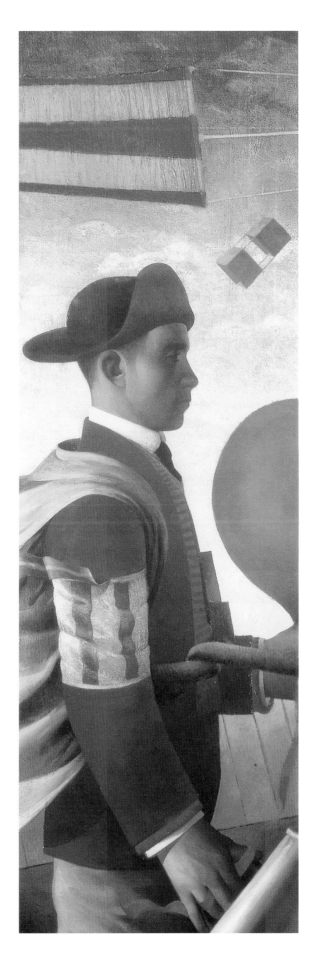

151 Stephen Conroy
Resolve: In a Sea of Trouble He Tries to Scale the Wind
1988
Oil, 182.90 x 61 cm
Private collection
Courtesy of Marlborough Fine Art, London,
© Stephen Conroy

dealers, and parasites. Conroy, whose work seems superficially so realistic and whose success with a wide audience has much to do with this illusion, is in fact a master of the artificial: his tableaux are essentially as puzzling as those of Steven Campbell, but where Campbell tantalizes us with the possibility of interpretation, Conroy's works seems essentially devoid of meaning. Devoid, that is, of referential meaning; as painting, as composition, as *matière*, they have immense presence. An example is *Resolve: In a Sea of Trouble He Tries to Scale the Wind* (1988). Here the single figure, like a quattrocento portrait seen in profile against a blue sky containing a meteorologist's box kite, is lashed (to a mast or wheel) and seems about to launch a red balloon with one hand while the other holds a loudhailer. He is clearly involved in some scientific field exercise, and the wind catches his cape and the brim of his trilby hat, and streams to the horizontal a coloured burgee immediately above his head. Yet the painting seems, despite all this information, to be completely static, nor is there any sense whatsoever of 'resolve' or 'trouble' or indeed any drama other than that of the interesting massing and contrasts of shapes and colours of the composition itself. Conroy's work often contains strong suggestions of mystery, but their drama is less in the human action depicted, however arcane that often is, than in the interaction of the artist's craft with the forms he invents.

In the work of artists as different as Eduardo Paolozzi, Will Maclean and Tom Macdonald, collage offered a direct evocation of the real world; the sculptor David Mach uses real objects to create large structures – a Greek temple, a submarine, a tank, a tidal wave carrying a real piano – made of car tyres, books, newspapers, glass bottles. The photographers Calum Colvin and Ron O'Donnell (both graduates of Duncan of Jordanstone College of Art, Dundee) make permanent chromalin prints from tableaux containing real objects interfered-with and touched-up. Ian Hamilton Finlay habitually crossed dividing lines between concrete and discrete, between verbal and visual art, and between different media. Concrete art, land art, and performance art have all questioned the primacy of the discipline of easel painting in oils.

Despite all the extensions of the boundaries of technique, materials and subject-matter, the challenge of the plane surface will always be there as the ultimate test. Its challenge has been met by Scottish artists of the past with vigour, style, and imagination; the prospect that this independent tradition will continue looks brighter today than it has for many years.

'Scottish painting,' said the critic Brian Sewell when I presented him with a copy of this book, 'does it exist?' Yes indeed, I do contend that Scottish painterliness does exist, non-literary and non-illustrative, seen even in the genre paintings of such different artists as Wilkie, Orchardson, the Glasgow School and the Colourists and more recently in the canvases of Jenny Saville, Steven Campbell and Peter Howson.

Some of these artists have achieved fame abroad: David Wilkie, the Glasgow School, Charles Rennie Mackintosh and Steven Campbell are obvious examples. We read that Brad Pitt, in common with the TV moghuls Don and Eleanor Taffner, admires Mackintosh, Madonna Peter Howson, and David Thomson collects the works of Melville. Andrew Carnegie bought one of the greatest of all William McTaggart's paintings, *The Storm* (now in the National Gallery of Scotland) for his Scottish house at Skibo.

Perhaps the trend may be said to have begun with George III's appointment of Allan Ramsay to the post of Painter-in-Ordinary to the King. Between then and now, although it is possible to argue for the existence of a School, the Scottish School has waxed and waned. Not that artists in Scotland have been any less consistent than their contemporaries. Where now are the snows of yesteryear, where are the New York School or the School of Paris today?

But while McTaggart's generation in the later nineteenth century demonstrated an almost total indifference to Impressionism, and the Colourists sometimes seemed more interested in Auguste Chabaud than in Picasso – and the New York School might almost never have happened as far as Scottish artists were concerned – some artists have been alive to contemporary developments, and have tried to understand them. One thinks of Mackintosh's involvement with Vienna and Cursiter's dalliance with Italian Futurism.

Today Alison Watt's pure style and simple subject-matter (suggesting an admiration for Georgie O'Keefe) and Jenny Saville's Freudian (Lucian, not Sigmund) treatment of very large women, which is carried out with beautiful empathy and an even-more-to-be-admired crisp, tender lyricism, demonstrate that great art and great painting still survive. The paintings of Jack Vettriano, by contrast, which seem to inhabit a demi-monde of courtesans and gamblers, like a twenty-first century version of the louche scenes of Georges de la Tour or the seedy motels and speakeasies of Edward Hopper, lack the same qualities. They are visually starved; perhaps this equates to their thinness of content.

How different is the career of Steven Campbell, whose memorial exhibition was held in 2009 in Glasgow School of Art. Campbell's large recent canvases pursue figure painting with a freshness, invention and vigour astonishing even by his standards. But abstract painting too offers limitless possibilities. This is proven by the huge fresco in gold-leaf which won the 2009 Turner Prize (ahead of a freeze-dried cow's brain) for Richard Wright (b.1960). Such work, with its confident scale and delight in the beauty of abstraction, points at least one way forward.

BIBLIOGRAPHY

GENERAL

Armstrong, Sir Walter, 'Scottish Painters' reprinted from *The Portfolio*, London, 1888

Brydall, Robert, *Art in Scotland; its Origin and Progress*, W. Blackwood, London, 1889

Cursiter, Stanley, *Scottish Art to the Close of the Nineteenth Century*, Harrap, London, 1949

Errington, Lindsay and Holloway, James, *The Discovery of Scotland*, National Galleries of Scotland Exhibition, Edinburgh, 1978

Firth, J., *Scottish Watercolour Painting*, Ramsay Head Press, Edinburgh, 1979

Fowle, Frances, *Impressionism and Scotland*, National Gallery of Scotland, 2008

Gage, Edward, *The Eye in the Wind: Scottish Painting since 1945*, Collins, London, 1977

Gordon, Esmé, *The Royal Scottish Academy of Painting, Sculpture and Architecture 1826-1976*, Charles Skilton, Edinburgh, 1976

Halsby, Julian, *Scottish Watercolours 1740-1940*, Batsford, London, 1986

Hartley, Keith and others, *Scottish Art since 1900*, Scottish National Gallery of Modern Art Exhibition, Edinburgh, 1989

Irwin, David and Francina, *Scottish Painters at Home and Abroad*, Faber & Faber, London, 1975

McKay, W.D., *The Scottish School of Painting*, Duckworth, London, 1906

Macmillan, Duncan, *Painting in Scotland: The Golden Age*, Tate Gallery Exhibition, Phaidon, Oxford, 1986

Rinder, F. and McKay, W.D., *The Royal Scottish Academy 1826-1916*, Glasgow, 1917

Thomson, Duncan, *Painting in Scotland 1570-1650*, Scottish National Portrait Gallery Exhibition, Edinburgh, 1975

Tonge, J., *The Art of Scotland*, London, 1939

CHAPTER 1

Sam Bough RSA, Sidney Gilpin. London, 1905

'Alexander Fraser RSA', Edward Pinnington. *The Art Journal*, 1904, pp. 375-9

Andrew Geddes 1783-1844: A Man of Pure Taste, Helen Smailes. National Gallery of Scotland, 2001

James Giles, Exhibition Catalogue by Fenton Wyness. Aberdeen Art Gallery, 1970

'Notes on Sir John Watson Gordon' by his grand-nephew, R.D. Watson. *The Art Journal*, 1903, pp. 301-4

'The Art of Sir Francis Grant PRA', Jack Gilbey. *Apollo*, 1951, pp. 154, 182

David Octavius Hill and Robert Adamson, Centenary Exhibition Catalogue by Katherine Michaelson. Scottish Arts Council, Edinburgh, 1970

John Knox, Landscape Painter, Exhibition Catalogue by Ian McClure. Glasgow Art Gallery, 1974

William Leighton Leitch: A Memoir, A. MacGeorge. Blackie, Glasgow, 1884

Horatio McCulloch 1805-1867, Catalogue by Sheenah Smith. Glasgow Art Gallery, 1988

Jacob More 1740-1793, James Holloway. Scottish Masters 4, National Galleries of Scotland, Edinburgh, 1987

Alexander Nasmyth 1758-1840, Janet Cooksey. Crawford Centre for the Arts, St Andrews, 1979

David Roberts RA, Helen Guiterman. London, 1978

David Roberts 1796-1864, Artist and Adventurer, Scottish Arts Council Exhibition, Edinburgh, 1982

John Thomson of Duddingston: Pastor and Painter, William Baird. Andrew Eliot, Edinburgh, 1895

CHAPTER 2

William Dyce 1806-1864, A Critical Biography, Marcia Pointon. Oxford University Press, 1979

William Dyce and the Pre-Raphaelite Vision, Edited by Jennifer Melville. Aberdeen City Council, 2006

The Life, Correspondence and Times of William Dyce, RA, typescript by J.S. Dyce (the artist's son). In Aberdeen Art Gallery

Centenary Exhibition of the Work of William Dyce RA, Catalogue by Charles Carter. Aberdeen Art Gallery, 1964

Fact and Fancy, Exhibition Catalogue of Sir Joseph Noel Paton, by A.A. Auld. Scottish Arts Council, 1967

Tales of a Grand-Daughter, M.H. Noel Paton. Privately printed, Elgin, 1970

Memoir of David Scott RSA, William Bell Scott. Edinburgh, 1850

David Scott and his Works, J.M. Gray. Edinburgh, 1884

A studio sale catalogue of David Scott's works was printed by Neill & Co., Edinburgh, 1849

'Pre-Raphaelite Paintings at Wallington: a Note on William Bell Scott and Ruskin', Robin Ironside. *The Architectural Review*, 1942, pp. 147-9

'A Pre-Raphaelite Gazette: the Penkill Letters of Arthur Hughes to W.B. Scott and Alice Boyd 1886-97', William E. Fredeman. *Bulletin of the John Rylands Library*, 49, pp. 323-62 and 50, pp. 34-82

'William Bell Scott: Observer of the Industrial Revolution' by M.D.E. Clayton-Stamm. *Apollo*, 1969, pp. 386-90

CHAPTER 3

The Indefatigable Mr Allan, Exhibition Catalogue by Basil Skinner. Scottish Arts Council, 1973

Alexander Carse c. 1770-1843, Lindsay Errington. Scottish Masters 2, National Galleries of Scotland, Edinburgh, 1987

'William Douglas', James Dafforne. *Art Journal*, 1869, pp. 137-9

The Brightest Ornament: Thomas Duncan RSA ARA by Robin Rodger. Perth Museum and Art Gallery, Scotland, 1995

The Faeds, Mary McKerrow. Edinburgh, 1982

For a discussion of Tom Faed's *From Hand to Mouth*, see Joany Hichberger, *The Mythology of the Patriotic Old Soldier in Academic Art 1815-1880*, in *Patriotism*, ed. R. Samuel. London, 1989

Walter Geikie 1795-1837, Talbot Rice Art Centre Exhibition Catalogue by Duncan Macmillan. Edinburgh, 1984

'John Graham and the Trustees' Academy', Hamish Miles. *Scottish Art Review*, new series, XIV, 4 & XV, 1

Harvey's Celebrated Paintings, Rev. A.L. Simpson. Andrew Elliot, Edinburgh, 1870

'Erskine Nicol ARA', James Dafforne. *Art Journal*, 1870, pp. 65-7

John Phillip, Centenary Exhibition Catalogue, by Charles Carter. Aberdeen Art Gallery, 1967.

Phillip of Spain: The Life and Art of John Phillip 1817-1867, Jennifer Melville. Aberdeen City Council, 2005

Pictures by John Phillip RA, James Dafforne. Virtue, London, n.d.

For Phillip, see also *The Late Richard Dadd*, Exhibition Catalogue by Patricia Alldridge. Tate Gallery, 1974

David Roberts, Helen Guiterman and Briony Llewellyn. London, 1986

David Roberts: Artist and Adventurer 1796-1864, Patsy Campbell. Edinburgh, 1981

William Simson RSA, 1800-1847, Catalogue by Robin Nicholson. The Fine Art Society, Edinburgh and London, 1989

The Life of Sir David Wilkie, Allan Cunningham. 3 vols, London, 1843.

The Etchings of Sir David Wilkie & Andrew Geddes, Catalogue by Campbell Dodgson. The Print Collector's Club, London, 1936

Tribute to Wilkie. Contributions by Lindsay Errington and others. National Galleries of Scotland Exhibition, Edinburgh, 1985

Sir David Wilkie of Scotland, H.A.D. Miles and D.B. Brown. North Carolina Museum of Art, Raleigh, 1987

Correspondence between Wilkie and William Allan is preserved in the National Library of Scotland, Edinburgh.

CHAPTER 4

'Alexander Hohenlohe Burr', James Dafforne. *Art Journal* 1870, pp. 309-11

'James Burr', James Dafforne. *Art Journal*, 1869

'The Life and Work of Peter Graham RA', W. Matthews Gilbert. *Art Journal*, 1899

Master Class. Robert Scott Lauder and his Pupils. Lindsay Errington. National Galleries of Scotland Catalogue, Edinburgh, 1983

The MacWhirter Sketchbook, Introduction by Edwin Bale. London, 1906

Sketches from Nature, John MacWhirter RA, Introduction by the artist's widow. London, 1913

The Life of Sir William Quiller Orchardson RA, Hilda Orchardson Gray. Hutchinson, London, n.d.

Sir William Quiller Orchardson RA, Exhibition Catalogue by W.R. Hardie. Scottish Arts Council, 1972

Sir William Quiller Orchardson 1832-1910, Exhibition Catalogue by Lindsay Errington. National Galleries of Scotland, Edinburgh, 1980

John Pettie RA, HRSA, Martin Hardie. A. & C. Black, London, 1908

CHAPTER 5

'Hugh Cameron RSA', Edward Pinnington. *Art Journal*, 1902, pp. 17-20 and 297-300

'A Few Recollections of Student Days', Hugh Cameron. *The Cairn*, 1911, pp. 6-10

George Paul Chalmers RSA, Alexander Gibson and John Forbes White. David Douglas, Edinburgh, 1879

George Paul Chalmers RSA and the Art of his Time, Edward Pinnington

'The Angus Rembrandt', Charles Carter (on George Paul Chalmers). *Scots Magazine*, 1963, pp. 345-9

The Art of Joseph Henderson, Introduction by Percy Bate. Glasgow, 1908

Robert Herdman (1829-1888), Lindsay Errington. Scottish Masters 5, National Galleries of Scotland, Edinburgh.

'Mr Colin Hunter ARA', n.d. *The Scots Pictorial*, 1898, pp. 295-6

'R. Gemmell Hutchison RSW, RBA,' Gabriel Setoun. *The Art Journal*, 1900, pp. 321-6

'The Works of Hamilton Macallum', James Dafforne. *The Art Journal*, 1880, pp. 149-51

'R.W. Macbeth ARA', A.L. Baldry. *Art Journal*, 1900, pp. 289-92

'Robert McGregor RSA', by James Shaw Simpson. *Scottish Country Life*, 1919, pp. 338 ff.

William McTaggart: A Biography and an Appreciation, Sir James L. Caw. Glasgow, 1917

William McTaggart 1835-1910, Lindsay Errington. National Galleries of Scotland, Edinburgh. 1989

George Manson and his Works, J.M. Gray. Edinburgh, 1880
'Sir George Reid PRSA', G. Baldwin Brown. *Magazine of Art*, 1892, pp. 196-203
Sir George Reid's correspondence with J. Forbes White is preserved at Aberdeen Art Gallery
For J.F. White, see Ina May Harrower's biography, Edinburgh, 1918, and *John Forbes White* by Dorothea, Lady Fyfe, Edinburgh, 1970
Sir James Lawton Wingate PRSA, 1946-1924, Catalogue by Jack Dawson. Fine Art Society, Edinburgh and Glasgow 1990
Two Van Gogh Contacts: E.J. Van Wisselingh, Art Dealer; Daniel Cottier, Glass Painter and Decorator, Brian Gould. Bedford Park, 1969

CHAPTER 6

William Buchanan and the 19th Century Art Trade in London and Italy, London, 1982
D. Y. Cameron: an illustrated Catalogue of his Etched Work, with Introductory Essay & Descriptive Notes, Frank Rinder. James Maclehose, Glasgow, 1900
Joseph Crawhall. The Man and the Artist, Adrian Bury. Charles Skilton, London, 1958
Sir James Guthrie, Sir James L. Caw. Macmillan, London, 1932
Guthrie and the Scottish Realists, Catalogue by Roger Billcliffe. Fine Art Society, Glasgow, 1981
James Watterston Herald, Catalogue by Roger Billcliffe. Fine Art Society, 1981
J. W. Herald 1859-1914, Kenneth Roberts. Forfar, 1988
'E.A. Hornel Reconsidered', W.R. Hardie. *Scottish Art Review*, new series, XI, 3 & 4, 1968
Edward Atkinson Hornel 1864-1932, Catalogue by Roger Billcliffe. Fine Art Society, Glasgow, 1982
Beatrice How 1867-1932 – a Scottish Painter in Paris, Foreword by Arnold Haskell. Fine Art Society, 1979
John Lavery, the Early Career 1880-1895, David Scruton. Crawford Centre for the Arts, St Andrews, 1983
Lavery, W. Shaw Sparrow. Kegan Paul, Trench and Trubner, London, 1911
Sir John Lavery RA, 1856-1941, Introduction by Kenneth McConkey. Ulster Museum & Fine Art Society, London 1984
The Life of a Painter, Sir John Lavery. Cassell, London 1940
Bessie MacNicol: New Woman, Ailsa Tanner. Privately published, 1998
Alexander Mann 1853-1908, Catalogue by Christopher Newall. Fine Art Society, London, 1983
Alexander Mann 1853-1908, Catalogue by Martin Hopkinson. Fine Art Society, London, 1985
Arthur Melville 1855-1904, Catalogue by Gerald Deslandes. Dundee Art Gallery, 1977
Arthur Melville, Agnes Mackay. Frank Lewis, London, 1951
'Francis Newbery and the Glasgow Style', Isobel Spencer. *Apollo*, XCVIII, 1973
The Paterson Family. One Hundred Years of Scottish Painting 1877-1977, Ann Paterson Wallace, Belgrave Gallery, London, 1977
James Paterson, Introduction by Ailsa Tanner. Lillie Art Gallery, Milngavie, 1983
John Quinton Pringle, Centenary Exhibition Catalogue by James Meldrum. Glasgow Art Gallery, 1984
John Quinton Pringle, Exhibition Catalogue by David Brown. Scottish Arts Council, Edinburgh, 1981
James Pryde, Derek Hudson. London, 1949
James Pryde 1866-1941, Foreword by John Synge to Exhibition Catalogue, Redfern Gallery, London, 1988
Edward Arthur Walton, Fiona McSporran. Privately printed, Glasgow, 1987
E.A. Walton, Exhibition Catalogue by Helen Weller. Bourne Fine Art, Edinburgh, 1981
The Glasgow School of Painting, David Martin. Blackie, Glasgow, 1897
The Glasgow School of Painters, G. Baldwin Brown. 1908
The Glasgow Boys, Exhibition Catalogue, ed. W, Buchanan. 2 vols., Scottish Arts Council, Edinburgh, 1968 and 1971
The Glasgow School of Painting, Exhibition Catalogue by William Hardie. Fine Art Society, London, 1970
The Glasgow Boys: the Glasgow School of Painting 1875-1895, Roger Billcliffe. John Murray, London, 1985
A Man of Influence: Alexander Reid, Exhibition Catalogue by Ronald Pickvance. Scottish Arts Council, Edinburgh, 1967
'International Glasgow', Elizabeth Bird. *The Connoisseur*, August, 1973

George Buchanan, 'Some Influences on McTaggart and Pringle', *Scottish Art Review*, new series, XV, 2 draws doubtful conclusions from the mass of valuable infomation on the collecting of French pictures in Britain to be found in Douglas Cooper, *The Courtauld Collection*, London University Press, London, 1953. James Paterson's *Memoir* of W.Y. Macgregor exists in typescript (private collection). Macaulay Stevenson's ms *Notes* and papers are in the William Hardie Collection, Mitchell Library, Glasgow.

CHAPTER 7

George Dutch Davidson (1879-1901). A Memorial Volume, Dundee Graphic Arts Association, Dundee, 1902
'George Dutch Davidson; The Hills of Dream Revisited', William Hardie. *Scottish Art Review*, new series, XIII, 4, reprinted with checklist of Davidson's work, 1973
Jessie M. King, Exhibition Catalogue. Scottish Arts Council, Edinburgh, 1971
Charles Rennie Mackintosh and the Modern Movement, Thomas Howarth, second edition 1977. Routledge and Kegan Paul, London, 1977
'Charles Rennie Mackintosh: Great Glasgow Pioneer of Modern Architecture by David Walker', *Glasgow Herald*, 8 June, 1968
Charles Rennie Mackintosh: The Complete Furniture, Furniture Drawings and Interior Designs, Roger Billcliffe, third edition, John Murray, London 1986. This definitive and beautifully produced book supplements the comprehensive bibliography in Howarth with a list of recent publications on Mackintosh and the Glasgow Style, including Billcliffe's own writings on J.H. MacNair, and *Mackintosh's Architectural Sketches and Flower Drawings (1977)*, *Watercolours (1978)*, and *Textile Designs (1982)*.
Charles Rennie Mackintosh. Margaret Macdonald Mackintosh. The 1933 Memorial Exhibition: a Reconstruction. This reprints Jessie R. Newbery's original Foreword. Fine Art Society, Glasgow 1983
Mackintosh Flower Drawings, Catalogue by Pamela Robertson. Hunterian Art Gallery, Glasgow, 1988
Remembering Charles Rennie Mackintosh. An Illustrated Biography, Alastair Moffat. Colin Baxter, Lanark, 1989
Mackintosh's Masterwork: The Glasgow School of Art, editor, William Buchanan. Glasgow School of Art, Glasgow, 1989
Charles Rennie Mackintosh. The Architectural Papers, ed. Pamela Robertson. White Cockade in association with Hunterian Art Gallery, Oxford, 1990
Newsletter of the Charles Rennie Mackintosh Society, Glasgow, 1973 et seq.
Margaret Macdonald Mackintosh 1864-1933, Catalogue by Pamela Robertson. Hunterian Art Gallery, Glasgow, 1984
Glasgow Society of Lady Artists, Centenary Exhibition catalogue by Ailsa Tanner. Collins Gallery, Glasgow, 1982
The Glasgow Style 1890-1920, Exhibition Catalogue, Glasgow Art Gallery, 1984
Charles Rennie Mackintosh, Architect and Artist, Robert Macleod. Collins, Glasgow, new edition 1983
Founder Members and Exhibitors 1882-c.1920 at The Society of Lady Artist's Club, Exhibition Catalogue. Scottish Arts Council, Glasgow, 1968
Glasgow School of Art Embroidery 1894-1920, Catalogue by Fiona C. Macfarlane and Elizabeth F. Arthur. Glasgow Art Gallery, 1980
'Ghouls and Gaspipes; Public Reaction to Early Work of "The Four"', Elizabeth Bird. *Scottish Art Review*, new series, XIV, 4.
Arts and Crafts in Edinburgh 1880-1930, Catalogue by Elizabeth Cumming. Edinburgh, 1985
Sir Patrick Geddes's papers are held by the National Library of Scotland and by the University of Strathclyde
Anne Mackie's Diary describing visits to France in 1892 and 1893 is in the Manuscripts Division of the National Library of Scotland.
The Evergreen: A Northern Seasonal, editor, Patrick Geddes. 4 vols, 1895-1897, Geddes and Colleagues, Edinburgh.

CHAPTER 8

Three Scottish Colourists, T.J. Honeyman. London, 1950
Three Scottish Colourists, Catalogue by T.J. Honeyman and William Hardie. Scottish Arts Council, 1970, contains a very full Bibliography by Ailsa Tanner

The Scottish Colourists, Roger Billcliffe. John Murray, London, 1989
F.C.B. Cadell 1883-1937. A Centenary Exhibition, Catalogue by Roger Billcliffe. Fine Art Society, London, 1983
F.C.B. Cadell; A Scottish Colourist, Tom Hewlett. Portland Gallery, London, 1988
Stanley Cursiter: Looking Back. A Book of Reminiscences. Privately printed, Edinburgh, 1974
Stanley Cursiter Centenary Exhibition, Catalogue by Erlend Brown, William Hardie *et al.* Pier Arts Centre and William Hardie Gallery, Stromness and Glasgow, 1986
J.D. Fergusson Memorial Exhibition, Catalogue by Andrew McLaren Young. Scottish Arts Council, Edinburgh, 1961
J.D. Fergusson Centenary Exhibition, Catalogue by Roger Billcliffe. Fine Art Society, London, 1974
The Art of J.D. Fergusson, Margaret Morris. Blackie, Glasgow, 1974
Colour, Rhythm and Dance. Paintings by Fergusson and his Circle in Paris, Catalogue by Elizabeth Cumming *et al.* Scottish Arts Council, Edinburgh, 1985
Fergusson's own writings include a short book *Modern Scottish Painting* (Glasgow, 1943); the article 'Art and Atavism: the Dryad' in *Scottish Art and Letters*, I, 1944; a Prologue (written in 1905) to an Arts Council exhibition of his work (Edinburgh 1954); and a 'Chapter from an Autobiography', *Saltire Review*, IV, 21
Introducing Leslie Hunter, T.J. Honeyman. Glasgow, 1937
Peploe: an Intimate Memoir of an Artist and his Work, Stanley Cursiter. London, 1947
'Memoirs of Peploe', J.D. Fergusson. *Scottish Art Review*, new series, VIII, 3
S.J. Peploe 1871-1935, Catalogue by Guy Peploe. Scottish National Gallery of Modern Art, Edinburgh, 1985
For *Rhythm* see also *Anne Estelle Rice*, Exhibition Catalogue by Malcolm Easton. Hull University, 1969
E.A. Taylor's account of pre-1914 Paris (our source for the influence on Peploe and the others of the work of Auguste Chabaud) is the Honeyman papers (private collection).
The Cadell and Peploe ms material quoted is in the possession of the artists' families.
Stanley Cursiter's letters to William Hardie regarding the Futurist paintings of 1913, written in 1973, are in the National Library of Scotland (Manuscripts Division)

CHAPTER 9

Edward Baird and William Lamb, Exhibition Catalogue by James Morrison. Scottish Arts Council, 1968
James Cowie, Memorial Exhibition Catalogue, Introduction by D.P. Bliss. Scottish Arts Council, 1957
James Cowie, Cordelia Oliver. Edinburgh University Press, Edinburgh, 1980
James Cowie, Richard Calvocoressi. National Galleries of Scotland, Edinburgh, 1979
Majel Davidson: an Artist's Life and Influences, Exhibition Catalogue by Frank Matthews. MacRobert Arts Centre Gallery, University of Stirling, 1984
Sir William Russell Flint, R. Lewis and K. Gardner. London, 1988
William Johnstone, Anton Ehrenzweig. Privately printed, London, 1959
William Johnstone, Retrospective Exhibition Catalogue by Douglas Hall. Scottish Arts Council, Edinburgh, 1970
William Johnstone, Douglas Hall. Edinburgh University Press, Edinburgh, 1980
Johnstone's own chief writings are: *Creative Art in England*, London, 1936, *Child Art to Man Art*, London, 1940, and *Points in Time, An Autobiography*, Barrie & Jenkins, London, 1980
James Kay, Exhibition Catalogue by Anne C. O'Neill. Perth Art Gallery, 1987
Henry Lintott RSA, Memorial Exhibition Catalogue by Cordelia Oliver. Scottish Arts Council, Edinburgh, 1967
William McCance, Exhibition Catalogue by William Hardie and Elizabeth Cumming. Dundee Art Gallery, 1975
The McCracken Collection, Illustrated Sale Catalogue. Webb's Auckland NZ, 1985
Mackintosh Textile Designs, Roger Billcliffe. Fine Art Society and John Murray, 1982
John Maclauchlan Milne RSA, 1885-1957. A Centenary Exhibition, Catalogue by Sinclair Gauldie. Dundee Art Gallery, 1985
Alastair Morton and Edinburgh Weavers: Abstract Art and Textile Design 1935-46, Catalogue by Richard

Calvocoressi. Scottish National Gallery of Modern Art, Edinburgh, 1978

James McIntosh Patrick, Catalogue by Roger Billcliffe. Fine Art Society, 1987

Paintings by Four Generations of the McNairn Family, Catalogue by Geraldine Prince. Edinburgh College of Art, Edinburgh, 1987

D.M. Sutherland 1883-1973, Introduction by Adam Bruce Thomson. Aberdeen Art Gallery, Aberdeen, 1974

It's all writ out for you: The life and work of Scottie Wilson, George Melly. Thames and Hudson, London, 1986

Four Colourists of the 1930s I: (Drummond Bone, Francis McCracken, Graham Munro & Anne Redpath) and II: (Majel Davidson, John McNairn, Graham Munro and Edward Overton-Jones), William Hardie. Edinburgh Festival, 1985 & 1989

CHAPTER 10

A Modern Scottish Painter: Donald Bain, W. Montgomerie. MacLellan, Glasgow, 1950

Donald Bain, Exhibition Catalogue by William Hardie and Elizabeth Cumming. Dundee Art Gallery, 1972

Donald Bain, Exhibition Catalogue by Callum McKenzie. Glasgow Print Studio, Glasgow, 1980

Robert Colquhoun, Memorial Exhibition Catalogue. Douglas and Foulis Gallery, Edinburgh, 1963

Robert Colquhoun, Exhibition Catalogue. Kilmarnock, 1972

Robert Colquhoun, Exhibition Catalogue by Andrew Brown. City of Edinburgh Art Centre, Edinburgh, 1981

Robert Colquhoun and Robert MacBryde, Catalogue by Richard Shone. Mayor Gallery, London, 1971

Douthwaite: Paintings and Drawings 1951-1988. Third Eye Centre, Glasgow, 1988

Joan Eardley, William Buchanan. Edinburgh University Press, Edinburgh, 1976

Joan Eardley RSA, Cordelia Oliver. Mainstream, Edinburgh, 1988

Alan Fletcher 1930-1958, Memorial Exhibition Catalogue with Foreword by Benno Schotz. Scottish Arts Council, Edinburgh, 1959

Carole Gibbons, Third Eye Centre Exhibition Catalogue. Glasgow, 1975

W.G. Gillies, Retrospective Exhibition Catalogue, Introduction by T. Elder Dickson. Scottish Arts Council, Edinburgh, 1970

W.G. Gillies, T. Elder Dickson. Edinburgh University Press, Edinburgh, 1974

Dorothy Johnstone ARSA, Exhibition Catalogue by Ian McKenzie Smith *et al.* Aberdeen Art Gallery in association with the Fine Art Society, 1984

Bet Low 1945-1985: Paintings and Drawings. Third Eye Centre, Glasgow, 1986

Robert MacBryde, Exhibition Catalogue. New 57 Gallery, Edinburgh, 1973

Tom Macdonald 1914-1985: Paintings, Drawings and Theatre Designs. Third Eye Centre, Glasgow, 1983

Sir William MacTaggart, Retrospective Exhibition Catalogue, Introduction by Douglas Hall. Scottish National Gallery

of Modern Art and Scottish Arts Council, Edinburgh, 1968

Sir Willam MacTaggart, Harvey Wood. Edinburgh University Press, Edinburgh, 1974

Sir William MacTaggart, Studio Sale Catalogue. Christie's Glasgow, 1981

John Maxwell, David McClure. Edinburgh University Press, Edinburgh, 1976

Anne Redpath, George Bruce. Edinburgh University Press, Edinburgh, 1974

Anne Redpath, Patrick Bourne. Bourne Fine Art, Edinburgh, 1989

Eric Robertson, Exhibition Catalogue by John Kemplay. City of Edinburgh Art Centre, 1974

Benno Schotz: Bronze in my Blood — the Memoirs of Benno Schotz, Gordon Wright. Edinburgh, 1981

The New Scottish Group, Naomi Mitchison *et al.,* Foreword by J.D. Fergusson.

New Painting in Glasgow 1940-46, Exhibition Catalogue by Dennis Farr. Scottish Arts Council, Edinburgh, 1968

The Edinburgh Group. Exhibition Catalogue by John Kemplay. City of Edinbugh Art Centre, Edinburgh, 1983

Independent Painting in Glasgow 1943-56, Text by Louise Annand. William Hardie Gallery, Glasgow, 1990

CHAPTER 11

Craigie Aitchison: Paintings 1953-1981, Catalogue by Helen Lessore and John McEwen. Arts Council of Great Britain, London, 1982

John Bellany: paintings, drawings and watercolours 1964-1986, Text by Keith Hartley, Alexander Moffat and Alan Bold. Scottish National Gallery of Modern Art, Edinburgh, 1986

Elizabeth Blackadder, Judith Bumpus. Phaidon, London 1988

Beyond Image: Boyle Family, Lynne Green. Arts Council of Great Britain Exhibition, 1984

Watermarks: Robert Callender and Elizabeth Ogilvie, Text by Hugh Adams. Scottish Arts Council, Edinburgh, 1980

Alan Davie: Paintings and Drawings 1936-1958, Exhibition Catalogue, text by Bryan Robertson and Alan Davie. Whitechapel Art Gallery, London, 1958

David Donaldson. Painter and Limner to Her Majesty the Queen in Scotland, Catalogue by Anne Donald. Glasgow Art Gallery, Glasgow, 1984

The Edinburgh School 1946-1971, Introduction by William Kininmouth. Edinburgh College of Art, Edinburgh, 1971

Ian Hamilton Finlay, Stephen Bann. Ceolfrith Press and Wild Hawthorn Press, Edinburgh 1972

William Gear, Exhibition Catalogue. Gimpel Fils, London, 1961

Willam Gear. COBRAbstractions 1946-1949, Exhibition Catalogue. Galerie 1900-2000, Paris, 1988

Jack Knox: Paintings and Drawings 1960-1983, Exhibition Catalogue by Cordelia Oliver. Third Eye Centre, Glasgow, 1983

Rory McEwen. The Botanical Paintings, Exhibition Catalogue by Douglas Hall *et al.* Royal Botanic Garden, Edinburgh, 1988

Glen Onwin: i) *Saltmarsh,* Edinbugh, 1974; ii) *The Recovery of Dissolved Substances,* Bristol, 1978

Eduardo Paolozzi. Exhibition Catalogue by Frank Whitford and the artist. Tate Gallery, London, 1971

Robin Philipson, Maurice Lindsay. Edinburgh University Press, Edinbugh, 1976

James Morrison: The Glasgow Paintings, Text by James Morrison and David Walker. William Hardie Gallery, Glasgow, 1990

Sir Robin Philipson, Catalogue by Roger Billcliffe. Edinburgh Festival, 1989

Four Seasons: Paintings by Derek Roberts, Text by Peter Hill *et al.* Tyne & Wear Museums Service, Newcastle-upon-Tyne, 1988

William Turnbull, Exhibition Catalogue by Richard Morphet. Tate Gallery, London, 1973

Seven Painters in Dundee. Catalogue by William Hardie. Scottish Arts Council, Edinburgh, 1970

Scottish Realism, Catalogue by Alan Bold. Scottish Arts Council, Edinburgh, 1970

Richard Demarco Gallery 10th Anniversary Exhibition, Catalogue text by Richard Demarco *et al.* Edinburgh, 1976

CHAPTER 12

Steven Campbell: New Paintings, Exhibition Catalogue. Riverside Studios, London, 1984

Steven Campbell: Recent Paintings, 'Pre-Ramble' by the artist and text by Tony Godfrey. Marlborough Fine Art, London,1987

Steven Campbell: Recent Work, 'Pre-Ramble' by the artist and text by Tony Godfrey. New York, 1988

Steven Campbell: On Form and Fiction, Exhibition Catalogue by Euan McArthur. Third Eye Centre, Glasgow, 1990

Stephen Conroy: Living the Life, Exhibition Catalogue. Marlborough Fine Art, London, 1989

Ken Currie, Exhibition Catalogue by Julian Spalding. Third Eye Centre, Glasgow, and Raab Gallery, Berlin, 1988

Gwen Hardie, Paintings and Drawings, Catalogue by Marjorie Allthorp-Guyton. Fruitmarket, Edinburgh, 1987

Peter Howson: Text by Waldemar Januszczak. Angela Flowers, London, 1987

Peter Howson: The Inhuman Condition, Text by Donald Kuspit. Flowers East, London, 1989

Adrian Wiszniewski, Exhibition Catalogue. Walker Art Gallery, Liverpool, 1987

'Glasgow's Great Hunger for Cultural Saviour', Alan Bold. *Glasgow Herald,* 23 December, 1989

Andrew Brown and Others: Art in Scotland 1987. Published on the tenth anniversary of the 369 Gallery

Alexander Moffat: New Image Glasgow, Exhibition Catalogue. Third Eye Centre, Glasgow, 1985

The Vigorous Imagination. Exhibition Catalogue, text by Keith Hartley *et al.* Scottish National Gallery of Modern Art, Edinburgh, 1987

The Compass Contribution: 21 Years of Contemporary Art 1969-1990. Scottish Arts Council and Compass Gallery, Glasgow, 1990

INDEX

Abbreviations

AAG	Aberdeen Art Gallery
ACGB	Arts Council of Great Britain
BAG	Birmingham Art Gallery
DAG	Dundee Art Gallery
ECA	Edinburgh College of Art
ECAC	Edinburgh City Art Centre
FAS	Fine Art Society, London
GAG	Glasgow Art Galleries
GSA	Glasgow School of Art
HAG	Hunterian Art Gallery, Glasgow
KAG	Kirkcaldy Art Gallery
MAG	Manchester Art Gallery
NGS	National Gallery of Scotland, Edinburgh
NLS	National Library of Scotland, Edinburgh
NTS	National Trust for Scotland
PAG	Perth Art Gallery
RA	Royal Academy, London
RIBA	Royal Institute of British Architects, London
RSA	Royal Scottish Academy, Edinburgh
SAC	Scottish Arts Council
SAG	Stirling Smith Art Gallery
SNGMA	Scottish National Gallery of Modern Art, Edinburgh
SNPGS	Scottish National Portrait Gallery, Edinburgh
TG	Tate, London
WAG	Walker Art Gallery, Liverpool